ART MONSTERS

ALSO BY LAUREN ELKIN

No. 91/92: A Diary of a Year on the Bus
Flâneuse: Women Walk the City

ART MONSTERS / *Unruly Bodies in Feminist Art*

LAUREN ELKIN

Farrar, Straus and Giroux
New York

Farrar, Straus and Giroux
120 Broadway, New York 10271

Printed in the United States of America
Originally published in 2023 by Chatto & Windus, Great Britain
Published in the United States by Farrar, Straus and Giroux
First American edition, 2023

Library of Congress Cataloging-in-Publication Data
Names: Elkin, Lauren, author.
Title: Art monsters : unruly bodies in feminist art / Lauren Elkin.
Description: First American edition. | New York : Farrar, Straus and Giroux, 2023. |
 Includes bibliographical references and index.
Identifiers: LCCN 2023021273 | ISBN 9780374105952 (hardcover)
Subjects: LCSH: Women and the arts. | Women artists.
Classification: LCC NX164.W65 E45 2023 | DDC 704.9/424—dc23/eng/20230609
LC record available at https://lccn.loc.gov/2023021273

Our books may be purchased in bulk for promotional, educational, or
business use. Please contact your local bookseller or the Macmillan Corporate
and Premium Sales Department at 1-800-221-7945, extension 5442, or
by email at MacmillanSpecialMarkets@macmillan.com.

www.fsgbooks.com
www.twitter.com/fsgbooks · www.facebook.com/fsgbooks

1 3 5 7 9 10 8 6 4 2

For Julien
 my little monster
and for Ben
 without whom

These were two of the adventures of my professional life. The first – killing the Angel in the House – I think I solved. She died. But the second, telling the truth about my own experiences as a body, I do not think I solved. I doubt that any woman has solved it yet.

—Virginia Woolf,
'Professions for Women'

She takes up too much space. Also she's mad. Which has nothing to do with anything. She lives in her own world because she makes the whole world hers.

—Kathy Acker,
Eurydice in the Underworld

feminism begins with sensation

—Sara Ahmed,
Living a Feminist Life

contents

the slash

In a 1931 speech addressing a group of young women at the beginning of their professional careers, Virginia Woolf praised the composer Ethel Smyth for the groundbreaking work she did as a woman in an industry dominated by men, calling her 'a blaster of rocks and the maker of bridges'.[1] For women to make their way in the world it is necessary to destroy, Woolf believed, but also to build; to fragment, but also to link. With this in mind I have written this book under the sign of the slash, to remind myself that fracturing and connecting are the essence of art; that it is the work of the writer and of the artist to lay bare the experiences which divide us but also those which link us together.

I've long had a weakness for the form of punctuation that we call in American English the forward slash, what in British English is called a stroke. It's sometimes, but less often, called a solidus, a whack, or a virgule. (In French, a virgule is a comma, and in Latin it means 'twig'.)

I like the way it's used to break things up. Express division yet relation. Or the way it brings disparate things together. Exclusion and inclusion in one stroke. Slash/stroke. Slash slash stroke.

The mark itself is the hieroglyphic equivalent of the verb to cleave, which simultaneously means one thing and its opposite. It slashes/tears, but it also strokes/heals. Against the grain; with the grain.

The slash provides alternatives, which sit together in an uneasy, impossible simultaneity.

The slash conjuncts, and and or, or or and.

The slash divides, and tells us by how much.

The slash activates. In programming, it's used to begin a command. In gaming, in World of Warcraft, or so I hear, it can make your character start to dance.

The slash creates a space of simultaneity, a zone of ambiguity.

The slash joins genres, genders, blurs, blends, invites, marks.

The slash is the first person tipped over: the first person joining me to the person beside me, or me to you. Across the slash we can find each other.

Across the slash, I think we can do some work.

I.

monster theory

jenny offill virginie despentes paul preciado artemisia gentileschi sandra gilbert susan gubar carolee schneemann ann hamilton emma sulkowicz toni morrison suzanne lacy judy chicago sandra orgel aviva rahmani susan stryker lucy lippard linda nochlin lee krasner helen frankenthaler genieve figgis rebecca horn jenny saville yishay garbasz cosey fanni tutti hélène cixous luce irigaray hannah wilke susan sontag theresa hak kyung cha anne carson clarice lispector mary ruefle virginia woolf vanessa bell lynda benglis ebony g. patterson eva hesse chris kraus donna haraway eileen myles nisha ramayya jane marcus

angels and monsters

1931. Virginia Woolf has just had an epiphany in her bathtub.

> I have this moment, while having my bath, conceived an entire new
> book – a sequel to A Room of Ones Own – about the sexual life
> of women: to be called Professions for Women perhaps – Lord how
> exciting! This sprang out of my paper to be read on Wednesday to
> Pippa's society.*

The paper she mentions is an address to the London and National
Society for Women's Service. Only twelve years earlier, the Sex Dis-
qualification (Removal) Act of 1919 had opened the white-collar pro-
fessions to women, easing them out of the domestic space where the
Victorians had wedged them. Whereas in *A Room of One's Own*, Woolf
had 'looked back on the history of women's silences and exclusions',
as Hermione Lee puts it, in the new project Woolf was eager to begin
thinking about what kind of future these professional women might
have before them. She knew that in spite of this legislation, women
still faced acute challenges in becoming, themselves, professionals.[1]
The genesis of 'Professions for Women' indicates she saw the women's
bodies in direct relationship to their professional lives: this intuition
would illuminate her thinking about gender and power for the last
decade of her life.

When she began her career as a writer, Woolf says in her speech,
she experienced a kind of resistance. Not, or not only, from 'the other

* Virginia Woolf, *The Diary of Virginia Woolf, Vol. 4 (1931–35)*, ed. Anne Olivier Bell
and Andrew McNeillie, New York: Harcourt Brace Jovanovich, 1983, pp. 6–7, 20
Jan 1931. Hereafter *D4*. I am indebted to Christine Froula's *Virginia Woolf and the
Bloomsbury Avant-Garde: War, Civilization, Modernity* (NY: Columbia University
Press, 2005) for prompting me to slow down and think about this image of Woolf
in her bath, and all the books that would emerge from this one night.

sex', but from her own, in the form of a figure she calls, famously, the Angel in the House.[2] Self-sacrificing and modest, with nary a desire of her own but to serve those around her, she was 'intensely sympathetic', 'immensely charming', and 'utterly unselfish'. She was also dangerous, slipping ideas about flattery, deception, and purity into the ear of the virginal but ambitious young writer. 'You have got yourself into a very queer position,' she would say. '[Y]ou are writing for a paper owned by men, edited by men – whose chief supporters are men; you are even reviewing a book that has been written by a man [. . .] Therefore whatever you say let it be pleasing to men. Be sympathetic; be tender; flatter; [. . .] Never disturb them with the idea that you have a mind of your own. And above all be pure.'[3] The Angel is well aware of the conditions of production for a young woman: the odds are against her. She will have to curry favour and avoid giving offence, if she is to get along in the world. If you must make art, the Angel implies, make it art they'll approve of.

Woolf was already thinking about this conflict several years earlier, as her 1927 novel *To the Lighthouse* attests. In the last part of the novel, the painter Lily Briscoe has returned to the Scottish isle she visited ten years earlier. In that time, several members of the family have died, including its matriarch, its angel in the house, Mrs Ramsay. Lily remembers, staring at a pattern on the tablecloth, that on her last visit she had been preoccupied with a painting – the problem of the foreground, and where to place a tree – and that she had not been able to bring it off.[4] She sets up her easel, attempts to capture what eluded her then, but she can't work with Mr Ramsay thundering about the place, out of sorts, cantankerous, a widower, like Woolf's own father. 'Every time he approached – he was walking up and down the terrace – ruin approached, chaos approached. She could not paint.' His very presence alters her vision: 'She could not see the colour; she could not see the lines; even with his back turned to her, she could only think, But he'll be down on me in a moment, demanding – something she felt she could not give him.'[5] She remembers from her youth what it is he's after: her own 'self-surrender', like that which she had seen on the faces of women like Mrs Ramsay, 'when on some occasion like this they blazed up [. . .]

into a rapture of sympathy, of delight in the reward they had, which, though the reason of it escaped her, evidently conferred on them the most supreme bliss of which human nature was capable.'[6]

Lily refuses to surrender, and so does Woolf. Faced with the angel's order to be nice, she takes up the inkpot and flings it at her. It is a matter of life and death after all: 'Had I not killed her she would have killed me. She would have plucked the heart out of my writing.'

'She died hard,' Woolf tells us.[7]

/

Or did she?

/

2014. I am struck by a phrase, recognising it without knowing, exactly, what it means. A few pages into Jenny Offill's novel-in-fragments *Dept. of Speculation*, a thunderbolt.

My plan was to never get married. I was going to be an art monster instead.[8]

Art monster.

Google search it.

Nothing; no original point of reference. The expression exists in French: *monstre de l'art*. Someone big and important and unreasonable. Male, obviously. Charismatic, an egomaniac. But in English, not at all. There are some near-rhymes in Chris Kraus's *I Love Dick* ('And I

told Warren: I aim to be a female monster too'), or Angela Carter's *The Sadeian Woman* ('A free woman in an unfree society will be a monster'). 'A woman had to be a monster to be an artist,' said the surrealist painter and sculptor Dorothea Tanning.[9] I find lots of writing about the monstrous feminine. In fact, this is the only connection I can find that associates *women* and *monstrosity* : the female monstrous, the female grotesque.

Dept. of Speculation takes a more realist tack, being a novel composed of the details of daily family life as they swamp the narrator's sense of self. '[A]rt monsters only concern themselves with art, never mundane things,' Offill's narrator reflects, setting women on one side, art monsters on the other: not, or rarely, women, and if women, then women who have renounced the mundane, meaning housework, children, admin: 'Nabokov didn't even fold his umbrella. Véra licked his stamps for him.'[10] Mother or artist, not both. You shall know the art monster by her dirty house, empty of children. Mothers who became art monsters did it by leaving or harming their offspring, through abandonment or suicide or abuse: Doris Lessing, Sylvia Plath, Anne Sexton.

Soon after Offill's novel came out the phrase was everywhere, peppering the personal essays of young women contemplating whether or not they should have children, the challenge and possibly the ontological impossibility of being a mother/wife/artist/monster. Art monster was quickly becoming as popular a phrase in the feminist lexicon as *the angel in the house*.

It seemed to me, however, that there was more to it than the tension between being an artist and having a family. I am the mother of a young child; I am wrapped in this constraint every day. But the art monster problem, more primary, nagged at me for years before my son was born; it was more to do with having grown up a white American female at the end of the twentieth century, groomed to be appropriate, exacting, friendly and accommodating, as pretty and as small as I could make myself, yet filled with rage at not being allowed to take up more space in the world.

And I heard something else too, something I understood implicitly: how difficult it is, when you have been socialised as a woman, to

allow yourself to be monstrous, but also how terrifyingly easy – how inadvertent.

<p style="text-align:center">/</p>

When I started writing this book, I thought it was going to be about monstrosity and creativity, about how difficult it was, for a woman artist, to take up space in the world. That, at least, is what I told my publishers I was going to write about. But as I reread 'Professions for Women' – a revised essay version this time, which Leonard published after Woolf's death – in the context of Offill's term, I realised that I had overlooked an important passage, the climax of it, actually, in which Woolf compares the process of creating to casting her line into the depths of her imagination like a 'fisherwoman', letting it 'sweep unchecked round every rock and cranny of the world that lies submerged in the depths of our unconscious being'. Then, as the line drifts and the thought flows, something happens, something Woolf believed 'to be far commoner with women writers than with men':

> [T]here was a smash. There was an explosion. There was foam and confusion. The imagination had dashed itself against something hard. [. . .] [S]he had thought of something, something about the body, about the passions which it was unfitting for her as a woman to say. [. . .] She could write no more. The trance was over.[11]

This disruption becomes a parable about self-censorship – about the ways in which women's art-making can be halted not by some external force, like a child, or a husband, but by an internalised warning: *alert! alert! we are entering dangerous waters!* As Woolf brings the essay to its conclusion, she returns to the double agenda she initially brought to her speech: the professional and sexual lives of women, identifying them as two of the key challenges of her life as a writer. 'The first – killing the Angel in the House – I think I solved. She died. But the second, telling the truth about my own experiences as a body, I do not think I solved. I doubt that any woman has solved it yet.'

This was it: this was, perhaps, what the art monster was trying to

do. She'd killed off the Angel, but there was still something stopping her. Something she was trying to say, but had been socially conditioned not to. So much of the discourse around the art monster thus far has focused on female artists' lives, but it seems just as crucial to look at their work: at what it was that they were so bent on doing that they ran the risk of being called a monster.

/

The work that remained to be done, as far as Woolf was concerned, had to do with screwing up the courage to remake the cultural tradition as we had received it, and to focus on the embodied experience as the primary means of doing this. Women who write, Woolf urged in *A Room of One's Own*, must learn to break the 'sentence' and then the 'sequence' if they are going to make work that will be truly theirs, free from the Angel's interference.[12] We must hear in this not only *women*, but *anyone who finds themselves outside of grammar*: another definition of the monstrous. What she was after was something like what she describes in *To the Lighthouse*, towards the end of the novel, as Lily struggles to say what she must in her painting: 'Beautiful pictures. Beautiful phrases. But what she wished to get hold of was that very jar on the nerves, the thing itself before it has been made anything.'[13]

In the speech version of 'Professions for Women' – the rawer, more urgent version of these ideas – Woolf explicitly personifies the imagination, giving it, in effect, its own body, with which it darts and rushes, off to the depths, 'heaven knows where'. And then she has to be pulled back, 'panting with rage and disappointment'. ' "My dear you were going altogether too far,'" the fisherwoman tells her.[14] She tries to mollify the offended imagination; it shall not ever be thus, she promises. One day men will be less 'shocked' when a woman 'speaks the truth about her body'.[15] 'We have only got to wait fifty years or so. In fifty years I shall be able to use all this very queer knowledge that you are ready to bring me. But not now.'

'Very well says the imagination, dressing herself up again in her

petticoat and skirts, we will wait. We will wait another fifty years. But it seems to me a pity.'[16]

/

1975. It is not quite fifty years after Woolf's speech. The artist Carolee Schneemann is standing on a table in an art gallery in East Hampton, New York, wearing neither petticoat, nor skirts. In fact she is not wearing very much of anything, save for a dainty little apron, which she soon removes. She has smeared herself with dark paint. She opens a copy of the zine she has written, *Cézanne, She Was a Great Painter*, and begins to read, striking a series of art model poses. Then she puts the book down, widens her stance, and slowly draws a roll of paper from her vagina. It looks a bit like an umbilical cord, thick and helical. She begins to read aloud:

> I met a happy man
> a structuralist filmmaker [. . .]
> he said we are fond of you
> you are charming
> but don't ask us
> to look at your films
> we cannot
> there are certain films
> we cannot look at
> the personal clutter
> the persistence of feelings
> the hand-touch sensibility
> the diaristic indulgence
> the painterly mess
> the dense gestalt
> the primitive techniques[17]

It had been thought that Schneemann was addressing her then partner, Anthony McCall, who was, indeed, a structuralist filmmaker, but in 1988 she told the film historian Scott MacDonald that the monologue was actually addressed to the *Artforum* critic and editor Annette

Michelson, who 'couldn't look at her films', and who kept her out of the feminist canon by not teaching her in her NYU film classes. Several phrases here are apparently things Michelson told her students about Schneemann's work – 'painterly mess', 'hand-touch sensibility', 'diaristic indulgence'.[18] These phrases form a feminist artistic manifesto that makes visible on the page precisely what Woolf's Angel had prohibited her from writing. Coming at the mid-point of the 1970s, Schneemann's *Interior Scroll* crystallises a moment when feminist artists committed themselves to making the body the site of liberation, making art that would extend out forwards and backwards and sideways in time, in a bright constellation of beauty and excess.

'I didn't want to pull a scroll out of my vagina and read it in public,' Schneemann has said, but she believed that performance was made necessary by the terror the culture expressed at her attempts to make 'overt' what it wanted to 'suppress'.[19] With *Interior Scroll*, Schneemann wanted to 'physicalize the invisible, marginalized, and deeply suppressed history of the vulva, the powerful source of orgasmic pleasure, of birth, of transformation, of menstruation, of maternity, to show that it is not a dead, invisible place'.[20] Schneemann gave the female body a way to speak it had not previously been able to access; *Interior Scroll* made the 'vulvic space' visible and legible, allowing it to be potentially procreative, but creative.[21]

When Schneemann died, in 2019, I posted an image from this performance on my Instagram account to pay tribute to her. Instagram took it down.

Schneemann would have expected nothing else. From the earliest days of her career as an artist, her work was censored and attacked for what it dared to depict; as an undergraduate, lacking access to nude models, she painted her naked boyfriend while he slept, his flaccid penis, as well as herself without clothes, and was kicked out of art school. ('No objections were raised to her posing nude for her fellow male painting students,' notes the curator Sabine Breitwieser.[22]) And when she included her clitoris in her *Eye Body* photographs of 1963, the art world recoiled. 'Why is it in the art world rather than a "porno" world?'[23] They called it obscene, pornographic, said it had nothing to do with art.

Ob-scene, possibly derived from *ob-* (in front of) and *-caenum*,

filth.* The obscene puts us in front of filth, what ought to be scrubbed away, or cordoned off. Matter out of place, in the anthropologist Mary Douglas's definition of dirt and impurity. The unseeable parts of the female body are, in art, matter out of place.

In 1991 Schneemann published a perceptive essay on the body, obscenity, and the intersections of professionalism and sexism, called 'The Obscene Body/Politic'. If in the preceding decades women had barged into the art world, she wrote, they were driven by the anger of several millennia at being sidelined as artists: denied their pronouns ('The artist, *he* . . .'), sexualised and 'fetishized', while their actual bodies were characterised as 'defiling, stinking, contaminating'. In a 1990s documentary about women artists, Schneemann says in voice-over, as an image of the *Rokeby Venus* appears on the screen:

> Historically, I was supposed to be confined to a canvas, interred in fact as an image, so the sense that I was authenticated as an image maker who also had a depictive body was an enormous question for me [. . .] could I have authority in a culture where there was no pronoun that had any authority in those years except *he*, the artist *he*, the student *he* [. . .][24]

Being both artist and art, Schneemann said, 'challenged and threatened the psychic territorial power lines by which women were admitted to the Art Stud Club, so long as they behaved enough like men, and made work clearly in the traditions and pathways hacked out by the men'.[25] Schneemann, like many feminist artists of the 70s, wanted to be taken seriously, but she doubled down on the challenges posed by her gender and her body. In one performance piece, *Naked Action Lecture* (1968), she stripped while giving a slide lecture on art history.

Art monster, I thought, walking through the massive Schneemann retrospective at MoMA PS 1, in late 2017. If Offill's term has resonated so strongly in recent years, I think it is in part because it points to the ways in which the culture punishes women for being something other

* According to the *OED*, another possible source for 'obscene' is ob-*scaevus*, 'left-sided, inauspicious'. You sometimes hear ob-*scaena*, or 'off-scene' (that is, what could not be shown on stage), but the *OED* dismisses this as 'folk etymology'.

Antonio Scroll

I MET A HAPPY MAN
A STRUCTURALIST FILMMAKER
--BUT DON'T CALL ME THAT
IT'S SOMETHING ELSE I DO--
HE SAID WE ARE FOND OF YOU
YOU ARE CHARMING
BUT DON'T ASK US TO LOOK
AT YOUR FILMS
WE CANNOT
THERE ARE CERTAIN FILMS
WE CANNOT LOOK AT:
THE PERSONAL CLUTTER
THE PERSISTENCE OF FEELINGS
THE HAND-TOUCH SENSIBILITY
THE DIARISTIC INDULGENCE
THE PAINTERLY MESS
THE DENSE GESTALT
THE PRIMITIVE TECHNIQUES

(I DON'T TAKE THE ADVICE
OF MEN WHO ONLY TALK TO
THEMSELVES)

PAY ATTENTION TO CRITICAL
AND PRACTICAL FILM LANGUAGE
IT EXISTS FOR AND IN ONLY
ONE GENDER

HE SAID YOU CAN DO AS I DO
TAKE ONE CLEAR PROCESS
FOLLOW ITS STRICTEST
IMPLICATIONS INTELLECTUALLY
ESTABLISH A SYSTEM OF
PERMUTATIONS ESTABLISH
THEIR VISUAL SET

I SAID MY FILM IS CONCERNED
WITH DIET AND DIGESTION

VERY WELL HE SAID THEN WHY
THE TRAIN?

THE TRAIN IS DEATH AS THERE
IS DIE IN DIET AND DI IN
DIGESTION

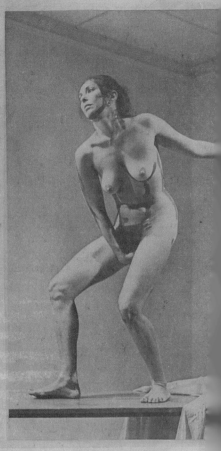

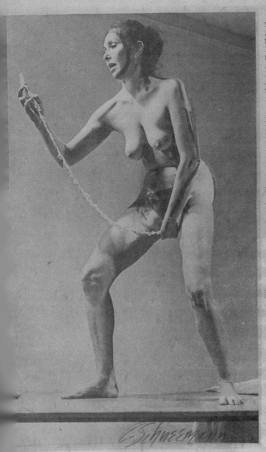

THEN YOU ARE BACK TO METAPHORS
AND MEANINGS MY WORK HAS NO
MEANING BEYOND THE LOGIC OF
ITS SYSTEMS I HAVE DONE AWAY
WITH EMOTION INTUITION INSPIR-
ATION SPONTANEITY -- AGGRAND-
IZED HABITS WHICH SET ARTISTS
APART FROM ORDINARY PEOPLE -
THOSE UNCLEAR TENDENCIES WHICH
ARE INFLICTED UPON VIEWERS...

IT'S TRUE WHEN I WATCH YOUR
FILMS MY MIND WANDERS FREELY
DURING THE HALF HOUR OF
PULSING DOTS I DREAM OF MY
LOVER WRITE A GROCERY LIST
RUMMAGE IN THE TRUNK FOR A
MISSING SWEATER PLAN THE DRAIN-
AGE PIPES FOR THE ROOT CELLAR
-- IT IS PLEASANT NOT TO BE
MANIPULATED

HE PROTESTED YOU ARE UNABLE TO
APPRECIATE THE SYSTEM THE GRID
THE NUMERICAL RATIONAL
PROCEDURES -- THE PYTHAGOREAN
CUES

I SAW MY FAILINGS WERE WORTHY
OF DISMISSAL I'D BE BURIED
ALIVE MY WORKS LOST.........

HE SAID WE CAN BE FRIENDS
EQUALLY THO WE ARE NOT ARTISTS
EQUALLY

I SAID WE CANNOT BE FRIENDS
EQUALLY AND WE CANNOT BE
ARTISTS EQUALLY

HE TOLD ME HE HAD LIVED WITH
A "SCULPTRESS" I ASKED DOES
THAT MAKE ME A FILM-MAKERESS?

ON NO HE SAID WE THINK OF YOU
AS A DANCER

Text from "Kitch's Last Meal"
Super 8 film 1973-76

2/3 1975

Carolee Schneemann, *Interior Scroll*, 1975.

than small and silent. Our boundaries have been policed; when we have overspilled them we have been called disgusting. What I think I hear in the term *art monster* is something to do with the way monstrosity authorises women to thwart received ideas about how we – and our art – should be, look, behave. And yet, in researching this book, as I've looked at work by writers and artists like Woolf and Schneemann, I've become less invested in legislating whether someone is or isn't an art . monster. I realised the word monster was just as effective as a verb: art *monsters*. In this new form the term tells us something about what it is art does: it makes the familiar strange, wakes us from our habits, enables us to envision other ways of being, and lets the body and the imagination speak and dream outside the strict boundaries placed on them by society, patriarchy, internalised misogyny. However we read it, as a noun or a verb, the art monster idea is a dare to overwhelm the limits assigned to us, and to invent our own definitions of beauty.

We tend to think of monsters as scary, outsized creatures, hiding under the bed or in the closets. They are 'vast and unwieldy', says the OED, often hybrid creatures, part human, part something else; they are always surprising in their dimensions and potentials, typically in a frightening or upsetting way. The word itself carries a satisfying physical charge. You *monster!* Like hurling a thunderbolt at someone.

According to the teratologist (that is, the theorist of monstrosity) Jeffrey Jerome Cohen, we can understand a culture by what it calls monstrous; the monster stands for everything a society attempts to cast out.[26] Monsters dwell at borders; you might even say the border creates the monster. Everything that is acceptable over here; everything that is not over there. But these lines have never been fixed. What is monstrous and what is not, the boundaries dividing evil from good, clean from unclean, human from animal, etc., are subject to debate, an invention of Western culture, maintained since antiquity by (male) philosophers who have often labelled 'monstrous' bodies that differ from that of an able-bodied white male.[27] Book seven of Pliny's *Natural History* gives an accounting of the wondrous people to be found in different nations, and their own unique habits and talents: the Anthropophagi like to drink from human skulls; the Abarimon have backwards-facing feet; the Ophiogenes can extract the poison

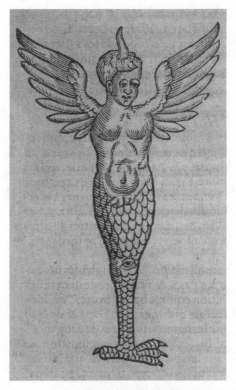

Figure of a winged monster, from
Ambroise Paré, *Des monstres et des prodiges*, 1598.

from a serpent's sting with the touch of a hand. Each description takes
the author and his own nation as the template for what is normal, and
casts the rest as monstrous. The word *monster* became a way of point-
ing to, explaining, and containing all manner of difference and excess.

Women are an easy double for this kind of chaos. Our bodies
are uncontainable: squishy, unreliable, unreasonable, mysterious,
unknowable. In antiquity philosophers used them to posit opposi-
tions between good and evil, human and animal, normal and abnor-
mal. 'Woman [is] a temple built over a sewer,' said Tertullian.[28] In the
Theogony Hesiod described woman as a 'beautiful evil' (*kalon kakon*)
invented by Zeus to punish humanity. A few centuries later, Aristotle
elaborated on the relationship between monstrosity and the feminine.
A monster is a mistake; a female is a deformed male, therefore a female
is a born monster. 'There are many monsters on the earth and in the

sea,' wrote his younger contemporary, the playwright Menander, 'but the greatest is still woman.'[29]

Western culture has exhausted itself inventing female monsters, '[e]mblems of filthy materiality, committed only to their private ends', as Sandra M. Gilbert and Susan Gubar put it in their now-classic study of women's literature, *The Madwoman in the Attic*.[30] Bitch-goddesses and beguilers like the Sphinx, Medusa, Circe, Kali, Delilah and Salomé, they write, are the very incarnation of a 'male dread of women and, specifically, male scorn of female creativity' – including, one presumes, female procreativity and all the mess that goes with it. All the way back to antiquity, women's bodies have provoked anxiety about the transgression of boundaries – 'hygien[ic], physical, and moral', writes Anne Carson:

> Deformation attends her. She swells, she shrinks, she leaks, she is penetrated, she suffers metamorphoses. The women of mythology regularly lose their form in monstrosity.[31]

In *The Second Sex* Simone de Beauvoir argues that patriarchy identifies women with nature. And nature, she writes, 'inspires ambivalent feelings in man, as has been seen. He exploits it, but it crushes him [. . .] Both ally and enemy, it appears as the dark chaos from which life springs forth, as this very life, and as the beyond it reaches for: woman embodies nature as Mother, Spouse, and Idea; these figures are sometimes confounded and sometimes in opposition, and each has a double face.'[32] Man dreams of transcendence, but finds himself condemned to immanence, and to the impure, ultimately doomed body. Woman 'inspires horror in man: the horror of his own carnal contingence that he projects on her'.[33]

Women have reckoned with this legacy in various ways – by making themselves un-monstrous, that is, by attempting to conform in their bodies and in their work to conventional standards of beauty, or alternatively by embracing the monstrous, revelling in what the culture terms excessive, dubious, ugly, *bad*. Both of these choices, however, accept the initial, Aristotelian premise of the monster as Other. When we uphold this pretty/ugly binary, we condemn ourselves to remaining the second sex. This version of monstrosity is a trap.

Negative associations with the term *monster* come late in the OED's list of meanings. Before it is *a person of repulsively unnatural character, or exhibiting such extreme cruelty or wickedness as to appear inhuman* (definition 5), and after it is a mythical creature (definition 1), the monster is *something extraordinary or unnatural; an amazing event or occurrence; a prodigy, a marvel*, though the editors note this usage is now obsolete. In Strong's Greek the monster is τέρας (teras), a wonder, a marvel. Acts 2:19: 'And I will show wonders [τέρατα, terata] in the heavens above and signs on the earth below, blood, and fire, and smoky vapour.' In Latin it comes from *monstrare*, to show (without forgetting that it also derives from *monere*, to warn). You *monster*: you marvel, you demonstration, you warning.

By the Christian medieval period, 'Monsters, like angels, functioned as messengers and heralds of the extraordinary,' writes the theorist Susan Stryker, urging transgender people to reclaim words like *monster, creature, unnatural*, to draw transformative and subversive energy from them. 'They served to announce impending revelation, saying, in effect, "Pay attention; something of profound importance is happening." '[34] For St Augustine, the monstrous is a sign of God's wondrousness, and distrust of the monstrous a sign of ignorance and intolerance.[35] Might the art monster derive more from the Augustinian sense of the monster as a wonder, rather than the more punishing Aristotelian sense as something evil and deformed? Perhaps we might retain St Augustine's open-mindedness, without the trappings of Christianity, and nominate Chris Kraus our philosopher of choice. In *I Love Dick* (1997) Kraus describes the monstrous as 'the Blob':

> mindlessly swallowing and engorging, rolling down the supermarket aisle absorbing pancake mix and jello and everyone in town. Unwise and unstoppable. The horror of The Blob is a horror of the fearless. To become The Blob requires a certain force of will.[36]

The Krausian monstrous: instead of making ourselves small, we allow our monstrous selves to grow unignorably large. Unwise and unstoppable! If Adrienne Rich calls herself a 'poet of the oppositional imagination', perhaps the art monster is a poet of the absorbent imagination, the aggregative imagination; she is the thief, the

collage-artist, the collector, the weaver, the Blob, whose mode of subversion is to overwhelm, in an *ars poetica* of excess.[37] 'I have the sense,' writes Schneemann,

> that [. . .] our best developments grow from works which initially strike us as 'too much': those which are intriguing, demanding, that lead us to experiences which we feel we cannot encompass, but which simultaneously provoke and encourage our efforts. Such works have the effect of containing more than we can assimilate; they maintain attraction and stimulation for our continuing attention. We persevere with that strange joy and agitation by which we sense unpredictable rewards from our relationship to them.[38]

'Aesthetics is born as a discourse of the body,' wrote Terry Eagleton,[39] and while I don't think he was thinking of feminist art when he said it, he's inescapably right. To be gendered female is to be caught between beauty and excess: made to choose. To be a monster is to insist on both.

/

Kathy Acker, *Don Quixote*, 1986:

BEING BORN INTO AND PART OF A MALE WORLD, SHE HAD NO SPEECH OF HER OWN. ALL SHE COULD DO WAS READ MALE TEXTS WHICH WEREN'T HERS.[40]

/

'For me the real crux of chauvinism in art and history,' Judy Chicago said ten years earlier, 'is that we as women have learned to see the world through men's eyes and learned to identify with men's struggles, and men don't have the vaguest notion of identifying with ours.'[41] This leaves women's art stranded in the position of forever either appropriating patriarchy's worldview, its imagery, its methods – or rebelling against it. 'Is that one of the injustices of "phallocentrism itself",' the writer Maggie Nelson asks in *The Art*

of Cruelty, 'that is, its suggestion that there's nothing else imaginable under the sun — not even a form of female aggression or rage or darkness — not shaped by or tethered to the male?'[42] Could it be that the monstrous is what 'ours' looks like when we stop making work against or around 'theirs'?

The art monster, with her *diaristic indulgence* and her *personal clutter*, takes for granted that the experiences of female embodiment are relevant to all humankind. Something like what I imagine Kraus had in mind when she asked in *I Love Dick* : '[W]hy not universalize the "personal" and make it the subject of our art?'[43] Which I take to mean not that the personal writings of one woman ought to be made to stand in for the experiences of all women — but rather that whoever we are, we might lay claim to the personal itself as not only worthy of anyone's attention, but necessary to attend to as the foundation for an ethical way of being in the world.

Rachel Cusk asks, in an essay on the painters Celia Paul and Cecily Brown, 'Can a woman artist — however virtuosic and talented, however disciplined — ever attain a fundamental freedom from the fact of her own womanhood?'[44] Perhaps not. Perhaps the only option is to go further in. To become the artists, to paint ourselves into the picture, remake the picture entirely, found a new language, cut it all to pieces, instigate processes of entropy, decreate to create.

In her essay Cusk considers the art monster, without using the term: 'The male artist, in our image of him, does everything we are told not to do: He is violent and selfish. He neglects or betrays his friends and family. He smokes, drinks, scandalises, indulges his lusts and in every way bites the hand that feeds him, all to be unmasked at the end as a peerless genius.' Is there a female variant of this figure, she asks?[45]

But that's just the point: that is my point in *Flâneuse*, that is my point here. Converting a masculine figure into a female one forever strands us on the side of the second sex, making work in reaction to or against the patriarchy. The art monster as I conjure her here is not a female version of a male figure anymore than a flâneuse was a female flâneur. I do not know how to say this more plainly. '[O]f any woman creator,' Cusk writes, 'an explanation is required of whether, or how,

she dispensed with her femininity and its limitations, with her female biological destiny; of where – so to speak – she buried the body.' [46]

No need to bury the body: it is at the centre of our practice.

/

Carolee Schneemann, 'The Obscene Body/Politic':

WE WHO ARE ADDRESSING THE TABOOS BECOME THE TABOO. THE SUPPRESSORS ARE CONFUSED. THEY CANNOT DISTINGUISH IMAGES FROM THE IMAGE MAKERS. [47]

/

2022. The gains feminists made over the course of the twentieth century, which we took for granted when I came of age as a young woman in the 1990s, no longer carry the force of inevitability and permanence they once did. In the country of my birth, a politicised Supreme Court with a conservative supermajority has overturned Roe v. Wade, the 1973 ruling which protected a woman's right to choose whether or not she uses her body to bear a child, with life-or-death consequences for the thousands of women who become pregnant in states where abortion is now banned. Violence against women, and the toxic masculinity which causes it, is at an all-time high (we only just got the pussy grabber out of office, two impeachments later), as is tribalism and nationalism and fear-mongering around immigration. Recent studies have shown social media dangerously impacts young women's mental health, far worse than the women's magazines that reigned when I was their age, because now it is all public, with a popularity metric built in. And we seem depressingly far from a context in which the rights of trans people are systematically protected and respected.

It has felt critical to think through these issues of monstrosity, of beauty and excess, of storytelling and form, in order to think about how to be in a female body in the early twenty-first century. We

feel so alone in our contemporaneity, but we might feel less so if we could look back to a tradition of women struggling with issues like the beauty myth, bodily autonomy, reproductive rights. Their work is not over and done but ours to continue asserting and refining, as our understanding of what it is to be in a female body evolves and transforms, perhaps leading us to the ultimate demise of the gender binary and the pressures and expectations it enacts.

There was a time when you could hear art historians (male ones) refer to the 70s as a 'lost' decade, in which nothing really happened. This perspective largely took shape during the money-wild 1980s, when the art market dramatically expanded and a work's value was monetary above all else. The 70s, with their interest in performance, ephemerality, conceptualism and impermanence, barely register on that scale. Yet that decade saw a proliferation of work by women artists who exploded all of culture as it had been handed down to them – compacted it up good and tight, and pulled the pin.

It was a decade in which performance art particularly thrived. To work in performance was to stick two fingers up to the art establishment: it can't be preserved on a canvas – only on film, but that's not the same thing. It is art that eats away at the idea of Art; art that decreates as it creates. Although the art of that time (and our histories of it) tends to centre the white, cis, and able body it was, in many ways, unprecedentedly daring, and called for a rethinking of how we represent the female body in all its forms. That conventionally attractive female body was shown to be a myth, a construction, imaginary. It was a time when you could regularly encounter women writing about and depicting, among other things, pregnancy, childbirth, breastfeeding, menstruating, masturbating, coming, shitting, ageing, menopause, and the vulva in all its glorious folds and ruffles. Is it any wonder that artists would turn to the body during the decade in which abortion was finally legalised, ten years after the birth control pill came on to the market? For the first time, women had some control over their bodies.

The feminist activists of the 1970s, as we'll see, worked alongside, and often in concert with, radical feminist artists. Just as those struggles were mutually reinforcing then, so they continue to be today, as

feminist art gives us language and imagery in which to think through the emancipations, personal and political (which, we learned from the 70s, is the same domain), of the body.

I found this book pouring out of me in the years following the election of Donald Trump to the White House, through women's marches and #MeToo and Harvey Weinstein and Brett Kavanaugh and Black Lives Matter and Covid-19 and the January 6th insurrection and the war on women's rights: it seemed crucial that we find a way to cure our self-repulsion, to expand – through an attention to the possibilities and forms of embodiment – our understanding of gender, to give young female or female-identifying or queer or trans or non-binary readers the sense that their bodies are powerful and that that power doesn't have to come only from abjection; to make room for complex feelings like shame and bewilderment and not being quite sure what the body means; to affirm that feminist art is not always polemical but often provisional; that the image is a way of exploring and not arguing, that epiphanies shift and change like the body itself; that nothing, not even art, can be mummified and preserved forever and that we wouldn't want it to be; that feminists sometimes get it dreadfully wrong or ecstatically right or both at the same time. That the best of feminism is a movement that makes room for the *at the same time*s, for the *I don't know what I'm looking at*s, for glorious ambiguity – that claims its space, and holds it, for the present, the past, and for the future.

carry that weight

Virginia Woolf famously declared that for women to make art, they needed £500 a year (rather more now) and rooms of their own. Her sister, the painter Vanessa Bell, less famously wrote in a 1941 letter to her daughter of how 'terribly difficult it is to paint seriously when one is responsible for other things, and hasn't room and space to oneself'.[1] It takes a monstrous gesture to claim that space. As artists we have learned we have to take up the whole house, upstairs and down, attic and basement. Alice-like we will have to spill out of all the windows and doors and out into the street, making the private public, the domestic political.

Rebecca Solnit has written about the artist Ann Hamilton, who asked her students – mostly young women – to carry around a 4 × 8 sheet of plywood with them for a week, so they could get used to taking up more space, and realise how often they apologised for themselves. Hamilton's own success may have been partly due to the 'sheer scale and ambition of her work from the outset', unusual when she began her career in the late 1980s, a time when young female art students 'made tiny, furtive things that expressed something about their condition, including the lack of room they felt free to occupy. How do you think big,' Solnit asked, 'when you're supposed to not get in the way, not overstep your welcome, not overshadow or intimidate?'[2]

This was the problem considered by Emma Sulkowicz, who was an undergraduate at Columbia University when she was raped by a fellow student. The university proved less than eager to help punish the guy who did it. In protest, for her senior art project Sulkowicz carried her dorm mattress with her everywhere she went to raise awareness about the fact that a student who had raped her was still attending the university; if he was expelled or left of his own accord, she would put down the mattress. *Mattress Performance (Carry That*

Weight) (2014–15) lasted the whole year.* Her rapist, who was accused by two other students as well, wasn't kicked out.

The project involved certain rules, which she painted on the wall of her studio for anyone who cared to come and read them. One of them was that she was not allowed to ask for help carrying the mattress, 'but others are allowed to give me help if they come up and offer it'. They did, and as they did, they implicitly accepted her story. One photograph taken during the project shows someone has stuck letters made out of red tape (a reference to the bureaucratic processes that ensnare and daunt so many who try to report their assaults) on to the mattress, forming the words CARRY THAT WEIGHT, along with a little equal sign, =, like two forward slashes that fell into bed together, like we should all be equal under the law and under the covers.

As the project got underway that school year, Sulkowicz spoke to the school paper, the *Daily Spectator*, in a video interview. She was nervous about losing her anonymity, she said, standing out on campus, becoming *that girl with the mattress*.

Before too long, she wasn't the only girl with a mattress: students on 130 campuses around the world brought out their own beds to protest campus sexual assault.

The mattress outside the bedroom, so familiar yet so strange, the intimate made public, material, visibly heavy and unwieldy: this is what drew so many people to her cause, and drove so many others crazy.

How to weaponise what looks like weakness.

/

Sulkowicz and Hamilton's projects owe a great deal to the 70s work of the German artist Rebecca Horn. In a photograph I first encountered hanging in the Tate Liverpool, in 2016, when I was in a phase of metaphorical expansion, claiming more room for myself and my desires, a woman stands in a room filled with sunlight. It looks like

* Sulkowicz uses both 'she/her' and 'they/them' pronouns; I have retained 'she/her' for continuity with her self-description as 'that girl with the mattress'.

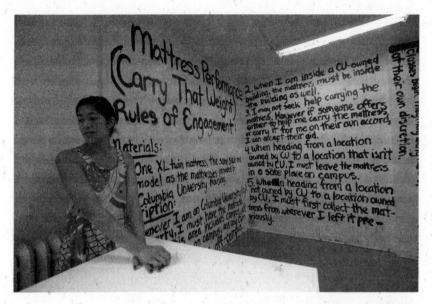

Emma Sulkowicz in the studio space for *Carry That Weight*,
Columbia University, New York, 2014.

a ballet studio: hardwood floors, a large mirror, no furniture. She is
in the centre of the room, feet parallel; her clothes look like a dancer's
rehearsal gear. Her arms reach out to either side. At the end of each
one are five long sharp sticks, like exaggerated claws.

The work is titled: *Mit Beiden Händen Gleichzeitig die Wände Berühren*
(*Touching the Walls with Both Hands Simultaneously*, 1974–5). Horn has
found a way to make herself bigger, to elongate herself from wall to
wall. It's such an *open* stance. As I write this, sitting in a café in Paris,
I pause and stretch out my arms, feeling it in my pectoral muscles. It
feels good. It feels like freedom.

These are not a ballerina's delicate fingers poised in attitude. These
open and close like a hawk's talons. What will they grasp? I think of
Loie Fuller dancing with rods attached to her arms to lengthen them,
so when she moved them the fabric swirled like nothing in nature.
Fuller used to collapse after her performances because they took so
much out of her. Horn looks like the weight of holding up her claws
could be getting to her. In other photos with them, the claws have
fallen to the ground, and her back curves in exhaustion. The gesture
of taking up space can be draining.

Horn uses the claw-gloves in a video performance called *Berlin –*
Übungen in neun Stücken (*Berlin – Exercises in Nine Parts*), 1974–5, which
she carried out during a week in November 1974, involving one or
two people depending on the sequence, plus a cockatoo. Artist, sculp-
tor and filmmaker in one, Horn walks slowly and methodically, as if
she were on a tightrope, away from the camera and back towards it,
scratching the walls as she goes, the sound they make amplified on
the tape. She is mirrored by her reflection, which makes it look like
she has four arms – denatured, dehumaned or deified, like Kali. The
moment when she turns to walk in the other direction, she unfurls
her claw-arms to the ceiling, as if in some strange ritual. But though
they're graceful in their movement, they put me in mind of a high-
school friend who used to let her nails grow long and yellow and
grainy. In the next video in the series Horn crouches in a corner, a
hand over one eye, imitating a bird. The cockatoo by the window
looks back at her.

The claws were built to the size of this particular room, Horn
has said, so that her body could expand to fit it. All of her early
work was devoted to exploring the relationship between the body
and space. 'I developed a sharpened sensibility for light and spatial
energy,' she said, 'an innate sense of the moment when a certain
action in a room should start; from these considerations I evolved
a new dialogue between spaces and sculptures.'[3] In the late 1960s
and early 70s Horn made a succession of bodily extension pieces:
Einhorn (*Unicorn*, 1970–72), an enormous horn to be fastened to a
woman's head, while her naked torso is bound in white fabric, and
the even more alarming *Kopf-Extension* (*Head Extension*, 1972), which
fitted around the wearer's waist and reached perhaps three metres
into the air; *Cornucopia, Seance for Two Breasts* (1970), a double ram's
horn leading from the breasts to the mouth; *Überstromer* (*Overflowing
Blood Machine*, 1970), a garment in which the wearer is wrapped in
tubes through which blood is slowly pumped; *Arm Extensions* (1968),
which encased the arms in long, bright red fabric tubes, like some-
thing a child would play with in a swimming pool, while the legs
were wrapped in criss-crossing fabric. Leg bindings like this recur in
the *Berlin Exercises*, as two people are attached at the leg as if in an

avant-garde three-legged race. These bindings and constraints that are also a form of freedom.

She also made an earlier version of the gloves in *Touching the Walls*, 1972's *Handschuhfinger* (*Finger Gloves*), photographing herself wearing them as she bends over and touches her claws to the ground, where they splay delicately, like spider legs. There is something tender about their touch. They were so lightweight, Horn said in 1979, that they could be used effortlessly and gave her a heightened sense of contact: 'The lever-action of the extended fingers intensifies my hand's tactile sensation. I can feel myself touching things, see how I grasp and control any chosen distance between myself and the objects.'[4] Distance, and communication between beings, and bodies and spaces, would become some of Horn's major preoccupations. How can we push further, connect with more intention, reach ever outward? These are questions that haunt her – that haunt me, as I write this book.[5]

To become artists, to be taken seriously, we have had to improvise with our materials. Go big to claim space. Cut and splice, repurpose, take matter and put it out of place. Unsettle those categories. Bare those teeth, unfurl those wings.

With so much at stake; when so much depends on keeping them sheathed and furled.

/

I'm reading, at the moment, a book recently published in France by the philosopher Paul B. Preciado, called *Je suis un monstre qui vous parle* (I am a monster who is speaking to you). It is the text of a 2019 talk which Preciado, a trans man, gave to a meeting of French psychoanalysts to confront them with the failure of their profession to think through the challenges to their field posed by the trans body. Well, he started to give it, but he was heckled so insistently that he had to break it off.

The other day, out for a walk by the Canal St Martin, I heard him on a podcast with the feminist journalist Lauren Bastide, talking about the importance, for marginalised people, of speaking in the first person. Those who are in power, he says, don't need the I; they speak from a position of universality. What they have to say is already

'objective'. But for the dominated, the marginal, the monstrous, there
is no choice *but* to speak in the first person. When he writes in the I,
the *je*, it is the I of the 'political genealogy of those who, like me, have
tried to live – especially over the course of the twentieth century –
outside the gender binary, and whom medicine has considered to be
monstrous, grotesque, mentally ill'.[6]

'It's the only possible political writing,' says Bastide.

'Exactly! Exactly,' says Preciado.

Somewhere down the centuries, I hear in Preciado's title an echo
of Rimbaud's famous formulation *Je est un autre*, I is another, and this
becomes, in my mind, *Je est un monstre qui vous parle*, I is a monster who
is talking to you.

If I is always a monster, so be it.

/

The first person is arguably the only voice with any political urgency,
but one that has often been denied women and other marginalised
people unless it confirms what they – *they*, the patriarchy, the taste-
makers, the ones who decide things – expect to hear from us. And
then it's rejected or minimised for being small, anecdotal, irrelevant to
the Big Concerns like politics, war, business, sport. Particular instead
of universal. We get accused of being narcissistic, inappropriate. We
say too much; we *overshare*. (The persistence of feelings!)

Anything women say about their lives is suspect, especially if there's
a white man nearby with a different account of things. At the 1612
trial of the man who raped her, Artemisia Gentileschi was tortured to
be sure she was telling the truth. Her fingers were placed in a *sibille*, a
torture device made of metal and cord. *È vero, è vero, è vero*, she repeated
as the *sibille* tightened around her fingers, risking breaking them, jeop-
ardising her ability to go on painting. As Christine Blasey Ford testi-
fied calmly before the Senate in 2018, describing what the Republicans'
Supreme Court nominee had done to her in high school, I thought
about Gentileschi, and the spectacle of female storytelling. For our
stories to be believed – and not just believed, but no longer *irritating*,

or *sentimental* – we have to remain coherent, give absolutely no hint of being 'hysterical', strike precisely the right note, neither insensitive nor sentimental, neither sharp nor flat. And yet there Blasey Ford was, being derided and disrespected because she threatened the rise and reputation of an entitled white man – who when it was his turn to testify, was incoherent and emotional and anything but 'professional'.

It would appear, at least since #MeToo, but also judging from the recent boom in personal narratives from women writers, that some room has opened up in the culture for our stories.[7] It is liberating to be able to take your personal experiences seriously when everything in the world has conspired to make you think they are small, petty, domestic; even more empowering for other people to validate them as worthwhile reading material. But – how much room, exactly? Watching Christine Blasey Ford that day, I kept thinking: this thing where we get to *tell our stories* is a con, another impossible hurdle we'll never be able to clear, another occasion for a woman to be made to perform her own virtue. I remembered watching Anita Hill's testimony at Clarence Thomas's Supreme Court confirmation hearings in 1991, how the Senate Judiciary Committee and the pundits in the media questioned her credibility and undermined everything she said. If any woman had a chance at being believed it's an educated upper middle-class white one like Blasey Ford, and yet there he sits, Justice Kavanaugh, on the highest court in the land. What chance is there for anyone else to be believed if she wasn't? Or, worse, if she was – and it *didn't matter*?

And with all this imperative to *tell* in order to see 'justice' done, what about stories that could not be told – the art historian Nancy Princenthal's 'unspeakable acts' – whether because the trauma could not be held in conventional language, or because the traumatised simply could not speak of it, or because rape as a crime was still a foggy legal concept and difficult to prosecute?★ It falls to artists, Princenthal writes, to 'give shape to experiences we don't quite know

★ This is still, by and large, the case. See, for example, Ian Urbina, 'The Challenge of Defining Rape', *New York Times*, 11 October 2014.

how to picture or name'.[8] The artist's job, according to Toni Morrison, is 'to rip that veil drawn over "proceedings too terrible to relate"' – a vital exercise 'for any person who is black, or who belongs to any marginalised category, for, historically, we were seldom invited to participate in the discourse even when we were its topic'.[9] You might even call it an ethical responsibility: to tell the 'truth of our experiences as bodies', as Woolf put it.

But we will need to invent our own forms for the telling.

/

At least since the consciousness-raising meetings of the 1970s, conventional feminist wisdom has held that storytelling is empowering. Gathering together and talking about their lives was a practice by which women became aware of the political and economic inequities they experienced; they talked about what they thought, how they felt, and began to organise and militate for changes in the law and in everyday life. It was in sharing their experiences that women could begin to see their oppression as structural, and the necessary remedies as collective. Inspired by the civil rights movement, the second-wave feminist artists saw themselves as activists in the street *and* in the studio, in their homes and out in the world. *The personal is political*, they chanted.

It was the feminist artists of that period who would come closest to Woolf's proposition: to finding ways to articulate their experiences as bodies, of breaking the sentence and the sequence. For them, this would be less a question of storytelling as we traditionally think of it, and more of letting the body speak through art.

In the wake of the dry, cerebral forms of modernism and minimalism, artists of all genders began to bring the body back into the work, turning from austerity to flesh.

At first, performance art and body art were a macho domain. 'By the mid-1960s,' notes Schneemann, 'performance played a major role in the New York art world, yet women were a conspicuous minority on the scene.'[10] It was not just a question of 'shyness that kept many women from making their own body art from 1967 to 1971', writes

the feminist art critic Lucy Lippard, a time 'when Bruce Nauman was "Thighing", Vito Acconci was masturbating, Dennis Oppenheim was sunbathing and burning, and Barry Le Va was slamming into walls'.[11] Body art seemed like just another area under the boys' control.

But artists like Yoko Ono and Joan Jonas, Carolee Schneemann and Adrian Piper, Mierle Laderman Ukeles, Meredith Monk and Hannah Wilke would reclaim it for women. 'A lot of women went into performance,' the artist Suzanne Lacy recalls. 'At the time it was harder for a woman to break into almost any field of the arts. It wasn't to become a performance artist. And that, I think, had to do with the wide-open experimental nature, and the fact that bodies had a certain prioritization.'[12] It was a way to talk about personal history but also about the history of women; they called on (admittedly bland, white-washed) archetypes of the Great Goddess and on the memory of women burned at the stake; they enacted 'sacred rituals'; they invented characters for themselves to play; they talked about trauma, assault and rape as a political as well as a personal problem; and they scrambled the boundaries of art, theatre, dance, poetry and film. These interventions 'totally transformed the substance and direction' of the medium of performance art.[13]

'You have to remember that in 1970 you could not find stories of women who were raped,' Lacy would later write. That year, she and Judy Chicago (along with Sandra Orgel and Aviva Rahmani) decided to stage a performance in which an audience would sit in the dark and listen to an audio tape of women talking about their rapes. The performance would finally be staged in 1972, and was called *Ablutions*: telling as a sort of purifying. 'Neither of us had ever heard women talking personally to each other about these things, let alone to an audience.'[14]

Ablutions consisted of three tubs of eggs, beef blood, and liquid clay. Naked woman dipped themselves in the different vats, and emerged to be wrapped in sheets, like corpses. Eggshells, ropes and chains littered the floor, and animal innards were strewn about and nailed to the walls. It ended with two of the women stringing ropes of light over the set, 'until the performance stage was a spider web of entrapment'.[15] Meanwhile a soundtrack played of women recounting their

rapes, concluding on one voice repeating, as if the tape had got stuck, *I felt so helpless, all I could do was just lie there.* The performance harnessed the power of repulsion to make its point – one they found could not be expressed in language alone. 'A study in excess', Princenthal calls it; 'no image could be adequate to the subject'. The old ways of making art or telling stories were no longer equal to the task of telling the story of the body under assault.[16] Perhaps they never had been.

If our stories are to be truly ours, we need to invent 'new words' and 'new methods', as Woolf says at the end of *Three Guineas* (1938).[17] The 'rights of all', she tells us, will be safeguarded not by capitulation to but by remaining outside of patriarchal modes. It has been an important social act to narrativise our trauma. But when it comes to art, we need to challenge our expectations of story. The monstrous gives us these new words and methods which help us to move past a conception of women's storytelling that binds us doubly into shame or empowerment, loyalty or betrayal, silence or freedom, domesticity or art. We don't live in these binaries; not really. And if we listen more attentively to what women are telling us, we'll find their stories don't live in them, either.

the hand-touch sensibility

In 1975, the artist Hannah Wilke was interviewed by the art critic
Cindy Nemser as part of a series of interviews with female artists – Lee
Krasner, Barbara Hepworth, Alice Neel, Eva Hesse and Betye Saar,
among others.[1]

CN:
I remember though, there was also some hostility to your exhi-
bition because it was so overtly sexual and I remember some people –
particularly some women – were offended by the idea of a woman
putting up art with such overtly sexual connotations. [. . .] I think you
touched a nerve, I wouldn't take it as an insult but as a compliment.

Listening to the tapes, you can hear a distinct defensiveness in Wilke's
voice as she responds. She feels on the back foot when it comes to her
reception by the art world, and especially by other feminists within it:

HW:
It is a problem that a woman artist cannot accept another woman
artist's work just because the subject matter has to do with female
sensibility [. . .] I'm sick of ugliness! I'm sick of going into a room at a
gallery opening and feeling more beautiful than the work! I respect art
too much and I would like to feel less than the art. I wanted to make
an art that looked better than me.[2]

Wilke's observation that 'ugliness' reigns in the art world is a provoca-
tive one. But she wasn't wrong. The artist Eva Hesse, talking to Cindy
Nemser in her own interview, said of the first sculpture she made in
her *Accession* series that it was 'a little too precious, at least from where
I stand now, and too right and too beautiful. It's like a gem, like a dia-
mond. I think I'd rather do cat's eyes now or even less than cat's eyes,

dirt or rock. [. . .] It's too right. I'd like to do something a little more wrong at this point.'[3]

Or of *Right After*, a fibreglass draping made for the Jewish Museum show called 'Plastic Presence':

> I felt it needed more statement, more work, more completion, and that was a mistake because it left the ugly zone and went to the beauty zone. I didn't mean it to be that. And it became for me – I don't even want to use the word in any interview of mine – decorative. That word or the way I use it or feel about it is the only art sin.[4]

Perhaps Hesse's aversion to beauty stems from a fear that if her work were to be found 'decorative', it would be dismissed, as so much work by women was. Then, too, decorative must have felt like an ethically suspicious mode, barely thirty years after the Shoah (Hesse and her family fled Germany in 1939) and the atom bomb, with the Cold War on and the Vietnam War in its second decade, and people marching in the streets for the rights of women and people of colour.[5] In response to all of this *history*, art, in Linda Nochlin's terms, was drawn to 'all the parts of experience that were considered degrading, low, smelly, unattractive, irregular, ugly, and acceptance of them and if you will a kind of glorification of them as part of the art experience'.[6]

In a more recent interview with the writer and editor Lori DeGolyer, the Jamaican artist Ebony G. Patterson discussed a series of tapestries she'd made about colonialism and the African slave trade.[7] To DeGolyer, they are at first sight 'beautiful', but 'upon closer inspection we can see that they also carry the weight of trauma and death'. Asked to elaborate on the 'use of fragmentation and layers' in those works, Patterson answered:

> For me, when I started making the tapestries that you're speaking to specifically, one of the problems I felt like I was encountering – and which is always a problem with the work – is that people kind of sit in its prettiness, and its buoyancy, and its tactility, and its shine; but I wanted to find a way that somehow made that difficult to just rest in. [. . .] I was really interested in creating these two contradictions that somehow capture the viewer in a question. Like when they would say, 'Oh, it's really beautiful.' But is it?

The turn away from beauty was a way for female artists to reject a racist, othering patriarchy, embodied in a classical aesthetics that were not their own – that cast them, like Schneemann, as beautiful bodies, as muses, or as servants and sex objects, and never as artists. In order to claim authority as artists, they believed they needed to make work that would be difficult to look at, excessive, somehow wrong. Helen Frankenthaler described what she was after in these terms: 'Instead of masterly, you want to be – well, two words I frequently use – clumsy or puzzled . . . One prepares, bringing all one's weight and graceful-ness and knowledge to bear [. . .] And very often a certain kind of "wrongness" is right and one must seize it.'[8]

But artists like Wilke wanted to remake aesthetics while querying what beauty could be. Capitalism had co-opted it, vulgarising it in into advertising copy and women's magazine notions of feminin-ity, selling women versions of their bodies they could never attain no matter how much money they spent. Never thin enough, tall enough, symmetrical enough, white enough, pain-free and able and unfeeling as a picture. Beauty had been divorced from feminism, from art; it became something to put in quotation marks, to be ironic about.

The female body itself became the site on to which different ideas about feminism and freedom would play out. As Marina Warner has said of the artist Helen Chadwick:

> She was taking photographs of her naked body. Nakedness was off-limits for feminists – especially beauty. Beauty was really, really dan-gerous territory. There were some, like Carolee Schneemann, who were working in this field, but it was very very rare in England, and it was very bold, she was making a statement about the aesthetics of the female body as a language and exploring it in an autobiographical fashion.[9]

Wilke (and, later, Chadwick) wanted to claim back beauty from the capitalist patriarchy. But the feminist artist who addresses herself to the question of beauty and the female body has to be ready for other people to see her as a monster: even other feminists.

/

The problem of Hannah Wilke is the central problem in this book, and that is the problem of beauty for feminism. When she was beautiful, they told her to stop taking her clothes off. When she was dying, they applauded the bravery of taking off her clothes. She was not a better artist when she was dying. She was not a better artist for having experienced pain and despair. If that is our standard, then we have not at all moved past the Romantic ideal of the suffering, isolated male genius.

Beauty is a poison pill. Beauty makes us sick, makes us spend all our money, makes us sad and desperate. We are socially obligated to try to make ourselves look young and beautiful, and then mocked and undermined when we don't succeed as well as when we do. It is no wonder so many feminist artists have turned to ugliness, abjection and roughness, in order to be taken seriously. There is something suspect about Wilke's beauty.

/

What is with this rejection of beauty, I wonder? Could there be a hint of internalised misogyny? Could the turning away be a way of anticipating, and rejecting, the label 'feminine'?

When asked about the meaning of femininity, the French writer Virginie Despentes told *Le Monde*:

> A study published about five years ago says it all. They held a fake audition for a yoghurt commercial for little girls and boys, around 5 or 6 years old. Without telling the kids, they put salt in the yoghurt. Each one of the little boys said 'yuck!' in front of the camera, because the yoghurt was disgusting. The little girls, meanwhile, pretended to love it. They had understood that they had to think above all of whomever might be watching, and please them. Well, that's femininity: don't be spontaneous, think of others before yourself, swallow and smile.[10]

Femininity is a story we've assimilated about how to please, how to dissemble, how to make ourselves smaller, neater, cleaner. Raised up to swallow the *yuck* and say how much we love it.

Anything not yucky, anything sweet, is called sentimental trash. Love stories, pin-tucks, puff sleeves, impractical shoes, cute things, ruching, smocking, ruffles, folds and bows, decoration, Tori Amos, millennial pink, wanting babies, provincial French dinnerware, singing the melody, delicacy, embroidery, love songs, Sylvia Plath, yoni meditation, Broadway musicals, vulnerability, scrunchies, rococo, flowered bedspreads, purple prose, too many cats. These things are superfluous, decorative, material and materialistic, only recuperable as kitsch, or camp, at one degree from sincerity. Conventional, unimaginative, reactionary, middle class. Femme-y. They mark you out as being undiscriminating, not knowing better, effeminate, *female*.

/

Andrea Long Chu, *Females*:

> Everyone is female [. . .] femaleness is a universal sex defined by self-negation, against which all politics, even feminist politics, rebels. Put more simply: Everyone is female, and everyone hates it.[11]

/

Femininity is a kind of abject, which Julia Kristeva theorises in her much-referenced 1980 work *Powers of Horror* as anything that reminds us of our own mortality and threatens the fragile enclosure of our bodies. It's the unclean, it's waste material, blood, faeces, nail clippings, a cadaver, even something as uneventful as skin on a glass of hot milk, which Kristeva associates with all the bodily processes that violate the border between inside and out: shitting, pissing, puking, fucking, menstruating, giving birth.[12] The abject is us, but it is not us. We spit it out, hide it, reject it. The abject is the 'jettisoned object', the ab-jected, what we toss away.[13] It is – as Beauvoir had it – femininity, the 'horror' of man's 'carnal contingence, which he projects upon her'.[14]

'It is thus not lack of cleanliness or health that causes abjection,' notes Kristeva, 'but what disturbs identity, system, order. What does not respect borders, positions, rules. The inbetween, the ambiguous,

the composite.'[15] The monstrous lives at these sorts of boundaries, announcing them, transgressing them. And so do certain kinds of art. Art whose properties include decay, instability, bodily excess – anything that prompts us to flinch or curl our lips or even feel a little sick – usually gets placed in this category. But I think, as well, we can include anything that is too female – that *hand-touch sensibility*, that *diaristic indulgence*.

What Hesse called 'ucky'. Not ugly, not yucky, but ucky.* An art of tactility, that restores touch to the aesthetic.

OED: aesthetic, from αἰσθητικός of or relating to sense perception, sensitive, perceptive

as opposed to

OED: anaesthetic, from ἀναίσθητος without feeling, insensible.

Though it might be perceived under the heading of the abject, or as abject because femme-y, cringe-y, uncool, this feminist art is not abject, or it is only abject-adjacent. It is art that makes possible a kind of *touching*, even though we keep our hands to ourselves. It touches us. Not just, or not only, in the affective sense. It does something to us bodily.

I get a certain feeling from this work that I am trying to put into words, and in so doing capture the urgency I feel it contains. I am trying to put my finger on it.

It's a bit like what the artist and musician Cosey Fanni Tutti seems to be referring to when she talks about her friend Helen Chadwick's relationship to her art. She had such a 'tactile' way with things, Cosey recalls:

[W]hen she picked things up [. . .] [*moves fingers on both hands as if palpating play doh*] that's exactly what she used to do, I can still see her hands

* So notes Sol LeWitt, in the documentary *4 Artists: Robert Ryman, Eva Hesse, Bruce Nauman, Susan Rothenberg* (New York: Michael Blackwood Productions, 1987). The full quote: 'She said she wanted to make her work "ucky", not "yucky" but "ucky" which meant that it had to have the right feeling to her which wasn't at all pure [. . .] she had to do something with it that made it feel good to her.'

now, like this [*makes the gesture again*] and when she talked she would go [*makes an mmmmm sound and moves fingers in hands near face*] on like that — so she felt everything physically that she worked with.[16]

There is an image by the Irish artist Genieve Figgis that has stayed with me since I first came across it, mindlessly scrolling on Instagram one dark pandemic day. Figgis has an Impressionist's palette, a Spanish court painter's poise, a German expressionist's feeling for ravaged faces, and a wobbly blobbiness that is all her own. Her paintings are at once very beautiful and very unsettling, 'a salutation from beyond the grave'.[17] The image was a painting called *Blue Eyeliner* (2020), in which a woman massages her face, smearing her make-up, but as if all her skin were coming off with it, as if the make-up were causing her right eye to explode, leaving a gaping hole. The self as regarded in the mirror melts. (Somehow it seems clear to me that she is looking in a mirror, that we are her mirror.) Make-up is not made to last; it comes off the moment you put it on. It conceals and alters, smears and defaces. Destructive, getting on everything, ruining everything. A make-up artist is an artist of ephemerality, of invention (make it up), of masking (putting on one's face), of lying, even (the truth, whatever it may be, there underneath). Art monstrosity, as with Figgis's painting, stages the dismantling of artifice to reveal that there is no unvarnished truth beneath; the skin comes away with the make-up; hand and face become one. There is beauty here but it is the ucky beauty of entropy, of unmaking, of the smear, the scratch, the slash.

It reminds me of Wilke's first video piece, *Gestures* (1974), in which Wilke, who trained as a sculptor, takes her face as her material, sculpting and moulding and folding and massaging it. Now sensual, now cosmetic, as if she were applying her night cream, now dragging, as if it were the end of a hard day of working and she's worn out, rubbing her forehead like she has a headache. She uses her fists, her nails, her palms, her fingertips, exhausting the repertoire of hand to face contact. She plays peekaboo. She hides behind her hair. She flips it out of her face. Gentle fingertips tap across her cheeks, like she's lightly working in moisturiser, or applying foundation. Her skin is as taut as a child's, but the movements and the furrows she creates are suggestive

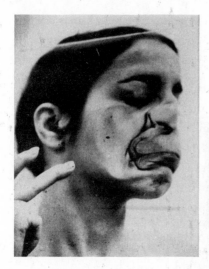

Left: Ana Mendieta, *Untitled (Glass on Body Imprints) - Face*, 1972.
Right: Hannah Wilke, still from *Gestures*, 1974.

of the ageing to come, the flesh falling, and then, for some, being tightened back into place. There is something gruesome about it; I feel like I'm watching a skull with flesh wrapped around it.[18] The more she smears her skin, the more impermanent it looks, like something she's only wearing. This is the hand-touch sensibility – quite literally. Or what I think of as a related work, Ana Mendieta's 1972 *Glass on Body Imprints* series of photographs. Like Wilke, like Schneemann, Mendieta is interested in her body as raw material for art, and the camera as not necessarily her friend; she smashes her face against a pane of glass, as if against the lens, letting this violence shape the appearance and very materiality of her body.

This is the underside of the distaste for femininity: beneath the pintucks dwells the changeable body, with its hair to be waxed away, its smells to be deodorised and perfumed, its skin to be tanned, or lightened, its flab to be tightened or smoothed. The body is always matter out of place, wayward and to be brought in line; the female, trans, raced, disabled body monstrously out of bounds. But the (cis) female body subject to nature – to hormones, menstruation, pain, pregnancy, ageing – confirms the place of that body in these misogynist narratives. If we make ourselves up and wax away the hair, it's not

Jessica Ledwich, *Untitled III*, from the series *Monstrous Feminine*, 2013–14.

only to confirm that body hair is unviewable, it is also to escape the narrative it casts us in as undesirable, bound in time like anyone else.

Feminist visual artists have explicitly engaged with these forms of bodily control: Eleanor Antin's 1972 *Carving* series of photographs documenting her dieting regime ('Technically it is carried out in what can be considered the matter of archaic and classical Greek sculpture (peeling small layers off an overall body image until the image is gradually refined to the point of aesthetic satisfaction)'), Orlan with her defiantly fake, even post-human surgical interventions, Amalia Ulman's Instagram selfies performance *Excellences & Perfections* (2014), or Jessica Ledwich's photography series *Monstrous Feminine*, which looks at the 'monstrous' beauty rituals women endure. In one image, a woman has squeezed herself into a pair of thigh-high hold-ups and control panel underwear. She holds a measuring tape around her waist, while below, the fat on her legs that has been squeezed out of the tights erupts up and over the top. The accessories which are meant to make her look nice make her look grotesque. The effort to be skinny backfires, the demure violence of social convention turned against the female body. If beauty is smooth, contained, then beauty is impossible

for a living body. To the right, a cute little indoor plant perfectly manicured to the shape of an hourglass mocks her. The devices we employ to control the excess invariably create more of it.

The art monster reclaims the body from these strictures, and takes joy in the very meat of her flesh. Or if not joy, then some kind of meaning, in this too-muchness of ourselves, or this not-enoughness.

The tang that emanates from the work is a sign the artist is doing something right.

The hand-touch aesthetic, as valid a mode as cool minimalism.

objects of vulgarity

Lynda Benglis, *Artforum Advertisement*,
Artforum magazine, November 1974.

In 1974, tired of the near-total domination of the art world by men,
Lynda Benglis took out an ad in the November issue of *Artforum*.
It depicted the artist herself, naked except for a pair of geometric
white sunglasses, holding an enormous double-headed dildo up to
her crotch. (Later that year she would cast the dildo in lead, affix it
to the wall and call it *Smile*.[1]) The ad spread across two pages, just
like a *Playboy* centrefold. Benglis called it the 'ultimate mockery
of the pinup and the macho' – a blatant retort to an art world that
only wanted to see a female nude as a sex object or art object, but
never an agent with a sense of humour.[2] Five of the magazine's
editors were incensed; publishing a letter in the following issue,
they called the ad an 'object of extreme vulgarity'.* It was obscene,

* They wrote: 'In the specific context of this journal, it exists as an object of extreme
vulgarity. Although we realize that it is by no means the first instance of vulgarity to
appear in the magazine, it represents a qualitative leap in that genre, brutalizing our-
selves and, we think, our readers.' Lawrence Alloway, Max Kozloff, Rosalind Krauss,
Joseph Masheck and Annette Michelson, 'Letters', *Artforum*, December 1974, p. 9.

pornographic, by which they meant *this is out of place, it does not belong in our magazine.**

In *Rabelais and His World* (1965), the literary critic Mikhail Bakhtin contrasted the classical body, perfected, clean, polished and associated with high art – and, it goes without saying, white – with the grotesque, the open, filthy, changeable body that belongs with low forms of entertainment: parody, buffoonery, carnival, feasts of the fool, folk culture. For Bakhtin, classicism is the mind, sublime and transcendent, while the grotesque concerns itself with 'copulation, pregnancy, birth, growth, old age, disintegration, dismemberment'. The grotesque body is not separate from the world but in a state of exchange with it: 'it is unfinished, outgrows itself, transgresses its own limits'. It stresses those parts of the body that are open to the outside world, on its apertures and convexities: the open mouth, the genital organs, the breasts, the phallus, the potbelly, the nose.[3] Bakhtin doesn't hold one body superior to the other. But it's clear what constraints the classical body places on the female form, and what liberations the grotesque might offer. Where the classical female body is masterable in its (supposed) wholeness, the grotesque erotic body, experienced in fragments, is always escaping into the unknowable, the uncontrollable.

Benglis's ad inverts the relationship between the two registers, offering the viewer a smoothness, hairlessness and plasticity that is classical in form but grotesque in affect; answering Schneemann's visible clitoris with the double dildo, transforming her earth goddess into an androgynous punk. Mary Russo's scholarly reading of the female grotesque is informed by Bakhtin's theory that the grotesque body challenges the 'established order'. In her renowned study *The Monstrous-Feminine* (1993), Barbara Creed also draws on Bakhtin's notion that there are three grotesque moments in the life of a female body: sex, childbirth and death, moments when 'the body's surface

* In an interesting twist, the photograph that inspired Benglis, a poster for Robert Morris's April 1974 Castelli–Sonnabend show, was taken by Krauss. Krauss, with Michelson, ending up resigning from *Artforum* over the controversy, and the two went off to found their own journal, the wonderful but austere *October*.

is no longer closed, smooth, and intact – rather the body looks as if it may tear apart, open out, reveal its innermost depths'.[4]

If, as Lynda Nead writes, 'the classical forms of art perform a kind of magical regulation of the female body, containing it and momentarily repairing the orifices and tears', we can perhaps consider it the business of the art monster to display these orifices and tears, and make an art out of them.[5] Nead's 'obscene' body is one 'without borders or containment', that 'moves and arouses the viewer rather than bringing about stillness and wholeness'.[6] The feminist obscene body reaches out and breaks the frame, ruins the hierarchy between viewer and viewed, and collapses the distinction between the classical and the grotesque body. The formerly classically beautiful body is depicted but marked off as obscene, as penetrable, as hairy, as dirty, as scarred. As able to speak its own truth.

/

but don't ask us / to look at your films / we cannot

/

Benglis, in *putting us in front of filth*, confronts the viewer with what might usually be exiled to the realm of pornography and worse, not to the kind of tasteful art-cum-pornography that sophisticated consumers of art could recognise as belonging to a Sadeian, Bataillean heritage, but to a debased – read, working-class – American buffoonery. Not to the avant-garde of perverse sexuality, but to the grotesque realm of the girlie mag. Benglis is hip to this, her masterstroke being to present the image not as art, but as advertisement.

The *Artforum* editors called the image 'an object of extreme vulgarity', and they were right – it *is* vulgar, loud and slick and tacky. That tan, the oiled skin, the sunglasses! It has all the hue and subtlety of a car-wash calendar. Aesthetically speaking there is nothing to redeem about it. It just wants to get in your face. But there is a pop queer erotics at work here that is one of the most salient challenges the image levels at the viewer: between the short hair and full pout,

she looks like some dude heartthrob in a teen magazine. It is clearly an attempt to wrong-foot people's expectations about the 'female' body, what it should look like, what attributes it should have. And it gives female desire the characteristics that have been attributed to male desire – aggressive, phallic. It turns machismo into a myth, as well as feminine passivity.

The way the ad wrong-foots the viewer makes it more impactful than an image like Cindy Sherman's *Untitled #175*, from 1987; on a sandy beach, an innocuous white bath towel is covered in a night-marish scene of a pantry raided and purged. Half-eaten brownies and Pop-Tarts are strewn in the sand alongside some unidentifiable green substance that resembles Silly String but which is probably some kind of icing; the towel itself is covered with vomit. In the reflective surfaces of an upside-down pair of sunglasses we see the agonised face of a woman (Sherman) who has ostensibly brought up everything she's just consumed, bingeing and purging. It's a revolting picture ('ugh!' I said loudly when I first saw it in vivid, chromogenic colour, 'ugh!'), the grainy pale orange puke dotted with what look like chickpeas and chunks of carrot ('I'll never be able to eat a brownie again'), draping itself sickeningly over the corner of a cream pie. Zoom in and the woman looks older, not some pretty young thing trying to stay skinny but someone who maybe used to be, trying to get back to a body she'll never again have, or maybe never had, her face twisted in torment.

The image is too much, it's too gross. But somehow it's less con-troversial than Benglis's ad; is it because the body is missing? We see only a head in reflection, in 'masquerade', as Russo calls it, linking the sunglasses to another of Sherman's images, *Untitled Film Still #7* (1978), 'suggesting an uncanny connection between masquerade and bodily abjection'.[7] But reading this image alongside Benglis's, it seems a much better-behaved work of feminist art. The abject is actually a way of not dealing with the female body.

When Kristeva's book was published in 1980 (1982 in English) the term rapidly entered the theoretical lexicon, and by the early 1990s, the concept had enough currency among critics and artists that an entire show at the Whitney was staged around it in 1993; by decade's

end, the art historian Rosalind Krauss was lamenting 'the insistent spread of "abjection" as an expressive mode'.[8]

Its immediate power could be seen as a response 'to a cybernetic age where the body is threatened with disappearance into virtual reality', as the art historian Christine Ross speculated in 1997.[9] (As I write this the whole world has retreated inside their homes fleeing the enemy virus, and we engage with each other mainly on Zoom and FaceTime: the nightmare of disembodiment is a reality, and will, we hope, soon be behind us.) Or its popularity could be attributed to its feminist retort to Kantian aesthetics of purity and disinterestedness: 'Abject performances of the female body [. . .] bring back the uncontrollable body within the frame of art', Christine Ross points out, with reference to Sherman's work.[10]

But the abject is of limited help in understanding the turn to embodiment, or the role of embodiment, in feminist work. The work I'm writing about here, from Woolf to Benglis and beyond, isn't only interested in the affect of disgust or the role the female body has played as a placeholder for that disgust. Instead it wants to *challenge* disgust as an affect produced by an encounter with the abject as the female body. It is made in response to a patriarchal art culture that sees anything pretty as feminine and therefore worthless, while reserving beauty for the sublime and the masculine. I wonder whether for some women artists it has been necessary to work within an abject vocabulary of images in order to be taken seriously? Feminist artists reclaimed the abject, the ugly, the bizarre, to protest against the way the patriarchy 'abjects' the female body. But the abject has been seriously banalised over the past decades, wielded like some indicator of a more sophisticated taste – look at me not flinching at the abject, with all the affect of the dead-eyed appraisal of an art-world aficionado taking in a gallery show. Or it's used as a shorthand for feminist commitment. But most problematically, it takes the body and repulsion as universal, ahistorical concepts when in fact they are anything but. By thinking about bodily repulsion in this way, we avoid having to look at or think about particular bodies – least of all our own.[11]

The art monsters that interest me here have refused to posit the abject as the major mode in which feminist work must operate, and

redefined what it means to make a bodily art. Carolee Schneemann said as much in a 2010 symposium on her friend, the late artist Ana Mendieta.[12] Looking back to the 1970s, she observed, 'we have forgotten the danger, the dangers of depicting the explicit sensuous female body, we have forgotten how much hatred and resistance that inspired', how often work that tried to do so was written off as 'narcissistic'.[13] Schneemann recalls the way that she and Mendieta and others doing similar work were 'despised' by the art world, how they both met with great 'resistance' to their attempts to put their own female bodies at the centre of their practice, 'deny[ing]' them 'full authority' as artists.[14]

These artists have been drawn to female embodiment as a subject to legitimise and explore in all its specificity. What a relief it would be, to be able to stop hating our bodies. To paint our faces out of joy and not to hide some untellable truths.

/

Theories of the abject don't begin to capture how women *themselves* feel about their bodies, from the inside. Which is not to say we are not often disgusted by our bodies. But to what degree is disgust innate, or learned? Our attitudes towards our bodies, as feminist philosophers like Denise Riley and Judith Butler have argued, are themselves constructed by the way the culture talks about them. And as Douglas has shown in *Purity and Danger*, what we see as dirty or repulsive is a matter of convention and habit and ritual, and not inherent meaning.

The abject has its limits. Look at Jenny Saville's 1992 self-portrait *Propped*, for instance, which shows her sitting on a black stool that makes it seem as though she's being impaled on a streetlamp – or like she's putting out the light with her lady parts (Les Lumières snuffed out by the dark wilds of the female body). Her feet are coquettishly crossed around the back of it, naked thighs together, hands crossed at the wrists, nails digging into her skin; her breasts push together (like those of her piano teacher, whose breasts Saville recalled being squished into her bra so they formed one large mammary gland). Her head might be shaved; at any rate, no hair is visible, anywhere; she is an expanse of flesh.

When Saville was beginning her career, she wondered: 'Could I make a painting of a nude in my own voice? It's such a male-laden art, so historically weighted.'[15] She didn't want to be only the artist or the subject; she wanted to be both, to be her own subject, in order to create on the canvas 'the disparity between the way women are perceived and the way that they feel about their bodies'. She painted her own body on a monumental scale, Rubenesque, in mottled shades of flesh and sinew. A quote from Luce Irigaray's essay 'When Our Lips Speak Together' is carved into the skin of the painting, backwards, as if by someone standing behind it:

> If we continue to speak in this sameness – speak as men have spoken for centuries, we will fail each other. Again words will pass through our bodies, above our heads – disappear, make us disappear . . .[16]

The words physically pass through Saville's body on the canvas, but they do not make her disappear; she counters them more insistently, her heft a counterpart to their spindly etching. Jenny Saville gives us another language of the flesh, beyond abjection or embrace.

slash/aesthetics

The 1970s saw concerted attempts to speak as a woman, to make art as a woman – as well as the strongest attempts to argue that there *was* no particular way to speak, or make art, as a woman, and that any attempt to depict the female body in art was playing right into the hands of the patriarchy, that the male gaze was inescapable. In *Speculum of the Other Woman* (1974), Luce Irigaray declared it was time to re-appraise everything, to '[t]urn everything upside down, inside out, back to front. Rack it with *radical convulsions*':

> Insist also and deliberately upon those blanks in discourse which recall the places of [. . .] exclusion and [. . .] reinscribe them hither and thither as *divergences*, otherwise and elsewhere than they are expected, in *ellipses* and *eclipses* that deconstruct the logical grid of the reader-writer [. . .] *Overthrow syntax* by suspending its eternally teleological order, by snipping the wires, switching the connections, by modifying the continuity, alternation, frequency and intensity. Make it impossible for a while to predict whence, whither, when, how, why [. . .] something goes by or goes on: will come, will spread, will reverse, will cease moving [. . .] by the irruption of other circuits, by the intervention at times of short-circuits that will disperse, diffract, deflect endlessly.[1]

If feminists were asking for work that would cut short, interrupt, reroute, that would overwhelm and overthrow syntax, metaphors, systems, it is in part due to the growing consensus that the old systems of race, gender, class, sexuality, ways of controlling people and keeping power in the hands of a very few, needed dismantling.

The following year Hélène Cixous would publish her manifesto 'The Laugh of the Medusa', as well as a book called *The Newly Born Woman*, with Catherine Clément; these texts valorise a certain disruptive, bodily writing and art that – importantly – did not have

to be made by women. *Écriture féminine* contests fixed meanings, and encourages a disruption of the dominant (phallocentric) discourse. Women should write, Cixous says, 'in order to smash everything, to shatter the framework of institutions, to blow up the law, to break up the "truth" with laughter'. (Catherine Clément: 'All laughter is allied with the monstrous.'[2]) It is a disruptive form of writing, interruption formalised. 'If woman has always functioned "within" the discourse of man [. . .] it is time for her to dislocate this "within", to explode it, turn it around, and seize it; to make it hers, containing it, taking it in her own mouth, biting that tongue with her very own teeth to invent for herself a new language to get inside of.'[3]

But, asks Irigaray in 1980, how might women write themselves in this male language 'that connotes her as castrated, especially as castrated of words, excluded from the work force except as prostitute to the interests of the dominant ideology', which is to say the sexuality of straight men and its 'struggles with the maternal'?

> [H]ow is this to be done? Given that, once again, 'reasonable' words –
> to which in any case she has access only though mimicry – are power-
> less to translate all that pulses, clamors, and hangs hazily in the cryptic
> passages of hysterical suffering-latency.[4]

In Kathy Acker's 1988 novel *Empire of the Senseless* she offers a kind of answer (and Acker has certainly been reading her Irigaray, her Cixous). If 'reason' has a tendency to 'homogenise' and 'reduce', to 'repress' and 'unify', literature can take aim at it. 'Literature is that which denounces and slashes apart the repressing machine at the level of the signified.'[5] How exactly to use literature in this way would be her life's project.

In the art world, feminist critics asked similar questions. Was there, could there be such a thing as a particularly 'female' or 'feminine' art? And if so, what would it look like? There was little consensus on either question. In the fall of 1973, Lucy Lippard gathered together a roundtable of female critics and artists and asked them if they thought there was such a thing as 'female imagery'. Some, like Joan Snyder, claimed to be able to walk into the Whitney Biennial and pick out which works were made by women. Others, like Linda Nochlin, were offended by the very question. '[T]he term is so constricting. I'm

human [. . .] an androgynous being that isn't slated to give birth to any particular imagery.' If there is one, she grants, it will be a question of 'process' rather than essence. 'But even there I get stuck.'[6] By decade's end, Lippard was still worried about the implications for feminist art when 'female imagery' had hardened into certain formulae, referring to the 'various traps' and 'clichés' lying in wait for feminist artists trying to make 'female art': certain 'images (fruit and shell, mirror and mound), materials (fabric and papers), approaches ("non-elitist"), and emotions (non-transformative pain, rage, and mother-love)'.[7]

Surveying the debate around women's art forty years later, at a time when our understanding of gender is crucially ever more elastic, I think it is important to return to these questions. The intervening years of feminist discourse have largely dismissed the idea of a female art as essentialist nonsense. Identifying these sensibilities and imageries and styles as 'female' runs dangerously close to the sort of thinking that prevailed in the Victorian period: because women painted flowers, women were *like* flowers. I'm not sure that today you could walk into the Whitney and pick out the women's work. The artist's gaze, shared in joint attention with the viewer's, asks us to layer certain meanings on to the bodies we behold – to challenge those preconceived ideas, to think about the way we co-create these meanings. '[W]hat is a woman? I assure you I don't know,' writes Woolf in her 'Professions for Women' essay.[8] The art monster says *I don't know either, and neither do you.* In the face of our cultural assumptions, the art monster calls into question the most basic things we think we know.

Knowing that there is no eternal feminine expressing itself through art, however, does not invalidate the work of these 1970s artists, or those who were (and continue to be) inspired by them. It seems to me that it's what artists do with these 'traps' and 'clichés' that matters; if they treat the fruit and the shell as some kind of archetypal timeless absolute connecting body to image it is likely the work will be sappy, and lacking in depth. There has to be groundedness, weirdness, uniqueness, contingency, openness.

In Nochlin's trailblazing 1971 essay 'Why Have There Been No Great Women Artists?' she argues that no 'subtle essence of femininity' connects the work of, say, Artemisia Gentileschi and Helen

Frankenthaler; 'the mere choice of a certain realm of subject matter, or the restriction to certain subjects, is not to be equated with a style, much less with some sort of quintessentially feminine style'.[9] Nochlin (astutely) emphasises the historical and social contexts that have resulted in women artists addressing certain subjects in certain ways. But what I want to think about here goes beyond subject matter, or content per se, and beyond 'style', to that hybrid blend of the two that is *form*.

While I agree that there is no 'essence of femininity', that does not mean Gentileschi or Frankenthaler were not grappling with what it meant in their times to be a woman through the formal properties of the work itself, whether or not a political movement called 'feminism' existed when they made it. They are united in disruption, in always writing or making work from the position of the outsider. What binds women artists together is a common heritage, an art historical or literary language that they did not invent, that actively conceived of them a certain way – that assigned these attributes (inward-looking, subtle, etc.) to them. To then claim that this is a 'female' aesthetics is to prolong the essentialising that gave ground to them. Perhaps instead of asking if there is a *female* or *feminine* aesthetic we might entertain the idea of a femin*ist* phenomenology of art and form. That if there is a female gaze, it is not an attribute of any art made by women, but something that attempts to express what it means to live in a female body – whatever form it might take.

/

I think feminist work that admits some instability around gender is some of the most liberating, and can point to how discourses of the monstrous can help us tell the truths, whatever they may be, of our bodies. The Israeli artist Yishay Garbasz kept a photographic diary of her transition – not from male to female, she says, but 'into the woman [she] already was'. Once a week for two years, April 2008 to April 2010, she stood naked in front of her camera, against a white background, feet parallel, hands at sides, face passport-photo neutral, lips slightly parted. She showed the photographs in the form of a zoetrope at the

Busan Biennale; they were next published as a flipbook, which I have. It's an ingenious form for this kind of project; the photographs are presented chronologically, and so if you turned the pages the way we habitually do in English books, reading from left to right and turning the pages right to left, you would see a transition from someone with a cock into someone with a pussy. But when I used it as a flipbook, letting the pages go quickly beneath my thumb as if they were a series of cartoon drawings coaxed into motion, I found I held the book with my right hand and flipped them under my left thumb, creating a counter-chronological film: a story from female to male. An against-the-grain narrative that reverses – and collapses – the very notion of 'transition' from one state to another. In this way Garbasz has successfully resisted the 'before' and 'after' binary of the transition narrative. This was a conscious decision, she says in her artist's statement; she was interested in the 'gray' more than the ' "black or white" of male or female'.[10]

The body is white – there is that privilege – but it is a body claiming its monstrousness, in Susan Stryker's or Chris Kraus's use of the term. The smooth creamy skin is unmarked, uncut from image to image. But the form of the flipbook and the reference to cinema is a metonym for the plastic surgery of transition (or 'clarification') surgery. As the cultural critic Vivian Sobchack writes in her afterword, 'flipbook and the celluloid cinema they became usually "suture" and gloss over the cuts in time (and between individual frames) upon which their kinetic visual effects depend. These are real cuts made both in time and on the body.'[11] In the flipbook, as in the offstage reality it traces, a woman has been carved out of time. The process of becoming is not smooth, but slashed, comprised and recomprised of all the selves we've been.

In its stark but classical presentation of the naked body, the project inscribes the transgender body into the history of art, exploding our ideas about beauty, prodding the limits of excess, fringing the abject and testing the viewer to be honest about the feelings the photographs invite, the meanings we are projecting on to this body as we look at it. Garbasz, at any rate, gives little away; she is not glib or provocative; her neutrality is ever so slightly vulnerable, different every time, but expressing nothing specific. When the gender clarification surgery

happens, in late November 2008, her eyebrows raise slightly, the light is starker, her shadow appears on the side – but other than that (and the replacement of penis with vulva) there is no other registering of the change. Like Orlando, who, awaking one morning as a woman after centuries of life as a man, looks in her mirror without surprise, and goes off to her bath. She has, as Irigaray called upon her to do, turned gender inside out, upside down, but however radical the convulsion, it has been performed coolly.

/

We have only just begun to explore what women – understood in the broadest possible sense of the word – feel about their bodies, within their bodies. These are stories that haven't been told often enough or heard widely. Why, for instance, did my childhood best friend cry when she got her period? I sat across from her in the cafeteria, baffled. When my own period came I had accepted the blood as something that was bound to happen. My friend felt no such sense of inevitability.

Today I can better speculate, without knowing for sure, why she was so upset. My friend was small, smaller than everyone else in our class; her body wasn't shapeshifting like the other girls'; maybe she thought she was winning out over biology. Maybe she experienced menstruation as rupture, as the onset of a womanhood she wasn't sure she wanted to accept, or that hadn't been her destiny. Or maybe she had absorbed some of the culture's disgust for menstruating, the kind that turns period blood into blue liquid in the tampon commercials, that, in some religions, makes menstruating women unclean, and estranges them from the community. Maybe my friend was in mourning for the way this turn of events forced her from childhood and relative neutrality into an adulthood of being secondary, unclean.

Like Schneemann, Cixous denounces a patriarchal culture that associates women with the abject, so as to expunge both from its masculine purity. The art monster offers an alternative. Feminist art-making attends to a vision of possibility, of freedom, without borrowing from masculinist tropes of power and violence to do it. This other art,

this feminist art, is a question of articulating the embodiedness of language, of art, of music, with our own tongues and our very own teeth; it interrogates what it feels like to be in a body, confronting a normative, patriarchal, racist, Eurocentric culture with the experience of non-normativity and marginality, with queer monstrosity that can be abject, but can also be beautiful.

While abjection is certainly an animating interest in the work of much feminist art, it is by no means the *sole* theoretical correlative of the feminist monstrous. Radical work by women borrows from the abject, but the abject itself is only part of the story when we tell the truth of our bodies. The abject as Kristeva defines it isn't social; it doesn't admit for the role of politics and discourse in our understanding of what the female body (or motherhood) is; it just leaves us alone in a room with our own vomit, our own breastmilk.

It has been a major contribution of feminist artists, since the 1970s at least, that the notion of the work of art as autonomous and apart from the world of politics, as possessed of objective aesthetic qualities, is a load of horseshit. The aesthetic and the political have always gone hand in hand.

No, not hand in hand.

The aesthetic and the political occupy the same body.

on sensation

Lippard's wariness of 'non-transformative' emotions like anger and pain sounds worryingly prescriptive to me, redolent of a classical approach to art that required it do certain things in order to be worthy of existing. For Plato, art was hopelessly irredeemable – a lie, a copy of a thing which was itself a copy of the Ideal Form; it was therefore unworthy of inclusion in the Republic. For Aristotle, art was cathartic, 'medicinally useful', in Susan Sontag's phrase.* For centuries Western ideas about art remained in this representational tradition, and all attempts to defend it had to remain within its logic of form versus content.[1] Sontag's essay 'Against Interpretation' attempts to move criticism beyond this question of the mimetic, in which content will always 'come first' in our considerations, and form will always be an afterthought, something conceived apart, a mode of reading which she calls 'impoverishing' – for art, and for ourselves. In apprehending the 'sensuous surface of art' we move away from a 'hermeneutics' – that is, arguments about 'meaning' – and towards an 'erotics' of art. I think of Kristeva's abject in this category, or at least of the uses that are made of it – as a form of over-interpretation, of forcing the body to mean something specific and sickening, when what is truly radical is to leave its meanings open.

Sontag turns, for instance, to the filmmakers Alain Resnais and Alain Robbe-Grillet's 1961 *Last Year at Marienbad* – an elliptical, oneiric film which was 'consciously designed' to inspire endlessly multiple interpretations as to what actually takes place, what it's meant to mean. 'But the temptation to interpret *Marienbad* should be resisted. What matters in *Marienbad* is the pure, untranslatable, sensuous immediacy of some of its images, and its rigorous if narrow solutions to certain

* Before using the term in this sense in the *Poetics*, Aristotle employed the term *katharsis* to refer to the release of *katamenia*, or menstrual fluid, from the female body.

problems of cinematic form.'² Or if we read the tank in Ingmar Bergman's *The Silence* as a 'phallic symbol' rather than, as Sontag does, 'as a brute object, as an immediate sensory equivalent for the mysterious abrupt armored happenings going on inside the hotel', we are missing out on 'the most striking moment in the film', and betraying our own 'lack of response to what is there on the screen'.³

Her word choice is telling: the most *striking* moment in the film. Our response to the film, if we are doing our jobs as critics or readers, is to be open to being almost, or actually, physically affected by it. But I think this is a property of art as well as of our response to it. I think of Woolf writing in her manuscript for *The Pargiters*: 'What I value is the naked contact of a mind.'⁴ Who longs for less than that, in the aesthetic encounter? Aesthetic: from the Greek *aisthētikós*, of or pertaining to sensory perception. If we attend to the sensuous surface of the work, we may allow ourselves to be *touched* by it.

But this is what seems to concern Lippard – that feminist art will be found to be non-transformatively emotional. That it will affect us without offering us a way out of the discomfort – without a catharsis. It is a surprisingly neo-Aristotelian moment for an avant-gardist, and there is even a bit of internalised misogyny to it – come on girls, don't let them catch you *feeling* things!

Here the poet Mary Ruefle's essay 'On Sentimentality' is illuminating. In it she tries to get to grips with what role, if any, sentiment might play in a poem. Poets, she writes, as sentimental beings, are either 'custodians of pointless and absurd traditions' or 'custodians of the highest form of human expression'.⁵ Which one really depends on whether the resulting poem is any good or not; if it isn't, you're sunk, and if it is, you may still be sunk because you've been caught being sentimental.⁶ And the person who makes the poem is probably in the worst position to figure out if the sentimentality is worth it. She follows with a wonderful description of writing as a physical process, and how physicality is tied to our experience of making and eventually re-encountering the work:

> As I speak, blood is coursing through our bodies. As it moves away
> from the heart it *marches* to a 2/4 or 4/4 beat and it's arterial blood,

reoxygenated, assertive, active, progressive, optimistic. When it reaches our extremities and turns toward home – the heart – well, it's nostalgic, it's venous blood (as in veins), it's tired, wavelike, rising and falling, fighting against gravity and inertia, and it moves to the beat of a waltz, a 3/4 beat, a little off, really homesick now, and full of longing. When we first write our poems, how arterial they seem! And when we go back to them, how venous they seem![7]

In the eighteenth century, the word *sentimental* was used approvingly, to indicate a work 'possess[ed] the most refined aesthetic emotion, exhibit[ed] exquisite taste'. By the next century, round about the rise of Romanticism, sentimentality becomes something 'mawkish' and indulgent. Ruefle urges a return to that earlier understanding, one that paired the '*sen* of sensuous' with 'the *mental* of mind'. Which is to say that poems are 'both arterial and venous. They give pleasure – or they put a lump in our throats – *and they make us think.*'[8]

Sentiment is etymologically rooted in sensation, in the Latin *sentire*, to feel, but as early as the fourteenth century it has been a way of referring to one's own *personal* feeling. The problem with sentiment might stem from these associations with individuality: we don't trust it if it's only one person's feeling. Then if it's a feeling shared by *many* people, this is where snobbery attempts to stand in for taste: the work which produced it must have mass appeal (read: female appeal); it does not require a certain refinement of spirit to appreciate; it cannot be trusted either. Feeling, over the course of the nineteenth century, becomes associated with femininity, with mass culture, easy reading, overblown art; masculinity carves either a hyper-aesthetic path for itself, preoccupied with a modernism that is autonomous from the sludge-y sentimentality of mass culture and daily life, or seizes the political, and wields that as a tool against the same targets: women and sentiment.

Even in the sphere of mass culture, there is something 'suspicious' about poetry: what does it do that is of any use? It doesn't put food in anyone's mouths (certainly not the poet's). Poets, Ruefle admits, are always saying things that are impossible to comprehend. '*Pinnacled dim in the intense inane,*' she quotes Shelley. 'One of my favorite lines in all

of poetry, but what does it *mean*? [. . .] Shelley can't be any clearer because he is clearly attached, sentimentally, to language.'[9] Which I take to mean that we have such *physical* connections to language that we feel in our bones what the words mean, in that order, and they must be in that order, and that is the end of that. And if other people like that order, then we're in luck; and if they don't like it, we can either carry on believing in our mission or go home and find another job.

The art that most beguiles and intrigues me is gunning for our sentiments. I don't want a degree of irony separating me from art, from experience, from feeling. I want Schneemann's *hand-touch sensibility*. The writer or artist who reaches across to make contact takes a risk, and that is the bare minimum art can ask of us. Focusing on the aesthetic, the sensory, the sentimental is not a departure from the most pressing needs of the day but takes us to the heart of issues like the relationship between politics and art, or between the individual body and the body politic. It teaches us how to locate, as Woolf writes in her *Letter to a Young Poet* (1932), 'the right relationship [. . .] between the self that you know and the world outside it'.[10] It helps us understand that sensitive boundary that is our own skin.

Thinking of feminist body art through the terminology of 'representation', as in a recreation of some corresponding thing that exists in the real world, seems like such a step backward, away from the achievements of the 70s (and older generations of) feminists, who made the body their medium, made the body *matter*. They were not engaged in some pale Platonic copy of the female body, at a degree or more away from some theoretical femaleness; instead, they reckoned with the very nature of materiality itself, through a process of simultaneous looking and feeling, a monstrous aesthetics of touch and texture.

/

The question all this opens up for art is not about fetishising certain images and forms as good and others as bad, some as innovative and others as old-hat, some as masculine and some as feminine. It is, rather: how can the image point away from what we know, towards

Lynda Benglis, *For and Against (For Klaus)*, 1971.

something we may not even know how to name? Art, in the twenti-
eth century, tried to escape from story, which doesn't stop us telling
stories about this very escape, perhaps to fill in the blanks left behind
by abstraction, by minimalism. But the unspokenness of visual art
puts it beyond the power of rhetoric; its texture, even when made of
sound, even – possibly? – when made of words, works on some other
part of our beings; it has a power a 'story' doesn't. Art is potentially
unbounded.

Nochlin herself describes what I am pointing to in an interview
with the curator Maura Reilly, evoking a sculpture Lynda Benglis
made for a 1971 show at Vassar College, where Nochlin taught. Called
For and Against (For Klaus) it consisted of five poured masses of black
polyurethane which emerge from the wall, in a 'deep cantilever' with-
out touching the ground, flowing and skating upwards like frozen
black waterfalls, or like sludge, or like claws. The work itself was
destroyed after this exhibition (Nochlin reports taking a piece of it
home with her from the gallery), but this image, of liquid frozen
mid-pour, recurs throughout Benglis's career, from *Wing* (1970/1975)
to *Double Fountain, Mother and Child, for Anand* (2007). Nochlin calls it

a 'total rejection of sculptural work as permanent, stable, firmly based on the ground, and monumental'.

> Yet if the dynamic thrusts extruded from the wall with sinister bravado made a mockery of traditional art itself, desecrating the building in which traditional art was taught and presumably sanctified, neverthe-less, contradictorily, the dripping folds of polyurethane themselves recalled past traditions, like Bernini's swirling, dynamic, dramatic dra-pery folds, themselves so different from both classical placidity and the contemporary Minimalist doxa [. . .] At a crucial moment within the burgeoning feminist movement, these solidified 'pours', as they came to be called, literally flowed with the sheer energy of women's liberation.[11]

What does this abstract pour have to do with women? It's like our leaky bodies, it is tempting to say. But leakiness is not a gendered state; pipes leak; men take leaks, and isn't there something urine-like in the stream, something phallic in the lift?

It is not in what it says – what *does* it say? – or in its imagery that this reads to me as a feminist work, but in its quest for texture, weight, even timbre; in its attempt to evoke an experience of being a body, not necessarily a female one; in its flight from narratives of wholeness or incompleteness; in its determination to invade the viewer's personal space, usually so well delineated: me here, art over there. The art mon-ster seeks out images and forms that build and break a lineage, that defy dogma with what Nochlin calls 'sinister bravado', deliberate and random, abject and beautiful, formless and seeking form – form and against form, determined by a decision – the artist's, to pour – met by the randomness of chance and gravity, time and atmosphere acting on material. In resorting to polyurethane Benglis is – like Eva Hesse, who would also work in these impermanent, unstable chemical materials, or, later, like Janine Antoni, with her chocolate and lard sculptures that she herself shaped through long-term licking – calling on a material history that doesn't exist yet in the art history textbooks. Benglis's piece has this dual impulse, *for* and *against*, that is at the heart of the feminist art project, a monstrous ambivalence.

on articulation

As I began writing this book, I became pregnant with my son, and my interest in a feminist art of the body became specifically concerned with *how the body speaks*.

Pregnancy was the strangest of experiences. My appetites changed, as did my ability to move in the world; my very sense of myself *in* the world shifted from a wiry *I can take care of myself* pugnacity to a feeling of vulnerability and risk. I carried myself differently, and closed my coat around my belly when I could. I took naps and got weepy on waking. It took so much effort to turn over, to get up. My legs and my thighs covered over with puckered fat. Eating a few bites filled me up, made me tight under the ribcage. As I got bigger and bigger I could no longer walk up the hill we lived on in Belleville without feeling something inside me driving me to the ground. One day, trying to get wherever and unable to, I sat down on the steps of Edith Piaf's house and cried. There was something new and low in my body, rumbling and trembling and twitching, with a new relationship to gravity.

There is so much extra blood circulating that my heart beats faster, I wrote in my journal. *It all feels so fragile, like my body is being asked to sustain too much life.* The person I had been was coming apart, as my body put my baby together, but it was a dismantling that paradoxically involved being added to. I felt caught between pleasure at being socially authorised to take up more space and astounded at how *unlike* myself I felt as I did so. I was transgressing boundaries I'd always felt to be unbreachable. No wonder the bodies of pregnant people have become one of the major battlegrounds of our time; the further beyond society's boundaries we venture, the more it tries to yank us back into its sphere of influence. I felt defiant and unrecognisable, outsized – I was Chris Kraus's Blob, taking it all in, unwise and unstoppable.

As I assembled these chapters in their earliest state, my body – given the command – assembled my son in the faraway nearby of my womb. 'Assemble': cells divide and differentiate, splitting, multiplying, in embryonic becoming. 'Assemble': articulate, Latin, *articulare*, divide into joints, utter distinctly. 'Assemble': articulate: my body spoke my baby.

This limit experience of embodiment gradually led me away from my original ideas about the monstrous, and towards what felt like more personal reflections on the body and feminist art. As my body took a new shape, so did this book. Looking back over it now, it occurs to me that it could only have been written by a woman who was pregnant, and then breastfeeding, and then mothering. In its shape, its rhythms and interruption, in the things it notices, in the way it makes meaning, or fails to.

Pregnant, the art monster idea nudged me not towards vampires or zombies, but into art made of the everyday experience of having a body. Towards monstrosity as a strategy for making work that reaches us viscerally, which overspills its container, and threatens, in response, to make us overspill our own. I was drawn to feminist artists who interrogated notions of appropriateness and excess, breaking down and rerouting expectations, imagining life outside the binaries of gender, cracking open our ideas about beauty to show that it is a quality that is not diametrically opposed to ugliness, but one that sits next to it, and often overlaps with it. An aesthetics of monstrosity would not be about countering beauty with ugliness or vice versa, or even adhering to pure categories, but about re-aestheticising the aesthetic, bringing touch and feeling back into our encounters with art, centring the body and its viscerality, liberating it from patriarchal and normative control.

The artists I'm thinking of in this category blur the line between author and subject, pushing at the boundaries of narcissism to make the *personal* a universally relevant category. They help us to take the monster out of the realm of morality, into some more subtle, harder-to-define ethics that is also an aesthetics, in the sense that I give it here: a way of feeling that art alone can produce. This monstrous art strives to understand or express something about what it is to be

embodied and socialised as female; it is femin*ist*, not feminine.* It is
seditious, excessive, hybrid, collaged; it rejects linearity and throws off
orthodoxies of patriarchy, heterosexuality, whiteness, participating in
a shared project of carving out 'psychic space', as the feminist scholar
Carolyn Heilbrun put it, and guiding society away from normative,
controlling, punishing, constrictive ideas about women.[1] It has been
called punk, performance art, body art, dada, surrealism, queer art; it
is all of those things but it is also something else – a monster theory
of art and gender, a monster theory for art and for life. If I focus on
art (including film and photography) and literature here it is because
these, more than dance or music, bear the burden of 'representation'.
They are more directly linked with explicit forms of storytelling, and
so while I don't see them as more privileged forms of radical feminist
art than the others, they are perhaps a more legible place to begin to
make these arguments.

For me, this book is as much an experiment in critical form as it is a
feminist intervention in conversations about female embodiment and
representation. I found I needed to follow the line of thought as it
developed; I couldn't impose a primary argument followed with sup-
porting chapters. It is purposefully un-disciplined, anti-disciplinary,
breaking down boundaries between art writing and literary criticism,
reading across the borders of nation and temporality, heartened by
what the philosopher Edouard Glissant calls a 'poetics of relation',
according to which 'each and every identity is extended through a
relationship with the Other'.[2] The shape of this history is necessarily
a weird one; to tell it chronologically would be to impose an artifi-
cial narrative and to present later artists as the de facto answer to the
earlier ones, when it is quite often the reverse that is the case. Even

* I am following a definition of feminist art as formulated by the renowned art
historian Griselda Pollock: 'An art work is not feminist because it registers the
ideas, politics or obsessions of its feminist maker. It has a political effect as a femi-
nist intervention according to the way the work acts upon, makes demands of, and
produces positions for its viewers.' In 'Feminism and Modernism', in R. Parker and
G. Pollock, eds., *Framing Feminism: Art and the Women's Movement 1970–85*, London:
Pandora, 1987.

if it is true that the later work I examine builds on the work of the 70s feminists, history doesn't actually line up that way like books on a shelf, one thing coming after the next. Artists who were an important part of the scene in the 70s, like Carolee Schneemann or Hannah Wilke, went on to make work for decades years afterwards. Artists who were just starting out in the early 80s, like Sutapa Biswas or Helen Chadwick, were hugely impacted by it, but also by everything that came afterward; Biswas is still making work, and Chadwick was active up until her untimely death in 1996.

I am also leaping over important feminist work around embodiment done in America in the 90s – Kiki Smith, Renée Cox, Janine Antoni – which I hope to return to in future; to properly historicise this time and place would require more narrative space than this book was able to provide. And so I have limited myself, by necessity, to building a constellation of correspondences around the radical feminist art of the 1970s. Reading forwards and backwards from this decade, I am trying to make another shape for the history of radical feminist art and literature. Julia Kristeva devised the term *intertextuality* to describe the way that the meanings of a work are created not only through our direct experience of it but through its place in a complex web of other works and references. Both the work and the reference are transformed by being brought into relation with one another.

The rhythm of my work on this book has also affected the form it has taken: the initial research and notes were made during my pregnancy, then evolved at a haphazard rate once my son was born, through the bits and pieces of time I could grab at when he was a tiny baby. They were developed more thoroughly as he began to go to the childminder a few days a week, and more thoroughly still when he started at nursery when he was a year old. Then came the pandemic, lockdown, the loss of a regular writing rhythm. At some point I had to stop fighting these stops and starts as impediments to the book I wanted to write, and acknowledge that they were baked into the book itself, a non-negotiable part of its form. During the summer of 2020, a crucial moment in the book's development, the library had a policy that you could not look at a book two days in a row; after a day spent with it it would have to go into some deep-cleaning

unit for forty-eight hours, after which you could borrow it again; I grew accustomed to a three-day rotation of sources. I could look, for example, at Eva Hesse's diaries on Monday, Thursday, and the following Tuesday, but not the days in between. This is still a sustained encounter, but one punctuated with little breaks that induce distance. I had to remain open to the particularity of this writing experience, at this time in my life and in history, and accept this measure of uncertainty as an invitation to a mode of writing I might not have allowed myself to access. It feels appropriate, looking back over it now, that a work about monstrosity and excess would itself prove so impossible to write in a conventional form.

The literary critic Eve Sedgwick points to the crucially varied and ambiguous meanings of queerness, 'the open mesh of possibilities, gaps, overlaps, dissonances and resonances, *lapses and excesses* of meaning when the constituent elements of anyone's gender, of anyone's sexuality aren't made (or can't be made) to signify monolithically'.[3] This helped give me permission to let the book take the shape it needed, as it investigated an aesthetics of female monstrosity. Monstrous art insists on multiplicity; story is never singular, linear, or straight; the art monster queers story, queers form, queers time.

The work is weird and the work is bold. What makes it good – what sets it apart – is its commitment to a sometimes-scathing honesty. These monsters might be telling you stories, but they're not telling you lies. They are, as Clarice Lispector writes in *Água Viva*, 'at the center of everything that screams and teems'.[4] They form a radical heritage that links Julia Margaret Cameron to Kathy Acker, Theresa Hak Kyung Cha to Sutapa Biswas; they are the inventors of new languages and therefore of new communities. Some of them were in actual community together, but even those who lived in different times and places are joined by a kind of kinship: what the French critic Émilie Notéris calls 'queer maternity', and the poet-critic Quinn Latimer a 'strange sisterhood of fire'.[5] They are finally able to venture out into the depths where Woolf's imagination wanted to travel; they have brought back the 'queer knowledge' they gleaned there, and put it to use.

The lines I trace between these works are not the only or even

Eva Hesse, *No title*, 1970.

necessarily the best ones, but those that were most apparent to me; there are others which might, and I hope will, be drawn. As the book has taken shape I've thought more than once of Eva Hesse's *No title* (1970): a tangled skein of materials, suspended from the walls at several key points.[6]

But most days, writing it, I have felt more like Hesse in the 1968 photograph by Hermann Landshoff, where she's lying down on her couch with one of her rope sculptures – this one? – lying on top of her, knotted and heavy-looking. Oppressed by the weight of her unruly work. Every moment I'm not writing this book I'm Eva Hesse, lying on that couch. And yet: it anchors me, as I feel the weight of my daily disentanglements to come.

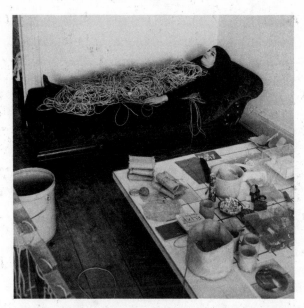

Eva Hesse with rope sculpture, photographed by
Hermann Landshoff, c. 1968.

Work like Hesse's helps us take back our bodies from narratives that
would deny their autonomy and their right to expression. Because to
reclaim touch for the aesthetic is not to lose ourselves in rarefied con-
versations about art and philosophy: it is to ask basic questions about
the relationships between our bodies, to ask how we come together
in our societies, to ask, as Kraus writes in *I Love Dick*, *who gets to speak,
and why*. Thinking collectively about the history of women's art might
allow us to cobble together a variegated, patchworked, monstrous
understanding of how to articulate female embodiment, in word and
in image.

/

Donna Haraway, 'The Promises of Monsters':

Articulation is not a simple matter. Language is the effect of articu-
lation, and so are bodies. The articulata are jointed animals; they are
not smooth like the perfect spherical animals of Plato's origin fantasy

in the *Timaeus*. The articulata are cobbled together. It is the condition
of being articulate. I rely on the articulata to breathe life into the arti-
factual cosmos of monsters that this essay inhabits.[7]

The art monster Frankensteins genres and texts and materials together,
there is no good or bad, same or different, self or other, there is only
matter combined with matter, and what does it do now?

The cultural critic Stuart Hall theorises articulation as 'the form of
the connection that *can* make a unity of two different elements, under
certain conditions. It is a linkage which is not necessary, determined,
absolute and essential for all time.'[8] Likewise Lawrence Grossberg
posits that articulation is 'the production of identity on top of dif-
ference, of unities out of fragments, or structures across practices'.
It links texts and their effects, meanings and realities, experiences
and politics, which are themselves linked – 'articulated' – into 'larger
structures', and so on.[9] Under certain conditions – those of making
art while being female – these unities flourish. And what grows in the
joints, but courage, and liberation? And what about what is not on
the canvas, or on the page; what has been left out, or obscured, those
present absences, pointed to but not articulated? How do you speak
the silent body?

These hybrid texts and works move beyond the logic of the frag-
ment to the organic, artful process of growing connective tissue.
Hesse's work, for instance, provided me with a way of conceptualising
the variety of writers and artists whose work I felt, on some physical
level, vibrated together. Her piece *Vinculum I* is one of the last pieces
she made, and was one of her favourites, the closest she felt she had
got to articulating what she had to say. It is two ladder-like structures,
linked by rubber hose material, like a shoelace. Like so much of her
work the whole shape of the piece changes depending on how its com-
ponents are arranged, how the linking bits hang. *Vinculum*, in Latin,
refers to a bond or a joining (Hesse says 'links and connections'), and
my greatest challenge in writing this book has been the transitions,
the joining together of these disparate figures and works.[10] The whole
book, you could say, has been put together under the sign of Hesse. In
a hyperalert state of linking and connecting.

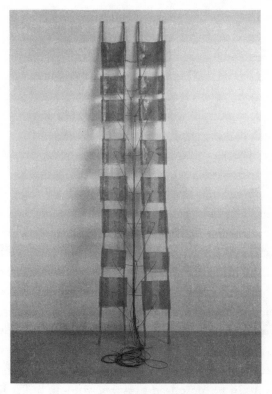

Eva Hesse, *Vinculum I*, 1969.

My partner Ben's mentor, the composer Roger Reynolds, once wrote a string quartet in which he excerpted four compositions he really liked and then found a musical line, a strand of sound, to connect them.* This has sometimes felt like my mode of operation, here. It has felt risky, incomplete, but the only way to say: this is how I see things. To follow the line as it weaves and enmeshes, as it slips between disciplines and periods.

And I have also held fast to some lines by the virtuosic poet of connectivity, Eileen Myles –

* The excerpted works were by composers he admired, and citing them was a way of paying tribute, to proclaim that they were, as the title of the piece makes clear, 'not forgotten'.

I can

connect

any two

things

that's

god

teeny piece

of bandaid[11]

— lines whose shape echoes that of Hesse's *Vinculum*.

For me this process of *linking* has been the only way through to articulate a rich feminist history that emerges ineluctably from the history of art and literature, one we can think of, inclusively, as *ours*, and be inspired by, to our own experiments in links and connections.

I invoke this imagery not to harness the 'lazy romanticism' of weaving metaphors (as the poet Nisha Ramayya calls it), but because if there is an *écriture féminine*, a language of women's creativity, it may well be in the weave.[12] Weaving is not an inherently female activity, and nor was it always practised only by women, but it has come to serve as a metaphor for women's modes of telling. The great Woolf scholar (and my PhD supervisor) Jane Marcus argues that in *Between the Acts*, Woolf's last, posthumously published novel, she uses Ovid's retelling of the Procne and Philomel story as a metaphor 'for the silencing of the female, for rape and the male violence against women which are part of patriarchal and fascist wars'.[13] Philomel was raped by her sister's husband, who cut out her tongue so she couldn't say what had happened to her. Undaunted, she weaves a tapestry (a peplos) telling her sister the story. When Procne understands what's happened she — *jesus* — kills her son and feeds his head to her husband for dinner. He tries to kill both women, who take flight, and are transformed by the gods into a swallow and a nightingale.

Marcus then turns to *Titus Andronicus*, where Shakespeare also makes use of the Procne and Philomel myth in order to portray the victim of rape as a 'speaking text' and to problematise the question of how to read her. In his play, Lavinia is gang-raped by the sons of her

father's captive in war, who cut off her tongue as well as her hands
to keep her from writing her tale. So she uses a stick held between
her teeth and stumps to carve the names of her rapists into the sand.[14]

These are horrific stories, but we have to face up to them, and
retell them, to free our bodies from the double bind in which they've
been caught. The art monster's job is to refuse to be silenced, but also
to find a material in which to tell the stories of her body. And this
is where Marcus exhorts us to put our emphasis – not on 'elevating
sexual victimization as a woman's poetics' but on evolving a 'feminist
aesthetics of power'; not on telling our stories again and again but on
finding new ways to speak our truths.[15] In calling for a literature of
embodiment, Woolf demands 'a new language [. . .] primitive, subtle,
sensual, obscene'.[16] I believe that is what is on her mind as she sits in
her bath in 1931, thinking of the book she will write on women's
sexual lives, and their professional ones. By reaching after the truth
of her own body, the art monster is grasping after an art practice that
is not simply a refutation of patriarchy but a gesture at building her
own aesthetics. It is neither a channelling of normative practice nor a
rebuttal of it; it is a deviation, a hard left into a new territory.

The art monster alerts us to what is outside of language. To what
is created when two genres meet, or some boundary is transgressed.
What is produced in this movement across – what grows in between –
is the sort of silence you *feel*. The beat between two thoughts, the cae-
sura, the slash. Work that is neither fully representative nor abstract,
but rather ambiguous. Work that charts the undoing of the body, and
even undoes and decreates itself.

Across the centuries, the art monster has confronted the problem of
how to allow the body to speak. Queer bodies, sick bodies, racialised
bodies, female bodies – what is their language, what are the materials
we need to transcribe it? What are the languages of the body?

II.

professions for women

virginia woolf julia margaret cameron george sand céline sciamma
hélène delmaire mary richardson angelica kauffmann elisabeth vigée-
lebrun sofonisba anguissola artemisia gentileschi laura knight karen
finley betye saar kara walker laura mulvey louise bourgeois elizabeth
alexander zadie smith dana schutz sutapa biswas isabelle tracy lubaina
himid griselda pollock mary moser frances borzello carolee schneemann
lorna simpson ellen y. tani roxane gay martha rosler howardena pindell
aruna d'souza jayaben desai

the angel in the image

John Everett Millais,
Emily Patmore, 1851.

Woolf took the phrase the 'angel in the house' from an 1854 poem
by the Victorian man of letters Coventry Patmore, in which the self-
sacrificing wife is the ultimate muse: the inspiration for art, not its
author. An entire century's ideas about a women's role in life were
formed by this poem. *The Angel in the House* begins by describing a man
who has won poetic fame, been crowned with honours and renown,
but who deserves these things much less than his wife. He praises her
'gentle self' in verse, though his words, he fears, are too bland to cap-
ture her sweetness; instead his thoughts 'lie cramp'd in narrow scope,
/ Or in the feeble birth expire'.[1] The Victorians went wild for it. The
poem is a distillation of all their ideas about how women should be:
'Her disposition is devout / Her countenance angelical'.[2] Modesty,
grace, loveliness, simplicity, circumspection: men might find in these
virtues a cipher to control; women looked to the page, and saw them-
selves there, smooth.

Patmore's own wife, Emily Augusta Andrews, gave birth to six chil-
dren, three sons and three daughters, and wrote a book of children's
poetry, published in 1859, under the pseudonym 'Mrs Motherly'. You
can find it on Google Books, if you look for it. There are poems about
seasons, and snails and squirrels, and quite a few about the family cat.
And one called 'The Train' about how exciting it is to go somewhere,
that is, implicitly, also about the need for trips to be chaperoned by
the man of the house: 'Whenever we want to be happy again / We
must ask to go out with Papa in the Train'.[3]

She was her husband's muse as well as that of his contemporaries;
she posed for a painting by John Everett Millais (now hanging in the
Fitzwilliam Museum in Cambridge) in 1851, and inspired Browning,
Ruskin and Carlyle in their own work. The portrait shows no sign
of her varied accomplishments; unlike a soldier (to gloss a point from
Three Guineas) a mother wears no tuft of horsehair on her shoulder
to signify every childbirth battle she's survived; no braid is added to
her dress for every bairn she's breastfed. Instead she receives a bouquet
of posies, a floppy pink velvet bow. A lace collar, one she probably
made herself – a coded reference, perhaps, to her own artistic talents.

In 1862, Emily died, aged thirty-three. No heroic burial for her.
Her memorial: her husband's literary tribute. Patmore would dedi-
cate his two-volume poem to her, or rather: 'To the Memory of her
by whom and for whom I became a poet'. To the memory of her, and
it's all about him.

Which brings me back to my point, or more accurately, Jenny
Offill's point.

Emily Augusta Andrews took care of her children and her husband.
This is why he had the time to immortalise her in his poem. Presumably
she had help in turn, some unseen servants who are not captured in poetry,
who made it possible for her to write her own book while raising six chil-
dren. Like Vera Nabokov, she was a helpmeet, serving a man who, one
assumes she believed, was a genius. Why have there been no great women
artists? Because they've been busy serving great men. Their labour has
been effaced. All that remains is the work: their husbands' work.

In the name of their genius, we have licked their stamps, and not
only their stamps. Made their lives as easy as possible, so they can

have the time and calm they need for whatever it is they do in that study all day.

Patmore believed in the Victorian tenet of separate spheres, the man navigating the public realm, the woman presiding over the home. This has only ever been a mythology; women of all classes had varyingly complex interactions with the 'outside world' while at home, as the critic Victoria Rosner points out, 'more rooms were given over to the gentleman of the house than to its mistress'. In this way we can see the theory of separate spheres as an attempt to manage the unmanageable, to keep woman in a 'place' that was invented for her, not working away in her own room, mistress of her own space, but there in the salon, entertaining, sewing, being luminous and reflective, like the moon.

And against this life indoors, so much violence, so much tearing of wallpaper, gnawing at bedposts, frantic flapping of wings.

/

Patmore's poem held so much imaginative power for women of his time that Woolf's great-aunt, the photographer Julia Margaret Cameron, named one of her photographs *The Angel in the House*, a three-quarter portrait of a young woman in soft focus against a dark background.

I went to the Central Library archives in Liverpool to see a print of it, one inscribed to the poet himself. Only in person could I appreciate the distinction in the young woman's hair, in the fur on her dress, on the velvet tabs on her collar, the modelling of the shadows on her face and her ear. In spite of the allegorical title, this is a portrait of an individual woman. She is not pictured with children, or in the home; she is not defined by her role or her actions, but alone in some non-specific setting. This fits the timeless, allegorical image; but it also sets her free from Victorian ideas about where a woman belongs.

Cameron made a name for herself taking portraits of Great Men in all their craggy specificity; there is none of that here. This belongs to her other favourite genre, soft-focus portraits of angels, maidens, children, innocents kissing or being kissed. All docile, mysterious, adorable creatures. Despite their sentimental subject matter, these

Julia Margaret Cameron,
The Angel in the House, 1873.

portraits have a shocking power and honesty and modernity; those of Ellen Terry or Annie Philpot look like they could have been taken last year. Yet for all its softness there is also something sculptural about it, like a Greek bust. This is woman as a work of art – but also a gesture at Cameron's own artistic powers, like Pygmalion in reverse.

Cameron worshipped in a cult of beauty like an opioid reverie from which, as soon as Queen Victoria was dead, an entire culture awakened, ashamed of their base sincerity, their sentimentality. Although today her work reads as a pure expression of Victorian values, in her day as well as after, she was ridiculed for her subject matter. Her angels, biblical scenes, characters from mythology, her 'Madonnas and May Queens and Foolish Virgins and Wise Virgins',[4] were deemed kitsch, even by those who otherwise supported her work, like Helmut

Gernsheim, who rehabilitated Cameron's reputation and brought her out of obscurity with a 1948 monograph, but also called her genre portraits 'affected, ludicrous and amateur'. Or Roger Fry, who wrote in an otherwise appreciative 1926 essay that Cameron's attempts at 'the poetical and allegorical compositions which were then in vogue' were 'failures from an aesthetic viewpoint'.[5]

Cameron's photographs testify to a vanished aesthetic, one that, nevertheless, in Fry's description, does not sound a million miles away from our own carefully constructed Instagram selfies. Looking at one of her groupings of women, Fry reflects: 'We realize something of the solemn ritual which surrounded these beautiful women. How natural it seems to them to make up and pose like this. They have been so fashioned by the art of the day that to be themselves part of a picture is almost an instinctive function.'[6] For the women, perhaps, raised on Pre-Raphaelite compositions in Cameron's day, as they have been on Kardashian feeds in ours, this is the case. But for the woman behind the lens, there is nothing naturalised about her decisions and what she leaves to chance.

But an attentive reading of both together reveals that Cameron was not mindlessly reproducing idealised Victorian women. In cataloguing these impossible, allegorical female figures, and setting them in these misty landscapes, Cameron seems to ask us to notice the distance between the allegories and the flesh-and-blood woman incarnating them. The young woman who sat for the photograph, Emily Peacock (what a brilliant name), was a house guest of the Camerons at their home on the Isle of Wight, and Cameron made much use of her, shooting her as Ophelia, the May Queen, and Aurora, Goddess of the Morning. Cameron seems truly to have loved her. Perhaps, then, the image doesn't have to be understood as an archetype, but literally as a portrait of Emily Peacock: the angel in Julia Margaret's house.

/

Another image in the Cameron archive caught my eye, which could very well be given the same title. A woman in a heavily draped drawing room bends over her lace making, hair braided like a crown around

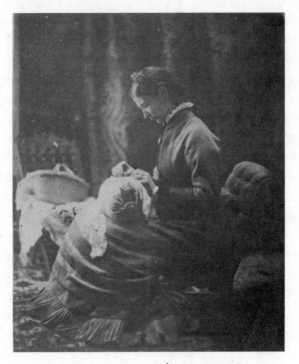

Julia Margaret Cameron,
Woman Making Lace, 1872.

her head. The pleated hem of her dress is indistinguishable from the skirt of her quilted chair. The room is dark, enclosed. She works away at her bobbins, in the midst of the family home, and I'm reminded of Jane Austen hiding her novels under her needlepoint. 'For women have sat indoors all these millions of years, so that by this time the very walls are permeated by their creative force,' wrote the photographer's grand-niece fifty-seven years later. Here, as elsewhere, Cameron's camera records, in Woolf's phrase, the 'unrecorded life'.[7]

/

What kind of profession for women was photography? Cameron took it up later in life, at age forty-eight, when her daughter gave her a camera as a present. Upper-class and well-off, she had already raised her five children (plus five orphan cousins and one Irish beggar), and

could, one presumes, take some time off for artistic pursuits. The nascent photography community was not exactly happy to have a housewife join their ranks. They called her amateur, because she refused to enlarge or touch up her photographs.* 'From Life', she would scrawl along the bottom of the matting, as opposed to the 'from nature' of her competitors, wanting, as the critic Amanda Hopkinson puts it, 'to capture an unrepeatable experience: those crucial minutes of that sitter's life. To wait until the print emerged, and then to tinker with it and prettify it was to falsify that reality.'[8] Unlike other contemporary photographers, she would not use restraints to keep her subjects still, but integrated their natural movements into her aesthetic. She saw that she was on to something, and didn't care if her contemporaries didn't understand it. '[W]ho has a right to say what focus is the legitimate focus?' she wrote in a letter to a friend in 1864. 'My aspirations are to ennoble Photography and to secure for it the character and uses of High Art by combining the real & Ideal & sacrificing nothing of Truth by all possible devotion to Poetry & beauty.'[9]

Worse still, she would scratch at the negative to achieve a certain texture, and splice together two different negatives to create a new composition. Julian Cox, one of the editors of the complete photographs, compares her plates to 'elemental skins', whose 'cutaneous layers' would register every blot and smudge. To Cameron such marks were part of the work itself, proof that she was an artist, capturing the world in line with her vision, instead of a hack portraitist giving her clients what they paid for – mindless perfection. Cameron was attempting to find a 'pictorial vocabulary' to express the cardinal virtues of her time, which centred on the importance of motherhood to

* Even Woolf would call her great-aunt 'the best amateur photographer of her time', although Cameron earned money from her photography and eventually set up her own professional studio. 'Pattledom', in Virginia Woolf, *The Collected Essays of Virginia Woolf, Vol. 4, 1925–28*, ed. Andrew McNeillie, New York: Harcourt, 1994, p. 281. Hereafter *E4*. Carolee Schneemann would include a tribute to Cameron in one of her early works, a 1961 multimedia ('kinetic') painting called *Sir Henry Taylor* which collages in Cameron's 1867 photograph of him, beside a pair of underwear dipped in plaster. In the bottom righthand corner is an image of a nude woman's back, taken from *Playboy*.

the family and to society at large.[10] The Victorian home was idealised as a 'locus of peace and innocence', and children 'inspired the Victorian middle classes to recover the humanity that was so threatened by the intense pressures of competitive public life'.[11] And yet the aesthetic in which she chose to do it – fingerprint, oilmark, bit of dirt, strand of hair – defied this ethereal disembodied ideal. Her work was sentimental: sentimental in the etymological sense, derived from *sentire*, to *feel*. Cameron's was a photography of embodiment. She refused to retouch; she let imperfections stand. These are not mistakes but active decisions to draw attention to the made-ness of the image, its fictionality, the presence of the photographer, the developer, the framer.

The nineteenth century was, as the art historians Griselda Pollock and Rozsika Parker put it in their foundational feminist study *Old Mistresses*, the 'hey-day' of seeing certain kinds of art by women as 'biologically determined or as an extension of their domestic and refining role in society, quintessentially feminine, graceful, delicate and decorative'; Victorian attitudes towards women 'attributed natural explanations to what were in fact the result of ideological attitudes'.[12] Is it any wonder, then, that Cameron took such pains to make her work less perfect, less beautiful, less ideal?

Cameron's 'Woman Making Lace' points us to a tradition of women's art-making that was rejected as amateur; it blurs the line between art and craft, between professionalism and amateur enthusiasm. The lace collar drips with superfluity, not art but decoration: made by a woman and fit only to adorn a woman, made in a female interior space to embellish it unobtrusively. (To be tasteful it mustn't call attention to itself.) What else is ornament, when it has been made with this degree of care, but art for its own sake? But fashion and home decor were not what the nineteenth-century writer Théophile Gautier was talking about when he proposed that art serve no other purpose but to exist: *l'art pour l'art*.

The story of that lace collar (and the other 'decorative' crafts Victorian women produced) is the story of art and craft where women are concerned. In medieval England, according to Pollock and Parker, embroidery was undertaken by both men and women, in the church (by both monks and nuns), in trade (by independent workers) and

in the royal household, used on clothing, book-bindings, and other textiles, mainly liturgical in character. But by the thirteenth and fourteenth centuries there was such demand for one particular form of needlework, Opus Anglicanum, that production had to be increased to meet it.

Over time production of this needlework came to be concentrated in 'tightly organized, male-controlled' workshops in London. Women were rarely admitted as members to these guilds, though women participated in all aspects of production. With the rise of early modern capitalism the Broderers Guild was 'reconstituted as a company in 1568. All the officials were men.' The men named themselves 'professionals', thereby writing off everyone who wasn't in their club (read: women) as amateurs.

The craft of embroidery, however, continued to be practised by queens, lending it a certain gentility which would popularise it as a pastime for upwardly mobile middle-class women. By the eighteenth century it was known as 'women's work', practised by the lady of the house as both a demonstration of her virtue – every surface in the house was soon covered in needlepoint, demonstrating the refinement of those who inhabited it – and of the economic success of the man of the house, who was well-to-do enough to allow his wife that kind of free time.[13]

It was perhaps inevitable that male opinion would turn against women's crafts as a waste of time, and that the women who had previously been encouraged to practise them would be accused of filling their own heads with nonsense. In 1815 Mary Lamb called for women to give it up unless they were being paid to do it.[14] (Wages for housework in 1815.) Husbands groused about how much money it cost to 'professionalise' their wives' endeavours; Pollock and Parker refer to a satirical article by Joseph Addison in which a man complains that his wife puts him to 'great expense by being too industrious. She painted fans and miniatures, which had to be mounted by specialists; she purchased materials for her embroidery and employed Huguenot assistants. "For as I told you, she is a *Great Artist* with her Needle," ' he writes, irony dripping from his italics.[15]

His (male) readers would of course find it hilarious, this idea of a housewife being a great artist. *Great Artists* were men! White men,

for that matter, and of a certain class. They were mostly educated, and free to travel alone, seeing art and architecture in far-flung places. They didn't have to be home tending to the children; they went out schmoozing, making contacts and winning influential supporters. They were also the art historians, the curators, the directors of the institutions that set the standards for what was good art and who was a good artist, and they were the teachers who instructed successive generations according to these criteria.[16]

They invented taste, and tastefulness, and beauty. They decided what it was, and how it should be deployed. Who got to use it, and who didn't.

/

'Why have there been no great women artists?' asked Linda Nochlin in 1971. There have been wonderful female artists, of course, but no one who has been considered Great on the order of Michelangelo, Van Gogh, or Jackson Pollock. Not because no female painter was as good as they were (or, possibly, without the proper training they couldn't be), but because art historical discourse didn't idolise women the way it did the men. Against the myth of the Great Artist as he whose genius will out – the hand of fate turning a lowly shepherd into Giotto and a disturbed Dutchman into Van Gogh – Nochlin writes that 'art is not a free, autonomous activity of a super-endowed individual', but rather a 'total situation of art making', the interplay of individual and social structures, 'mediated and determined by specific and definable social institutions'.[17]

The only to-hand mythology we have for female genius is the madwoman, the suicide.

/

In 1875, Cameron and her husband moved to Ceylon, where he had an imperial career in his youth, and where her three sons were established as well. Doing what, I wonder; what colonial exploitation underwrote Julia Margaret Cameron's career as an artist? Keeping up the

photography business took a great deal of money, and there are some suggestions that the family needed to conserve its resources. Cameron wanted to make her husband happy, and to be close to her children; how wrenching it must have felt to be across the world from them, before aeroplanes, telephones, penicillin.

When they arrived she took a few portraits of Sri Lankan women and then stopped taking pictures altogether. Was her retirement a result of the humid weather, the scarcity of resources (back at Freshwater she used several pails of water a day developing prints), the expense of materials and chemicals, and the impossibility of publishing any future work? What did the great photographer see when she looked at empire close up? Was she so stunned by what she saw there that it silenced her?

It seems cruel to have transported her away from England, just as she reached the height of her success and her creative powers. I can't imagine how it felt to lose that creative outlet. Did she stare wistfully at people in certain lights, did she frame them in her mind, was she forever storing up ideas for new images, on the off-chance she could ever make them again?

/

To be a good wife is to accommodate yourself to someone else's story, a story in which you are not an artist.

sibyls and slashers

For centuries, artists of any renown were mainly noblewomen and the daughters of painters, who received training, and could more easily meet prospective buyers. Dominant ideas about gender and propriety controlled what they could paint and how they could present themselves. They were not allowed to paint from the nude, which greatly limited their subject matter: they stuck to portraits, or genre paintings, still lifes and flower paintings, and as a result this kind of art became identified with femininity and dismissed as small, unimportant, formulaic. Women artists were stereotyped as excelling more at colour (emotional, sensual) over line (intellectual, rigorous).[1] Social convention hardened into biological predetermination: women painted flowers because they themselves were flower-like, delicate and decorative. Ergo, women's art was flowery and delicate.[2]

These restrictions also prevented women artists from being considered full practitioners of their profession. Two of the founding members of the Royal Academy of Art were women, Mary Moser and Angelica Kauffmann. But when Johann Zoffany painted his group portrait *The Academicians of the Royal Academy* in 1772, the two women could not be depicted among the group of artists gathered; they are represented, instead, by their (vague, difficult to make out) portraits hanging on the wall. Moser and Kauffman are not artists among their peers, in this rendering, but works of art twice over.[3]

Women were barred from attending art schools until the mid-nineteenth century, and once they were in, they were forbidden to draw the nude male body, which was the template for the human form. One women's life-drawing class photographed by Thomas Eakins in 1885 gathered around a cow. When female art students were finally allowed to draw a nude at the Royal Academy in 1893, the male model's bits were tastefully draped.

This is the heritage of the female artist – what Carolee Schneemann calls 'art istory'.

/

Some eras were more tolerant than others of a lady artist. But there has always been something monstrous and excessive about the relationship of women to art. So much going on beneath the calm surface. Female artists were always to some extent deviant, making art when they should have been doing something else. They risked, in short, being seen as 'grotesque transgressor[s] of womanliness'.[4] The art historian Frances Borzello paints a verbal portrait:

> She stands at her easel losing hairpins by the handful and taking herself ridiculously seriously given the second-rate quality of her work. Or she was seen as a prodigy (with monstrous as well as flattering connotations), as sexually suspect (not half so positive as bohemian) or as an amateur (which encodes the idea of the second rate).[5]

When I read this another image comes to mind, George Sand as glimpsed by her erstwhile lover Prosper Mérimée as she rose from their bed early one morning to write, squatting down to build a fire.

> [Mérimée] once opened his eyes, in the raw winter dawn, to see his companion, in a dressing-gown, on her knees before the domestic hearth, a candlestick beside her and a red madras around her head, making bravely, with her own hands, the fire that was to enable her to sit down betimes to urgent pen and paper. [. . .] the spectacle chilled his ardor and tried his taste; her appearance was unfortunate, her occupation an inconsequence, and her industry a reproof – the result of all of which was a lively irritation and an early rupture.[6]

The madras tied around her head lends her a certain exoticism, underscoring how deeply foreign Mérimée found this activity – to the point of comparing Sand to a servant, quite possibly a woman of colour, imported from the colonies to tend his fire.

This image in turn recalls an early scene in the director Céline Sciamma's *Portrait de la jeune fille en feu* (2019), a nighttime shot where

the young portrait painter Marianne sits naked in front of her fire, smoking a pipe. In my memory she, too, had a madras around her head, but having just looked at the film again I see I misremembered, perhaps blending it with this memory of Sand, an association of artist, woman, pipe, a pipe that is long and phallic. She is not of this island, which seems to be inhabited only by women; she is a visitor there, brought to paint a portrait of the daughter of the house in exchange for financial compensation; we have just seen her take her twin canvases from their crate, which she dove into choppy water to save when it slipped from the boat; she wipes them dry; they are as if primed with sea water. She places them on either side of the fire to dry, and places herself in the middle, nude, smoking. There is something about these artist women crouching or sitting before their fires that seems to ask us to see them as defying the codes not only of woman-liness, but of whiteness.

/

Marianne has come to paint, in secret, Héloïse's wedding portrait, posing as a lady's companion and painting at night; Héloïse has previously refused to sit for one, to be turned into an object, a gift for her future husband. She was not meant to be the daughter getting married, but her older sister threw herself off a cliff, and Héloïse must step in.

The first portrait Marianne paints of Héloïse is too much a performance of its genre, the object Héloïse fears becoming; it is perfectly correct, but it does not capture the living quality of its subject. It was made, moreover, without its subject's knowledge; Marianne posed ('posed') as a lady's companion, intently studying her subject during the time they spent together, and carrying out her commission at night. When Héloïse finally sees the work, she points out its defects.

> Marianne: I didn't know you were an art critic.
> Héloïse: I didn't know you were a painter.

Marianne crushes a turpentine-soaked cloth to the portrait's face, and wipes it out, leaving the rest intact. It is not just for love of Héloïse

that she does it, but out of an artist's pride. She is impatient with conventional beauty; she is after truth.

The artist who painted the portrait that appears in the film, Hélène Delmaire, apparently came to Sciamma's attention when she saw some of her *Eyeless* (2016) series on Instagram: portraits of young women across whose eyes Delmaire had painted a decisive daub of paint, blocking them out. What a decision. You painstakingly create this likeness, this work whose success hinges – as it does in the film – on capturing something of the living vibrating presentness of an individual – a quality of movement photographs can rarely manage – and then you get a good glob of paint on a brush and you slop it across in a thick vision-cancelling impasto. Monstrous to work against the portrait in this way. Decreate to create.

/

Formally, this moment in the film echoes another decreative artistic gesture: the day the suffragette Mary Richardson slashed Velazquez's *Rokeby Venus* with a meat cleaver in 1914. Both were feminist acts of destruction against a particular vision of beauty. 'I have tried to destroy the picture of the most beautiful woman in mythological history as a protest against the Government for destroying Mrs Pankhurst,' Richardson declared, voicing her support for the suffragettes' imprisoned leader, Emmeline Pankhurst. In so doing, she declared herself a kind of artist of justice. For justice, she writes, 'is an element of beauty as much as colour and outline on canvas'. That picture does her no justice, we say; and we mean, it is unfair to paint her that way. Aesthetics are bound up with ethics.

/

The female nude is art or obscene, depending on the context. Made by a man, in the context of the history of art, it is beauty itself. But not always; this beauty is historically contingent. In Velazquez's day – seventeenth-century Spain – the strict religious regime made it illegal to paint a nude: the punishment for it was excommunication. Critics

speculate he may have made it abroad, and then brought it back with him, but importation of nude images was illegal. He took quite a risk, creating his Venus.

But if the painting had been painted by a woman, a self-portrait, say, it would have been an even more notorious painting, a scandalous one, slashed long before Mary Richardson came on the scene, its author stripped of her status and excommunicated. Velazquez's sister: a suicide, like Shakespeare's sister in *A Room of One's Own*.[7]

They talked about Richardson in the newspapers like a 'wild woman', like a beast. She was for them the embodiment of 'deviant femininity [. . .] in which the calm exterior is simply a dissembling mask for desocialized and violent female drives'.*

As if the calm exterior of the woman on the canvas could never camouflage such drives.

/

For Velazquez, who painted her in the late 1640s, she was *La Venus del espejo*, the Venus of the Mirror. They call her the *Rokeby Venus* because for eighty years she hung in a Palladian country house called Rokeby Park in Yorkshire. But the English title, as it identifies her within the frame of her former home, misdirects us from the painting's technical sleight-of-hand: Velazquez has painted Venus looking in the mirror, and we see her reflection framed within it. And given the angle at which she is lying, and the head-on image of her face in the mirror, we ought not to be able to see her full face. This has come to be known as the Venus effect: painterly misdirection. A cut within the painting itself, long before Slasher Mary made it on to the scene, a severing of the girl's head from her own shoulders.

/

* *The Female Nude*, pp. 37, 38. Richardson later joined the British Union of Fascists under Oswald Mosley, where she went on to become Chief Organiser for the Women's Section in 1934. She left after two years, disappointed with the party's lack of commitment to women.

Velázquez's *Rokeby Venus*, slashed by a suffragette in 1914.

But her skin. Her skin is pearlescent, uninterrupted by anything as banal as a brushstroke. She looks like a statue warmed with life. As if she weren't something made by a mortal man, but a deity who one day appeared on the canvas.

It is this smoothness, perhaps, that Mary Richardson wanted to interrupt, and that the museum tried to restore. Apparently you can barely see the slash marks now.

Imagine if they had simply left them in place – the painting become a collaboration across the centuries between a man daring against the law to paint the nude female body, and a woman daring against the law to express her anger with what the nude female body had come to represent. Seven slashes across Venus's naked body to draw a line through the fantasy, each one a cancellation.[8]

Mary Richardson was sentenced to eighteen months of hard labour, and unaccompanied women were barred from many museums. That is, of course, unless they were already hanging on the walls.

(The rhetorical question on the iconic 1989 Guerrilla Girls poster: 'Do women have to be naked to get into the Met Museum?'*)

(Do women have to slash each other's bodies to make a political point?)

/

The spot I am drawn back to time and again when I look at the *Rokeby Venus* is the soft blush on her cheek, real and reflected. What has put it there? Has she just woken up? Or is it a blush of modesty? If so, why? Has Cupid said something cheeky? Has a lover just left her in bed wearing nothing but a postcoital glow? Or could she, possibly, be taking pleasure in her own appearance? In her own body?

/

I wonder who she was, the woman in this famous painting, the current value of which, I imagine, could have fed a whole Spanish province for all of the 1640s. An Italian model? Someone Velazquez was remembering, or making up? Could it be his lovely wife, Juana Pacheco, the daughter of his painting teacher? Her he painted in around 1630 as a Sibyl, who sits mutely holding something that could be a primed canvas, about to set down a prophecy in paint. (Perhaps Juana, the daughter and wife of painters, dabbled a bit as well.) Seventeenth-century convention sometimes called for painters to present Sibyls – female prophets or oracles – as wearing turbans, and this gesture can be seen in many self-depictions. Self-portrait of the female artist as all-seeing. In a 1784 self-portrait of herself holding a portfolio and a porte-crayon, Angelica Kauffmann depicts herself wearing a turban. When in 1787 Elisabeth Vigée-Lebrun daringly painted herself cuddling her daughter and showing (baring?) her teeth (her *teeth*!), she's wearing a turban.

Vigée-Lebrun's is one of my favourite paintings, since I became a mother. To dare to make motherly love the subject of her art,

* It then reads: 'Less than 5% of the artists in the Modern Art sections are women, but 85% of the nudes are female.'

Elisabeth Vigée-Lebrun,
Self-Portrait with her daughter, Julie, 1786.

to show herself as artist *and* woman *and* mother, is a major state-
ment. And then there is the sheer physicality of the pose, the way
she wraps her arms around her daughter's small body, the way the
daughter holds her hand between her cheek and her mother's
chest – this is not a sentimental portrait of motherhood, this is a
rendering on the canvas of what it is to hold your child, a painterly
rendering of the physical sensation of holding a small frame, that
is like nothing else.

And she's blushing. Motherly pride? Or monstrous art passion, cir-
culating just under the surface of the skin?

/

Barred from drawing from the nude until the late nineteenth century – and even afterwards, they could only do so when they could afford to pay a model – women artists turned to their own images not through narcissism but by necessity. The female artist knew that her self-portrait would be 'scrutinized' in a way that a male artist's work would not be, writes Borzello. For much of art history, female artists had to 'reconcil[e] the conflict between what society expected of women and what it expected of artists'.[9]

One of the pitfalls of self-presentation was looking 'boastful' – you didn't want to come across as having too high an opinion of yourself or your work; an excess of self-regard would scan as a moral failing. There were certain conventions in place for how a woman should be presented on canvas: they 'could not show their teeth, could not show their hair unbound, could not gesticulate and certainly could not cross their legs'.[10] These conventions may be strictly speaking no longer in active effect, but their echo lingers, governing our responses to women's self-representation. A sign of femininity on the canvas was a sign of respectability.

Physical appearance aside, notes Borzello, a woman painter had to address the fact of her painting at all. She did not want to look as though she had forgotten about her other responsibilities – and so she would sometimes include husbands or children or other family members in the scene, or religious objects for a touch of piety. Nor did she want to come across as competing with male painters who could make trouble for them or bar them from professional advancement.

This 'creative defensiveness', as Borzello terms it, has been in operation for as long as there have been women artists, anticipating what is expected of them, and deciding how to deal with it: do they delicately calibrate their work to meet public expectation, or take the risk of surpassing it, which could bring glory, but could just as easily bring infamy.[11]

Again and again, they painted from the mirror, at great pains to present themselves as serious artists. In the sixteenth century Sofonisba Anguissola painted herself no less than nine times, joining the ranks of Dürer and Rembrandt in sheer quantity of self-reproductions. In the next century Artemisia Gentileschi would paint herself in a rather more

dramatic posture as painting incarnate (the first four letters of her name *were* Arte), emphasising the physical exertions involved in art-making.

Gentileschi adapts from Cesare Ripa's 1593 treatise *Iconologia*, which describes Painting as 'a beautiful woman, with full black hair, dishevelled, and twisted in various ways, with arched eyebrows that show imaginative thought, the mouth covered with a cloth tied behind her ears, with a chain of gold at her throat from which hangs a mask, and has written in front "imitation"'. But Gentileschi has deleted this word; this is not *imitatio* but *poiesis*; it is making. We don't see what she's painting, only the laser-like focus leading from her eyes, up her arm, to the tip of her paintbrush.

Some scholars think she needed *two* mirrors to capture her body at this particular angle. In addition to the posture, I am taken with the masses of oily-looking green fabric that serves as her sleeve, which shimmer with a sickly mauve, while above hovers a mask like a death head hanging from her golden chain necklace. This gives the portrait the air of a memento mori; with its physical dynamism and the ambiguity of the charm, Gentileschi's painting suggests not only that life is short and art is long, but that the artist herself will live on even as her body will not.

/

In 1913, the year before Mary Richardson slashed the *Rokeby Venus*, Laura Knight raised the stakes in this history by painting a self-portrait of herself painting a nude model named Ella Naper. The artist herself is fully clothed, in a thick skirt and smock, a kerchief around her neck, and a dark hat on her head, the brim of which appears to be obscuring her view of the woman she's painted on her canvas. To the side, almost in another room, is her subject, who adopts a classical contrapposto stance with a womanly twist, holding her arms up above her head. The spatial arrangement of the three female figures is so out of whack as to suggest that there is strong ambivalence here, both about painting herself as an artist and about making a naked woman her subject. She's not even really looking at her – but off to the right, as if at someone off to the side, asking her what she's doing.

/

But what makes me think my impressions of ambivalence in the Knight painting are not the whole story, however, is the palette.

I have stood for longer than seems necessary in front of this painting at the National Portrait Gallery, experiencing its colours like a fever dream. The dappling mad vermilion of her smock! The explosive orange of the Japanese screen! Doubled by the painter's canvas! Peeping from the flowers on her hat! Echoed in the stripes on the rug beneath the model's feet, which glow red-orange in the reflection of the screen, travelling upwards to cover her buttocks in a *Rokeby Venus*-like blush, like someone's been spanking her. The model's white body is contoured with Impressionist greens, and unlike the *Rokeby Venus*, the brushstrokes are not trying to camouflage themselves but stand out, announcing the very made-ness of this image. The unfinished bits at the bottom of her canvas, just above her left arm, suggest her courage is momentarily flagging, but the visible brushstrokes are a wink at the viewer: she has already done it, it's too late! Something naughty is going on. Knight showed the painting once in 1913, and it was rejected later that year for the Royal Academy's summer exhibition. Critics called it inappropriate, 'vulgar' – sixty years before Lynda Benglis's dildo. 'It repels,' wrote the *Telegraph*.[12]

Given the colouring and the very scale of the work – five feet high by three feet wide – Knight's formal choices very much do not suggest she is apologising for her subject, but offering her to us in all her fleshy beauty, as if to say *she's glorious. Wouldn't* you *paint her?* The Sibyl's turban has become a hat, with a black slash of a brim; she looks off to the right, as if towards the future of the artist's body.

extreme times call for extreme heroines

By the late twentieth century, feminist artists rebelled against these ideas of appropriateness on the canvas, and against the art historical inheritance. 'These are not my aesthetics,' said the artist Karen Finley in the landmark feminist art and literature anthology *Angry Women*. '[T]hey have been given to us by men for thousands of years. You go into museums or read "histories of art" and women just aren't included – you only see women as the "Nude" or as the Object of Desire.'[1] How women portrayed women would be a major issue in late twentieth-century feminist art.

Women artists of colour were doubly discriminated against, when they weren't ignored altogether.[2] The African-American artist Betye Saar has spoken about how difficult it was, when she was starting out in the late 1960s, even to call herself an artist, claiming, instead, to be 'a designer or an artisan or a craft person'. 'To say I was an artist,' she told the art critic Cindy Nemser, 'took a lot.' Asked why, she spelled it out for Nemser: 'Because I was really insecure about that, you know? About being that. Also, at that time, blacks were not particularly encouraged in the arts.'[3]

Saar became radicalised when Martin Luther King, Jr was assassinated in 1968, and she turned from a career in printmaking to one of collage and juxtaposition. One of her earliest works as a politicised artist saw her take an old, abandoned window frame and paint a Black girl in silhouette looking out of it, face and hands pressed up against the invisible glass, her palms and fingers covered in moons and stars and Linnaeus's three gender symbols: male, female, neutral. *Black Girl's Window* (1969), she called it, an autobiographical assemblage. Above her head, in the grid of the windowpanes, we peer out into a night scattered with stars that burn and shiver and signify. There is a dancing skeleton in the centre, a baying lion (a reference to Saar's astrology sign), an illustration of a pair of Black children embracing one another,

and an eagle with the word LOVE emblazoned on his chest. There
is a phrenology chart of a Black man's head and a daguerrotype of an
old white woman, pointing back to the same late nineteenth-century
Eurocentric way of seeing the world that invented the Jim Crow laws,
based on pseudo-scientific ideas about supremacy rooted in the body.
Except the white woman is Saar's own grandmother, who was Irish.
What can we know about a person by seeing with our eyes, Saar seems
to be asking? What do we think they tell us about race?

In 1970 Saar visited the Field Museum of Natural History in Chi-
cago and was fascinated by the African and Oceanic art she saw there,
especially its use of feathers, skin, dirt, hair – all the textures and shed-
dings of the body. It wasn't easy to find, though, as it was being kept
in the basement. 'Back then,' she told the *New York Times*, 'even black
Americans were sort of ashamed of African art.'[4] This spirit of ritual-
ised, mystical energy and the occult has driven Saar's work ever since.

She has also repurposed bits of racist Americana in order to challenge
sentimentalised versions of American history, and to raise questions
about how far the artist could go in rewriting her own history, dis-
tinct from one she didn't ask to be born into. 'For many years,' recalls
Saar, 'I had collected derogatory images: postcards, a cigar-box label,
an ad for beans, Darkie toothpaste.' Eventually she came across 'a little
Aunt Jemima mammy figure, a caricature of a black slave, like those
later used to advertise pancakes'. Saar decided to turn her into her own
work of art – 1972's *The Liberation of Aunt Jemima*:[5]

> She had a broom in one hand and, on the other side, I gave her a rifle.
> In front of her, I placed a little postcard, of a mammy with a mulatto
> child, which is another way black women were exploited during slav-
> ery. I used the derogatory image to empower the black woman by
> making her a revolutionary, like she was rebelling against her past
> enslavement.[6]

Saar made the piece in response to the call from a Black cultural
centre in Berkeley, California for artists to contribute to an exhibition
about Black heroes. This Aunt Jemima has been liberated from her
previous life as a notepad holder, at the ready to offer people (white
people) the material they needed to say what they wanted. Now the

notepaper is gone, replaced by the postcard, on which the information it wants to convey is printed on the front, not in language but in image.

As Deborah Willis and Carla Williams note, representations of Black women in Western art have mainly confined them to three categories: 'the naked black female (alternatively the "National Geographic" or "Jezebel" aesthetic); the neutered black female, or "mammy" aesthetic, and the noble black female, a descendant of the "noble savage". Even imagery that resists these stereotypes,' they observe, 'alludes to these figures.'[7] Saar resists racist representations of the Black female body through direct confrontation of them, inscribing this radical action in the history of avant-garde art. The claiming of a found object for art went back to Duchamp and the Baroness Elsa, but in the context of the civil rights movement Saar gave the gesture political urgency. Because this isn't just any found object, but one charged with a previously racist use value. Saar's work is a radical feminist form of collage, and one that has had particular importance for Black feminist artists, practising what the artist Lubaina Himid describes as 'gathering and re-using':

> Gathering and re-using is like poetry, a gathering of words, sounds, rhythms and a re-using of them in a unique order to highlight, pinpoint and precisely express. [. . .] Gathering and re-using takes time, measurable in hours certainly but also a sense of time having passed before, a sense of history and most importantly a sense of survival . . . Gathering and re-using is an essential part of Black creativity.[8]

Patchworking, cut-outs, collages, pastiches: these are forms that allow for breaking down, and building up. As the writer and curator Sasha Bonét notes in the *Paris Review Daily*, Black artists have often turned to collage in order 'to envision unfathomable futures in the face of violence and uncertainty [. . .] a creative way to love each other even though we haven't been shown care, to express the depths of our experiences even when no one ever asked how we felt, to give evidence to all the things unseen.' She cites the 60s art collective Spiral, for whom 'collaging served as visual representation of Black quotidian life' and 'deconstructed internalized white-supremacist stereotypes of Blackness, providing momentum to the civil rights movement', or

more contemporary artists like Mickalene Thomas, Tschabalala Self, or Lorna Simpson, who specifically rethink the 'layered and fractured identity of Black womanhood'.[9] 'We're fragmented not only in terms of how society regulates our bodies,' says Simpson in the press material for a 2019 Hauser & Wirth show, 'but in the way we think about ourselves.'[10]

Simpson's *Without really trying* (2019) gives us two collages, each torn out, it seems, from a 1960s Black women's hairstyling feature. In each one, a lovely bride in a veil smiles happily to reveal vampiric incisors. In laying the photograph of the bride *over* the magazine feature, Simpson replaces one story with — something that isn't quite story, so much as disruption. The seeming casualness of collage masks the labour of art-making, just as the perky tone of the women's magazine belies the labour involved in preparing one's appearance every day — time mainly women are encouraged to waste. Bonét calls this Simpson's 'counternarrative', and yes, it is that, but it is also more than this: it is a gesture at remaking narrative itself in a way that is attuned to the way stories are so often left at loose ends. *The Liberation of Aunt Jemima* was its own counternarrative and inspired countless others: Angela Davis has credited the piece with igniting the Black women's resistance movement.[11]

/

Saar's work is a trenchant critique of the Great Artist as sole originator of the work of art. She would play a prominent role, writes Ellen Y. Tani, in the development of West Coast assemblage in the 1960s, a form which 'challenged the conventions of what constituted sculpture and, more broadly, the work of art itself [. . .] Saar honors the energy of used objects, but she more specifically crafts racially marked objects and elements of visual culture — namely, black collectibles, or racist tchotchkes — into a personal vocabulary of visual politics.'[12] She turns to everyday materials to examine the way racism is inscribed in the American everyday, in something as seemingly benign as a salt shaker or a bottle of pancake syrup, and her work can be read as a commentary on postwar American consumerist culture. But her critique is

of the way quotidian and institutionalised racism was experienced specifically by Black *women*. At a time when elsewhere in California the mostly white participants in Judy Chicago and Miriam Schapiro's *Womanhouse* project were making art out of (mostly white) women's experience of being confined to the home, and made into no better than domestic servants, Saar's work was grappling with the history of Black women's actual enslavement – their transformation into private property in white households, where they were tortured, raped and genocided.

Saar has returned multiple times to Aunt Jemima throughout her career, most recently in the political context of 2017, a time when it became most urgent to refute the racism and misogyny of the Republican regime. A piece she called *Extreme Times Call for Extreme Heroines* presents a smiling Aunt Jemima figure on a vintage washboard, holding a broom and a semi-automatic rifle, while above her head the piece's title floats in all capital letters, and above that sits an old-fashioned alarm clock. In this washboard series (called *Keepin' it Clean*, 1997–2017) Saar uses 'this humble object of hard labor to subvert notions of fine art'.[13]

/

I think we hear an echo of Saar's armed Aunt Jemima and extreme heroines in Kara Walker's 2014 installation *A Subtlety, or the Marvelous Sugar Baby*: both women present the racist trope of the subservient Black woman in order to indict those who profited from it.[14] Walker's piece was a hugely unsubtle, thirty-five-foot tall, seventy-five-foot long sugar-coated mammy figure in a Sphinx pose, which Walker built in the old Domino Refinery, through which passed masses of raw sugar cane harvested in the Caribbean and ready to be transformed into refined sugar and sold to rich Americans. (A 'subtlety' was a kind of sugar sculpture used as a centrepiece at the dinner tables of the wealthy, as early as the fourteenth century in Europe.) Standing here and there in the space were statues of little Black boys covered in molasses, offering baskets of bananas. Looking at her body from human height, her face in a grimace, a kerchief on her head, her bare

nipples pointing forward, her paws like hands, gripped into fists. One makes a figa gesture, which simultaneously expresses vulgarity, defiance, fertility and luck; she would preserve this part of the sculpture after the rest of it was destroyed.

A walk around to the back of the statue reveals a smooth vulva and a cave-like opening below her impressive derriere and her folded feet, slightly reminiscent of the artist Niki de Saint Phalle's *Hon* (1966). Here, the nineteenth-century medium of the silhouette has given way to absurd monumentality, the antebellum south to ancient Greek and Egyptian/Nubian mythology. According to the old stories, the Sphinx was a man-eating creature with the head of a woman, the body of a lion, and the wings of a falcon. The Sphinx, as the story goes, was sent by Hera to punish the city of Thebes by sitting outside the city gates, and posing a riddle she'd learned from the Muses to everyone who tried to enter the city. Those who could not answer – that is, everyone – she devoured. One day Oedipus happened by, and answered correctly. Filled with shame at having been bested, she threw herself from her cliff-top perch and died, freeing Thebes from isolation. As a reward, Oedipus was offered in marriage the city's queen, Jocasta. And we know the rest of it. Oedipus's tragic flaw was his hubris: his belief that he could defy the oracle's prediction.

It is, of course, the Great Sphinx of Giza that springs involuntarily to mind when we think of a Sphinx, a limestone statue that predates by far the Greek and Roman mythological creature, having been erected, most likely, around 2500 BCE, in which time the Sphinx was worshipped as the solar deity Hor-em-akhet. This Sphinx is male, has no wings, and is said to bear the face either of the pharaoh Khufu or of his son Khafre. His nose went missing some time in the medieval period. But this is the Sphinx Walker references.

The Sphinx entered the popular imagination in the nineteenth century, after Napoleon's campaigns in Egypt. But again, s/he wouldn't stay fixed as this lion-like figure in the desert. It wasn't long before she – in her Greek form – was appearing on Symbolist canvases like Gustave Moreau's *Oedipus and the Sphinx* (1864). If you were to look only at the top half of the canvas, it would appear that Oedipus is in a loving embrace with a bare-breasted angel. Include the bottom half,

and there is her animal form, a string of beads around her midriff, one paw delicately placed on Oedipus's fig leaf. But their eyes are empty, they gaze at each other as if looking at nothing, or beyond nothing. There is an impasse in understanding.

In her pose and her lack of wings Walker's Sphinx has more in common with the Egyptian than the Greek Sphinx, but she has made the Sphinx a woman, like her Greek counterpart. A hybrid of Sphinxes, a reclaiming of classical culture, suggesting that Western Enlightenment values of freedom and rationality have always been constructed on the backs of the non-white, non-masculine Other, in opposition to the dark mystery they have been thought to embody. The Sphinx, in both her Greek and Egyptian formats, stands in for what cannot be known. The presence of an absence of understanding. A hybridity we don't know how to understand. An antidote to racial purity.

What is the riddle Walker's Sphinx poses? Does it place us at the same impasse?

/

Walker has worked across multiple media, from paint to film to installation, making work that defies the viewer to contend with the history of race in America, and particularly the way violence, power and desire have shaped that history. Her work has often met with controversy, especially her large-scale silhouettes depicting brutal scenes from plantation life. No matter how intricately, subtly and delicately the images have been scissored (lasered?) out, once they are assembled across gallery walls they are called overpowering, demeaning, pornographic, scatological. The form itself seems too jaunty, too middlebrow, to take on topics like slavery and trauma. The silhouettes can never do their subject justice – but nor does it seem as if they're trying to.

There's a 'too-muchness' about her art, Walker has recognised, that also, I think, reads as a not-enoughness – what, after all, can art actually do? Especially – in the case of the silhouettes – in such a gestural form, hinting at kitsch figuration while simultaneously abstracting a

figure to its outline. And yet – what an expressive line Walker has; how much she manages to say, in such a mute form. Silhouettes are a shadow art, Walker acknowledges, that makes both artist and viewer 'more complicit in the goings-on. [The image] maintains anxiety and intensity and leaves it there.'[15] Her silhouette tableaux extend around the room, in an unbroken circle, no beginning, no ending. These stories are not easy to read: not simply because they deal with impossibly difficult subject matter, but because they lack a clear way in, or out. They are the breathtaking shadows of a repulsive history.

The silhouette form offered Walker a profound meditation on violence and quite literal displacement, as she told Hilton Als: 'the paradox of removing a form from a blank surface that in turn creates a black hole'.[16] The silhouette is, like photography, an art which captures a trace of the real, and is comparatively cheap and easy to produce. The subject would pose, backlit, and their profile would be traced on to the sheet of paper behind them. The subject is more *there* than in a portrait, done freehand. But when it emerged as a middle-class art form in the nineteenth century, it was co-opted by phrenologists classifying humans into types based on their physiognomy.[17]

Kara Walker, art monster, defying the rules about what kinds of images (Black) women can make. She has said she was drawn to working with silhouettes because it was something of a debased medium, 'forgotten and small, female and domestic', done by 'invalids and women', and 'a few itinerant artists'.[18] The amateurism associated with the silhouette form is no doubt part of the art establishment's reaction to Walker. *She gets a genius grant for doing arts and crafts?** But Walker is asking provocative questions about the kind of work an artist can make – and any worries about what a female artist can or can't do seem to have been put aside. The question, for Walker, would seem to be more about what a Black artist can or can't do.

/

* In 1997, aged twenty-eight, Walker was awarded the prestigious MacArthur fellowship, or 'genius' grant – one of the youngest people ever to receive it.

It seems like stirring up trouble to write about Saar and Walker together. Saar called Walker 'a black artist who obviously hated being black', whose 'revolting' work was made for the 'amusement and the investment of the white art establishment'.[19] For some viewers, Walker's silhouette cut-out figures of enslaved persons seem suspiciously complicit in their mistreatment, and the artist Howardena Pindell has suggested that the work 'consciously or unconsciously seems to be catering to the bestial fantasies about blacks created by white supremacy and racism'.[20] (Saar may also not have felt comfortable with the line that leads from the silhouette she herself used in *Black Girl's Window* to Walker's imaginings. We just don't know what the next generation is going to make of our gestures.) Saar also reportedly sent hundreds of letters to people in the art world, signed: 'an artist against negative black images'. Zadie Smith challenges this reading of Walker's work: 'That the black artist might be following their own nose – pursuing their own preoccupations and obsessions – is here given no credence. The white viewer, in these debates, is really the only thing on a black artist's mind.'[21]

But though it seems like gender is irrelevant here, both are negotiating the navigational pull of obedience, explicitly invoking it in the mammy stereotype. They do this on different planes of affect: Saar's work operates at the level of deceptive jollity, while Walker's images spark aversion and outrage, repelling us from the work, perhaps even making us feel manipulated by something that leaves us no other response *but* outrage – which awakens us to our own monstrosity if we do manage to step back and regard it as a work of art.

The film theorist Laura Mulvey made an essay film in the 1970s about the Sphinx with her former husband, Peter Wollen. 'The Sphinx is outside the city gates,' Mulvey says to the camera;

> she challenges the culture of the city, with its order of kinship and its order of knowledge, a culture and a political system which assign women a subordinate place. To the patriarchy, the Sphinx as woman is a threat and a riddle, but women within patriarchy are faced with a never-ending series of threats and riddles – dilemmas which are hard

for women to solve, because the culture within which they must think is not theirs.[22]

The Sphinx is an extreme heroine, who was always the Other in the story. Associated with death and funerary monuments, she was the unknowable, chaos, disruption. These are the implications coded into Walker's Sphinx, as well as Saar's Aunt Jemima.

Looking at each artist's work in the light or the shadow of the other's is tremendously illuminating in terms of understanding the monstrous interventions that feminist artists have made in the world, that they have felt historically *compelled* to make in the world. What can we understand of Aunt Jemima, in the context of the Sphinx? How do we come to *A Subtlety* once we have seen Saar's Aunt Jemimas? Each artist is grappling with the notion of the Black feminist artist's inheritance of a history that when it thought to include them invariably made them subservient and inscrutable.

/

In a 1990 review of an exhibition of objects from Sigmund Freud's collection, which included several Sphinxes, Louise Bourgeois notes the chasm that separates an artefact from a work of art.

> An artifact is first of all useful, and does not relate to anything more vitally than to its use. It is isolated in its momentary meaning, and is easily reproduced. It is not an original. [. . .] Is a little Tanagra statuette from the Greek period a real embodiment of that civilization? These figures were made by the thousands, from molds [. . .] Art is a reality. The artifact is a manufactured object; a work of art is a language.[23]

Is a little Aunt Jemima figurine a work of art? What about a massive Sphinx made of sugar? It depends on the context. An assemblage, as installation, they become a 'language' in the sense I take Bourgeois to mean: a language of questions, to which we can only attempt, together, to riddle out some answers.

If history has been the ultimate subject for artists, what can an artist do with the question of Black history? How can it be represented

without capitalising on it, building a reputation and a financial life on the back of it? When some truths are so painful that just about anyone talking about them is going to get it wrong? What does the art object ask of us, and how can we avoid getting chewed up when we attempt to answer?

/

Of Kara Walker's 2017 work *Christ's Entry into Journalism*, the writer Roxane Gay remarked on how 'difficult' and 'painful' it was to look at those images, a monumental drawing of African-American history up to the present day. 'And it is important that you don't look away – that you sit in that discomfort. There is a lot of productive work that happens in these uncomfortable spaces where we're forced to confront history,' Gay told the BBC.[24] This is very true, and important to acknowledge; there is work that compels us, on an ethical level, to engage with it, that dares us to look away. But I think Walker is after something more active even than 'sitting' with discomfort. Her work indicts the viewer, Black or white or any other race, in the same crimes it recreates. Her Sphinx poses a riddle, confronts us with the history of slavery, in America and elsewhere, and no matter how much pigment we have in our skin, no matter what our personal histories, we have to make some response, even if we risk getting gobbled up by the Sphinx. The only thing worse than the wrong answer is no answer.

Walker stages this evasion of difficulty in a video she made of the 130,000 people who went to see *A Subtlety*, called *An Audience*. The visitors photograph their kids with the little molasses boys, pose for selfies in front of the Sphinx's massive breasts, pet her like a dog, and raise up their phones reverently in an attempt at communion. It seems – well – *mean* of Walker to have caught them out. People are at their most vulnerable when they're earnestly looking at art, and their most foolish when they hold their phones up to it. But what else can we do? My reaction, too, when I saw Walker's *Fons Americanus* installed in the Turbine Hall at the Tate Modern in 2019, was to hold my phone up and film it: a way of seeing and not seeing at the same

time. 'No one gets out of Kara Walker's world alive, not even the artist,' writes Jerry Saltz.[25]

/

In a 2000 essay in *NKA: Journal of Contemporary African Art*, the curator Hamza Walker argues that Walker's art is 'shameless three times over. In her choice of imagery, she has abandoned the historical shame surrounding slavery, the social shame surrounding stereotypes, and finally a bodily shame regarding sexual and excretory function.'

> The work's refusal to acknowledge shame when dealing with issues of race and desire set within the context of slavery, allows Walker to challenge, indeed taunt, our individual and collective historical imaginations.[26]

The work itself produces shame. Shame in the audience, shame across cultures. Shame flung back against Walker: the shame of telling the right wrong story. The shame of airing your family's dirty laundry. The shame of not being Black the right way. *You should be ashamed.*

She owns up to that shame in a 2017 interview with Doreen St Félix: 'If the work is reprehensible, that work is also me, coming from a reprehensible part of me. I'm not going to stop doing it because what else could I do?'[27] The work is intimately bound up with who she is, and what she has lived through; it takes this shape because that's the only shape it *can* take; it is an almost physical part or byproduct (coming from 'some part') of herself.

Perhaps 1998's *Burn* is a self-portrait – the silhouette medium makes it impossible to verify who this could be, what her background, what her story. There is only the moment of self-immolation suspended, in undecidability, like the girl's arms, like the can of petrol she drops accidentally on purpose.

Where Saar's Aunt Jemimas are locked and loaded and ready to fight, Walker tells us scrambled, cyclical stories that can't be relegated to the abyss of history: they are alive, and we are all their shadows, carefully cut from the same material, so as not to miss a single damning detail.

Kara Walker, *Burn*, 1998.

difficult conversations

2017. The Whitney Biennial includes a painting by Dana Schutz, a white artist, of Emmett Till in his coffin. The painting hurts and offends many in the Black community. Protest begins immediately upon the opening of the show. A young Black artist called Parker Bright stands in front of the painting, partially blocking the view of it, wearing a T-shirt that reads BLACK DEATH SPECTACLE on the back. Other protestors join him. That afternoon the British-born artist Hannah Black writes an open letter (signed by forty-seven artists, writers and curators) to the Whitney demanding they remove the painting, and that it be destroyed. The letter ignites a fierce debate about who gets to make what kind of art, who has a right to protest it, and in what terms, that is also a debate about institutions and power: who has it, and who doesn't.

Emmett Till was a fourteen-year-old Black boy falsely accused of flirting with a white woman in Mississippi in 1955, and subsequently abducted, tortured and lynched by her husband and brother-in-law.* (An all-white jury found the two not guilty, though they went on to admit to having killed the boy.) At his funeral, his mother decided to leave the casket open: 'I wanted the world to see what they did to my baby,' she said. Photographs of the casket were reproduced in newspapers across the country, fomenting outrage in Black communities. Till became an icon of the civil rights movement, sacrosanct in Black history. Yet even his memory is not safe from thugs and murderers: his memorial, placed at the spot where his body was pulled from the

* Carolyn Bryant Donham, the woman he supposedly flirted with, or whistled at, recanted in 2007 and admitted it wasn't true, it hadn't happened, to the scholar Timothy Tyson, as he was researching his book *The Blood of Emmett Till* (2017). As recently as August 2022, a Mississippi grand jury refused to indict Donham on charges of kidnapping and manslaughter.

Tallahatchie River, had to be replaced several times because it kept getting shot at. The new memorial, installed in 2021, weighs 500 pounds and was made to be bulletproof.

For Hannah Black and those who supported her letter, the problem with the painting was one of appropriation, and went 'to the heart of the question of how we might seek to live in a reparative mode, with humility, clarity, humour and hope'. Emmett Till's death and display was, quite simply, not Schutz's story to tell, and Black urged Schutz and the Whitney to accept responsibility for having crossed a line. 'If Black people are telling [Schutz] that the painting has caused unnecessary hurt, she and you must accept the truth of this,' Black addressed the curators. 'The painting must go.'[1]

People on all sides of the spectrum weighed in with gusto – artists *can do what they want! Only Nazis destroy art!* Kara Walker, having faced similar reproofs over the course of her career, defended Schutz's right to make the painting. But she did so in markedly art historical terms. Her first response to the controversy was to post an image of Artemisia Gentileschi's *Judith Beheading Holofernes* on Instagram, writing in a caption:

> The history of painting is full of graphic violence and narratives that don't necessarily belong to the artists own life, or perhaps, when we are feeling generous we can ascribe the human artist some human feeling, some empathy towards her subject. Perhaps, as with Gentileschi we hastily associate her work with trauma she experienced in her own life. I tend to think this is unfair, as she is more than just her trauma. As are we all. I am more than a woman, more than the descendant of Africa, more than my fathers daughter. More than black more than the sum of my experiences thus far. I experience painting too as a site of potentiality, of query, a space to join physical and emotional energy, political and allegorical forms. Painting – and a lot of art often lasts longer than the controversies that greet it. I say this as a shout to every artist and artwork that gives rise to vocal outrage. Perhaps it too gives rise to deeper inquiries and better art. It can only do this when it is seen.[2]

The post was subsequently deleted – why, I wonder? Was it composed too much in haste? Did Walker see the painting and reconsider

her stance? Or did she simply decide to stay out of the fray? Gentileschi's painting seems a strange image to choose; of course there is the fact that as a woman, she wasn't encouraged to paint anything at all, much less bloody scenes of decapitation. But Gentileschi's painting is a case of the less empowered claiming the right to paint what she wants; Schutz, as a white woman painting a Black boy who was lynched supposedly in the defence of white femininity, was hardly in the same position.

Walker's comment towards the end of her post, about the 'deeper inquiries' that controversial art can inspire, reminds me of Roxane Gay's comment about Walker's own work, that it's important to 'sit' in the 'discomfort' it inspires. Nearly everyone who weighed in about the Whitney controversy spoke in similar terms, to the point that the 'difficult conversation' became a bit of a trope. The ICA Boston curator Eva Respini called Schutz's painting a 'flashpoint [. . .] around conversations of race, representation, and cultural appropriation. That is absolutely an important and difficult conversation to have.'[3] The artist and curator Coco Fusco, writing in *Hyperallergic*, wrote in favour of 'reasoned conversation[s]' about the representation of 'collective traumas and racial injustice' by creators of 'all backgrounds'. 'I welcome,' she wrote, 'strong reactions to artworks and have learned to expect them when challenging issues, forms, and substance are put before viewers.'[4] At an event held by the poet Claudia Rankine's Racial Imaginary Institute on 9 April 2017 at the Whitney, nearly every speaker commented on how good it was to be having that difficult conversation about race and representation. *Art provokes*, one of the speakers at the Whitney event said. *This is what art does*.

But why, argued those who objected to the painting, does the provocation quite so often have to do with the shedding of Black blood? 'Black bodies in pain for public consumption have been an American national spectacle for centuries,' wrote the poet Elizabeth Alexander in 1994 in an essay called 'Can you be BLACK and look at this?', concerning the videos of Rodney King being beaten by police several years earlier. 'White men have been the primary stagers and consumers of the historical spectacles I have mentioned, but in one way or another, black people also have been looking, forging a

traumatized collective historical memory which is reinvoked at con-
temporary sites of conflict.'[5] A white female artist and the institution
that supported her were the primary stagers of this art spectacle, and
for the Black people who had to look at it, it was an obvious and hurt-
ful re-invocation of a collective historical trauma.

Because all the while art is, or isn't, making these connections, it is
part of a hierarchised capitalist marketplace. This makes art a site of
contention, of power struggles that are outside the frame but affect
how we read what is inside of it, and that determine how we even
come to see art in the first place: which works make it out of the
studio, and on to the gallery walls.

A 'transformation' of the art industry and the workings of its insti-
tutions 'would hinge on black people being able to tell their own
stories', writes the art historian Aruna D'Souza.[6] While I don't agree
that the autobiographical is the only mode by which art may access
authenticity, I do think it's clear this debate reminds us to attend, once
more, to Chris Kraus's question: 'who gets to speak, and why'. The
problem with Schutz's painting comes back, once again, to the ques-
tion of storytelling – not, or not only, of who is telling the story, but
of how they are telling it.

I am curious about the notion of the unseeable, the unrepresent-
able, and how art – feminist art, radical art, queer art – might respond
to it. Certain stories, from certain storytellers, are going to be listened
to more readily than others. It is the job of the art monster to trouble
these narratives. To push back against the tired moralising *blah blah* of
how *art teaches empathy* or *how to live together* and to force our attention
to the canvas, and who dipped the brush, and what they did next.

I turn to Schutz's work here to trace out a potential boundary, to
ask whether there are places even the art monster cannot, in good faith,
go. It is not enough simply to make work that offends people, claim
it as transgressive, and step away from the easel. A *feminist* monstrous
aesthetics requires a bit more labour than that, a work of thought and
perception, of looking and reflection and calling into question, work
that I do not believe Schutz has done.

/

Schutz herself explained that the way she came to the painting was 'through empathy with [Till's] mother'. 'Art can be a space for empathy, a vehicle for connection,' she said. 'I don't believe that people can ever really know what it is like to be someone else (I will never know the fear that black parents may have) but neither are we all completely unknowable.'[7] It is this question of what we can and cannot know of one another that bedevils me, both in art and in life. Art may spur us toward systems of comprehension – activism, philosophy – but it is not itself a system for comprehending, at least not with our rational minds. Art points to the incomprehensible, to what is outside language or rational thought. 'The sleep of reason produces monsters', as Goya's famous satirical etching has it (1797–9). Art is the sleep of reason. It is simplistic to assert that *art builds empathy*, or *offers us ways of going towards others*. It may, it can, and how wonderful when it does, but how it does so is of paramount importance; how does it guide us towards knowledge of each other? In what terms, in what forms? I wonder at Schutz's aesthetic choices within the framework of the particular affective political context that is early twenty-first-century America.

To my mind, the painting itself is lacking in compositional as well as ethical thought. And, I would submit, the two are linked. To take one example: Emmett Till's open casket had a pane of glass over his body. If you look at the photographs from the funeral, you can see various reflections on its surface – the fabric lining of the top half; a photograph that was placed there; his mother leaning over it and wincing in grief. Looking at Schutz's painting, you'd never know you were peering through a window. This pane of glass is important pictorially as well as theoretically; Schutz's focus on the body, and not the context of its presentation, suggests that there is some neutral way of representing this body. There is not.

Perhaps had she acknowledged the barrier Schutz might have found a way to acknowledge her own whiteness within the frame of the painting, her own cultural and historical distance from the subject, her own status as white onlooker; that she is crossing a boundary to come to Emmett Till as an artistic subject – one that, in interviews, she has acknowledged she intuited. As she told Calvin Tomkins of the *New Yorker*, Schutz felt instinctually that Till was 'maybe off-limits'

or even 'extra off-limits'. But she persevered, believing 'any subject is O.K., it's just how it's done. You never know how something is going to be until it's done.'[8]

But maybe the work wasn't done when she thought it was. Something else she told Tomkins comes to mind. The painting was first shown in Berlin in 2016 at an exhibition which she named after the J. M. Coetzee novel *Waiting for the Barbarians* – 'which I'm ashamed to say I haven't read'. I think of that line from Audre Lorde's 'The Transformation of Silence into Language and Action': 'I am [. . .] a Black woman warrior poet doing my work – come to ask you, are you doing yours?'[9] Borrowing Emmett Till is like borrowing the title of a novel one hasn't read: Schutz was not doing her work. Maybe the work of the painting was to go through the making of it, come out the other side, and decide it wasn't good enough, it wasn't appropriate, whatever epiphany was available to her – and then make a *different* piece about Emmett Till, if that story still had a hold on her. How much more powerful would it have been for Schutz to paint, for instance, Carolyn Bryant, the white woman whose lies led directly to Till's death?

There is a photograph of Bryant in the Tallahatchie County courthouse at the trial, flanked by her own two sons; she looks at the camera with set mouth, brows like insect antennae, eyes like lasers. The light touch of her little boy's fingers resting on her arm – that, for me, is the photograph's punctum, what Roland Barthes described as the thing that 'pricks' us in a photograph, unpredictably and uncontrollably. That image still would have been a difficult painting to make, and still would have courted controversy – perhaps along the lines of that stirred up by Philip Guston's portraits of the KKK – but it would have gone some way towards acknowledging white women's complicity in Till's lynching (and in lynchings more generally). Schutz has, as we've seen, said her way in to making her painting was her empathy for Till's mother. But motherhood as an institution and an affective experience is shaped and produced by historical circumstance. Race does not disappear in conversations like this one; empathy is not enough. It seems deeply maudlin to, as a white mother, project herself into Mamie Till's position; how much more challenging, and therefore possibly more artistically and

ethically valuable, would it be to imagine herself into the position of the white mother who deprived a Black mother of her child? It is not the role of the critic to say an artist can't paint what they want, but it is absolutely in our remit to say: your vision is clouded; there is more here than you have managed to see.

/

Can artists paint anything they like? This might be one of the riddles of Walker's Sphinx. The artist can only make work and hope the singularity of the image seeps into the viewer's consciousness, where it might dislodge something equally untellable, and make a small indescribable difference in the world. But the artist is also free to *not* make the work. To feel the instinct of discomfort, to ask around – do you think I should make this painting? – and be ready to say OK, maybe I shouldn't make this painting, maybe someone else should. Or maybe paint is not the right medium for this historical image; maybe the original photograph is all we need.

The questions protestors raised had less to do with the painting itself, and more to do with the material circumstances in which it was shown at the Biennial. 'I often wonder,' writes the art historian Aruna D'Souza, 'what would have happened had Black's letter not begun with an incendiary call for the work's destruction.' Perhaps the controversy it occasioned obscured the more salient aspects of the letter, reducing its argument about cultural appropriation to 'censorial essentialism' – that is, a policing of who could paint what – instead of reading it as 'a materialist argument, a struggle over resources'.[10] 'For many onlookers,' writes D'Souza, 'what was at stake was not simply *Open Casket*, but its entire framing.'[11]

At the Whitney event hosted by Claudia Rankine's Racial Imaginary Institute, the performance artist Lorraine O'Grady made a point from the audience:

> This whole discussion has to be framed within the institutional context that we are sitting in [. . .] why was the Whitney not prepared for what the eventuality of this Biennial would produce? Why has the Whitney not increased the curatorial staff of color in twenty-five

years? We can discuss a great deal about lynching and its significance in the racial imaginary and all of that. But we are here in a very specific context [. . .] that of the museum and its intellectual discourse. We need to hold the Whitney accountable.[12]

/

Ben and I went to that Biennial in 2017, on a visit to New York. I remember feeling distinctly uncomfortable in front of the Emmett Till painting; I didn't know where to look, how to situate myself as a white woman in front of it. I thought, as I often do, of my father's cousin, Andrew Goodman, also shot to death by white supremacists in the American South, for registering Black voters. I remember wondering what Andrew Goodman would do in my place, and thought he would have looked at Schutz's painting out of a feeling of having to bear witness, the way I feel when I read the stories in the paper of the people who died in the pandemic, or in the latest gun massacre, because I don't think I have the right to look away. And then, after looking for what felt like a respectful amount of time, I did exactly that, on to some other piece, that would make me feel comfortable again, or at least make me feel less uncomfortable.

One of the three paintings by Schutz that the Whitney included that year was called *Shame*, made for that show. It depicts a woman in lurid, hot pinks and peach skin tones, standing in murky red-glowing water, holding her hands up to her face, as if strenuously washing it, or sobbing. The notion of shame comes up several times in the Tomkins profile, specifically in relation to Donald Trump, a man without shame, who had recently won the 2016 presidential election. It's clear, looking at Schutz's other work, that shame interests her, that her work interrogates difficult feelings and sensations, trying to transform them into a pictorial image. 'I wanted to paint what it felt like to sneeze,' she told Tomkins of a series of paintings of a girl sneezing.[13]

I wonder if the very act of painting Emmett Till wasn't a misguided attempt at facing down white shame. In her essay on the controversy

Kara Walker, *Figa*, 2014.

Zadie Smith noted a nervousness around the eyes and mouth, a 'clear caution': 'Schutz has gone in only so far. Yet the anxious aporia in the upper face is countered by the area around the mouth, where the canvas roils, coming toward us three-dimensionally, like a swelling – the flesh garroted, twisted, striped – as if something is pushing from behind the death mask, trying to get out.'[14] It is there that the shame lies. That is her real subject. If the whole canvas had only been that mouth, perhaps the conversations about the piece might have been very different.*

I do think Schutz ought to have destroyed the painting. Not because she was encouraged to, but out of her own assertion of her authority as an artist. We don't *always* need to think of the work of art as some holy object that must be preserved at all costs. We can invoke Mary Richardson and the *Rokeby Venus*; even Kara Walker's sugar sphinx was eventually disassembled. Only its left paw – the one making the

* This passage in the painting is also reminiscent of Ana Mendieta's *Glass on Body Imprints*, particularly *Face*, reproduced earlier in this text. But even there, Mendieta acknowledges the pane of glass.

rude gesture – was preserved, and continues to be shown in fragmented form, as the work *Figa* (2014).

Maybe this is a potential future for Schutz's painting: to be destroyed except for that place around the mouth, the place where shame becomes paint.

get out your steak knives, Kali

1985. A young art student at Leeds University called Sutapa Biswas is working on her final project. She has found a bright red tunic at Miss Selfridge that is covered with a pattern that could be eyes, or mouths. It speaks to her. It has to be in the work. She makes three pieces for her final show in which it figures prominently, including a painting which will become her best-known work, *Housewives with Steak-Knives*, a depiction of the Hindu goddess Kali as a pissed-off British housewife. Years from now, on a return visit to India, the country of her birth which she fled with her family as a little girl, she will find a similarly printed tunic on a figure of Kali on her grandmother's mantelpiece.

Kali is a deity with a particularly strong following in Bengal, where Biswas was born. Her history goes back at least to 600 CE, where she first appeared, like the Sphinx, like the Medusa, as a goddess on the fringes of society. By casting her as a housewife Biswas reclaims the figure from the middle-class white women who made so much art about domesticity in the 70s, countering their anger with that of a specifically located British-Indian story of postwar and Thatcherite Britain. The painting, as the art historian Gilane Tawadros has written, 'defies the distinction drawn between the private and avowedly "feminine" domestic sphere, in this case exemplified by the kitchen, and the public, allegedly "masculine" domain of political action'.[1]

She brandishes in her several hands not a steak knife but a machete dripping blood, the head of a man who we can presume defied her will, a red flower (somewhere between an English rose and a red poppy, flower of remembrance) and a little flag. She's sticking out her tongue. Her hair is snaky, her eyes wide – she looks like a gorgoneion. Usually she wears a skirt made of human arms, but here she sports only a necklace made of decapitated heads – Biswas has explicitly identified them as those of 'an archetypal colonial type', a 'sort of patriarchal rather well-fed overfed character', as well as a 'Hitlerish

effigy'.[2] Her name is Sanskrit for She Who is Black, but here she is brown, thin, and ropey.

Kali is a complex figure, a warrior goddess created to destroy evil, according to Hindu mythology. But 'each time Kali killed an incarnation of evil manifested in its human form', Biswas has said, 'another would rise up from the blood spilled. She was thus engaged in an endless war that drove her to a state of near-madness.'[3] She has the mad yet joyful wrath of Valerie Solanas's *SCUM Manifesto* (1967), the Society for Cutting Up Men, but there is also the warning, in the hand raised in peace, that creation comes from destruction – *must* come from destruction. She is the goddess of both war and peace, both threatening and protective, and therefore a challenge, Tawadros writes, to 'the Western notion of "femininity" as essentially fragile and passive'.[4] The painting is Biswas's *Second Sex*, an assertion that – Tawadros again – 'the dominant order of white, male individuality [. . .] will be overturned by black creative resistance'.[5]

Where some of the earlier feminist work of the 1960s and 70s has often found itself accused of using mythology and goddess imagery to prop up some essentialist (and white) notion of femininity, Biswas was specifically interested in using this imagery in order to critique empire, and an appropriative attitude towards bodies judged by white patriarchal culture to be, more or less, furniture – women, the working class, and people of colour.[6] 'I'm interested in the female narrative,' she told the curator Courtney J. Martin in 2019. For South Asian immigrants like Biswas and her family members it was 'critical' to maintain a 'matriarchal' collective; it was a question of 'surviving England'.[7] Looking back to when the painting was made, Biswas said that in the 1980s, 'the portrayal of South Asian women in a British context was as these meek and voiceless chattels. So to frame us as Kali was to celebrate us too.'[8]

Housewives, Biswas said, 'placed the narratives of Afro-Asian women at its centre in response to the systemic racist and patriarchal violations that we faced daily as Black women'.* The Grunwick strikes

* Biswas saw herself as a Black artist not only under the heading of what gets called 'political blackness' – the notion that there is power in collective identification – but,

of 1976–8, led by Jayaben Desai against the racism and exploitation faced by female immigrant workers, largely of South Asian descent, seriously impacted Biswas, who was a high school student in the suburbs of London at that time. Desai could be seen as one of the models informing *Housewives*: 'It was highly uncommon to see a feisty working class Indian woman, donning a modest sari, who broke all the stereotypes, represented within any context of our mainstream media, let alone leading striking workers and winning the hearts of a wider public.'[9] Biswas was also incensed about the virginity tests being carried out on Indian women emigrating to the UK; they would be referred to a medical examiner who would 'determine whether the passenger has borne children which could be relevant to his decision whether a passenger should be admitted', as a 1979 *Guardian* article put it, announcing that the practice had been banned by then Home Secretary Merlyn Rees.[10] The title of Biswas's painting, remember, is plural: not one housewife, but many, armed to the teeth and out for blood.

/

Too often, the political content of a work like *Housewives* overshadows the made-ness of it. It is as if the political affect – important though it is – overwhelms anything else we might say about the piece.

And yet the materiality of the piece is just as political as its themes. *Housewives*, for instance, is a mixed-media work on paper, using pastels, acrylic and house paint. 'House paint is cheaper than acrylic paint and the paper used was relatively inexpensive,' Biswas explained to Martin. 'The pastels were of a high quality though,' she added.[11] There's a housewifely parsimony to the materials, and Biswas has been similarly nonchalant about the work itself.

Her interest in texture, too, directly contravenes the art historical

Biswas has said, because when she was applying for UK citizenship, there were two boxes to tick: *Are you white?* or *Are you black?* 'The state identified us as Black, and identifying ourselves as Black was important to forming critical allegiances between those of us who were "Othered" by the state and who shared histories of being oppressed by colonialism.' Biswas, *Lumen*, p. 25.

tradition. She has said that she was inspired to make *Housewives* by Robert Rauschenberg's white paintings of 1951; but Rauschenberg wanted to create perfectly smooth, 'pristine' surfaces which would look 'unmarred by handling' (in the words of his Foundation).[12] To achieve this he invited friends and assistants like Cy Twombly or Brice Marden to help him paint and smooth, paint and smooth. Whereas Biswas wants the work to bear the marks of its experience in the world: every time *Housewives* has been shown, the paper has creased a bit more. The creases were, in and of themselves, she thought, beautiful; they challenged the idea of 'fixity' and the 'longevity' of art. The idea, she has said, was that 'you might have to repair it a little bit every time along the way'.[13]

There is another piece of paper glued into the work – a piece of photocopy paper, a copy of Artemisia Gentileschi's *Judith Beheading Holofernes* (1620) which Biswas has given Kali as a little flag to wave. This is the second version of the painting Gentileschi made; the first was completed in 1612, the same year as the rape trial (it hangs in the Capodimonte museum in Naples; the later, more sumptuous version can be seen in the Uffizi in Florence).* In the 1620 version, the blood spurts more dramatically, the sword is longer and its metal starker against the bedsheet; now, Judith and her maid are flecked with blood. The painting, comments the art historian Nanette Salomon, depicts the precise moment when Holofernes's heart is 'still forcefully pumping blood', while Judith's action has 'rerouted' its course. He is captured 'between life and death [. . .] the most terrifying moment of all, the moment when a person is still alive enough to know that he or she is dying and there is nothing that can be done about it'.[14] On her arm in the second version of the painting is a bracelet depicting Artemis, the artist's namesake, goddess of the hunt, and female chastity. Scholars, on the whole, agree that Gentileschi has given Judith her own face.

* The painting has been retroactively viewed as an act of painterly rage against the man who raped her, Agostino Tassi, the painting teacher who had been hired to teach her the rules of that all-important Renaissance trick: perspective. According to the story, after the rape she attacked him with a dagger.

Biswas's use of the painting is scrappy and visionary. Just as Judith saved her people from the threat of Holofernes, here the heroic Housewife – to whom Biswas has also given her own face – has saved hers by severing the head of the colonial menace, and whoever crops up after him.

But there is another intertextual reference embedded here: the photocopy was taken from Griselda Pollock and Rozsika Parker's now-classic work of feminist art history *Old Mistresses*. Pollock was Biswas's tutor at Leeds University, and would play an important role in her burgeoning feminism. Except, she noticed, there was not a single artist of colour in *Old Mistresses*. It was, Biswas has said, 'a way of saying to Pollock "Where am I in your narrative [. . .]?" '[15] Although under the direction of the art historian T. J. Clark the fine arts course at Leeds was among the more progressive in the country in terms of integrating Marxist and continental theory into its practices, Biswas was one of the earliest voices challenging the Eurocentrism of the way art history was taught. 'I would present Griselda with a series of questions at the end of her set essays on questions relating to the Eurocentricity of art history / imperialism in terms of the subjects we were studying at the time,' she told Imogen Greenhalgh of *RA Magazine*. 'She was a patient and supportive tutor, and remarkably always responded to my set questions that I wrote for her at the end of my set assignments.'[16] Biswas was the only woman of colour on her course. Pollock would later credit Biswas with 'forc[ing] us all to acknowledge the Eurocentric limits of the discourses within which we practise'.[17] 'I want people to research into my culture, as I have been doing in European and Western culture,' Biswas told *Spare Rib* in 1986.[18] The reference to Gentileschi, then, signifies on several different levels, like *Housewives* itself; it is Biswas painting herself into a tradition, and also signalling her alienation from it: inclusion and exclusion at once. She wanted the viewer to 'consider the possibilities of Shakti, creative force, the Tantric force, in terms of our daily lived experience. To just mess everything up.'[19]

/

Nisha Ramayya:

> I propose a Tantric poetics. 'Tantra' may be defined as both 'frame' and
> 'threads', from the Sanskrit verbal root 'to stretch, spread, spin out,
> weave'. Further, 'tantra' is etymologically cognate with 'text', from
> the Proto-Indo-European verbal root 'to weave'.
> [. . .]
> A Tantric poetics affirms closeness, relationship, and community,
> without enforcing touch, agreement, or commonality.[20]

/

1985. The artist Lubaina Himid is asked to curate an exhibition of
Black artists in a twenty-metre-long corridor of the Institute for Con-
temporary Art. Himid had actively been militating for the work of
Black British women to be seen, and *The Thin Black Line* was the third
in a series of shows that would be remembered as having put Black
women's art on the map. 'Black women artists were not getting the
grants they deserved because they did not know the right avenues to
follow,' Himid later wrote. 'I was hungry to show with other black
women to see whether there was a conversation to be had amongst
ourselves around showing space, political place and visual art histories,
how to develop ideas around making, visual representation, belonging
and identity [. . .] we wanted to exhibit the work we were making in
our kitchens and back bedrooms.'[21]

 Biswas introduced Himid to Pollock, whom Biswas interviewed for
her thesis, and Himid in turn decided to include some of Biswas's work
in her show, alongside that of Sonia Boyce, Maud Sulter, Claudette
Johnson, and a handful of others. When Kali was hung, Biswas angled
it out from the wall, so it leaned over the visitor.

 One visitor spat on it.*

* In 2009, two Hindutva groups, the Forum for Hindu Awakening and the Uni-
versal Society of Hinduism, pressured the Bradford city council to stop publicly
displaying the painting, complaining that the painting trivialises the sacred goddess.

As Jeffrey Jerome Cohen reminds us, 'the monster exists only to be read: the *monstrum* is etymologically "that which reveals [. . .] that which warns"'.[22] In her exhibition catalogue for her 1998 show *Safety Curtain*, created for the Vienna State Opera, Kara Walker includes a letter to the nineteenth-century Austrian poet Peter Altenberg, from her 'cell' in 'Vienna's Modern Asylum For Uncooperative Americans of African Descent':

> I am and shall continue to be the monster in your closet. Prodding at your tightly wound arsenal, your history.
> Let Me Out.
> And. You. shall. seek. to. put. me. back. in.
> And together we will: in and out and in and out together HAHA![23]

Writing to a culture that defines itself as 'white' against the 'blackness' of the 'American of African Descent' Walker steps into the role of nudge, nag, pointer, prodder with not a little glee.

Biswas has ventured a similar theory about the varied responses to her work:

> I think my work fucks with you, which is maybe why some people find me difficult to digest. People tend to not like brown women fucking with them.[24]

/

Everyone writes about the Gentileschi painting when they write about *Housewives*; how could you not? But look more closely at Kali's little flag and you'll see another image just to the right: Gentileschi's *Judith and Her Maidservant* (1625–7). A few years after her second Judith painting, Gentileschi returned to the story one more time, now depicting the women as they leave Holofernes's tent, the maid Abra gripping his decapitated head. Judith holds her hand up as if to say *wait – it may not be safe to leave*. The light from a candle shines on her palm, like the red blood on Kali's. It is an image of female companionship, of

accompanying one another in daring – the patriarch can't be slain by Judith alone. Temporally, too, this double reference complicates the Kali painting, which is conjugated into two moments – the moment of violence, and the moment just after, when new threats may emerge, with the potential for more violence.

The multiplicity of Judith images that Gentileschi painted – these two, plus the earlier Holofernes beheading – underpins Biswas's own decision to paint the Kali figure into several different works, wearing her Miss Selfridge tunic: there is a large diptych called *As I Stood, Listened and Watched, My Feelings Were This Woman Is Not for Burning* (1985–6), in which two women – Biswas and her sister I believe – embrace. In a mixed-media piece on paper called *The Only Good Indian . . .* (1985) Biswas depicts herself watching the news while taking a peeler to something she holds in her hand like a potato, but which bears the face of a white man.

/

There is another work connected to this group not by the tunic but by the figure of Kali, and the destructive-creative spirit of shakti.

1984. In a scratchy public access television-style video, a young British-Indian woman addresses the camera like a newscaster:

> What you're about to see is the documentation of a performance which took place in January of 1984. [. . .] The performance is [. . .] about imperialism, and the [. . .] domination and exploitation of the East by the West. Kali is the heroine and represents the East. Raban is the devil and represents the West. This is a performance but also about performance itself. Who performs, who spectates. It plays on the power of the performer to the spectator and vice versa. It questions who is in control and who is not. Who are the performers, and who are the viewers.

Behind her is an early 80s television screen, possibly an old editing machine, on which we see the scene we are watching duplicated in miniature: Biswas sitting in front of the camera, wearing exactly what she's wearing, as if quoting herself, the way *Housewives* quotes Gentileschi. But in the Kali video the Gentileschi flag has been swapped

out for the Union Jack, which hangs, giant, behind Biswas – based on the exact measurements of Jasper Johns's encaustic painting *Flag* (1954–5).

A flag is an avatar for the nation, and such a powerful one that at least in the country of my birth it's a great scandal to burn it, though also a right protected by the First Amendment as 'symbolic speech'. Biswas's relationship to the concept of nation is complex. Her family originally came from East India, in what was for a time British India, then East Pakistan, and today Bangladesh. She has discussed, in interviews, the fractured relationship she has to the concept of nation; the land is mutable, and always being claimed by somebody new. After India won its independence from Great Britain in 1947, it faced the catastrophic trauma of being divided into the largely Hindu India, and largely Muslim Pakistan. Sectarian violence was rampant. Fifteen million people were displaced, and between one and two million were killed; 75,000 women were raped, with some disfigured or dismembered. As Nisid Hajari writes in *Midnight's Furies*, 'some British soldiers and journalists who had witnessed the Nazi death camps claimed Partition's brutalities were worse: pregnant women had their breasts cut off and babies hacked out of their bellies; infants were found literally roasted on spits'.[25] Biswas's family witnessed it all. If the Stars and Stripes has been swapped out for a Union Jack, we can easily imagine that this act of substitution recalls that by which the Union Jack was imposed on the Indian subcontinent.

/

At Leeds, Biswas had been thoroughly trained by her tutors in performance art, feminist art, Fluxus, film history, and all of these references are there in this piece; Biswas was also in touch, by this point, with artists in the Black Arts Movement like Himid and Boyce and was also exposed to what Stuart Hall would go on to call (citing Dick Hebdige) a 'cut-and-mix' technique of collaging, mixing, blending, sampling.[26] There is Kathak dancing, a range of musical references in the score composed by Biswas and Andrew Rodgers, music from the anti-apartheid Bahumutsi Theatre Company – a 'cacophony' of

influences, writes the art historian Alina Khakoo in her catalogue essay on the film, 'tending towards ambivalence rather than the articulation of coherent new meanings' and 'using multi-dimensional collage to cut these discourses open and leave them unsealed'.[27] It is a fantastically assured piece of work for an artist in her early twenties (for an artist of any age, really). Each time I watch the film I am more impressed by this young artist, daring the narrative to make room for her, transforming it with her presence.

Part of the film, Biswas-as-newscaster warns, will be in Bengali and Bantu, which may not be accessible to the viewer. This is deliberate. The piece is, she says, 'about the power and politics of language'. Who gets to speak, and why; who claims the right to speak, and how.

/

Pollock enters, smiles, friendly. She thinks she's there for a crit (an art school term, a session in which tutors respond to students' work); she doesn't know she's been cast in a student film. She sits in a chair, and a pillowcase with eyeholes is placed over her head. Biswas is there with a friend, a student called Isabelle Tracy; she paints a bright fluorescent orange-red circle on the floor around the chair, similar to the poppy red on Kali's palm. Biswas shuffles loudly as she goes, moving backwards, counterclockwise. The music on the soundtrack sounds amateur, like 'dirty underground techno', Ben, a composer of electro-acoustic music, says when I play it for him; 'probably German, given the time'. The camerawork is messy and imprecise, by design, incapable of giving us a straight shot, an uncomplicated sense of what's going on.

Cut to a scene of Pollock without the bag on her head, looking at herself in the mirror.

Cut to a shot of Kali's wild eyes.

Cut back to the room, the camera following the red of the circle around and around, as if we were in the room, doing head rolls, the camera itself warming-up to dance.

Cut to Pollock with her head in a bag, now she's slumped over, like she's been there a while; the light is different, daytime. Like she's being held hostage. The girls wear all black, overlaid with bin bags,

their hair in ponytails. Art bandits. Biswas finishes her circle and cuts out the lights.

Black.

When the lights are back it is hard to see what's happening. Everything is blurry, bodies move in front of the camera. Nothing's in focus. Shadows with lit-up outlines move on the walls. When we come to – as if all of this has been happening while we've been unconscious, as indeed we have been – Biswas and Tracy leap around Pollock leering and shaking – what? Boxes of lentils? Mischievous spirits in an exorcism, an art ritual. The camera tries to focus on the texture of the pillowcase on Pollock's head; the light is so bright it's overexposed, but here and there the weave is apparent. The camera rests on an age-speckled mirror, in which Pollock looks at herself. For a long while it stays tightly focused on Pollock, sharing in her limited view, her partial understanding.

When they're done shaking the lentils they dance, feet splayed, knees bent. It's a very small room. There is something intriguing playing out on Biswas's face, she has a look that's at once determined but hesitant, open to information, what happens next. She glances frequently at her friend out of the corner of her eye. I try to capture it in screenshots.

Someone has a can of beans. It drops to the floor. They throw something on Pollock – something white and granular. Biswas eats some. They bring out puppets that play and fight each other in glorious chaos, Fluxus synthesised with Kathak dancing and feminist performance art against an unchanging soundtrack, driving but flat. Glimpses of the word kali in the mirror, backwards, fragmented written on the wall opposite. Goddess of chaos.

The music stops and all we hear are Biswas's footsteps. She holds up a fake cardboard knife (papier-mâché machete?) while her friend crouches on the ground, head down neck exposed, ready for the blade. Biswas hits her shoulder a couple of times, then the ground. Screechy on the soundtrack like the little shrieking thing the dentist uses to remove plaque. She paints a green circle around the remnants of the puppet. Throws the knife. Paints pink lines on her friend's back. The paint goes on thick and easy but the brush stutters on the

bin liner as it thins. The precise, classic gesture of the painter painting, brought up against the challenge of the bin bag canvas on bended back. Smoothness is impossible. Jump cuts as sets of lines appear. Line, cut. Line, cut. The image appears with another jump and a throbbing of the bass guitar. She's been painting a swastika. The lines aren't facing the Nazi way thank god, but the left-facing way, the *this is an ancient symbol from my ancient culture* way, the *I dare you to be outraged at the way I am reclaiming this symbol from my culture that was co-opted by Western fascists* kind of way. The bass line sounds sick, like an electrified muffler on the fritz. Cut, cut, slice, mix, the video dwells in some joyful place between creation and decreation, between representation and abstraction, between the image and its own cancellation.

Credits.

let it blaze!

After that night in the bathtub, when the idea for a book called 'Professions for Women' first came to her, Woolf began to keep scrapbooks documenting the relation between women's private lives, and their public ones: newspaper clippings, photographs, letters, pamphlets, reading notes, and associated ephemera, anything to do with, among other things, the status of women in Britain, empire, nationalism, the church, sexuality, sports, family, control of women's finances, masculinity, the university, feminist organisations, the League of Nations, inequalities in education, fascism, and encroaching war. There is a *New Statesman* article about abortion, a piece about the first female pilot to receive the Air Ministry's first-class air-navigation certificate, a clipping on the maternity death rate, and one about the Union of Postal Workers demanding 'smartly-cut uniforms'.[1] You can see the scrapbooks today at the University of Sussex, with their cracked and decaying marbled covers, labelled NOTES & CUTTINGS, the newsprint gone brittle and orange over the years, tacked to the page with old-fashioned sellotape, the elements exhaustively indexed and annotated in Woolf's distinctive hand-writing, not in the familiar purple ink of her manuscripts, but in pedestrian black, red, green.

We might compare Woolf's scrapbooking to that of Walter Benjamin, for whom 'tearing statements out of context' was 'like a robber making attacks on history'.[2] The fragment-compiler as thief, the illegitimate collector turned whistleblower: repressive institutions can and will be brought down by the steady collection and cunning deployment of facts. From time to time, while she worked on other projects, Woolf would add to her collection, steadily building up the raw material of what she called her 'war book'.[3] Woolf integrates these news clippings and photographs into the collage-essay of *Three Guineas*, as if to underscore the degree to which it is rooted in the incontrovertibly real world, rather than in the imagined world of the

novelist, or in 'female' emotionality. Of these scraps, orts and frag-
ments, she noted in her diary, 'I have collected enough powder to
blow up St Pauls [sic].'

Powder: a letter away from Power. Woolf is referring, of course, to
explosive powder, a powerful image in and of itself, but perhaps she
was also thinking of the other kind of powder some women see on a
daily basis: pressed powder, the kind some of us dust on our faces in
an attempt to make our faces smooth and flawless, to erase the grain
of the skin, to absorb sweat and grease: evidence of the body at work.

Three Guineas is a bid to stop dusting over the imperfections. Blow
up St Paul's with a lifetime's worth of face powder.[4]

/

(In 1973 Ana Mendieta carves her silhouette into the earth, lines it with
gunpowder, sets it alight.)

/

(In 1975, Hélène Cixous, mystical-angry-comedic:

Woman, who has run her tongue ten thousand times seven times
around the mouth before not speaking, either dies of it or knows her
tongue and her mouth better than anyone. Now, I-Woman am going
to blow up the Law.[5])

/

The match came in the form of a letter Woolf claims to have received
from a gentleman reader, a barrister, asking her, in her opinion, how
'we' might avoid going to war. Woolf confesses, with typical irony,
to being surprised to receive the letter at all: 'since when before has
an educated man asked a woman how in her opinion war can be pre-
vented?'[6] Her reply would consist of a lengthy argument that roots
fascism in the family and in private property. Patriarchy, she reminds
us, is inherently violent. It is patriarchy that invades, colonises,

exploits, rapes, divides and punishes. The arguments *Three Guineas* makes against war and fascism are inseparable from its goals as a feminist polemic. The daughters of educated men, she tells her interlocutor, are the 'advance guard' of his own pacifist movement. 'They were fighting the tyranny of the patriarchal state as you are fighting the tyranny of the Fascist state.'[7] Fascism and violence begin in the home.

Three Guineas, published in 1938, is one of the works that grew out of the 'Professions for Women' speech. Woolf's impulse in 1931, remember, had been to write about the professional lives of women, defying the Angel to do so, and inspiring her readers and listeners to contemplate what it meant to be a woman, and to live in a woman's body. The intervening years saw worldwide economic crisis, the downfall of Labour in Britain, fascism on the rise in Europe, and increasing concern on the part of its intellectuals and political thinkers to try to prevent, at all costs, another war. Each chapter regards the potential gift of a guinea to various organisations who might be able to do so. She gives one guinea to a fund to rebuild a women's college, one to a society for the support of women in the professions, and one to found a group called the Outsiders' Society, in the belief that those who operate from the margins of culture may transform it more radically and successfully than those who labour within it.

What all three groups have in common is that they are comprised of women who have only been allowed to enter the professions and earn their living since 1919, whose brothers' education was prioritised over their own, and for whom the making of war is an unfamiliar impulse. But while much of the essay is about patriarchy and its crimes against humanity, there is a strong through-line which asks women what they have done to support and uphold these crimes, interrogating the ways in which they have been accomplices, and not victims: only then might they begin to imagine a different world.

Women in positions of power will still make war, but they do so as self-appointed Athenas, handmaidens to the patriarchy, trying to prove themselves within its value structure. But those who would join the Outsiders' Society must adhere to a structure 'without [. . .] any hierarchy';[8] they must 'press', among other things, 'for a living wage in all the professions now open to her sex', and 'press for a wage

to be paid by the State [. . .] to those whose profession is marriage and motherhood'.[9] (Wages for housework in 1938.) They would 'bind themselves [. . .] to reveal any instance of tyranny or abuse in their professions. And they would bind themselves not to continue to make money in any profession, but to cease all competition and to practise their profession experimentally, in the interests of research and for love of the work itself'.[10] And, finally and among other things in this astonishing manifesto, 'they will dispense with personal distinctions – medals, ribbons, badges, hoods, gowns – not from any dislike of personal adornment, but because of the obvious effect of such distinctions to constrict, to stereotype and to destroy'.[11]

By the time Woolf has given form to the epiphany she had in her bathtub concerning the professional lives of women, she has thoroughly undermined the concept of the professional as it has historically taken form under the capitalist patriarchy. No longer content to kill off her personal Angel, she wants to completely restructure what it means to make work, to labour, to profess.

In her letter-within-a-letter, she imagines her reply to the honorary treasurer of the women's colleges at Cambridge, who has written to her to ask for money to rebuild the crumbling schools. Why, she asks, should money be given to promote education for women, when education, as it exists at the moment of writing, is merely a means of inculcating in women the values of men – that is to say, the values of possession and force, and therefore war-making. 'If I send it, what shall I ask them to do with it? Shall I ask them to rebuild the college on the old lines? Or shall I ask them to rebuild it, but differently? Or shall I ask them to buy rags and petrol and Bryant & May's matches and burn the college to the ground?'[12]

This is one of Woolf's central arguments: she will not be able to support women's so-called education so long as it replicates the values of the patriarchy that only dimly allow it to exist. Woolf will send the guinea, she writes, only the treasurer must guarantee it will be used to educate students in pacifism. But since neither the old version of the school nor a reformed one will do this, she concludes, 'the guinea should be earmarked "Rags. Petrol. Matches," and it should have a note attached to it: "Take this guinea and with it burn the college

to the ground. Set fire to the old hypocrisies. Let the light of the burning building scare the nightingales and incarnadine the willows. And let the daughters of educated men dance round the fire and heap armful upon armful of dead leaves upon the flames. And"' – she lets loose here, pyromaniac – ' "let their mothers lean from the upper windows and cry, Let it blaze! Let it blaze! For we have done with this 'education'!" '[13]

/

I looked through the scrapbooks filled with a sense of wonder and respect that Woolf was able to carve this narrative out of so many disjointed elements; I thought, not for the first time, about voice, and point of view, and how they are so often the same way of trying to make sense of what we see, and then articulating the sense we've cobbled together. How would I have written up this war book, I wondered? What do the *Three Guineas* notebooks have to offer me, as I make my way through the accumulation of my own fragments?

And then I came across one page dedicated to notes Woolf retyped from Margaret Collyer's *Life of an Artist: an Autobiography* (1935), in which the artist describes the difficulty she encountered as an art student accessing the same education as the young male artists. They, for instance, could paint nude bodies in the classroom; as we have already seen, women could not. How, then, could the young women artists 'compete' with the men for prizes and medals when they had 'half the amount of tuition and less than half their opportunities for study'? But Woolf, with her eye firmly trained on the practical and pecuniary ways the benefits of masculinity work to the detriment of women, also retyped a passage about the financial hardship the students endured in order to pool their resources and rent a studio outside school hours and pay a model to pose for them four nights a week: 'The money that we, as the committee, had to find, reduced our meals to near starvation diet. Like myself, many brought sandwiches for lunch, but as many poor hardworking girls could not even afford these, and were too proud to share the food of a luckier individual, we all agreed to pool our food so that everyone could get a snack at the

midday rest hour . . . I have many times seen nice cheery girls collapse and faint dead away as they stood at their easels.'[14]

Although the reference in the actual text of *Three Guineas* is minimal, it is telling that in this furious, urgent book about fascism, feminism and freedom, Woolf makes room to talk about the professional lives of women artists. It is, perhaps, a little gift to her sister the painter, but it is also an occasion to connect the lives of working female artists with those who labour in other fields; in a footnote quoting Collyer's book Woolf elaborates, referring to the profession of artist as one that is only 'nominally open' to women, but in fact full of obstacles designed to keep women from advancing. Others include medicine – the London hospitals did not let women work in them, even if they came through the London School of Medicine; quotas were placed on how many women could enter the Royal Veterinary College, because otherwise they would outnumber the men.[15]

This passage seems like just another example among many of the ways in which Victorian fathers kept their daughters under their control, but it helps us see the continuum between public struggles for freedom, and women's professional ones. Moreover, it suggests that Woolf saw a connection between what women artists could not represent on the canvas, and the unpictured photographs of the Spanish Civil War (on which, more to come). The question of the body – what to depict, and in what state – would be one of the major battlegrounds for feminist artists, and Woolf recognised it in 1938.

We can think of the argument of *Three Guineas* as being as much aesthetic as it is political – that women artists shouldn't have to battle their way into the men's art classes, but do away with the whole system: burn down the Royal Academy along with St Paul's, found their own schools in their own rented accommodations, pool their resources, work communally.

/

The grand-niece of a photographer and the sister of a painter, Woolf would write incisively about art and artists over her career. But her preoccupation with the visual structures *Three Guineas* in surprising

ways. The book is punctuated with photographs – though if you have one of the editions published between 1942 and 1993 you wouldn't know it – of Important Men decked out in full regalia: a general, a professor, a magistrate, an archbishop, some trumpeting heralds.* These silks and ceremonies, badges and medals, ribbons and gowns and wigs denote an intricate language of rank and hierarchy, and support the pomp and pageantry of nation and empire. Woolf is interested in the way women are excluded from these systems while also profiting from them – evolving their own unofficial hierarchies of dress.

Looking through the images in Woolf's scrapbook I'm struck by her interest in costume – there are posh ladies in London wearing the most ludicrous hats, but which, coming several pages after a photograph of the Pope in his crown, only succeed in making him also look like a slave to the latest millinery fashion. The images do not have an illustrative function, but rather create a particular atmosphere, writes the critic Rebecca Wisor.[16] Woolf, she writes, 'relies on them as a kind of visual shorthand'; she knows that readers will associate them with contemporary 'speeches, policies, and/or rulings'.[17] The decision to use the photos in this vague sense may have been a calculated one; Wisor describes the 1934 Incitement to Disaffection Bill which outlawed 'seducing' a member of the military into abdicating their duty towards country – under which persuading them not to, for instance, 'drop bombs on a town in an enemy country' would become a prosecutable offence.[18] Using the pictures like this was a way of protecting her readers as well as herself – 'had Woolf voiced her indictments of the particular leaders of Church and State [. . .] she would have left herself vulnerable to charges of seditious libel.'[19] In that diary entry about having saved up enough powder to blow up St Paul's, the very next sentence is: 'it is to have 4 pictures'.[20]

* The men in these photographs were not chosen at random but were well-known figures who would have been recognisable to readers in Woolf's day: the former Prime Minister, the Archbishop of Canterbury, the Lord Chief Justice, the founder of the Boy Scouts. Perhaps this is why they were cut after the 1943 edition. These were restored in the UK in 1993 in Michèle Barrett's joint edition of *A Room* and *Three Guineas* and in the US in 2006, in Jane Marcus's US edition.

There are other photographs Woolf purposefully did not include, to which she makes explicit reference in the text – those which she mentions early on as having received in the post that morning, of 'dead bodies and ruined houses'. These are photographs of the destruction wrought by the Spanish Civil War, which were mailed out by the Republican forces twice every week so that the world could see the physical cost of the fight against fascism, as General Franco's forces advanced. These photographs are 'not arguments addressed to the reason' either, Woolf writes, but 'simply statements of fact addressed to the eye'.[21]

> This morning's collection contains the photograph of what might be a man's body, or a woman's; it is so mutilated that it might, on the other hand, be the body of a pig. But those certainly are dead children, and that undoubtedly is the section of a house. A bomb has torn open the side; there is still a birdcage hanging in what was presumably the sitting-room, but the rest of the house looks like nothing so much as a bunch of spilikins suspended in mid-air.[22]

The photographs do not address our reason, no; they address the eye, and thus the brain, the nervous system; we see them and we feel things. They short-circuit a rational system of thought and lead us straight to outrage and fear. The decision not to include them can only have to do with this affective punch – either they would distract from the eminently rational argument Woolf wants to make, or they would make an argument by appealing to the emotions instead of to reason.

But leaving them out was clearly the strongest choice. Like Barthes deciding not to include the photograph of his mother in *Camera Lucida* – 'For you, it would be nothing but an indifferent picture, one of the thousand manifestations of the "ordinary" ' – Woolf intuits that they will detonate even more powerfully off-stage.[23] They become a haunting, absent presence, the description of the bombed-out house an eerie prolepsis of the future bombing of Woolf's own home in Tavistock Square. As Sontag writes in *Regarding the Pain of Others*, 'photographs of the victims of war are themselves a species of rhetoric. They reiterate. They simplify. They agitate. They create the illusion of consensus.'[24] Rather than perpetuate this illusion, Woolf

would prefer to maintain the emotional aura of these photographs, shifting her emphasis on to her real target: the violence and exploitation of patriarchy and fascism, which takes its most ridiculous yet deadly serious form in the pomp and circumstance of masculine spectacle. And while these photographs invite the same rejection of war as an 'abomination' in the mind of both Woolf and, she imagines, her interlocutor, the basis for this response differs for each of them. The rhetorical aligning of photographs seen and unseen underscores the continuity of tyranny, in Woolf's argument, from the private house to the public sphere to the theatre of war. The personal is political. For daring to point this out, Woolf would be vilified.

/

Her friends kept their distance when the book came out. In July 1938 she wrote in her diary that 'not a word [was] said of it by any of my family or intimates', and in November 1938 and October 1939 she reports having been 'sent to Coventry over it'.[25] Vita didn't like it.[26] Leonard wasn't particularly enthused about it either.[27] She had a good many letters from women who loved the book – some friends and acquaintances, some working-class women, some Quakers. The reviews were mixed; for the most part, they indicate a deep discomfort with the degree of anger it contains.[28] Some, like the *TLS*, praised it; others were divided; on the 4th of June 1938 *Time and Tide* had Theodora Bosanquet calling it 'this year's finest example of what England can produce in literature', a 'revolutionary bomb of a book', while the 25 June editorial in the same magazine claimed that Woolf's theme 'is not merely disturbing to nine out of ten reviewers but revolting'. Graham Greene, while admitting the 'brilliance' of the essay, wondered if its author hadn't perhaps lived too 'sheltered' a life, and if its tone wasn't 'a little shrill?' Queenie Leavis, that avowed anti-feminist, eviscerated *Three Guineas* in a reckless critique in *Scrutiny* which accused it of 'some nasty attitudes', and asserted that because Woolf was writing from the perspective of an upper middle-class woman, she couldn't possibly have anything to say to women from other classes. For all the facts Woolf compiled, Leavis still called her 'ill-informed'.

John Maynard Keynes said the book was 'silly', Quentin Bell said 'odd'; Nigel Nicholson said 'muddled . . . neither sober nor rational'.[29]

'What really seemed wrong with the book,' as her nephew and biographer Quentin Bell put it, 'was the attempt to involve a discussion of women's rights with the far more agonising and immediate question of what we were to do in order to meet the ever-growing menace of Fascism and war. The connection between the two questions seemed tenuous.'[30] This was a rhetorical juxtaposing that post-war feminist artists learned from Woolf – think of Martha Rosler's 1967–72 photomontage series *House Beautiful: Bringing the War Home*, which brings images of the war in Vietnam together with pictures cut out of *House Beautiful* magazine. The personal overlaps with the political; the domestic with the foreign; peace with war. And today's abolitionist feminism movement, which acknowledges the violence of the state and systemic injustice and privileges community-building over a punitive, carceral state power, can also be traced back in part to Woolf's polemic.

But these connections were not at all clear or even valid to point out in 1938; Woolf's contemporaries could not accept the link she made between feminism and pacifism, between women's rights and the question of the impending war. E. M. Forster, soon after her death, in his 1941 Rede lecture, called it 'cantankerous', a giving-in to the feminist 'spots' that 'mar her work, like a disease'.[31] She wouldn't have been that surprised, however. Not long before the book was published, she wrote to Vanessa: 'I shan't, when published, have a friend left.'[32]

Before she called it *Three Guineas*, she thought about calling it *On Being Despised*.

/

But all of that is still to come. In 1931, as she soaks, naked, in her bathtub, Woolf is just beginning to realise what she is going to have to do: find a way to represent the unrepresentable, say the unsayable. Woolf's twin desires are linked; the death of the Angel means the life of an art of the body.

III.

bodies of work

virginia woolf kathy acker hélène cixous adrienne rich audre lorde
bell hooks harryette mullen cathy park hong theresa hak kyung cha
maria lassnig nancy spero carolee schneemann maya deren lee miller
dora maar ana mendieta helen chadwick meret oppenheim hannah
wilke lynda benglis cindy sherman julia kristeva rei kawakubo lucy
lippard mary kelly sutapa biswas eva hesse eleanor antin fanny burney
del lagrace volcano jo spence eve sedgwick judith scott ingeborg
bachmann susan sontag lady gaga jana sterbak tori amos kate zambreno
chris kraus simone weil vanessa bell mary ann caws

this monster the body

If I have returned again and again in this book to Woolf's 'Professions for Women' speech, it is because I am enduringly fascinated by gestation, both creative and procreative. During the period between conception and birth, so much can go wrong.

Woolf never had children – her doctors advised against it – but she had many difficult periods while creating her books. The one that particularly interests me here is the material that grew from 'Professions for Women'. From the germ of Woolf's bathtub epiphany blossomed a series of books and essays: the 1931 speech, the finished essay version, and, by the mid-1930s, a novel about women's professional and sexual lives, that would, yet again, attempt to speak the truth of her experience as a body. As Woolf began work on the book she thought would be *Professions for Women*, she conceived it as an all-encompassing hungry maw of a book: 'it's to take in everything, sex, education, life &c'. The book as Blob, as Chris Kraus defines it, 'swallowing and engorging, [. . .] Unwise and unstoppable.'[1]

To pull it off it was clear to her that the usual genres of fiction or non-fiction would not do; she needed some other form in which to be both lyrical and forthright. Woolf conceived her book as a Novel-Essay, to be called *The Pargiters*, which could alternate chapters of fiction and fact. The fiction: extracts from an imaginary novel, the story of a family, in several generations. The fact: essays on these social strictures, illustrating the constraints on women's lives, and the power and privilege of men's. The envisioned admixture of fact to fiction in this work has been likened by Woolf scholars to the relationship between 'granite' and 'rainbow', truth and personality, terms Woolf uses in her 1927 essay 'The New Biography'.

> And if we think of truth as something of granite-like solidity and of
> personality as something of rainbow-like intangibility and reflect that

the aim of biography is to weld these two into one seamless whole, we shall admit that the problem is a stiff one [. . .][2]

Between October and December 1932 she wrote over 60,000 words; she found she could experiment with 'representational form' in ways she 'could not dare' when she wrote her earlier fiction.[3] But at the same time, she was aware that she had to retain a certain amount of control over her text, '¬ be too sarcastic; & keep the right degree of freedom & reserve'.[4] We can detect in this note to self the fear that she is not quite managing to strike this balance; otherwise she gives no explanation for why, a month later, she gives up on trying to balance fiction with non-fiction. *The Pargiters* was never to be completed; the fictional material was the basis for her novel *The Years*, and the essays went on to become *Three Guineas*. In this sense, the attempt at the novel was not a failure, but a period of incubation.

/

The day Woolf made the decision to cut the essays, she wrote in her journal, 'I'm leaving out the interchapters – compacting them in the text; [. . .] A good idea?'[5] The openness and unresolved quality of this question has occasioned much commentary, as has the ultimate success or failure of the novel she went on to create: *The Years* is perceived by some never to have recuperated from the loss of its genesis material. For the Woolf scholar Mitchell Leaska, its 'fusion' of fact and fiction – or 'granite' and 'rainbow' – soon gives way to 'confusion', an 'aesthetic confession of a thinly-veiled autobiographical order'.* He writes, 'Woolf found herself trapped in both directions. And how was she to free herself?'[6]

Yet to a reader conversant with the autobiographical experiments of the past half-century, the 'fiction' and the 'essays' of *The Pargiters* do not

* Leaska, *The Pargiters*, p. xi. Even the published text of *The Years* reads as unfinished and unpolished to Leaska; we encounter 'splinters of memory, fragments of speech, titles of quoted passages left unnamed or forgotten, lines of poetry or remnants of nursery rhymes left dangling in mid-air, understanding between characters incomplete, and utterances missing the mark and misunderstood. In one sense, the novel eloquently communicates the *failure* of communication' (p. xviii).

read easily as one or the other. Reading the manuscript of *The Pargiters*, it is easy to lose track of what kind of chapter you're dealing with: the essays read much the same as the novel chapters.★ The essays' sociological commentary often slips into outright fiction-making, exposing all texts as fictions, even non-fictional writing with a pretence to transparency. They are the raw material of Woolf's ongoing attempt to break out of the novel form to find a shape that better suited her radical feminist vision.

Leaska suggests that one reason for giving up the novel-essay form may lie in the Speech: that if there were certain things that were taboo for women to say, the very act of her saying them would disprove her point. 'And if she did not describe those repressions with the directness they required, she would be unable to analyze and explain their debilitating effect.'[7] The scholar Sidonie Smith has suggested that whatever 'truth' Woolf wanted to tell, but could not, about her 'experiences as a body', was the 'unspeakable truth of repression'.[8] There were things she could not, herself, say, their omission or unspeakability pointing to 'the troubled relationship between the autobiographical subject and the female body'.[9]

There were things Woolf was trying to say about the body, which she could not; perhaps she was hoping the form itself would speak for her as the genres blended and took on a life of their own.

/

Throughout Woolf's life as a writer, it was physical feeling that drove her to the page – often sudden, unexpected feeling, like a 'shock', which would then be followed by the 'desire to explain it'.

> I feel that I have had a blow; but it is not, as I thought as a child, simply a blow from an enemy hidden behind the cotton wool of daily life; it is or will become a revelation of some order; it is a token of some real thing behind appearances; and I make it real by putting it into words.[10]

★ Pamela L. Caughie suggests that as *The Pargiters* wears on, it is increasingly difficult to tell essay from fiction, but I would argue this blurry indeterminacy is evident from the very beginning of the text. Pamela L. Caughie, *Virginia Woolf and Postmodernism: Literature in Quest and Question of Itself* (Urbana and Chicago: University of Illinois Press, 1991), p. 95.

In her 1926 essay 'On Being Ill', Woolf was already thinking about the problem of writing 'the daily drama of the body'. 'People' – by whom she means men and the women who want to impress them – 'write always about the doings of the mind; the thoughts that come to it; its noble plans; how it has civilised the universe'. Nowhere have they hurled their minds against, say, the 'assault of fever or the oncome of melancholia'.[11] And so 'this monster, the body' goes unwritten.[12]

/

The body, the body. What does Woolf mean by the *daily drama of the body*? Whose body we are dealing with has much to do with how we summon it into language. With how we even come to language, and how it comes to us.

/

1979. Audre Lorde is giving a talk at NYU, at a conference to commemorate the thirtieth anniversary of *The Second Sex*. The text of her speech will eventually be published as one of her most well-known and oft-quoted essays, 'The Master's Tools Will Never Dismantle the Master's House'.[13] In it, Lorde lambasts the organisers for inviting – at the very last minute – only two Black women to speak, and for reiterating Beauvoir's assertion that patriarchy constructs women as Other, without considering who is constructed as Other by feminist theory: 'poor women, Black and Third World women, and lesbians'.[14] How can such an assembly purport to fight patriarchy when they are reinforcing its beliefs, its structures? It is mere 'reformism', when what is needed is total revolution in the shape of 'real connection'. She urges 'interdependency', 'community', the need to 'make common cause' across alterity 'in order to define and seek a world in which we can all flourish', turning 'differences' into 'strengths'.

For the master's tools will never dismantle the master's house. I hear, here, an echo of Woolf's ideas in *Three Guineas* – that we cannot leave the

structures of patriarchy standing; we have to rebuild them from the ground up.

But what, concretely does this mean for women who were never part of Woolf's revolutionary vision, which only made room for people like herself, the 'daughters of educated men'?

The poet Adrienne Rich, who was close to Lorde, addresses this problem in her 1981 essay 'Towards a More Feminist Criticism': 'For white feminists, who make up by far the largest group of academic feminists, this involves deliberately trying to unlearn the norm of universal whiteness, which is the norm of the culture of academia and of the dominant culture beyond; it also and equally means trying to unlearn the norm of universal heterosexuality.'[15] It is the 'next step', she says, and it has to go beyond 'ritualistically' including a token person of colour here, a queer person there. Rich is trying to find a way to decentre whiteness, and straightness ('compulsory heterosexuality'), from the heart of writing itself.

In 1968, aware of this, she wrote:

> this is the oppressor's language
> yet I need it to talk to you[16]

/

bell hooks – whose very name, in the undercase spelling on which she insists, disrupts grammar – riffs on this line in *Teaching to Transgress* (1994). She recognises the power of a line like this, but submits that it is not the language itself that inflicts violence, but rather the way her oppressors use it, 'how they shape it to become a territory that limits and defines, how they make it a weapon that can shame, humiliate, colonize'. Black American writers, hooks tells us, took the English that was forced into their mouths and turned it into a 'site of resistance', remaking it 'so that it would speak beyond the boundaries of conquest and domination'.

> Often, the English used in [singing] reflected the broken, ruptured world of the slave. When the slaves sang 'nobody knows de trouble

I see –' their use of the word 'nobody' adds a richer meaning than if they had used the phrase 'no one', for it was the slave's *body* that was the concrete site of suffering.[17]

In her 1987 essay 'Mama's Baby, Papa's Maybe: An American Grammar Book', Hortense Spillers makes an important distinction between the body and the flesh, specifically by turning to the processes of abduction, enslavement, rape and torture that turned the African's body inside out, 'popped open', and 'ungendered'.[18] There is the violence done to the flesh, and a different kind done to the body, which becomes, in Spiller's argument, 'a metonymic figure for an entire repertoire of human and social arrangements'.[19] All ethics, all individuality goes in the face of the 'procedures adopted for the captive flesh'. The language Spillers herself uses in the essay is as lacerating as the acts it describes; it lashes and names, academic prose as counter-violence, born knowing that 'sticks and bricks might break our bones, but words will most certainly *kill* us'.[20]

/

We are making an arrangement with language to save our lives, those of us who would speak outside of grammar. In Harryette Mullen's poetry collection *Sleeping with the Dictionary* (2002), the narrator devours her reference books, voluptuously shredding conventional poetic meaning, *booboo, Bora Bora, Boutros Boutros, bye-bye,* being 'licked all over by the English tongue', bringing it close to her body, *glug-glug, go-go, goody-goody, googoo.*[21] Running a finger down the page, finding meaning in patterns, in parallels, in nonsensical repetitions. 'Aroused by myriad possibilities, we try out the most perverse positions in the practice of our nightly act, the penetration of the denotative body of the work.'[22] Her 'Outside Art' is *A humble monumental / music made of syllables / or a heartbroken crystal / cathedral with gleaming walls / of Orangina bottles.*[23]

We need to go to the gleaming walls, between and beyond and deeper in, to where we'll find new language.

/

Because there are things you can do to language. To syntax, to punctuation, to form and technique. Ways to have it your way. To take possession of it, to centre your own margin. To break the sequence, break the sentence, make a new tool of the shard. In its first definition, now obsolete, the OED says that a sentence is *a way of thinking*. This way of thinking – which we may as well call 'politics' – drenches our subjects, our verbs, our nouns with obedience; our pronouns are electric with meaning when we overturn with them, surprise with them. We can be disobedient on purpose. 'It was once a source of shame,' writes the Korean-American poet Cathy Park Hong,

> but now I say it proudly: bad English is my heritage. I share a literary lineage with writers who make the unmastering of English their rallying cry – who queer it, twerk it, hack it, Calibanize it, other it by hijacking English and warping it to a fugitive tongue. To other English is to make audible the imperial power sewn into the language, to slit English open so its dark histories slide out. [. . .]24

In 'Professions for Women' Woolf explicitly aligns the Angel with a relationship between the genders that reigned in the nineteenth century for reasons having to do, Woolf says, with 'the British Empire, our colonies, Queen Victoria, Lord Tennyson, the growth of the middle class and so on'.25 Empire, class, the monarchy, capitalism: all are structuring aspects of the relationship between (among) genders, and the way that in turn shapes the way we write. But Woolf's phrasing – writing 'our' colonies – she betrays a worldview that places her clearly, if uncomfortably, on the team of the coloniser rather than the colonised. A reminder for us, for me to be on my guard and not beatify our art monsters into heroines.

Woolf's point is that women have had to kill off, and keep killing off, whatever directives we have internalised that try to contain us. This includes the very language we use. Hong continues:

> Ever since I started writing poetry seriously, I have used English inappropriately. I played with diction like an amateur musician in a professional orchestra, crashing my cymbals at the wrong time or coming in with my flute too early. I used low diction for the high occasions,

high elocution for casual encounters. [. . .] I wanted to chip away at the pillar of poetry. More than chip. I wanted to savage it.[26]

/

One of the writers Hong looks to in her quest to 'other English' is the Korean-American writer/artist Theresa Hak Kyung Cha, whose masterwork *DICTEE* was first published in 1982 as these debates about feminism, language and the body were raging.

I remember encountering that book as a college student in the late 90s, when I would spend my evenings flitting around in the library stacks, following one book to the next, always on the lookout for women's first-person narratives, diaries, letters, autobiographies, or writing that strayed across genre. I knew a dictée to be an exercise from French class, one in which you copy down phrases that the teacher reads aloud and are graded on your comprehension and spelling. Though an uneven student, disinclined to focus on any schoolwork that didn't interest me, I excelled at these kinds of tasks; they made me feel like maybe I had a home in language. I took a certain pedantic pleasure in identifying the phonemes correctly. (I'm not alone in this, either; dictée competitions take place in France every year, like spelling bees for adults, the most famous one run by the well-known literary critic and television presenter Bernard Pivot.) French: a language I wasn't given but one I had to work for: every phoneme I could decipher and put on paper reinforced my sense of self. Something as obedient as dictation was an act of rebellion against the authority of my native language.

But then there is the question of authority within the learned language, the awareness – and this twice over for Cha, in English and in French – that you are being judged on your ability to master it; Cha, who moved to America from South Korea when she was eleven, would have understood this imperative better than I, facing not just xenophobia, but outright racism in her adopted country.

Cha was educated at a French Catholic school, and *DICTEE* channels this pressure to assimilate into a literary culture.

Aller à la ligne.

The instruction to begin. Go to the *line*, put word after word, but not in the old way.

> Aller à la ligne C'était le premier jour point Elle venait de loin point ce soir au dîner virgule les familles demanderaient virgule ouvre les guillemets Ça c'est bien passé le premier jour point d'interrogation ferme les guillemets[27]

Cha translates it in the next paragraph:

> Open paragraph It was the first day period She had come from a far period tonight at dinner comma the families would ask comma open quotation marks How was the first day interrogation mark close quotation marks

In these first paragraphs the writing also flattens out, assumes the same level of importance as punctuation, or is it that the punctuation is raised to the level no longer of (unremarkable, customarily practically invisible) form but of content.

/

But here I am writing 'dictée' when the book is printed without the accent over the first e, like this – *DICTEE* – making it a book as much about a dictation as about the person to whom something is dictated, a word somewhere in between English and French. There is the diseuse and the dictée, the speaker and the spoken, a play on the notion of the male genius taking dictation from god. And the diseuse, the one who imposes her words on the dictee, is the one whose whose language is 'dead from disuse'.[28]

/

Speaking is itself Cha's subject. Not as much what we say, but that we say it, and how. Voice as a bodily production; voice itself as a material that can be collaged, getting louder as it gets thicker. Three different languages vie with each other in the text, English French Korean, in different states of being, typeset, handwritten,

and calligraphed. Form and content bind together, and take apart the book, in a Mallarméan sweep across the page. It places the text in parallel, so you read lefthand page to lefthand page, instead of straight across, which it prepares you for by being in French and English for a while, later switching which language gets which side of the page, verso to recto, then recto to verso, spilling on to the following pages so the languages read less like translations and more like echoes of one another. It sends you back and forth across the spine (here again, the bodily book), a paragraph here on the left, a paragraph there on the right, and so on as it trails off into gaps and blank spaces. 'Contained. Muteness. Speech less ness.'[29] A collage text doing away with the form of the book itself.

The book like the body is teaching us how to read it.

/

Cha introduces spaces where a less attentive speaker would see none, finding words within words, like speech less ness or uni formed. Her peculiar stop start syntax bends words into new functions – *They entrance you*, she writes, and the word now means to make of you an entrance as well as to put you in a trance. In places she fights 'their punctuation', in others she assents to serve it, to become it, 'She would become, herself, demarcations.'[30] She writes in French and English, at the same time, verso and recto, across the spine of the book:

> [. . .] Cracked tongue. Broken tongue.
> Pidgeon. Semblance of speech.
> Swallows. Inhales. Stutter. Starts. Stops before
> starts.
> [. . .] where proper pauses were expected.
> But no more[31]

Cha is tracking the embodied experience of speech, which 'murmurs inside'.[32] The body, the breath. She includes illustrations of the air passages and the lungs, the larynx and the vocal folds. How it feels to speak. How the way we speak shapes what we say, how verbs inflect and shape our meaning.

/

(*Semblance of speech*. How I sometimes feel when I speak French: giving the impression of speaking French.

Now imagine the language wasn't something you chose.)

/

At the core of this embodied rupture from language, behind the invasion of the body by French, by English, is the colonisation of Korea by Japan. 'Unfathomable the words, the terminology: enemy, atrocities, conquest, betrayal, invasion, destruction. [. . .] Not physical enough. Not to the very flesh and bone, to the core, to the mark, to the point where it is necessary to intervene, even if to invent anew, expressions, for *this* experience, for this *outcome*, that does not cease to continue.'[33]

> '*Render voices to meet the weight of stone with
> weight of voices*'[34]

Broken ness and form less ness as expressive of loss rather than avant-garde daring.

/

Because of its relationship to the break, the slash, the cut, the fragment may be the art monster's native form.

I think back to the way that Adrienne Rich had to reckon with the 'dissonance' created between the humanist view of the neutral (male) poet, and the realities of her own life as a woman and a mother, feeling herself to be in *perpetual translation*. Everyone, she says, who lives 'under the naming and image-making power of a dominant culture' runs the risk of 'mental fragmentation', and needs to find their way to a language of their own, an 'art that can resist it'.[35]

Perhaps laying down the world in fragments is the reflex of artists who have seen themselves, so often, torn to pieces by their own clashing

responsibilities, and their lived experience of being Othered. But the fragment is not necessarily the evidence of a world in pieces, the aftermath of some violence; it is the material from which we can rebuild. When we have burned down the old world – let it blaze! – we can build a new one with the fragments that survived. Jenny Offill's *Dept. of Speculation*, where the art monster makes her first official appearance, is itself a work that consists of fragments, its very title slashed and abbreviated. The woman in pieces may see herself in fragments as a way of holding herself together – or reconfiguring the body language she was given.

/

'Some will not know age. Some not age. Time stops. Time will stop for some.'[36] This appears in the text of *DICTEE* typeset and then handwritten. The pronouncement is there twice as if the writing of

Aller à la ligne C'était le premier jour point
Elle venait de loin point ce soir au dîner virgule
les familles demanderaient virgule ouvre les guil-
lemets Ça c'est bien passé le premier jour point
d'interrogation ferme les guillemets au moins
virgule dire le moins possible virgule la réponse
serait virgule ouvre les guillemets Il n'y a q'une
chose point ferme les guillemets ouvre les guille-
mets Il y a quelqu'une point loin point ferme
les guillemets

Open paragraph It was the first day period
She had come from a far period tonight at dinner
comma the families would ask comma open
quotation marks How was the first day interroga-
tion mark close quotation marks at least to say
the least of it possible comma the answer would be
open quotation marks there is but one thing period
There is someone period From a far period
close quotation marks

Theresa Hak Kyung Cha, *DICTEE*, 1982.

it, the making of writing into image, cast the spell which brings this awful fate home to its author.

Cha was raped and murdered a week after her book was published. Not long after, her book went out of print, brought back in 1994 by Third Woman Press, in whose edition I first encountered it, all those years ago in the Barnard library.

'All along, you see her without actually seeing, having seen her. You do not see her yet. For the moment, you see only her traces.'[37]

There is awful power in words, and that is why I am afraid of them.

/

Cha's death poses a problem for those who would write about her work, as Hong details; it is so tragic and ghastly that to describe it feels lurid, disrespectful to her family and possibly to her memory as well.

I believe in the text as a quest for embodiment but the things that man did to her body bring me up short; they can not be described on Cha's behalf, and Cha is not here to de scribe them. Words have destructive not restorative powers.

/

/

/

Cha's epigraph, which we may read as an epitaph, is from Sappho: *May I write words more naked than flesh, stronger than bone, more resilient than sinew, sensitive than nerve.*

Sappho – a priestess in the cult of Aphrodite – did not write in fragments; it is fragments that survive to us, some of them stronger than sinew, stronger than time. We must mark the place where the fragments connect; we have a fibula and a rib-bone; we must conjure up the rest of the body.

body awareness

Some time in the 1960s, the Austrian artist Maria Lassnig grew weary of using her training to depict the world she saw before her. She wanted to paint what it felt like to be a body: to go 'beyond skill, beyond the security of the real'.[1] The problem she faced was how to both observe and picture herself at the same time. What kind of imagery would convey what the body *feels* rather than how it appears; 'small sensations' rather than 'big emotions'?[2] She called them 'body awareness paintings', and would spend the rest of her long life attempting to delineate in visual form the precise physical experiences that comprised this thing of being Maria Lassnig, tuning in to the electrical charge of the body on a given day, how it sings, how it falters.

But where to begin apprehending the body, when it isn't a static entity, but always in a state of flux? Lassnig understood that; she worked from blunt sensation, the feeling of what it is, for example, to have an arm: 'i.e. allowing my emotional shoulder blades to extend, as pliers, into the optical table'. (She can't feel her hair, so most of the time she just leaves it out.)[3] The work she would make – the 'body awareness' paintings – are not a question of depiction, but of feeling and transposition; not 'artwork', but 'register-work'; they are a feeling *for* or *toward* something.[4] Her paintings remake her body on the canvas, in such a way that, looking at them, I become aware of my own bodiliness. There is great 'freedom', she wrote, in this kind of practice; you can 'switch from the ground plan to the elevation of a body; you can paint while sitting, standing, lying in an airless void'.[5]

She would lie down on the canvas, close her eyes, and paint.

/

Painting from the physical feeling outward is painting against the grand art historical tradition: against craft, technique, perspective. As a student Lassnig didn't have access to anything *but* that tradition: the Nazis were in power, and all the modern art books had been removed from the library at her art school in Vienna. The students saw no modern art; they were encouraged to paint in 'shades of brown, as few pure colours as possible'.[6] Landscapes, Rembrandt-like portraits. Lassnig found her way to modernism all on her own. In 1968, when she arrived in New York, nearly fifty years old, they didn't understand her body awareness paintings – some of which she called her 'dumplings'. It was slightly too early for that kind of work; its 'distortion' was judged 'pathological'. 'They wouldn't even show my work, said it was trash. And my upstairs neighbour in the loft said to me: you just can't paint.'[7]

One wonders what experience of physicality a 1964 work called *Self-Portrait as Monster* transcribes. It's an anthropomorphic blob, rendered in a beautiful shade of fuchsia, with red undertones set off by a cerulean background; it is recognisably human in its face, but somewhat ET-like in terms of the shape of its head, its neck, its pushed-up nose. What my eye returns to is the way the neck seems almost undifferentiated from the immediate background, which is painted the same red-fuchsia; it looks like a cape, or like the thick neck of a very young foetus. Or as if the colour of the figure were bleeding, somehow, out into the world around her. I feel empathy for the figure on the canvas, with her sleepy eyes, parted lips, droopy jowls, and oversized, pale-pink philtrum. She is a human being in another key. In her journal Lassnig wrote about an image she calls the 'Red Monster', which must be this painting: 'The spatial feeling of the parts of the face shifts the proportions, what comes out is a monster, the monster within us. Angels also have monsters in them – all of us are monsters.'[8]

In New York, with paintings like this in her portfolio, she had the space to let her work develop as it would, because nobody was interested in it. Perhaps that is why the self-portraits she made during this period are among her most powerful, a blend of figurative and suggestive, as in 1971's *Self-Portrait with Stick*, in which the artist sits in a chair, topless, a wooden stick disappearing into one side of her

chest and emerging out the other. A drawing of her mother, who has recently died, appears on the canvas behind her. Her mother's face is a sketch but her hands, a ghostly pale dead colour, sit on the artist's shoulders. Lassnig herself wears a complicated expression on her face, one of surprise and longing, fear and apprehension. The hair on the right side of her head turns a textured green like a lettuce leaf. Is the memory of her mother keeping her from painting, frozen with apprehension in her chair, her heart pierced by – what could be an elongated paintbrush? Her mother, her own angel in the house, is, here, the monster, haunting her daughter and interrupting her work.

There's something odd about the chair she sits on, as well; it reads to me as both alive and ghostly, belonging both to the foreground and Lassnig, and to the background and Lassnig's mother; it is both a prop in the 'real' world of the painting and also a drawing on the canvas. It appears most solid in the little corner between Lassnig's legs, but elsewhere disappears to make room for the stick, as if it too were being pierced like her flesh, as if the ghostly presence of the mother were dissolving the firm reality of the wood, and would eventually see her daughter turn into a phantom as well. Lassnig's work is full of chairs becoming human, or humans becoming chairs, and she referred to another chair painting, 1964's *High-Seated Female Figure*, as one of her 'monsters'. The latter – painted in viscous shades of green, highlighted by slate blue and white – is remarkably human-like in the most unexpected ways – in the nubs of the spine in the lower back; in the way the parts of the leg encounter one another in a kneeling pose, thigh to calf. The chair hunches over, like a figure in a chair.

Chair is, as she would certainly have known, French for flesh, the body reduced to its elemental state.

/

Lassnig's body awareness paintings often address the desperation and difficulty that comes with being a body. *Self-Portrait Under Plastic*, painted the following year, shows the painter with a sheet of plastic wrap stretched over her face, clinging to her nostrils as she inhales; yet

she looks mournful rather than apprehensive. In other self-portraits from this time she replaces her face with a gas mask. Critics read these images as critiques of plastic consumption in America, or of the war in Vietnam, and this feels right. Body awareness, for Lassnig, is a direct conduit to social, historical awareness. Why this body, and not some other body. This place, and not some other place. Her 'radical acts of self-portraiture' situate her 'not only as an artist in a studio, but also as a citizen of an increasingly technological and conflict-filled world', write Kasia Redzisz and Lauren Barnes, who curated the show at Tate Liverpool where I first encountered Lassnig's work, in 2016.[9] That was where I remember being captivated by her *Small Science Fiction Self-Portrait* (1995), in which her head has melded with what looks like a virtual reality headset, as if she had anticipated the way, twenty years later, these technological devices would have become no longer even simply prosthetics, but inseparable from our very bodies. And in *Pink Electricity/Electric Self-Portrait II* (1993) the artist has evaporated in a field of pink particles, charged by an electric blue current. I can imagine this self-portrait as a body awareness painting looking back to a time in the 70s when she was electrified by a different current, shocking blue in a field of pink, her body one giant light source.

/

It was the American artist Nancy Spero who met Lassnig in Paris and advised her to go to New York, where there was a burgeoning scene of like-minded feminist artists. There Lassnig became an activist, painting banners, attending marches, and eventually, in 1974, co-founding a group called Women/Artist/Filmmakers, Inc. with, among others, Carolee Schneemann. 'We were each painters dedicated to various materials, images,' Schneemann wrote. 'Our paintings had been consistently marginalized in the New York City world of heroic male traditions. Would presenting ourselves as both artists and filmmakers lead to a double marginalization?'[10] They met in each other's studios, raised funds together, and equally distributed them among themselves.

While in New York, Lassnig's practice took an unexpected turn: she started studying animation at the School of Visual Arts. As her friend

and fellow W/A/F member, the artist and filmmaker Martha Edelheit, recalls: '[S]he bought a 16mm hand-cranked Bolex from a pawnshop, found discarded bricks in an empty building lot, a broken slab of milk white glass on the street, cheap photoflood lamps, and made her wonderful animated and live performance films with this improvised equipment.'[11] Film was a way of getting at embodiment from another direction, and animation appealed to her sense for the hybrid: 'Almost every animation student begins with an egg that bursts open from which a monster emerges and then turns into a machine.' Shapeshifting was an intrinsic part of drawing for animated film, 'if only because a chair that one copies twenty times, no matter how precisely, becomes a few millimeters thicker or thinner'. But what was she going to commit to drawing over and over? 'I would have liked to illustrate ideas about the women's liberation movement,' she wrote, 'about my life in New York, or to have my friends appear as comic figures.' But she couldn't think of anything that would hold up 'under the tedious, boring process of creating animation'.[12]

So she decided to work with the same images she had been painting for years – anthropomorphic chairs, dumpling creatures merging with technologies like cameras or televisions or robots – to attempt to translate her concept of body awareness to film. In New York she had a television for the first time (not to mention a refrigerator) and would, some days, spend up to eight hours watching it. She worried about its impact on her painting, but couldn't tear herself from the screen. She was learning a new medium, one that demarcated the limitations of her original one. The paintings could only depict slicing and splicing; film animation was literally made of it.

/

The attractions of film caught Lassnig by surprise. She distrusted cameras, and hated being compared, for instance, to Francis Bacon, who often relied on photographs to make his work, especially the glass boxes in which he sometimes placed his subjects. His attention to the glass surfaces was meticulous; he painted, she said, '[l]ike a good boy. So diligent'. She conceded that he was a good painter, a genius even.

'But he was not a kindred spirit, because of his painting from photographs; I only painted from my imagination.'[13]

In her live-action film work, she used the camera to paint, so to speak, from her imagination, leaving its 'realist' conventions behind as she explored what else it was capable of doing. In her film *Baroque Statues* (1970–74) a woman dances in the Austrian countryside near a twelfth-century cathedral to a soundtrack of neo-Baroque organ music. A direct reference to the surrealist filmmaker Maya Deren's *A Study in Choreography for Camera* (1945), *Baroque Statues* plays with what film can do to a body in movement – doubles her so it looks like she's dancing with her ghostly self, or solarises her, reversing the negative, film pushed to the point of abstraction. This whirling figure is a dramatic contrast to the homely painted wooden sculptures of saints and their beasts in the cathedral that open the film. Even in the way Lassnig's camera observes these inanimate objects, it asks us to consider their bodiliness: the thick overlong toenails of one statue, the nostrils of a bull, the way one statue's fingers curl and clutch at a book in his hand. Another's noticeably stubby fingers – not something we commonly associate with religious statues, but something only an artist keenly observant of the body and its idiosyncrasies would notice.

You can see the influence of the filmmaker Stan Brakhage, a celebrated contemporary experimental filmmaker, on Lassnig's work as on Schneemann's – scratching, collage, multiple exposures, painting on celluloid, film impasto. But like Schneemann, she would ask how this medium could be a means of expression for the female body. *Iris* (1971), arguably her cinematic masterpiece, is an attempt to find out. This short film reads to me as a sustained engagement with the twin inheritances of surrealist art – the tendency on the part of the original male practitioners to see women's bodies as fragmented body parts, and the response of female surrealists like Lee Miller or Dora Maar to participate in this kind of fragmenting to make that body strange. In *Iris*, Lassnig films a friend of hers on a bed; the film opens on one bare breast, around which the bedding rearranges itself in stop-frame animation. An arm emerges at an unexpected angle to the breast; you think, for a moment, are there two women in this bed? (There are: the model and the invisible camera-person.) In the next shot we

see another body part and we can't even tell what it is – a knee? a bum? – and then on to an image of a breast seeming to stand, pressed up against a pane of glass, while its owner reclines. This shot is what decisively binds Lassnig to artists like Ana Mendieta, Hannah Wilke, Genieve Figgis, Jenny Saville and Helen Chadwick: the body reproduced on a photocopy machine, or up against its limits, visible but not attainable, untouchable for the artist and the viewer. Smoothness is not a lack of texture, only another kind, one that the body interacts with to create new bodily sensations, and new impressions.

The way that *Iris* defamiliarises the female body puts me in mind of Lee Miller's photograph *Nude Bent Forward*, but dynamic, filmic, and against the current of the classical nude aesthetic. Lassnig pursues her course over the terrain of the female body made strange. Here is a joint of flesh, but what is it – an arm against a torso? and as it begins to move it resolves into something recognisable – ah, it is a thigh rising from a calf – and as we make sense of what the body is, we begin to locate Lassnig as filmmaker: the camera is upside down.

There is a torso shot that is definitely an homage to Miller, an upside-down breast torso. Stay with this shot, as Lassnig does. It is so beautiful. The creamy skin, shadowed where the ribs meet, the muted olive background, the contrast of the warm pillow beneath her, the colour of toast. The camera rising up subtly from below so the chin comes in, looking like a strange peak between the breasts rather than the banal nadir of the face; then the image is flipped upside down, the dislocation reminding me of Francesca Woodman's *On Being an Angel*, which she will make in a few years (did she see *Iris*?) or – again – Lee Miller's photography, this time *Revenge on Culture* (1940), the image of a statue of a woman lying in the London rubble during the Blitz, a brick on her breast and an iron bar going across her neck, symbolically decapitating her. (There is also, I am persuaded, a Lee Miller reference in her film *Art Education*, which depicts a Renaissance painter at his easel, his mistress posing for him. She can't sit still or stop talking. He paints her lips in the sky, like Man Ray.)

It's a film that asks us to think twice about the usual ways of representing the art historical female nude. *Iris* – the model and the film – invites the viewer to do what we always do, run our eyes all over the

naked body of a white woman. The looking gets maniacal; the body doubles and flips, cut cut cut mouth pubes eyes, zoom in on the dark, dark bum crack. Scenes of voluptuous repose are interspersed with jittery shots of feet dangling upward; a small black dog enters the scene.

The scene before us gets melty and weird. A softly distorting mirror turns everything very luxurious, Fragonard but as if the paint were melting. I'm sure Genieve Figgis saw this video, that it is one of the influences behind her drippy rococo. A long braid of brown hair between a pair of breasts. Flesh distorted in the mirror, now a funhouse, now a brothel. The Female Nude in Art History has been gone over with a turpentine sponge, and smeared into what she always was to begin with: a breathing body.

But above all what strikes me is exactly this: this body breathes, unlike the ones on the canvases, even Lassnig's, which try to inhabit bodiliness and transmit its squelch and tension to the viewer, but which, ultimately, are at a remove. The surprise entrance of a little black puppy brings another texture into the film, and we feel, as it snuffles on her stomach, the way it feels to have a small animal snuffle at our stomach. A foreshortened image of Iris from the fluff upwards makes her, too, into a furry creature. Lassnig carefully allows herself, filming, to be present in the warped metallic background, as in Jan van Eyck's canonical *Arnolfini Portrait* (1434), in which the painter has included a self-portrait of himself at work, his reflection distorted in the convex mirror behind the husband and hugely pregnant wife who are its ostensible subject. Looking back at van Eyck's painting in the context of Lassnig's film, Madame Arnolfini's swelling belly seems even rounder, and the round mirror echoes its form. In Lassnig's film, this is the moment of transition, where it goes from doing one thing to something entirely different. The piquant estrangement or distancing or alienation from the body through its disarticulation – or its surprising re-articulation – is replaced with the melting body, which shores up the solid one.

The image in the mirror has all the stillness of the baroque statues, yet it's always in movement: the complex psychedelic swirls of flesh you get like something a painter would have to do some serious drugs to envision, the body multiplied. On the soundtrack the style

of contemporary music where you feel the composer and the musician are working against the instrument, against the way it's been played for hundreds of years, enshrined in a classical tradition that leaves no room for failure, for thinness of sound, for the body, you hear the strings of the bow hitting the strings of the instrument, there is no key or melody, just rumble and noise, the exploration of aural space. Rembrandt-dark (Lassnig has not left her Viennese training behind), the body folded into self-embrace, what can the body see?

fuses

My film is always dirty because of the way I edited with the
cats moving around and the windows wide open.
—Carolee Schneemann

In her first major work, *Eye Body: 36 Transformative Actions for Camera*
(1963), Carolee Schneemann asks if a woman can be both art and artist:
'It was my wish to transform and vitalize an actual artist's female body
as part of her materials.'[1] In this series of photographs, taken nearly
a decade before this kind of work would be more common, Schnee-
mann is a wild woman, an art witch, naked and smeared with grease
and paint and chalk, her hair bedecked with rope – a cross between
an Amazon and a survivor of a shipwreck. Completely capable of
slashing a major painting in a museum. *Eye Body*, she later wrote, was
'a shamanistic ritual of the sacred erotic at a time when the female
nude dwelled mainly in girlie magazines, pornographic detective fic-
tions, photographic reports on "primitive natives", classical Western
painting, Abstract Expressionist dis-memberments, and the iconic,
frontal-spread paper dolls of Pop art. Could there be any other erotic
iconography?' she asked.*

Yet, she wrote, she was not only interested in presenting herself
as both image and image maker, but in 'the image values of flesh as
material'.[2] In one image she lies down with snakes slithering across her
naked torso, a line painted evenly down the middle of her face. She
looks unspeakably gorgeous and strange. Here she poses with the car-
cass of an umbrella. There, her face is refracted into a fanned-out splay
of mirror shards. In fragmenting her body, juxtaposing it with these

* Carolee Schneemann, 'The Obscene Body/Politic', p. 28. A gallery invited her to
exhibit *Eye Body*, then disinvited her.

surprising props – the umbrella in particular – Schneemann appears to be taunting the surrealists who were always showing women in fragments, for whom the definition of the marvellous was 'the chance meeting on a dissecting table of an umbrella and a sewing machine'.[3] But here, in refutation of Man Ray's photographs of Lee Miller or Meret Oppenheim, both great artists in their own right, the artist and the model are one and the same.

/

She didn't take these pictures herself – the photographer was the Icelandic artist Erró – but she designed and posed for them. This was the challenge: could a naked woman turn the camera on herself and retain the title 'artist' without slipping down a rung to 'narcissist'? Since the answer was inevitably *no*, this became the project itself: the I body becomes the 'eye body'; the I who is barely permitted to speak claims the power of vision. 'The body is in the eye,' Schneemann wrote in her journal in the early 60s; 'sensations received visually take hold in the total organism. Perception moves the total personality to excitation. Insight is a result of sensation's creative action on our capacity to experience and discover functional connections. (We are a part of nature and of all visible and invisible forms).'[4] The naked female body returns the gaze.

/

I hear in the title a possible reference to Georges Bataille's scabrous 1928 novella *Story of the Eye*, in which the anti-heroine, Simone, pleasures herself by inserting, variously, hard-boiled eggs, a bull's testicles, and a priest's eyeball into her vagina. These items are a making-visible of that which otherwise, in more well-behaved texts, remains hidden. The eyeball reroutes the priest's theological-patriarchal vision, and confers sight on the vagina. The mind/body split collapses; the female body can finally look, and perceive, having appropriated to itself the literal tool of the patriarchy: its means of viewing, surveilling, judging. The eye is made to penetrate that most forbidding of dark spaces:

the female body.[5] In *Interior Scroll*, as we've seen, Schneemann would allow those dark spaces to speak for themselves.

/

Though *Interior Scroll* is a performance piece, and often reproduced in photographs, the monologue written on the scroll is in part about what we can, or can't, look at on film.

> you are charming
> but don't ask us
> to look at your films
> we cannot
> there are certain films
> we cannot look at[6]

The unwatchable film Schneemann refers to here is no doubt *Fuses* (1964–7), a beautifully graphic, densely impressionistic film which consists of Schneemann and her then partner, the composer James Tenney, having sex under the watchful gaze of their cat. It is perhaps unseeable because it is also never quite explicit; it is shadowed, it has rhythm, it cuts away, it wavers, it speeds up and slows down – and Schneemann used to show it in two different speeds. As much as it calls attention to the fact of its medium – sprockets, splice-marks, and flares are occasionally visible – it is, in a sense, abstract. You don't know what you're looking at, only very occasionally will you catch a glimpse of something, maybe, it's hard to be sure. The images on the screen flip and flicker and jerk in Super8 scratchiness; the effect is of trying to watch porn late at night on an antenna television that doesn't quite receive *that* channel. Through all the switching and cutting, Schneemann's bottom glistens in the oversaturated colourscape; the head of Tenney's penis, slick, red, emergent, becomes a membrane, glistening with her period blood; bodies pulse on the screen like my baby's heart on the screen of the ultrasound monitor, love become movement.

/

Schneemann knew it would take several viewings before an audience could approach *Fuses* as a work of art. Initially, Schneemann thought that people would be so distracted by the 'genital heterosexuality' they were invited to watch that they would have to watch it several times '– if they ever came back to see it again –' before they would be able to appreciate its 'structure', the 'musicality of it', its formalist shape, its 'coherent muscular life'.[7]

I must reluctantly include myself in this category; all I could think when I first saw the film at Schneemann's MoMA PS1 retrospective in 2017 was *I am watching Carolee Schneemann have sex with James Tenney*. I could see it as maybe a subversive pro-sex feminist comment on porn, I could appreciate the project of the work of art appropriating to itself a measure (a whomping measure) of tactility, but I couldn't perceive it as a work with certain formal characteristics or musical shapes. But if we take the film as a literal representation, like pornography, as two people having sex, we are missing all the specificity of it as an art object. 'The camera brings back very strange hallucinatory imagery and it's *not real* – its representations are imprinted on this material and then projected.'[8]

In the blue light, shot from below, James Tenney's face looks like a Guy Fawkes mask. It's Christmas, and the tree, and then Carolee's naked body, are wrapped in Christmas lights, then echoed in the next shot by the lights of the city, the lights going over a suspension bridge at night. Cows stand in a pink field while colour washes over them.

And the recurring rectangle of white light that is the window, trolling her friend Stan Brakhage, who filmed the birth of his daughter Myrrena in *Window Water Moving Baby* (1959), with her own perspective. Schneemann admired his bravery, but, she said, 'I was still very concerned that the male eye replicated or possessed the vagina's primacy of giving birth. [. . .] The camera gave birth as he held the camera; this was metaphoric for the whole gendered aesthetic struggle in our friendship.'[9] A shot of Tenney's face as he moves over Carolee dissolves into a field; usually invisible, memory takes the shape of overlap, of superimposition. At rest, the light pools on a hipbone; an overexposed shot turns Schneemann into

white light, with dark hair and a dark line below. As much as it is about love and encounter, it is a film about light, and painting with light on film.

/

Fuses certainly gives us the unviewable in the form of the male genitals, covered with fig leaves for most of art history, and shots of Carolee's impressively full bush, very *Origine du monde*, if the model had borrowed someone's Bolex and handed it to Courbet saying *here: film me. This is my work now.* Tenney's fingers explore her labia; in return her camera zooms in on the pores and the bumps on his scrotum, its central stitch, its heavy support of the cock, like a heart bearing up the aorta. (To identify this feels like an admission of the things that I can recognise, criticism as a necessary violation of my own privacy.)

Even the material of the film itself is thickly collaged with different inks and feathers glued on to it; Schneemann baked certain images on to it, and even hung footage outside to 'interact with the elements'.[10] When it was printed, the film lab had to put it through the machine by hand, sprocket by sprocket. With this painterly layering, this insistence on the materiality of film, Schneemann later said that she wanted to 'allow [it] to give me the sense that I was getting closer to tactility, to sensations in the body that are streaming and unconscious and fluid – the orgasmic dissolve unseen, vivid even if unseeable'.[11] How else to explain the inclusion of Kitch the cat, whose primary ways of understanding the world include rubbing up against it? It isn't difficult to notice, on repeated viewing, that what seems like a chaotic barrage of images is actually coherent, deliberate, a 'delicately constructed architecture of visual relationships, involving color, texture, direction, and kind of movement'.[12] What makes the film difficult to see as art is what gives it its rhythm; it shares the kinetics of *Meat Joy*, or Schneemann's other work with the Judson Dance Theater. It is a challenge to accept this work on its own terms.

/

When *Fuses* was presented at Cannes in 1968, about forty men in the audience shredded the seats with razors and tossed around the padding.[13]

(But why did they all have razors with them?*)

/

The film was political, but in a sexual instead of a social sense, and perhaps this explains why they were so outraged: it was unlike anything else being shown at the festival. At the University of Massachusetts in 1973, the screening degenerated into a brawl when a man in the audience complained it didn't give him a hard-on. Audiences were having trouble reading it: if it wasn't supposed to stimulate them, what was it supposed to do? By the late 70s, the film was being dismissed as 'sentimental shit', Schneemann told MacDonald, who is surprised by all the negative responses. On a purely aesthetic level, he says, *Fuses* is 'so beautiful to look at'. 'Well,' she answers, 'it used to be considered too ugly to look at: jumbled, broken, chaotic. In California it seems to have become too beautiful. Perhaps the California people were into leather and straps.'[14]

/

Another important critique of the film came in the early 70s from the lesbian community, who protested that having fought to overcome compulsory heterosexuality, they didn't want to have to see straight sex on screen.

Schneemann to MacDonald:

Well, of course, I felt that, first, they didn't have to look at it, and, second, they were perfectly justified to object to it, because if they

* The festival was interrupted a week early that year, in solidarity with the student and worker protests in Paris.

needed a role model, the heterosexual one in *Fuses* was going to be antagonistic. But then a woman yelled to them, 'All my life I've been pushed around by fascistic men telling me what to look at and what it means, and I'm not going to be pushed around by fascistic women telling me what to look at and what it means.'[15]

Schneemann is very clearly not an emissary of the hetero-patriarchy; the film does not perform heterosexuality as necessary to anyone except, perhaps, these two people in this particular moment. By making heterosexuality visible in this particular way, with these particular aesthetic choices, she does invite the critiques she received from these various sources: too straight, too choppy, too sentimentally beautiful. And yet the eccentricities of the film – the cat, the cock, the cunt, the cows – and the way it deals with the specificity of its medium redeems it, I think, from the domain of the easily dismissed, whether as dogma or drippiness.

/

Rewatching *Fuses* now, Sontag's 'Against Interpretation' comes to mind, her defence of art as more than the sum of form + content but the indivisible blend of the two, and that an understanding of this wholeness can give us an erotics, and not a hermeneutics, of art. (She must have seen *Fuses*, I think, to have written that.)* Art isn't there for us to forever reduce it down to what it's 'about'. Sontag yearns for criticism which 'reveal[s] the sensuous surface of art without mucking about in it'.[16] In that first viewing of *Fuses* I was so uncomfortable that I hurriedly tried to 'read' it, cordoning it off as a work of art encountered in the public space of the gallery, as a way of keeping a distance from it.

It is no mean feat to appreciate a work's formal qualities when its content is so blazingly loud, so intense, pulling you into its protracted embrace; as the two bodies tangle with each other, so are we

* At any rate, the timing is right – Schneemann was working on it and showing it as early as 1965; 'Against Interpretation' was 1966. Sontag glancingly mentions Schneemann in her essay on happenings, as well as the Judson Memorial Church where she first staged *Meat Joy*.

entangled with its aesthetic pull. We are so far from the realm of the Kantian, Brechtian, minimalist aesthetic of critical distance and reflection. There is no standing back from *Fuses*. Likewise, we are far from the Bataillean/Sadeian vision of sexuality as violence, as irony, as comedy. I think here of Hannah Wilke's dedication to making 'formal imagery that is specifically female, a new language that fuses mind and body into erotic objects that are nameable and at the same time quite abstract', which is even appropriate at the level of its vocabulary.[17] Schneemann has given body and aesthetics to Sontag's erotics of art: a disavowal of splitting; a holistic embrace of messiness and interconnectivity that fuses lover to lover, lovers to the world.

/

'Vision is not a fact but an aggregate of sensations,' Schneemann wrote in 1966.[18] During the editing of *Fuses*, she began to suffer from hallucinations of the Vietnam War, seeing bodies hanging from trees. It was the very beginning of the war, and she had started collecting newspaper clippings and photographs, apparently via access to the Liberation News Service, and via European news sources, before they were even appearing in the US media. Building this collection was the only response she could make once she had learned, from a Vietnamese colleague, what was happening in his home country.

Schneemann sought an artistic form that would, she said, 'physicalize and concretize energies concerning [her] sorrow and outrage at the war'.[19] She again turned to film, harnessing the movement of the camera to amplify the nausea and disorientation she was experiencing. For lack of a zoom lens she taped a magnifying glass to a borrowed Bolex camera, sat down on her floor, and began to film the images, physically moving to create the feeling that the viewer is 'traveling' within the photographs, or that they are coming to life. The film she made, *Viet-Flakes* (1965), is an off-kilter, slightly dizzying experience. The camera zooms in and out, the photos come in and out of focus, 'a visual trace of the embodied act of looking itself'.[20] In her conversation with Kate Haug, Schneemann described herself and her contemporaries in the 1960s as being overwhelmed by the power of the

image and the impulse to *do* something with the 'startling and taboo and terrible' information they brought: it 'made you convinced you had to do something. To enter the image itself!'[21]

Watching *Viet-Flakes*, I feel self-conscious in my position as viewer, both visually caught up in the movement of the film, and separate from it. The device is both immersive and alienating, underscoring the range of possible emotional responses: responsible and implicated, or distant and uninvolved. The soundtrack, composed by James Tenney, consists of glimpses of popular music, classical music, and Vietnamese folk songs, as if you were slowly turning a radio dial, an aural echo of the privilege of the American public's ability to, when they are tired of the tragedy overseas, change the channel. Improbably mixed into the Hammond organs and Bach organs are the irrevocable forward-driving sounds of trains and noises from Schneemann and Tenney's orgasms.

In her diary two years earlier, Schneemann had railed against an art that wanted to be 'useless', which she called '[t]he Fro-Zen, the expanse of slight sensation, the twist to existing conventions: not to be shocked, disturbed, startled, not to exercise the senses thoroughly . . . to be left as you were found, undisturbed, confirmed in all expectations'.[22] Schneemann found the Cagean Zen Buddhist aesthetics that were popular at the time intriguing, but limited. Her own art was sense-full, tactile, engaged; she strapped herself and her collaborators into harnesses and trapezes to make it; she fucked on film; she writhed on stage; she painted like her life and all of art depended on it.

And yet she knew her work happened in a global context in which she enjoyed the privilege of being the visionary while others paid the price for her peace. 'There is always a double pull in my work,' she said,

> between the ecstatic, sensuous, and the violent destructive militarisms which surround my privilege as an artist at this time. And so the range of erotic depiction in my self-shot film *Fuses* and its premise of domestic dailyness and bliss would be transformed by the overwhelming weight and destruction of the Vietnam war.[23]

/

Schneemann's collection of atrocity images and the impulse to make art with them reminds me of Woolf's scrapbooking response to fascism in the 1930s. The clipping of the article, or the photograph, is a way to capture the reality of the atrocity, to mull it over, to refuse to turn the page and let it go. But it is also, perhaps, the beginning of a means of integrating it into one's own life. The movement of Schneemann's camera dramatises this turning towards and then away and then towards; at times, watching *Viet-Flakes*, you get the distinct impression of seeing and not seeing at the same time. 'I wanted to get as close as I could,' she told Duncan White, 'so that you're in the pixel, and so that the illusion that creates the recognisable image gets broken into, and also to degrade the image.'[24]

I wonder if somewhere in Schneemann's unconscious she was inspired to make the piece by Woolf's angry anti-war polemic. Elsewhere she cites Woolf as an important influence on her work, especially *The Waves*, but I think she must also have been influenced by Woolf's writing on the role of the image in both forming alliances and pointing to places where those alliances fray. The question that Woolf poses – what is depicted, and what is left out – is one that Schneemann would develop in a 1967 performance piece, *Snows*, which integrated *Viet-Flakes* at its conclusion. In *Snows*, writes the scholar Erica Levin, 'attention to "the image values of flesh" necessarily took on new, politically fraught, significance'.[25] In the handful of years that saw the making of both *Fuses* and *Viet-Flakes*, Schneemann found a way to show bodies bound up in one another: in love, and in agony.

her body is a problem

The mid-1970s saw the beginning of a reckoning with the way feminist artists approached representing the female body. Some artists and critics wondered whether the ways feminist artists were depicting their own bodies or those of other women were not inevitably playing into male fantasies about the sexualised female body, and their ownership of it, however temporary or theoretical, through the gaze. This, at least in part, explains the to-do over the artist Lynda Benglis's ad: it was perceived by some to be bad for feminism. While Lucy Lippard called it a 'successful display of the various ways in which woman is used and therefore can use herself as a political sex object in the art world', the *Artforum* editors complained that it made 'a shabby mockery of the aims' of 'the movement for women's liberation'; in the *Feminist Art Journal* the feminist art critic Cindy Nemser called it 'another means of manipulating men through the exploitation of female sexuality'.[1] The 'uproar' caused by the image was conclusive proof 'that there are still things women may not do', Lippard concluded.[2]

I understand the feminists' discomfort. Theirs was a tenuous movement at the time, and it needed supporters; it needed its practitioners not to do things to fuel the anti-feminists' fire. But you didn't have to oil yourself up and pose with a dildo to be accused of exploiting female sexuality in 1974. Earlier that year, the artist Hannah Wilke began to use her naked body in her work. In *S. O. S. Starification Object Series* (1974–5) she strikes a number of poses, in the fashion plate style, while naked from the waist up. They're so over the top it feels like falling for a prank to describe them, but let me try: rollers in her hair, straddling a chair, pouting. Rollers in her hair, shirt gaping open, fingers lightly touching her lips. Topless, an arm of her sunglasses resting on her lower teeth, fuck-me eyes. Topless, in sunglasses and a cowboy hat, holding a pair of toy guns in her hands, *bang bang*!

The images, it has to be said, are pretty cringeworthy, but, I think,

Wilke anticipated, and hoped for, exactly this response. They remind me of that 'women laughing alone with salad' meme. They beam into their lettuce, smile at their strawberries, throw their heads back and laugh at a floret of broccoli speared on a fork. They are hegemonic poses of exaggerated unreal joy; they are for the viewer, to tell her how to eat in order to be healthy and thin. Wilke's photographs knowingly, mockingly adopt this *be like me, girls* attitude. In a way, they are as hard to look at as the cancer photos she would take at the end of her life, depicting her beautiful body as it bloated and suffered.

To me, a feminist who came of age in the ironic 1990s, it's clear the *S.O.S.* images are not meant to be read straight. But when the photos were shown at that delicate mid-decade moment when feminists had to get their message *just* right, Wilke was accused of narcissism, vulgarity, gratuitous nudity – of courting the straight male gaze, and thwarting the female one.

/

In her 1976 essay 'The Pains and Pleasures of Rebirth: Women's Body Art', Lippard worries that for female artists to show themselves naked was not always as radical a gesture as they may have intended: '[T]here are ways and ways of using one's own body, and women have not always avoided self-exploitation.' She confesses to not having much 'sympathy' for 'women who have themselves photographed in black stockings, garter belts, boots, with bare breasts, bananas, and coy, come-hither glances'; she allows that it may sometimes be in the service of parody, but that 'the artist rarely seems to get the last laugh'.[3] She is watching the men to see how they respond, and the men are laughing. This provokes a feeling of feminist protectiveness, but also one of irritation that these female body artists open themselves up for misogynist attack.

Lippard critiques the social context whereby it is presumed that 'any woman who presents her nude body in public is doing so because she thinks she is beautiful. She is a narcissist [whereas Vito] Acconci, with his less romantic image and pimply back, is an artist.' And while she says she admires more those women with 'less than beautiful

bodies who defy convention' by making body art, she admits that 'those women who *do* happen to be physically well-endowed probably come in for more punishment in the long run'. The understanding she extended to Benglis seems, here, to extend to Wilke, though she hasn't mentioned her by name. When she does, her bite is unexpectedly sharp. She calls Wilke 'a glamour girl in her own right who sees her art as "seduction"', who 'flaunts her body in parody of the role she actually plays in real life':

> her own confusion of her roles as beautiful woman and artist, as flirt and feminist, has resulted at times in politically ambiguous manifestations that have exposed her to criticism on a personal as well as on an artistic level.[4]

A year after Lippard's essay came out, Wilke made a poster of herself wearing a man's tie and little else; printed on to the image are the words MARXISM AND ART – BEWARE OF FASCIST FEMINISM.

/

Beware of fascist feminism. I'm habitually intrigued by internecine strife among feminists: the way certain conflicts can make the broad church of feminism feel like a single pew in which we're all jostling for a seat. Feminism is less a cohesive movement than a series of concerns that sometimes overlap, yet just as frequently fail to catch us all, and fragment just as we need them to hold us together.

/

Later in life Lippard would recant completely, explaining that when she wrote that essay she was in her 'combat boot period' and that Wilke 'constantly preening' rubbed her the wrong way.[5] But in the 1976 essay, Lippard's use of the passive voice and her references to public opinion make it seem like she herself isn't sure how much of her response to Wilke's work comes from an art critical place, and how much is just feeling personally stung. It is instructive to remember

that once upon a time, even feminists didn't know what to make of feminist body art.

Writing in *Screen* magazine in 1980, the film critics Judith Barry and Sandy Flitterman-Lewis called it out for practising the 'glorifica-tion' of an 'essential female power [. . .] residing somewhere in the body of women'.[6] Leaning on Laura Mulvey's influential 1975 essay 'Visual Pleasure and Narrative Cinema', about narcissism, film, and the male gaze, they wrote: 'While we recognise the value of certain forms of radical political art . . . this kind of work, if untheorised, can only have limited results.' Their article would decisively mark off the 1980s from the 1970s as far as feminist art was concerned; to one side, there were the feminist body artists, 'untheoretical', 'essentialist'. On the other, artists whose approach was more psy-choanalytic and post-structuralist, like Martha Rosler (*Semiotics of the Kitchen*, 1975) or Mary Kelly (*Post-Partum Document*, 1973–9). Barry and Flitterman-Lewis judged Wilke harshly: 'It seems her work ends up by reinforcing what it intends to subvert.'[7] They insisted that personal experience 'must be taken beyond consciously felt and articulated needs of women if a real transformation of the *structures of* women's oppression is to occur.'

According to their form of iconoclasm, the female body – nude *or* clothed – could not be represented without upholding the male gaze and all the violence and erasure of agency that could imply. By 1981, when Andrea Dworkin published her watershed manifesto *Pornography: Men Possessing Women*, the idea that 'pornography is vio-lence' had become 'doctrine' (though not uncontroversially among sex-positive feminists).[8] '[W]hen the image of a woman is used in a work of art, that is, when her body is given as a signifier, it becomes extremely problematic,' Mary Kelly told the American artist Paul Smith in 1982.[9] 'Most women artists who have presented themselves in some way, visibly, in their work have been unable to find the kind of distancing devices which would cut across the predominant rep-resentations of woman as object of the look, or that would question the notion of femininity as a pre-given entity,' she said. The film-maker and theorist Peter Gidal would go even further: 'I do not see how [. . .] there is any possibility of using the image of a naked woman

[. . .] other than in an absolutely sexist and politically repressive patriarchal way in this conjuncture.'[10]

/

Women of colour struggled with this interdiction in particular ways, proving its limitations as a general rule – one invented by white feminists, for other white feminists. Sutapa Biswas was at art school in Leeds at this time, being told by one of her feminist tutors that it was problematic for her to represent the female body. 'My work at the time was mainly figurative self-portraits, and Marie categorically stated that I could not do these kind of drawings because it was just perpetuating the stereotypical images of women that we are confronted with everyday.'[11]

But stereotypes of Black or brown women are very different from those of white women, and the nude has been a way for artists of colour to strike back against racist characterisations of their bodies. Deborah Willis and Carla Williams write that the 1970s and 80s were also an important moment for Black female artists (they are specifically referring to photography, where these issues are even more fraught), who 'have used their own likenesses and those of other black women to create an autobiography of the body and to develop themes of home, family, gender, representation, and identity in contemporary society. Their work,' they remind us, 'reflects their self-awareness as social beings and critics, observers and participants, image-makers and interpreters.'[12] The painter Claudette Johnson has written that for Black women in particular, their sexuality has been 'the focus of grotesque myths and imaginings': seen as 'bestial' or as the 'seductress', their bodies used by white male painters to 'explore their strange fantasies of purity versus impurity': the black skin of the servant in Manet's *Olympia*, for instance, 'highlight[ing] the whiteness [. . .] of the reclining woman'.[13] 'I couldn't find images of us that I recognised,' she told the Tate. Her 1982 drawing *Woman with Earring* depicts a woman who both reveals herself and shields herself from view; she smiles, but there is a distance to her expression; she is a woman enjoying a private moment, not someone who is displaying her body for

an imagined desiring viewer. The titular earring is of a double mirror of Venus, the circle with a dangling cross which is the symbol of femininity, but here it suggests either female friendship or same-sex desire. Circles echo elsewhere in the drawing – behind her back, as if she were seated within the circle; and there is the hint of another in the top-right corner. Her body, too, seems to have been drawn using a compass turned to various degrees, to create the curves of her arms, her neck, her face, her hips. Within these circles, she is not contained, but poised, calm; notes Johnson: 'There's something so powerful about just giving space to the presence of a Black woman.'[14]

/

To conclude with the feminist iconoclasts that the female body cannot be shown is to wall it off in a kind of politically correct purdah, unrepresentable, is as essentialist and reductive as anything the 1970s feminists said. It makes the female body invisible: un-seeable; it makes it impossible to reclaim the body as a rebuttal to patriarchy and its systems of sexism, racism, and control. As Adrienne Rich wrote in 1976, perhaps thinking, in part, of this issue:

> Whatever is unnamed, undepicted in images, whatever is omitted from biography, censored in collections of letters, whatever is misnamed as something else, made difficult-to-come-by, whatever is buried in the memory by the collapse of meaning under an inadequate or lying language – this will become, not merely unspoken, but unspeakable.[15]

Even in its less extreme forms, this idea that the solution to the problem of the nude female body is to show it while employing some 'distancing technique' strikes me as counter to what monstrous art does at its best: goes closer, gets touchy, tacky, ucky.

'The backlash against feminism in the 1980s involved not only outright misogyny,' writes the artist and critic Mira Schor, 'but also the reestablishment of art values and traditions that feminism had called into question.'[16] The art world became a marketplace; from the dematerialised and unsellable Happenings and performances of the 60s and 70s emerged the highly consumerist gallery and auction scene; people

with money began to see the art world as a good place to park it. According to Diana Crane's history of the New York art world, there were around twenty galleries showing American artists in the 1940s, whereas by the late 70s you had to count on seeing 'twenty-five to thirty galleries *per day* in order to keep up with developments in the art world'.[17] Meanwhile for all that the 70s had seen an explosion of women's galleries and art collectives and protests, by the 1980s little had changed on a practical level. To take just one example, in the 1984 Museum of Modern Art's exhibition celebrating its renovated and expanded facilities, their show called 'An International Exhibition Survey of Recent Painting and Sculpture' included 164 artists – thirteen of which were women. The following year, the Guerrilla Girls circulated their first posters.

'The conjuncture between radical politics and radical aesthetics that had been so important in the 1970s seemed to have outlived its usefulness,' Mulvey wrote in 1986.[18] Feminist art became textual and/or technological (Jenny Holzer, Barbara Kruger), while women's performances became completely impersonal (Cindy Sherman) – heavily under the influence of post-structuralist French theory. This is important work and I do not want to do it down. But French theory was not widely available to these women in the 1970s; even if they had access to certain texts in English, it was not as widely understood or pervasive then as it would be a mere decade later. The feminist interventions of the 1980s built on the work done in the 1970s; feminism had to move through what it would later reject as 'essentialist' in order to value the female body as worthy of theorisation to begin with.

I also resist the suggestion that if the feminist artist does not 'theorise' her work by explicitly situating her experience within social structures, she is lost in the personal, mired in her own problems to the exclusion of anyone else's. This sort of critique isolates the personal from the political, the domestic from the public – and we hear it launched at women who paint or write in the first person *all* the time. As if women in their houses alone with their bodies were completely cut off from the wider world, unaffected by it, with no concern for it.

What about women who cannot join the collective, whether for reasons of geography, lack of mobility, care responsibilities, chronic

pain, or simple timidity? The woman making work alone in her room
is not any less of an activist than someone in a consciousness-raising
meeting. To have to suggest over and over that *the personal is political* is
exhausting. Even by 1980, it had been said, and said, and said. But we
still, it seems, are impoverished when it comes to reading the poli-
tics of a work of art. Probably because it moves not only through the
mind but through the affects, and through our bodies. We still haven't
found that erotics, which is also a politics, of art.

/

What a culture – even a feminist one – finds 'problematic' about
images of nude women is an integral part of how it thinks about and
constructs 'masculinity' and 'femininity', Lynda Nead argued in 1983,
in the midst of these debates.[19] Part of the project of feminism was to
question and disavow an outdated, mindlessly obedient femininity.
Art that seemed to further its values of *prettiness, pleasingness, pleasure*
was politically questionable; in some quarters it could only scan as
reactionary, or narcissistic.

But that was precisely what Wilke was interrogating, her defenders,
like the art historian Amelia Jones, have argued. Female narcissism is
dangerous, Jones speculates, because it has no need of the desiring male
subject's desire or his approval. The feminists accusing Wilke of being
in thrall to the male gaze couldn't prevent themselves from reproducing
restrictive ways of looking at the female body. Can one not be flirt *and*
feminist, beautiful woman *and* artist, without being judged 'confused'?
As Carolee Schneemann wrote, 'there were only two roles offered for
me to fulfill: either that of "pornographer" or that of emissary of Aphro-
dite'.[20] And it isn't only men maintaining those categories. Despite their
best intentions, these feminist critics could not find a way to think
through, along with Wilke, the complexity of 'beauty', of pleasure,
of the desire to look, within a feminist framework. 'There's more than
a hint of Warhol in her deployment of her own glamour,' notes Nancy
Princenthal.[21] Why is Warhol's self-fashioning art, while Wilke's is
narcissism? Narcissus was a boy but it's the girls who get smeared with
his name.

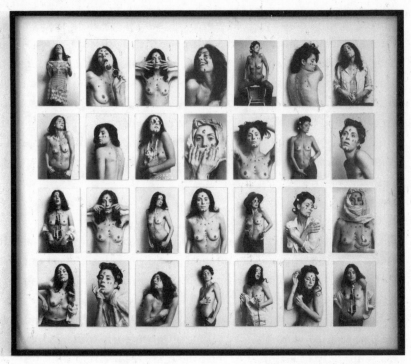

Hannah Wilke, *S.O.S. Starification Object Series: An Adult
Game of Mastication*, 1974 (detail).

/

However 'natural' Wilke's body might appear, to an audience
accustomed to seeing similar pictures in magazines where they're
being sold something, from depilatory cream to an idea of how
a woman should look, it has in fact been lit, posed, processed,
developed, just as in our day it would be photoshopped within
an inch of its life. The problem, for Wilke, is how the aestheti-
cised body can find a way to, in John Berger's terms, act as well
as appear?

There are all sorts of cues in these photographs to remind us that
these images are constructed: little chewing gum vulvas she's stuck
all over her torso and face. They reference the cunt as scar, as wound.
Chewing gum was the perfect metaphor, Wilke said, for the way
women were treated in American society: 'chew her up, get what

you want out of her, throw her out and pop in a new piece'.* In their reference to the toothy vagina dentata, they embody a threat: women might bite back.

The vulvas were a major motif in her work, abstract and representational at the same time, and Wilke was among the first to use them, which long predated other artists' use of 'core imagery'. Other, earlier projects consisted of hundreds and hundreds of labial sculptures: some were tiny and cute, others larger and more abstract, still others in scalloped pink latex, affixed to the wall. Wilke made scores of them, in a variety of materials associated with domesticity, including clay, gum, Play Doh, whatever took her fancy. Wilke said she was interested in 'formal imagery that is specifically female, a new language that fuses mind and body into erotic objects that are nameable and at the same time quite abstract'.[22] Her association of genitalia with gender is of its time, but that doesn't limit the potential ways of reading these objects in different historical contexts; I don't know what her gender politics would be today, but it is inarguable that she presents the pussy as something which can be constructed. It was her mission 'to wipe out the prejudices, aggression, and fear associated with the negative connotations' of female genitalia.[23] 'Who has the guts to deal with cunts?' Wilke asked the journalist Barbara Schwartz in 1973.[24] Wilke did. She made scores and scores of them, like sexy hamantaschen, each one unique, and showed them all together.

/

* S.O.S. was originally an installation called *S.O.S. Starification Object Series: An Adult Game of Mastication*, first shown in the exhibition Artists Make Toys, at P.S.1, New York, on 1 January, 1975. Later that year, Wilke exhibited in 5 Americaines à Paris, where she gave members of the audience a piece of gum and instructed them to chew it up and then give it to the artist, who would place it on her body or on sheets of paper she hung on the wall. In other performances associated with this project, she asked audience members to chew the gum for her, and she would use their gum for her individual sculptures.

Sometimes she used dryer lint, finding her material, she said, by doing laundry for her partner from 1969–77, Claes Oldenburg. (The art monster making work out of the material circumstances of her presumed debasement as helpmeet to the 'Great Male Universal Artist'.[25]) The lint sculptures are surprisingly, extremely beautiful – so much more colourful and bright than I expected. I try to imagine the clothing that would have thrown off this lint, so red and pink and green and fuzzy. The sheddings of another era. (Today this piece would be, perhaps, a comment on domestic labour as well as on its environmental impact; all the plastics we release out into the water system every time we wash our clothes; all the electricity we waste drying them.) These don't particularly resemble vulvae; some of them look like shawls, or towels some guy would throw around his neck at the gym. Wilke was exploring form, trying to understand its basic components. The original idea when she made the very first ceramic vulvae was to create a very simple structure, moving from a 'flat painterly surface' to a three-dimensional form that is very quickly changed by a 'gestural motion', she told Cindy Nemser.[26] The fact of each piece being a gesture is, Wilke said, more important than what it evokes. This is important: Wilke is not operating solely in the realm of figuration, but of movement and embodiment.

She was, after all, a sculptor by training, and this is how I think of *S. O. S.*: as a series of sculptures, using, instead of clay or gum or lint, herself as the medium. And as such she felt herself to be working against art history, with its 'traditional historical sculptural premises',

> because most of sculpture up until the twentieth century was concerned with solidity, like a marble sculpture is destructive, always taking away. [. . .] I'm concerned with showing how this piece was made. When you look at all the layers of the latex you can still see each individual layer [. . .] you can see the entire process.[27]

By posing in the register of the classical rather than the grotesque, Wilke was trying to show that women could make art as well as *be* art – and that the female body had to be reclaimed from patriarchy. It may be anachronistic to imagine Wilke was commenting on the construction of white femininity, but she was certainly noting the ways

women's bodies are bought and sold in postwar American culture – and they couldn't see the distance between what she was doing and what she was critiquing. All they saw was a conventionally attractive body. Wilke recalled, years later, 'I had a woman come into the gallery and say "Oh, you're the model." And I said "Yes, I'm the model – and I'm also the artist. This is my show." She didn't expect this.'[28] And, wrote one art critic in *Artforum* about her 1973 show at the Ronald Feldman Gallery, 'Every time I see her work I think of pussy.'★

The pussy, for Wilke, is political. The title of the *S.O.S.* series plays on the word *scarification*, referencing some African and Polynesian tribal rituals in which scarring is part of a process of beautification. The 'scars' are symbolic, performative, literally signifying at skin level. The most basic of readings would suggest that, with the play on words, she is suggesting Western women scar their own bodies, so to speak, in order to meet Western beauty standards. Wilke herself underwent rhinoplasty in early adulthood and changed her first name from Arlene to her middle name, Hannah. Perhaps in these images we can detect the invisible scars of the selves we have cast off in our attempts to be who we think we need to become.

But they are a reference, as well, to more sinister scarring practices: the Nazi's tattoos on the Jews in the camps. 'Remember that as a Jew, during the war,' Wilke wrote, 'I would have been branded and buried had I not been born in America.'[29] Remember, too, the internal scars borne not only by those who went to the camps, but by their descendants or distant family who didn't; the scars of diasporic guilt; the scars of violence further back, villages erased in pogroms, desperate flights to America. All of this, compacted into little cunts made of chewing gum.

/

★ James Collins, 'Hannah Wilke, Ronald Feldman Gallery', *Artforum*, Summer 1974. In 1980 Guy Trebay wrote in the *Village Voice* that Wilke's vagina 'is now as familiar to us as an old shoe'. 'Has anybody ever said this about Chris Burden's penis?' Chris Kraus wants to know. *I Love Dick*, p. 49.

In archival film footage, Wilke stands amongst her latex wall hangings, talking about how anxious she becomes when she is photographed next to her work, and she does seem nervous, shifting position, tossing her hair back. 'Because there's always a problem as to Hannah Wilke showing herself or showing her art. I think that's the basic problem that most women have had making things, people would rather look at women than [. . .] at art and I think maybe that's why I made an art which is beautiful. It's about seduction [. . .] My art is erotic.'[30]

'Seduction' may seem to belong to the register of romance novels and the advertising industry that Wilke purports to critique (it certainly is not the sophisticated terminology of the psychoanalytically inflected work of other feminist artists). It activates the second-wave feminist's disdain for women who use their beauty to target and bewitch. But perhaps there's a way of interpreting her seduction, and that of other feminist body artists of the period, that doesn't necessarily see it as the sort of heterosexual bewitching that Wilke's feminist critics scorn. Seduction creates a reciprocal relationship between artist and art, art and viewer, one that invites us as viewers to confront the monstrosity of beauty, the desire not for an ethical *yuck*, as in the case of the more widely approved-of mode of the abject, but for an ethical *sensuality*, tactility, connection. It invites the viewer to attend to the surfaces of the work – to scrutinise the grain of a beautiful woman's skin, and realise it is covered in ambiguous, troubling, possibly abject objects, referencing moments of pain healed over but not forgotten, and thus be invited to a visceral, material experience of art, a valorising of pleasure as an aesthetic response. There must be room for pleasure, if art is going to have any meaning or impact at all. Wilke counters the feminist embrace of the grotesque as a more ethically pure form with a deconstructed (chewed-up) classical aesthetics; she shows that there is pleasure in play, in voyeurism, that the female body is not a fixed entity but always in a state of becoming.

vanitas

'The artist rarely seems to get the last laugh,' Lucy Lippard wrote in her essay on Wilke. But Wilke *would* have the last laugh, albeit a bitter one. In 1987, Wilke was diagnosed with lymphoma, and she died in January 1993, aged fifty-two. In the years preceding her death, she continued to take nude photographs of herself, documenting the impact of cancer and chemotherapy on the body that had once been rejected for being too glamorous, too in love with itself. The poses are similar – magazine contrapposto – but the body on display is inarguably grotesque. Hairless. Bruised. Bloated. No more chewing gum scars but real ones. Bandaged at each hip from her bone marrow transplant. Pierced and ported. Always up for a pun, she called the series *Intra-Venus*.

Taken as a whole, Wilke's oeuvre seems like a lifelong experiment with the vanitas, a recurring motif in art history that reminds the viewer of the transience of life and the emptiness of greed, lust and physical beauty. A frequent vanitas image shows women admiring themselves in mirrors, sometimes accompanied by a skeleton to indicate the briefness of beauty and the inescapable eventuality of death, a close cousin to the memento mori. I am sure Wilke was thinking about Hans Baldung Grien's *Allegory of Death and Beauty* (c. 1509/10) when she created the diptych *Portrait of the Artist with Her Mother, Selma Butter* (1978–81). On the right, Selma Butter looks down and off to the side, topless, displaying one bare breast and one mastectomy scar, the skin irritated where it healed, into red blisters, possibly erupting into new tumours, and knotted and gnarled as the scar tracks its way to, or from, her armpit. She is old, wrinkled, withered; the kind of body you don't often see in nude photographs. Her chest, brown skin stretched tautly over her ribcage, looks much like that of Death in Grien's painting.

It makes a stark contrast to the peachy-white skin of her daughter in the flush of youth and health. Wilke's skin is powdered, she wears pale

Hans Baldung Grien,
Allegory of Death and Beauty, c. 1509/10.

blue eye shadow, there are round spots of blush on her high cheek-
bones. Scattered around her torso are a number of little metal objects,
apparently artefacts from her ray-gun collection, gifts to Oldenburg.[1]
Both images are in vibrant Cibachrome, pointing up the artifice both
of make-up and of colour photography. And of course, three breasts
where there ought to be four.

Wilke noted that her mother's diagnosis with breast cancer is
what prompted her to take pictures of her own body, or direct other
photographers to shoot her nude, in what she called *performalist self-
portraits*. This biographical fact lends a keener subtext to the *S.O.S.*
photographs. Her mother had her radical mastectomy in 1970, and
Wilke made *Gestures* and *S.O.S.* in 1974, and *Super-t-Art* in 1975. She

started the series *So Help Me Hannah* (1978–82), from which the left photograph in the diptych is taken, then, when her own cancer was diagnosed in 1987, she began photographing her own body in sickness.

/

One thing that has always bothered me about the vanitas genre is that the paintings always seem to be *about* the young woman in a way that implies she can't see them too. It's like a moralising lesson that takes her as its object but not its recipient, making fun of her supposedly shallow concerns with beauty to make a statement about the brevity of that beauty, of the body. As John Berger wrote in *Ways of Seeing* : 'You painted a naked woman because you enjoyed looking at her, you put a mirror in her hand and you called the painting "Vanity", thus morally condemning the woman whose nakedness you had depicted for your own pleasure. The real function of the mirror was otherwise. It was to make the woman connive in treating herself as, first and foremost, a sight.'[2] Wilke blends the crone and the beauty *throughout her career*, and not simply in the pictures taken during her final illness, to say I am here, I can hear you, I am aware of the hourglass over my head. But also as a retort to those who criticised her for showing her body, who called her a flirt confused about feminism. *The hourglass is over your head too, ladies*, she seems to imply. *Is this really how you want to spend the time you have?*

/

These are not allegories, Wilke's images; they are real bodies subject to time.

/

In the vanitas tradition, beauty and death are interwoven; *eros* cannot exist without *thanatos*. We know this. Hannah Wilke knows this. Wilke tried to tell us: her work is erotic, which also makes it deathly.

We have to read *Gestures* and *S.O.S.* and *Super-t-art* as vanitas as

well. In Wilke's vanitas, the silly young woman is the artist, the one
with the vision, who knows, who really, really knows, what life holds
in store: death – as would become very clear from the self-portraits of
her final illness, in which maiden and crone, classical and grotesque,
are one and the same. The border between beauty and ugliness is so
permeable, it can hardly be said to exist.

/

There are other photographs Wilke took of her mother, the *Seura
Chaya* series, in which she appears gaunt and suffering but trying
to make the most of things. They have an eerie resemblance to
photographs of Holocaust survivors returning from the camps, and
this – from the artist who referenced Nazi branding practices in
S.O.S. – cannot be a coincidence, or an overreading.

But it is the diptych that haunts me, that missing gland, the scar. The
breast, when it's not sexualised, is associated, of course, with mother-
hood. To depict her mother as missing one breast is to pictorialise the
separation of Hannah the child from her mother, becoming her own
person, with her own subjecthood; it also draws a line through ~~the
notion of beauty and femininity on which women themselves sub-
sist for survival~~. But, most obviously, it is a harbinger of illness, and
a reminder of mortality more powerful, because more abject, than
Grien's ghoulish figure. Is it more abject because of the power of pho-
tography? The photograph's indexicality, its link to the 'real'? Grien's
figure is something out of a story; Hannah's mother was a real person
who was born, lived, breathed, had children, lived and breathed some
more, lost her breast, and died a few years later.

To photograph the missing breast is to gesture at the future decom-
position of the body.

/

One of the earliest accounts of a mastectomy is in an 1812 letter Frances
Burney sent through the Napoleonic blockade from her home in
France to her sister in England, describing the operation performed

on her without anaesthetic the previous year. She had the very best care; her surgeons included Dr Larrey, Napoleon's field surgeon, and M. Dubois, the Empress Marie Louise's obstetrician. It's an amazing story, and an engrossing narrative. 'Qui me tiendra ce sein,' asks Dr Larrey, before making the first incision. *Who will hold this breast for me?* 'I will,' says Burney.[3]

She is awake throughout the proceedings; a cambric handkerchief is placed over her face but she can still see the men and their instruments through its weave. Her description of the pain is eviscerating. The feel of the steel cutting through 'veins – arteries – flesh – nerves –'; the air as it 'rushed' into the newly exposed 'delicate parts' was 'like a mass of minute but sharp & forked poniards', then the instrument striking again, 'describing a curve [. . .] while the flesh resisted in a manner so forcible as to oppose & tire the hand of the operator, who was forced to change from the right to the left'. And then, when the breast was removed, the scraping. 'The evil,' she wrote, 'was profound.'[4]

She survived the operation, and some twenty-nine years beyond it, but for months afterwards the trauma returned any time she recalled it. She wrote to her sister only because word of the operation had apparently begun to spread across the Continent – she was an author of some renown at this point. The letter took three months to complete, and once she had reached the end of the story, Burney could not bring herself to reread it.

But the scholar Julia Epstein wonders whether this was actually true; the manuscript is completely unmarked, with no revisions or emendations, and the fact that she gave the letter a title when she included it in her journals and letters years later 'suggests a more studied text than the usual casually informative, familiar letter'.[5] It becomes not merely personal testimony, but a work of literature, as well as a medical case history.

The letter and its literary framing 'demonstrate the complex ways in which the act of writing, like the act of surgery, can be simultaneously wounding and therapeutic'. Epstein calls it an 'act of social defiance' to put words to something that was not spoken of (cancer, surgeries, breast cancer especially). But, the account having finally been written, what story does it tell? 'Can this story be told?' asks

Epstein.[6] We know – from our own experience, as well as from Elaine Scarry's *The Body in Pain* – that the body in pain speaks a language no one else does; that our suffering is mute to anyone else; that we can only gesture at describing it. But we can succeed in wounding our listener; perhaps not with the same pain, but with another, referred pain.

There are, necessarily, blanks in the text. A full evocation of the sensations, Burney comments, would be impossible; 'description is baffled'.[7] And yet the description is keen enough that I considered putting a trigger warning above, lest Burney's story prove too difficult for some readers who may have experienced the loss of one or both breasts, or known someone who survived breast cancer. Burney's biographer, Joyce Hemlow, provides one such warning, asking that readers either prepare themselves either to read the 'gruesome' details, or turn the page.[8] This account of a breast amputation from over two hundred years ago is the 'jerk' in my text, as Woolf called it; the incarnation of the aesthetics of monstrosity, the place where touch is restored to the aesthetic, and for that I can't apologise; I can only hope that it feels germane to the discussion, organic to it, that its excess is nevertheless not gratuitous. The story Burney tells is one of pain passed on, *aestheticised* in the sense of transmitting *sensation*. This is a key text in the history of women writing the body: specifically in terms of the narrativising of pain and the attempt to find a formal means of reflecting the unwritable.[9]

/

I know another mastectomy story, but this one doesn't have words. It is only an image. The key elements – the who, the why, the how – are missing. It is an afterimage.

It looks a bit like blueberry pie until you realise what it is. There's an immediate squelch, followed by curiosity. Is this, then, what they really look like?

The images of the twinned breast are, according to the art historian Patricia Allmer, 'an absolute rejection, a radical refusal, of the male gaze; they undermine and deny traditional representations by male artists of breasts as desirable objects. Instead the breast is, literally,

served and fed back to the male gaze as diseased/dead meat.'[10] Miller's photograph invites another kind of desire that is foreclosed when the photograph clicks into mental focus and we realise what we're looking at: the insides spilling out, violence within the socially approved field of medicine.

The photograph is always shown side-by-side with a second photograph, showing the breast from a different perspective. The doubling produces a feeling not only of abjection but of superfluity; even though there is nothing more natural than two breasts side by side, you look at the photograph thinking of her ingenuity, showing that image not once but twice. Here the natural is de-natured; the female body is alienated from itself.

The image itself is untitled, cannot be titled, can only be identified parenthetically.

Lee Miller was twenty-two years old when she tracked down Man Ray at a café near his studio in Montparnasse and informed him that she was his newest student. While out on an assignment for him to the Sorbonne medical school, she came across the breast in a medical waste bin. She took it straight to the *Vogue* offices (a walk of at least half an hour – *what* did she carry it in?), where she had done some work as a model, and shot it as we see it, like it's an illustration for the cookery section. What we in English call a still life, and the French a *nature morte*. Miller and her severed breast were thrown out of *Vogue* the minute somebody caught wind of what she was up to.[11]

I wonder about the woman it belonged to. Who she was, how she fared afterwards. Did the amputation help? Did she survive? Did she ever hear of a beautiful young photographer called Lee Miller?

And also: what did Miller do with the breast when she was done photographing it?

/

Miller is one of many women who modelled first and then became artists. (Can you think of any acclaimed male artists who started out as models? I can't.) She modelled for *Vogue*, and played the Muse in

Lee Miller, *Untitled (Severed breast from radical surgery in a place setting 1 and 2)*, Paris, France, c. 1929.

Cocteau's *The Blood of a Poet*; later she would become a photographer for *Vogue*, an acclaimed fine art photographer, and would go to the Second World War as a photojournalist, surviving the firebombing of St Malo, posing for a photo in Hitler's bathtub, and documenting Dachau just after its liberation. *Severed Breast* was taken at a hinge moment between working for Man Ray and striking out on her own. But why a severed breast, in this narrative of independence? What would it have meant to her?

Miller's biographer, Carolyn Burke, has written about the trauma Miller endured when she was raped, aged seven, by a family friend, subsequently contracting a venereal disease which required painful treatment. In trying to understand how this would have shaped Lee's life, Burke turns to the writing of Maya Angelou, who was also raped at around the same age, and who called it 'a breaking and entering when even the senses are torn apart'.* The episode, according to Burke, 'marked the end of [her] sense of security and, in some ways, her childhood'.[12] Does the severed breast represent some lost feeling of safety and wholeness? Some never-to-be-recovered relationship to the world, to her senses, to her body? The severed breast is a strong statement of an embodied feeling of violence, from the woman whose own breasts legendarily inspired a glassmaker to create a champagne glass moulded after their shape.

It occurs to me there is an autobiographical pun in Miller's photograph. In French, the kind of glass you drink champagne from (besides a flute) is a *coupe*.

Coupe is French for cut.

/

Unlike the sculptor carving away at the stone to free the body within it, Wilke, Burney and Miller make work from the parts that threaten to undo the whole.

We are not dealing in metonyms but in bodies. Cancer, Sontag

* Quoted in Burke, *Lee Miller*, p. 16. As if that weren't bad enough, the assault left Miller with a case of gonorrhea. Burke describes the traumatising treatment, which Miller's mother had to administer.

forcefully wrote after undergoing her own brush with breast cancer in 1975, is not a metaphor; not a punishment; not a character flaw. It is a disease. The metaphorisation of it is 'a vehicle for the large insufficiencies of this culture, for our shallow attitude towards death, for our anxieties about feeling'.[13]

/

Kathy Acker told the story of her breast cancer in the *Guardian* in January 1997. She had been diagnosed with breast cancer and was offered the choice between a lumpectomy with radiation or a semi-radical mastectomy without radiation. The decision she made was financially motivated, a product of the American healthcare system, or lack-of-care system:

> At that time, I was working as a visiting professor at an art college and so did not qualify for medical benefits. Since I didn't have medical insurance, I would have to pay for everything out of my pocket. Radiation on its own costs $20,000; a single mastectomy costs approximately $4,000. Of course, there would be extra expenses. I chose a double mastectomy, for I did not want to have only one breast. The price was $7,000. I could afford to pay for that. Breast reconstruction, in which I had no interest, begins at $20,000. Chemotherapy, likewise, begins at $20,000.[14]

They discovered, afterwards, that there was no cancerous tissue in her breasts: the mastectomy had been unnecessary. There was, however, in her lymph nodes. The attending doctor could only offer an additional ten per cent chance of survival if she underwent chemotherapy. Losing all faith in conventional medicine, which she felt was 'reducing' her 'to a body that was only material, to a body without hope and so, without will', she refused chemo, and decided to treat the cancer unconventionally. Her friends pleaded with her but she would not be convinced. She believed the advice of her nutritionist, psychics, past-life regression specialists, and spiritual healers, that

if she wanted to get well, she would have to look inward, to what 'caused' the illness.★

'I entered the school of the self. I thought I was, unwillingly, confronting cancer, instead, I was confronting myself. I no longer have cancer.' She thought she was telling the story from a point some time afterwards; that it was over. It wasn't over. She died in late November that year.

/

She called the essay — or someone at the *Guardian* did — 'The Gift of Disease', but there's most certainly a double entendre in there — the gift of dis-ease.

/

Acker believed that there was something impossible to articulate happening in the way the healer approaches the body, some experience of the confrontation of pain that does not take place through the mind, that is the body's way of thinking. As someone committed — like most feminist artists — to dismantling the mind/body split, Acker was, of course, putting all her faith in this narrative.

The *Guardian* piece was accompanied by a photograph taken of Acker by the gender-variant photographer Del LaGrace Volcano (de la grâce, I love their name, freeing grace from its normative associations); over her

★ There is no guarantee the chemo would have helped Acker, and, writes Anne Boyer in her own memoir of breast cancer, *The Undying*, had she undergone traditional treatment she would have spent the last months of her life 'with some variation of the following: tremendous pain, dry itchy eyes, skin lesions, anal lesions, mouth lesions, a bloody nose, wasted muscles, dying nerves, rotting teeth, and without hair or an immune system, too brain-damaged to write, throwing up, losing her memory, losing her vocabulary, and severely fatigued' (New York: Farrar, Straus & Giroux, 2019, p. 194). Carolee Schneemann, when she heard Acker had had a mastectomy, was aghast; she was already 'in the arms of the patriarchy'. Quoted in Jason McBride, *Eat Your Mind: The Radical Life and Work of Kathy Acker*, New York: Simon & Schuster, 2022, p. 460.

naked chest she wears a lavishly feathered black jacket, her head tilted back, eyes closed like some haughty ecstatic punk crow. In another, the one I prefer, she wears a brown velvet frock coat over black jeans, and a snake necklace around her neck. She is moving, caught in a twist, her feet facing away from the camera, her torso facing forward, her eyes locked on the viewfinder. Her chest is bare; we see the scars. With her shaved hair dyed blonde she looks like Claude Cahun meets Johnny Rotten. The freedom in this photograph is palpable. It's the freedom of the in-between, of no longer having to be legible in any traditional pictorial way; it is another slash through the body of the *Rokeby Venus*.

/

Matias Viegener, *The Assassination of Kathy Acker*:

> When I saw Kathy after her mastectomy eighteen months ago, I saw death. I told her she looked better. I knew she was going to die, and how she would die, and that I would be there because I wasn't afraid of it, or if I was, my fear was minuscule in proportion to her fear of it. Her fear outshone mine as if the sun had blotted it out.[15]

Viegener, Acker's close friend and executor, writes that until Kathy was dying he understood from the world that gender was the 'primary distinction' between people, more than race or class or wealth. 'But what I see now is that the real binary, the most frightening division, is between life and death. And all the others in a sense are arranged around it, to protect us from that distinction – because that irreversible and absolute division is too terrible.'[16]

I see her mastectomy portraits as an intervention in the visible, a cutting through of those protective senses, even through the inchoate fog of her belief in her healers. Kathy knew about the power of appearance. I wonder if that day, shooting with Del, she was thinking about these photographs outlasting her. Was she looking not only at Del through the lens but at us, today, meeting our gaze, willing it back up from the scars to confront whatever it is she has to say?

/

Wilke's cancer photographs are often written about in conjunction with those of Jo Spence, her near-contemporary, who died the year before Wilke. Did she see Spence's 1989 *Narratives of Dis-Ease*, the photo-chronicle of her own treatment for breast cancer and leukaemia?

Like Acker, Spence finds politics at the site of the afflicted breast; patriarchy inscribes itself on the sick body, turns it into a collection of potential fragments, conveys the impression 'that our body is merely a set of parts, and that those parts are someone else's property'.[17] This is the idea behind her 1982 self-portrait, 'Property of Jo Spence?', in which she has written these words on her bandaged left breast, 'like a tattoo', says Stella Bolaki, 'blurring the boundaries between image and text'.[18] She had the man she lived with take that picture before she went to hospital, and she kept it with her 'like a talisman', she said later, 'to remind myself I had some rights over my body'.[19] But she is not only referring to moments when the breast in question is subject to the medical establishment: she's talking about a whole life of being the one to whom the breasts are attached, yet they belong, as it were, to the rest of the world. To the people who find them lacking or excessive. The men who sexualise them. The babies who suckle at them (whose thriving or failure to thrive is blamed on the breasts). Then, after being intrinsic to our value as women, if they are found to be sick, they must be handed over to the medical establishment.

Once she was diagnosed with cancer, Spence put making work about 'those wounded particulars' of people and flesh, in Anne Boyer's terms, at the centre of her practice.[20] She called it 'phototherapy': using photography as a means of self-soothing and self-expression, and she wanted to use it not only for her own personal healing but to make a difference in the world.

The self-portrait *Exiled* is, I think, one of the weirdest and best in the series. She's parted what looks like a hospital gown to show her nakedness beneath; we only see the bottom part of her face and her torso to the upper part of her thighs. Prefiguring the riot grrrls, who a couple of years later would scrawl SLUT and WHORE on their bare midriffs, Spence writes MONSTER.

She is all dissymmetry, with the *Phantom of the Opera*-style half-mask, the partial mastectomy, her stomach as it bulges on one side, the uneven pubic hair, the unevenness of the lighting on her skin; she is working against classical, Aristotelian narratives of beauty, but also against even an againstness of beauty. It is not a challenge to the viewer to find her body beautiful. We are beyond the binaries of *beautiful* or *ugly*. We are not even in the same category. The aestheticisation of the post-surgical sick body is not about shocking the viewer, nor is it a challenge to find beauty in her condition. This image offers the 'obscene' or 'grotesque' body as *the only body we have*. It is a self-portrait of our shared immanence.

/

After her mastectomy, Audre Lorde elected not to wear a prosthesis. She evokes the reasons why in her luminous, powerful *Cancer Journals*. Prosthetics and reconstructive surgery only reinforce a dangerous mythology of how the female form should look. 'I find little support in the broader female environment for my rejection of what feels like a cosmetic sham,' she says. 'Socially sanctioned prosthetics', she writes, keep women with breast cancer 'silent and separate from each other'.*

When she visits the doctor's office, she gets precious little support from the nurses, either. 'You will feel so much better with it on,' they tell her. 'It's bad for the morale of the office.'[21] Sara Ahmed reads this as a classic feminist killjoy moment, in which the body in pain is accused of making other people uncomfortable, frightening those who must travel down the same path, the 'broken body intrud[ing] into social consciousness, becoming a reminder of illness and fragility that is unwanted'.[22]

Lorde draws a contrast between the social imperative to wear a prosthetic breast and the Israeli Prime Minister's eyepatch:

* Audre Lorde, *The Cancer Journals* (1980), San Francisco: Aunt Lute Books, 1997, p. 14. I want to be clear I am not advocating any particular response to mastectomies – Lorde's is particular to her own experience.

nobody tells him to go get a glass eye, or that he is bad for the morale of the office. The world sees him as a warrior with an honorable wound, and a loss of a piece of himself which he has marked, and mourned, and moved beyond. And if you have trouble dealing with Moishe Dayan's empty eye socket, everyone recognizes that it is your problem to solve, not his.[23]

'Well,' she continues, 'women with breast cancer are warriors, also. I have been to war, and still am. So has every woman who had had one or both breasts amputated because of the cancer that is becoming the primary physical scourge of our time.' Lorde draws explicitly on the memory of the Dahomey Amazons surging out to war on horseback, one breast removed so as to better wield their bows, and she imagines a sisterhood of modern-day Amazons.* 'What would happen if an army of one-breasted women descended on Congress and demanded that the use of carcinogenic, fat-stored hormones in beef-feed be outlawed?'[24] What power in the collective, what companionship, what solace for other women experiencing the same illness, or who might one day find themselves in a similar position? What might be changed through an adjustment in the visible?

/

Had they been alive today perhaps Lorde and Acker would have got mastectomy tattoos – another form of body art, imprinted on the skin in the place of the breast that's gone, a presence instead of an absence, a form of self-care working against the norm of the beauty industry, replacing cosmetic surgery with body modification, and loss with a slashed form of beauty.

* As Jeff Bezos may or may not have been aware, in ancient Greece the term Amazon was believed to derive from the fragments *a*- (ἀ-) and *mazos* (μαζός), 'without breast'.

Kathy Acker to Sylvère Lotringer:

> Tattoo means writing. It's how they used to write in Tahiti.[25]

/

In writing on Lorde's refusal, Ahmed delves into fragility, what it means to be fragile, a state of being perhaps 'too breakable', liable to shatter (and then to become sharp).[26] Perhaps this fragility is the aesthetic at the heart of Wilke's *Intra-Venus* images, the willingness to show the public what they don't usually see, the body vulnerable, the mutilated female form. Not in violence but in attempted healing. The body grown monstrous. The photograph a kind of tattoo on light-sensitive skin.

/

The most haunting parts of the *Intra-Venus* series are the Tapes, the home movie-style videos Wilke and her then partner made, which were meant to be shown all at once on sixteen screens arranged in a grid (Wilke loved the grid), from the earliest tape at the top left, to the latest at the bottom right. They are a quirky blend of the animal, the human, and the surgical. On one screen a pair of lovebirds sit on her knees and squeak; in another, a conure parrot investigates her mouth, in a weird blend of Rebecca Horn's cockatoo and Carolee Schneemann's cat. Further on, she combs out her thick dark hair. By the later tapes, her hair has mostly fallen out, clinging in short fuzzy patches, which she gathered up and affixed to large sheets of Arches paper, calling the resulting drawings *Brushstrokes*.

You can hardly catch it, mixed in with the cacophony of the other moments on the other tapes, all rolling at the same time, but if you listen you can distinctly make out her saying:

> 'Nothing's upsetting me any more, I'll make it into art!'

ucky

Leon Borensztein, portrait of Judith Scott, 1984.

There is a photograph I love of the artist Judith Scott hugging one of
her sculptures, taken by Leon Borensztein. The sculpture is typical of
Scott's work, a tangled oblong cocoon-like thing bigger than her head
and torso, woven of multicoloured yarn and ribbon and rope and twine
and fabric and whatever textiles felt right under her fingers; Scott presses
her face into it, holding her arms up around it, her fingers folded in,
her eyes closed. We are all fiercely protective of what we do, we speak
in birth metaphors to describe the process of creating (well, and some
of us in excremental ones, though as anyone who's given birth will tell
you the two are intricately bound up in one another), but I had never
seen an artist show this degree of physical emotion towards their work.

Scott is considered an 'outsider' artist, because she wasn't formally trained. Born with Down syndrome, she was also deaf, though this went undiagnosed until she was an adult, and she did not speak. Outsider artists used to be called 'naïve', the presumption being that their work comes about outside of traditional art historical knowledge. But there is nothing naïve about the spellbinding woven objects in wild colours and undulating shapes she made, which put me in mind of some of Dorothea Tanning's more abstract fabric art. Scott's work is surrealist in the sense of creating the shapes that we see in our dream-lives, and hardly ever while awake.

There's a video of Scott in the studio, working on one of her sculptures. She takes a long strand of gorgeous deeply dyed yarn, cuts it, slips it underneath an already-present strand on the piece, pulls till it's even, and fastens it at the bottom, which is accumulating a little fringe of yarn ends. It's not uniform. The colours shape and shift and vary. She braids and sews and knots and winds the wool into patterns and places of tension; some strands loop loosely while others stretch and tighten and bind. You could lose yourself in the metaphors.

There is another element of her biography that I can't help but weave in: embarrassed by her disability, her family sent her to an institution when she was seven. She was separated for thirty-five years from her twin sister, who eventually got herself appointed Scott's legal guardian and brought her to live in Berkeley. There she took Scott to the Creative Growth studio for disabled artists in Oakland, where she made her first works – indeed all of her works.[1]

In this context, weaving yarn is a gesture of umbilical strengthening, of permanently bringing together disparate elements of the same material. Scott's method of tying the bits of thread around the other threads echoes the practices of some cultures which ritualistically tie fabric around trees, to attract spirits, or ward off back luck. Maybe there is even something calming about the act of tying knots. There is certainly something associative about the act. I remember back at summer camp the procedures by which we strung and knotted embroidery yarn into complicated patterns and gave them to friends to wear around their wrists. She wouldn't

have seen Eva Hesse's work, but I see, in Scott's tangles, an echo of one of Hesse's last works, *Untitled (Rope Piece)* from 1970, the one that holds this book together, my touchstone image. Haunting, really, to think that Scott, without having studied art history, much less feminist art history, would weave herself directly into the heart of it.

But I am wary of reading the biography too literally into these works. Some mystery guided Judith Scott, the contours of which we will never know. Making art by touching and feeling, the love lavished on it saturating the fibres.

/

The Borensztein photograph is on the cover of Eve Kosofsky Sedgwick's 2002 book *Touching Feeling*.★ In the introduction, she recalls a graduate student of hers at Duke called Renu Bora, whose essay 'Outing Texture' brilliantly and delightfully distinguishes between 'texture' and 'texxture'. Texture with an extra x is, Sedgwick writes, 'dense with offered information about how, substantively, historically, materially, it came into being. A brick or metalwork pot that still bears the scars and uneven sheen of its making would exemplify texxture in this sense.'[2] It's as true of a photograph as of a sculpture; we can't always touch the image with our fingers, but we can apprehend its surface with the eye.

Texxture is 'the stuffness of material structure'.[3] Like Hannah Wilke's vulva sculptures, bearing the imprint of her fingers as she pressed into the clay. The extra x, the supplement, the overkill, the overshare. The book that doesn't just communicate something; it also tells you what it was like to write it. Texxture as the aspect of a work that tells you, wordlessly, everything you need to know about it.

But, Sedgwick adds, 'there is also the texture – one x this time – that defiantly or even invisibly blocks or refuses such information: there is

★ Eve, whom I had the honour of knowing slightly during graduate school, died of breast cancer in 2009.

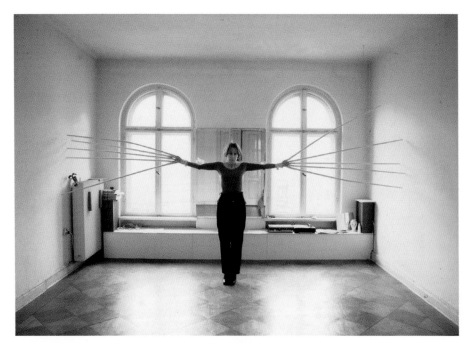

Rebecca Horn, *Touching the walls with both hands simultaneously*, from *Berlin Exercises*, 1974–5.

Cindy Sherman, *Untitled #175*, 1987.

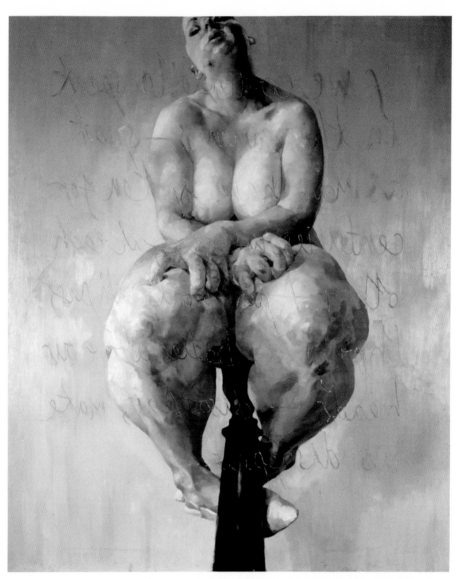

Jenny Saville, *Propped*, 1992.

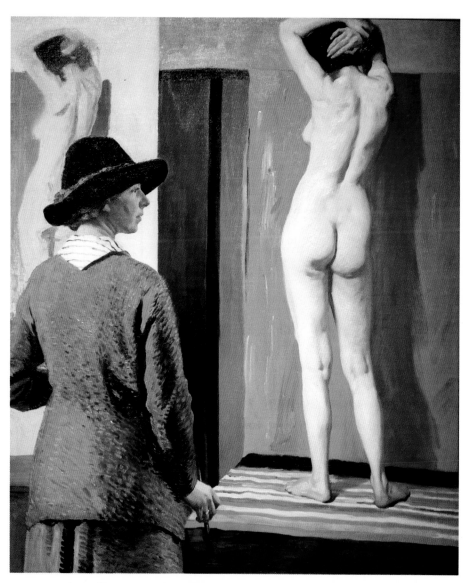

Laura Knight, *Self-Portrait with Model*, 1913.

Lorna Simpson, *Without really trying*, 2019.

Kara Walker, *A Subtlety, or the Marvelous Sugar Baby, an Homage to the unpaid and overworked Artisans who have refined our Sweet tastes from the cane fields to the Kitchens of the New World on the Occasion of the demolition of the Domino Sugar Refining Plant*, 2014. Installation view at Domino Sugar Refinery, Brooklyn.

Sutapa Biswas, *Housewives with Steak-knives*, 1985.

Maria Lassnig, *Self-Portrait with Stick*, 1971.

Maria Lassnig, *Self-Portrait as Monster*, 1964.

Maria Lassnig, two stills from the film *Iris*, 1971.

Carolee Schneemann, two stills from the film *Fuses*, 1967.

Claudette Johnson, *Untitled (Woman with Earring)*, 1982.

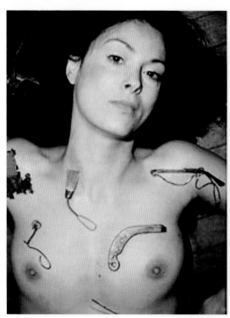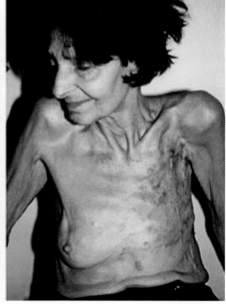

Hannah Wilke, *Portrait of the Artist With Her Mother, Selma Butter*, 1978–82. Diptych.

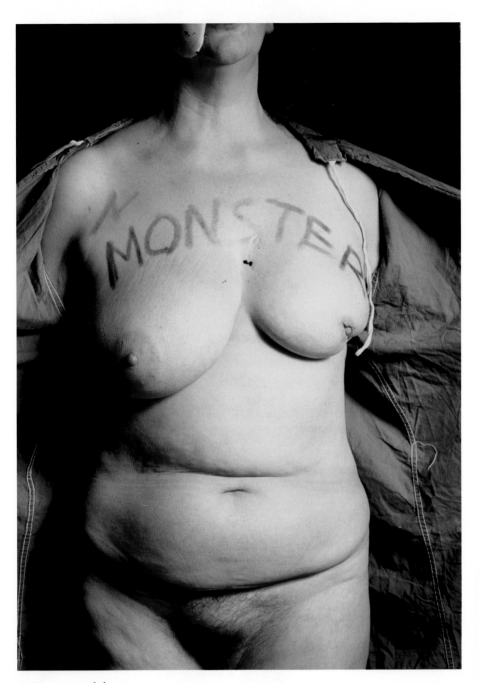

Jo Spence, *Exiled*, 1989.

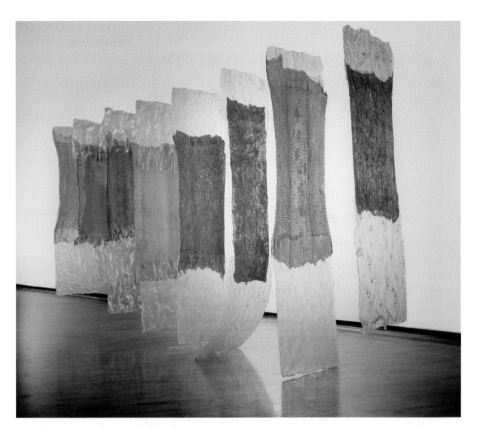

Eva Hesse, *Contingent*, 1969.

Ana Mendieta, stills from *Alma, Silueta en Fuego*, 1975. Super-8mm film, colour, silent.

Helen Chadwick,
Enfleshings I, 1989.

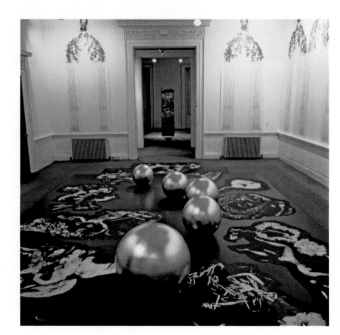

Helen Chadwick,
The Oval Court, 1986.
Installation view at the
Institute of
Contemporary Arts,
London.

Vanessa Bell,
*Virginia Woolf in a
Deckchair*, 1912.

Virginia Woolf, annotated front cover
of Volume I of the *Three Guineas*
notebook.

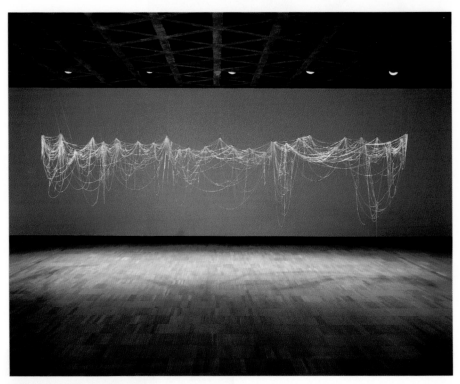

Eva Hesse, *Right After*, 1969.

texture, usually glossy if not positively tacky, that insists instead on the polarity between substance and surface, texture that signifies the willed erasure of its history'.[4] This work isn't telling you everything, but perhaps inviting you to fill in the blank.

And texture can and often does go beyond touch into the realm of other senses; at the very least it lives 'on the border of properties of touch and vision', as Bora puts it.[5] Monstrous art gives us even more than that: too much and just enough. It threads its arms around us and draws us close to it, too close and ever closer.

/

I was thrilled to encounter some of Scott's work in the flesh (so to speak) at the 2017 Venice Biennale. There is work we're content to view at a distance, and work we want to get right up close to, to study its fibres, to see how it's done, or what lives at the level of its skin; Scott's is the latter. Enthralled by the layers and layers of fibre, I got my face a little too close to one, and the alarms went off. The irony.

Also at the Biennale that year were a number of other fibre-based works, troubling the boundary between 'art' and 'craft'. How often do we slot women's handiwork into the latter category, with their weaving and knitting, their soft materials, to which associations of domesticity and sentiment cling like lint? Even for those of us who admire it, tactile art wrong-foots us, I remember thinking, standing in front of a beautiful brass curtain made by the Portuguese artist Leonor Antunes, called . . . *then we raised the terrain so that I could see out*. It hung in the middle of the long Arsenale space, so you had to confront it, and walk around it (or, perhaps in a nod to the bead curtains of yore, through it). It was made of an industrial material, but adapted to a decorative object; it wouldn't be out of place in a hipster coffee shop.

Someone told me afterwards we were meant to, or at least allowed to, touch it. We are used to art being untouchable. We are confused about its status; thread is not as 'old master-y' as bronze or oil paint. Touch, says the artist Rosalyn Driscoll, is 'a way for *all of us*', including the visually impaired, 'to know art'.[6] She proposes what she calls

aesthetic touch as a more attentive act than our everyday contact with surfaces, phones, keys, shoelaces, what have you. This would bring our focus instead to 'formal elements such as shape, space, and pattern' and allow for an attunement to the 'emotional implications of what we perceive'.[7] Touch, for Driscoll, 'encompass[es] kinesthesia, proprioception, balance, temperature, pain, and pleasure – indeed the whole body'.[8] Aesthetic touch frees us up from the burden of 'understanding' art and makes it an act of 'experiencing' – of knowing in a more embodied sense. Judith Scott, in embracing her work in the Borensztein photograph, is letting us in on her emotional relationship to her work, but also demonstrating a deep knowledge of her art. An aesthetics of touch changes our sense of what it means to know.

The haptic sense, according to Driscoll, is a form of knowing that comes from our guts, born of an atavistic, instinctual experience of being alive that is encoded in our DNA, and prompted our ancestors to commit life to paint on the craggy pockmarked walls of caves, themselves a record of time.[9]

But it can overwhelm us, the amount of information we can glean from a multiplicity of sensory engagements. I think this is where the distinction between art and craft comes in, allowing us to better organise, and even hierarchise, our aesthetic perceptions.

Craft: touch it.

Art: don't touch it.

/

We describe – or we would if we weren't afraid of sounding sentimental – the work as 'touching' when we mean we were affected by it, as if it reached beyond the frame to touch us.

Or, if we totally want to discredit something, if we feel manipulated by it, or if it gets too close to us and makes us uncomfortable, if it threatens the carefully constructed exoskeleton of 'cool' we have excreted to protect ourselves in a macho world, we might call it 'touchy-feely'.[10]

'[T]o talk about affect virtually amounts to cutaneous contact,'

writes Sedgwick.[11] Don't let it in, keep it at a distance, don't let it get you.

/

From Eve to Eva. Writing about Eva Hesse I run the risk of writing sentimentally. But I can't not write about her; if Hannah Wilke's work is the problem this book poses, Hesse's is the answer.

/

Eva Hesse was born in Hamburg in 1936. A little under three years later, she and her older sister Helene, who was five at the time, were shipped off to Holland on one of the last Kindertransports. I am trying to picture a five-year-old responsible for a two-year-old, holding her by the hand. I think of Eva Hesse's mother, Ruth, try to conjure her feelings even as I sit here, myself, eighty-one years later. I am trying to imagine putting my son, almost two, on a train in the care of people who think he is dirt because he is Jewish, with no guarantee I would see him again, with no idea what would become of either of us. Thank god they were reunited six months later. What word did she have from her children, during that time? How was she towards her children when she got them back? How does a mother's anxiety filter down a generation? (I am anxious; I need to know this.) Eva Hesse's mother was bipolar, they say, and then there was the Holocaust. Eva Hesse's parents split up in 1944. When Eva Hesse's mother learned that both her parents had died in a concentration camp, she jumped off the roof of their building. Two days later, Eva Hesse turned ten.

/

When does a mother's anxiety become something insurmountable, that takes her away from the very children who gave birth to it?

/

Eva Hesse couldn't sleep at night without her feet touching the bottom bars of her bed frame.

/

So much writing on Hesse has focused on her childhood trauma, on her early death. Griselda Pollock calls this the 'sacralization' of Hesse, while Anne M. Wagner contends that 'Hesse as wound' has become firmly engrained in criticism about her, and urges readers to 'depathologize' the way we approach her work.[12]

And here I am turning the poor dead girl into a monster. I am drawn by its texture, but I would be lying if I said it was not, in part, the texture of the life that I see on the sensitive surface of her work.

I'm not interested in the wound (that's a lie) or in wound culture (that's also a lie) but I am interested in (this is the truth) how the wound registers on the canvas, in the work, and also in why I feel in order to sound like a serious critic and not a sappy one I need to pretend I'm not interested in the wound or the culture of the wound. Am I sentimentalising Eva Hesse? Buying into her myth? Is there any other way, when you fall madly in art love?

/

Eva Hesse didn't start out wanting to make sculptures, or objects, or three-dimensional paintings, or however you want to talk about her wonderfully anti-generic works. Initially, she wanted to be a painter. She went to art school, studied with Josef Albers at Yale, graduated, took her first few steps in the art world of New York City. She wanted to throw off all the 'restrictions and curbs' imposed on her from within or without. 'I will strip me of superficial dishonesties,' she wrote in her diary. 'I will paint against every rule.'[13]

Painting didn't always go well. On bad days, she wondered if she was meant to be doing something else. She got 'distrustful' of herself. She longed '[t]o be able to finish one and stand ground; this is me, this is what I want to say'.[14] We all have bad days and it doesn't mean we should change mediums. But for Eva Hesse, it did. She struggled

under the weight of art history. She felt too conscious of it; what she was doing felt like a performance of the thing and not the thing itself. 'Painting has become that "making art, painting a painting"; the history, the tradition is too much there. I want to be surprised . . .' she wrote in her diary.[15]

She married a sculptor called Tom Doyle. They were happy at first; then not. On an artist's residency with him in Germany (origin of the mother, origin of the wound) she tried to paint, made a couple of expressionist things she liked, and despaired. She wrote to Sol LeWitt to tell him she'd made some progress and would keep at it. 'Much difficulties, but at least I'm pushing, and I will be. I swear it.'[16] He wrote back to her the best letter an artist could ever receive from another artist:

> *Just stop thinking, worrying, looking over your shoulder, wondering doubting, fearing, hurting, hoping for some easy way out, struggling, grasping, confusing, itching, scratching, mumbling, bumbling, grumbling, humbling, stumbling, rumbling, rambling, gambling, tumbling, scumbling, scrambling, hitching, hatching, bitching, moaning, groaning, honing, boning, horse shitting, hair splitting, nit picking, piss-trickling, nose sticking, ass-gouging, eye-ball poking, finger pointing, alley-way sneaking, long waiting, small stepping, evil eyeing, back-scratching, searching, perching, besmirching, grinding, grinding, grinding, grinding away at yourself. Stop it and just do!*[17]

They went back and forth, praising action at all costs, even if it ended in nonsense, egging each other on. Hesse complained that she wanted to love the process and not just the product. 'Stop worrying about big deep things,' LeWitt said. 'You must practice being stupid, dumb, unthinking, empty. Then you'll be able to DO.' Stop trying to make the work be about something, I think she understood; let it be expressive of itself, of its own materiality.

We should all have our own Sol LeWitts.

Her studio was in an abandoned textile factory, littered with old machinery and wires. She started to draw what she saw, and soon she was making art with the bits of detritus. The paintings popped off the wall, became bodily, animal, grew nipples and tails, thin cables erupting from holes. She had been working with line in her drawings;

now the lines took up space in the world. How strange it must have been to move from two dimensions into three: a process of 'translation', she called it.[18]

/

When she came back to New York, she left the wall behind; her pieces moved out into the centre of the room, and by the end, with her final piece, *Untitled (Seven Poles)*, they took up the whole damn place.

/

Hesse would situate herself as a Post-Minimalist, working with repetition, scale, grid, and industrial material, but unlike artists like Donald Judd and his followers she insisted on giving her work the organic, unfinished, tactile quality that she thought was missing from theirs. She and LeWitt would raid the shops on Canal Street for material that would inspire them. At that time Canal Street was filled with stores selling all kinds of stuff to do things with: little rubber things, round things with holes in them, tiny steel things, sprocket-y things, things that went around other things, things that went inside other things, things that stacked, clattered, spun. It's dauntingly abstract, but for an artist like Hesse it was a wonderland of new possibilities. She started working with rubber tubing, rope, cords, magnets, wires, weights, washers, resins, silicone, silastex. She enlisted the help of a company called Aegis Reinforced Plastics, which helped artists with the technical side of their art dreams. She was drawn to materials like rubber or fibreglass which weren't known for their longevity. Vita longa, ucky brevis. ('Form — it's because there are consequences,' writes the poet Lisa Robertson.[19])

Doug Johns, her assistant, described the process of making *Repetition Nineteen* (1968), a series of nineteen small open-topped cylinders, rendered in fibreglass, slightly slouching, like paper bags or crushed soda cans. When she saw what Johns had made, she was aghast — they were too perfect. So she did them again, this time creating models in papier mâché that Aegis promised to reproduce exactly. These worked

much better. Nearly translucent, they managed both to reflect and hold the light, thanks to the way she'd formed them. Hesse's friend Gioia Timpanelli recalls in Marcie Begleiter's 2016 documentary: 'The specificity was personal, was physical, and was her touch, her way.'[20] As Timpanelli speaks she moves her fingers against one another, she screws up her mouth, she evokes, with her body, the specificity of touch.

/

Scott would weave in personal treasures (or even just things she picked up around the Creative Growth studio) to her pieces and then weave over them, so no one knew they were there. Her twin, Joyce Wallace Scott, speculates that all the 'wrapping and covering' was an expression of the abuse and neglect she suffered in the institution, and a means of hiding and protecting 'what had been stolen and abandoned'.[21] This sounds, to me, like a way to read the embodied trauma of Hesse's work.

Phyllida Barlow on Hesse:

The artist is there, embedded in what you're looking at.[22]

/

What happened in Germany? Was it the encounter with her mother tongue that made Hesse's artistic language more 'visceral'?[23] I don't know how sharp, or not, her German was when she went back; maybe she didn't understand as much as they thought she would. Or maybe she understood what she heard, but not what she heard behind what people said. A trip to Hamburg to visit her mother's relatives was fruitless and upsetting. When she went to Germany, says Lucy Lippard, she was an abstract expressionist, but when she came back, she was a surrealist. She was attuned to something prior even to abstraction: to what surrealists and psychoanalysts called the unconscious. This makes sense for Hesse, who was in analysis all her life, starting in her teens.

/

(I don't say this to force a biographical or a psychoanalytic reading of her work, though I'm skating close to it. It's so tempting to put words to it. To make a story of it. The childhood trauma, the loss of her mother, her unlocatable, incomprehensible source in Germany – the work, I feel sure, would have been different without these things, might not have existed at all. Had there been no Nazis. No depression. No bipolar mother. Would there still have been an Eva Hesse?)

/

No. I bring this up because of an artist statement she made in 1968. 'I would like the work to be non-work [. . .] to go beyond my preconceptions [. . .] to go beyond what I know.'[24] The work as a transition between thought and language: what *can't* be put in words, only intuited, felt. The cords coming out of the circles which I can't help reading as milk from her mother's breast, even if Eva herself didn't want children, or live long enough to change her mind. The one called *One More than One* (1967). Streams of milk coming out and ending on the floor undrunk. Or like two severed umbilical cords, Eva's and her sister's. (A line from Judith Scott to Eva Hesse, born seven years, one ocean and two catastrophes apart.)

/

Hesse would have hated this reading. Her circles were 'non-anthropomorphic, non-geometric, non-non'; they were not representing something outside of themselves, not logic or body parts or sexual feeling, they just *were*.[25] Even I hate it a little, with its facile psychoanalysis. But it is what I see. And I do not see why her circles cannot be themselves, and also be something else, memories, desires, propositions.

And yet this inarticulable thing – this is what is hanging from the ceiling in *Contingent* (1969).

Eight panels hang, tacky like flypaper. It's hard to know what they're made of; I'd even believe flayed and stretched animal skin.

There is a barbarism to them. They are a record of communication, like papyrus in a museum. Or – seen in a different light – they look like fabric, like the nightdresses that hang in Louise Bourgeois's *Cells*, or like something Rei Kawakubo would design. I can see it, an oversized sleeveless deconstructed kind of thinned linen apron dress, with two layers of skirt, and untrimmed edges, in a lemony cream colour, with a pocket in a slightly darker colour, the colour of paper dip-dyed to look antique. (I can see it so clearly in my mind's eye I wonder if I'm recalling a dress Kawakubo has already made.)

But the panels are actually cheesecloth dipped in latex, counter-weighted on top and bottom by fibreglass. They are painfully beauti-ful, inflected by what would be her fate; she collapsed while working on this piece in April 1969, and was operated on for the brain tumour that would kill her the following year, at the age of thirty-four.

/

The art critic John Perreault reviewed Hesse's first solo show in the *Village Voice*, describing, not unkindly, the 'rough illegibility' of her work. It provokes, he writes, 'bizarre anthropomorphisms' whose 'queasy uneasiness [. . .] makes one want to stroke them gently, to soothe and smooth them down'.[26] Perreault was a great champion of women's work, but his tone here does strike me as a little conde-scending. It's coming from a good place I think, but still: in Perreault's fairy tale he is the art prince come to soothe the beautiful, damaged princess. He wants to turn her texxture into texture.

/

Rosalind Krauss sees *Contingent* as 'a retreat from language, [. . .] a withdrawal into those extremely personal reaches of experience which are beyond, or beneath speech'.[27] Well, almost. If the work is 'illegible' or seems 'beyond, or beneath speech' it is because we are still not seeing the work itself *as* speech, or rather, its texxture, as eros.

/

I will paint against every rule. Instead of oil paints she wound up using industrial materials *as if* they were paint, utterly against the way they'd been conceptualised by their inventors and producers and marketers; she subjected industrialism and all we might associate with it to her personal vision. And in so doing she stripped out the *superficial dishonesties* from her work, building it up again in layers of latex. Hesse wanted her materials to look handled; for the visual to contain suggestions about what it feels like, what it might have felt like to make it, information which may be totally at odds with the actual materials and process. The *Accession* series (1968–9) looks soft and furry inside, but I bet the 29,000 plastic tubes are more resistant than they look, or who knows what they'd feel like today, fifty years on . . .

/

Looking at Hesse's work alongside Judith Scott's, I think about all the pieces Hesse made with fibres, the cobwebby fibreglass cord thing called *Right After* (1969), dipped into latex and loosely hung from the ceiling, or the ropes of *Untitled (Rope Piece)* from 1970, like a ship's rigging after a bad storm. She allowed for the former piece, as she wrote in her diary, 'to be hung irregularly, tying knots as connections, really letting go as it will, allowing it to determine more of the way it completes itself. non-forms. non-plans, non-art, non-nothing.'[28] 'Maybe I'll make it more structured, maybe I'll leave it changeable. When it's completed its order could be chaos. Chaos can be structured as non-chaos,' she told *Life* magazine, for an essay that included images of Lynda Benglis pouring her multicolored latex on to the floor of an art gallery.[29]

Everything is connected; we are bound up in each other; Scott and Hesse tried to show us this. And the connections often lie outside of what can be spoken, within what can be strung together; silent links are, too, a kind of articulation.

/

Much of Hesse's art has today become unstable, has changed colours, or grown brittle and fragile. Sources do not agree on whether

this eventuality mattered to her.[30] Doug Johns told her when they first started working together that rubber is 'fugitive': it doesn't last more than ten or fifteen years before it starts cracking and turning to dust. 'She said: "Good. Let them worry about it." Talking about the museum people. "So what. I want what the effect is *now*."'[31]

When she started making this work, she owned the specificity of her medium, and all its mortal implications. By 1970, facing her own mortality, she was less bold. 'At this point I feel a little guilty when people want to buy [latex works]. I think they know but I want to write them a letter and say it is not going to last . . . life doesn't last, art doesn't last, it doesn't matter.'*

Which brings me back to Woolf in her bathtub, where I can imagine her, forty-nine years old, five years older than I am when this is published, contemplating her body in the water, the irrefutable and irreversible changes wrought by time on her flesh, and I wonder if her changing, ageing body was at the root of her intuition that it was necessary to speak of our public and private lives at the same time, that one was not possible without the other. To be in a body is to live with failure, to acknowledge eventual decay; to tell the truth of one's experiences within that body has to involve making room for failure, and decay, in one's practice. Like Woolf's, Hesse's work was a question of throwing in her luck with materiality and its uncertain futures. Life is matter; matter has limits; form has consequences.

* In a roundtable discussion in 2000, Sol LeWitt claimed that she wanted her work to last. 'She certainly didn't have the attitude that she would mutely sit by and let it disintegrate before her eyes.' Jonathon Keats, 'The Afterlife of Eva Hesse', *Art and Antiques*, April 2011.

the nature of fire

I have been thinking, lately, about an image from the film adaptation of Ingeborg Bachmann's *Malina*, the one with Isabelle Huppert bent down to light her cigarette from the open flame of her gas stovetop. It brings to mind a widely quoted passage from that novel, though it's actually a quote from Flaubert: 'With my burned hand, I write about the nature of fire.'[1] Ingeborg Bachmann died of the burns sustained in a fire that broke out when she fell asleep holding a cigarette. This gives the quote a more dire undertone of premonition, shapes the life and the work and that image from the film, too, into a death wish, or at best a dangerous predilection. We have all been burned, and still we go back to the fire, to wonder at its intensity, to try to understand its nature, or our own, in being drawn back.

Some friends and I watched *Malina* together not long ago, each in our own homes, as a way of being together in lockdown. When that scene with the gas flame happened, I thought: that is for the chapter on Ana Mendieta, the artist of the elements, of blood, of fire and rain. Sweet Ana, furious Ana, who came to Iowa from Cuba, a refugee, and made the fiercest, most committed work before her early death in 1985, when she fell from the window of her high-rise Manhattan apartment under suspicious circumstances. How does knowing what would happen to her change how we look at her art? A question we may well ask of many of the women in this book – Woolf, Cha, Hesse, Wilke – but for some women more than others, like Bachmann or Mendieta, it feels important to try to sort out the mythology from the work. This is complicated by the fact that Mendieta's work is itself so invested in myth and story.

Sontag thought that art, at its origin, must have been 'incantatory, magical [. . .] an instrument of ritual'.[2] This is certainly true of Mendieta's *Silueta* series (1973–80), in which she traced the outline of her body in the ground, burning or carving and kneading the earth

until it made the form she wanted. Later she would use a piece of plywood to create the human figure. Many of the works from the series that I've seen have involved smoke – emanating from some clitoral or vulvic mound or hole in the ground. She poured gunpowder in the shape she'd carved out, and set it on fire, filming until there was nothing left.*

Towards the end of 2018 I went to see some of these Super 8 films. My son was a couple of months old. I'd never left him for longer than it took to have a quick meal nearby; it was the first time I'd even been on the metro since he was born. I headed west to the beaux quartiers where the museums are, hoping to get through Ana Mendieta at the Jeu de Paume and Paula Rego at the Musée de l'Orangerie in something like three hours, and then run home, where I knew, from the videos Ben was sending, that the baby was making little purring sounds at the light-up butterfly suspended above his play mat.

At the Jeu de Paume I sat in a darkened room and looked at Iowa in 1978. In the film, Mendieta set fire to one of her silhouettes, its form traced in gunpowder. It is troubling; it reminds me of the chalk outlines they draw around bodies at crime scenes. I have the same difficulty with her 1973 film *Moffitt Building Piece*, in which she filmed passers-by who looked, or avoided looking at, a grisly splash of cow's blood on the ground outside her Iowa City apartment. 'Instead of making a spectacle of the abject body,' wrote the painter Ara Osterweil in *Artforum*, 'the film presents the afterimage of violence as an occasion for observing the witnesses – a psychological experiment devastating in its simplicity and objective remove.'[3] But the image

* Production note for *Untitled, Silueta* series, 1979: 'In a grassy field, Mendieta mounded an abstractly physical shape using hay and cut a trench running lengthwise along its vertical axis. She filled the trench with a combustible firework material. When the film opens, fire burns at the figure's head and begins to work its way along the trench, toward the base. As it progresses, the fireworks spew from within the recessed space like spilled entrails. The film lingers upon the smoking viscera for the remainder of the reel.' Production note for *Untitled, Silueta* series, 1979, Iowa; in Howard Oransky, ed., *Covered in Time and History: The Films of Ana Mendieta*, Berkeley: University of California Press, 2015, p. 242.

becomes not only devastating, but almost unseeable as a prefiguration of her own eventual death by falling.

I do not want to read Mendieta's work through her death, but it speaks to my anxieties; how you never know which day of the year you're going to die; all the years of my life I've lived through that day and didn't know it, like walking on my own grave. Becoming a mother has exacerbated my morbid thoughts – so much more is at stake now. I go to Ana Mendieta to escape from motherhood, and am confronted with myself as irrevocably become-mother. I cannot heave this new weight from my body.

She gets closer than any artist I can think of to confronting the abject body, and instead of jettisoning it, taking it in her arms, lying down with it.

For Mendieta, *Moffitt Building Piece* was bound up in the recent rape and murder of a student at the University of Iowa. That was its meaning for her: the ever-present threat of violence against women, of domestic violence, and onlookers' reaction, or non-reaction. Smoke emanates from the grass and brush all around.

But after the fire has burned out, what is the work? What is left behind? After the fire is out, Mendieta's camera lingers. From time to time, a puff of smoke.

The wall captions read: memory, history, ritual.

/

Yagul, Mexico, 1973. She places herself in an Aztec tomb, covered with flowers. 'The analogy was that I was covered by time and history.'⁴ We see: feet, legs, arms, hair, no face, only flowers.

Yagul, Mexico, August 1974. A pile of rocks pulses, as if something beneath them were breathing, and they fall away from the disruption. Ana Mendieta is beneath them, as if she were the ground coming to life – or going to ground, the other way, expiring there. The rocks must be heavy, crushing her. It reminds me of Michelangelo – the way he chisels away at the rock to free the statue trapped inside. But here, the statue is alive. (Hesse: 'Is it right for a girl to be a sculpture?')

More smoking gashes. Figures etched into the ground. Wings outstretched.

/

A fireworks piece. *Silueta de Cohetes*, made in Oaxaca, Mexico in 1976. A form appears, in flames. It looks like a burning cross. The smoke streams off it and little embers fall here and there. The thing transforms as it burns away. It takes a while for the last flame to go out, but the camera cuts out before it does.

As Mendieta put it in 1982: 'Through the making of earth/ body works I become one with the earth. It is like being encompassed by nature, an afterimage of the original shelter within the womb.'[5]

Was Mendieta studying the nature of earth or the nature of fire? Not what fire does to earth but what earth does to fire?

/

University of Iowa, October 1974. We see her reflection in a mirror that leans against a small thin tree. Her head is bent forward, her long hair falling over the shoulders. Pre-Raphaelite. She looks almost as though she's pregnant (Sontag quoting St Jerome: 'The one there [. . .] is pregnant with his own death'), hence the piece's title, *Mirage*.[6] She embraces her belly. I see in this image Francesca Woodman's *Untitled*, made some time between 1972 and 1975, the one where she's naked and crawling through a gravestone in Boulder, Colorado. The slow shutter release and long exposure has captured her as a blurry streak like a ghost. Something about the natural backgrounds, the long straight hair, the similar timeframe, the ultimate deaths by falling to the streets of Manhattan (but it's not the same, pushed or jumped, it's not the same), makes my brain file them together. I hate it. I have to stop seeing these girls as ghosts. The critic Elizabeth Gumport writes on this tendency in an essay on Woodman for the *New York Review of Books*:

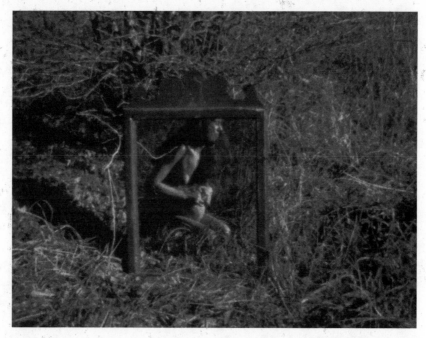

Ana Mendieta, still from *Untitled (Mirage)*, 1974.
Super-8mm film, colour, silent.

Everyone agrees that Woodman's work is too often evaluated in light
of her suicide, her ghostly portraits miscast as experiments in self-
effacement. 'Francesca Woodman,' a friend says firmly, 'was not trying
to disappear.'[7]

I agree with her friend: I think she was trying to *appear*. Like the
deeply asthmatic photographer Alix-Cléo Roubaud, who also made
nude self-portraits during this period in empty decaying rooms, a few
short years before her early death of a pulmonary embolism in 1983.
The silhouette prefiguring the grave.

Did they all see each other's work? Alix, Francesca, Ana? Was it just
l'esprit du temps that possessed each of them, that was recorded, like
a ghost, on the sensitive paper of the photograph?

There's an old cliché about the brilliant girls burning bright in their
youth, too brightly to last. Kara Walker drew their silhouettes. And to
them Harryette Mullen made the answer: *Don't burn. Consume yourself
more slowly*.[8]

Francesca Woodman,
Untitled, Boulder, Colorado, 1972–5.

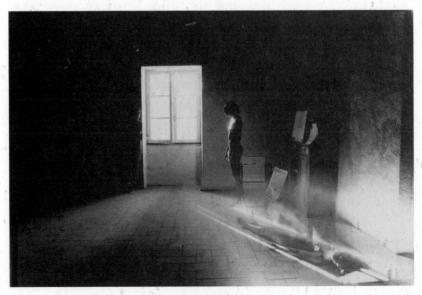

Alix-Cléo Roubaud, *Sans titre*, from the series
Si quelque chose noir, 1980–82.

/

Like Hesse or Schneemann, Mendieta began as a painter, and then moved off the canvas, out into the world, to the earth. In a 1981 artist's statement, she wrote that the work she did as a painter lacked the 'power' and 'magic' she wanted to convey.[9] She decided, then, that she had to go 'to the source of life, to mother earth'. She made her sculpture on a 'human scale' in order to think about 'the body as an extension of nature and nature as an extension of the body'. There is something about the tight framing of the siluetas that means you can't really tell how big or small they are. Mendieta herself was tiny, barely five feet tall. They vary in shape and posture, some with arms down at sides, others with hands up in an archetypal goddess posture, or as if in response to a man with a gun. Different ways of going into the earth.

She saw the *Silueta* series as a 'dialogue between the landscape and the female body', a direct result of 'having been torn from my homeland (Cuba) during my adolescence', an experience she described as 'having been cast from the womb (nature)'. Her art, then, was a 'return to the maternal source'.[10] By using her body, she wanted to 'transcend' it 'in a voluntary submersion and total identification with nature'. She saw this as a means of making contact with Cuba, the culture, its land, and with her ancestors. She took colour photographs of the earthworks she made, to preserve for a moment her engagement with nature, and then left the place to be returned to the earth.

Pain of Cuba / body I am, she wrote in 1981.

The gash is the making visible of the wound. The blood, the afterbirth.

Lying in the earth, an experience of the grave. How comforting to feel all that weight on oneself.

/

Read it back the other way. To her childhood in Cuba, their world on the beach, playing in the sand, making sandcastles, making shapes in the sand, enormous female bodies with massive bosoms to make everyone laugh.[11] She was, by all accounts, a tiny, beautiful little goofball. She was born into a well-established old Cuban family, and spent summers and holidays at her grandparents' massive home on the beach. Read it back to the kitchens of their own home, where Mendieta and her sister would sneak into the kitchen to listen to the maids talking about Santería. Back to the sense of difference and otherness she herself experienced in America, the racial slurs in Iowa, the slights in the New York art world, which couldn't understand her pro-Cuban feelings. The Mendietas were Catholic; the girls went to Catholic school.★ Transubstantiation as artistic practice. Re-paganised.

'I started immediately using blood – I guess because I think it's a very powerful, magical thing. I don't see it as a negative force.'[12] In one film she stands naked in front of a creek and slowly covers her body with blood – she bends over and dips her hand in a jug and smears it on her legs first, then her arms, stomach, breasts, buttocks, then her face. A little bit of a femme à sa toilette vibe – as if the blood were a moisturiser or some other form of self-care or decoration. A bloody vanitas. An intense ritual of the smear.

/

Blood Sign, 1974. She traces a line in blood around her body on a white wall, using her hand to smear the blood. Makes a line like a doorway arch around her. Hair like snakes down her back. 'There's a devil inside

★ In the schism between the Catholic Church and the Cuban Revolutionaries, Ana's family took against Castro and decided to send Ana and her sister to America so they would not have to live in a Communist country, and where they could practise their faith freely. Their father, who was involved in the revolutionary movement against Batista, subsequently fell out with Castro's regime, and for a variety of reasons agreed that his daughters should leave Cuba. The girls' mother and younger brother followed five years later, and then eventually Ignacio Mendieta, who was imprisoned for eighteen years, was allowed to go.

me,' she writes in blood inside the arch. The 'me' she goes over and over with the paint, transforming the letters into abstract forms. This is all at odds with the emo piano music I can hear in the other room, accompanying a documentary about Ana Mendieta, narrated by the artist herself.

One of the siluetas she filled with blood.

/

Self-Portraits with Blood, 1973. Four of them – it looks like she has been beaten up. She looks defiant in one of them. Devilish indeed. Almost as if she had willed herself to bleed from the head, nose, mouth. The blood makes different shapes on her skin – drying in topographic patterns. In another it looks like she's sweating blood, coming out in little droplets all over her forehead. The blood inside becomes visible through her own effort, not because someone has beaten it out of her, or pushed her through a window.

/

Critics talk about how she began with work in which the body was absent – like the *Moffitt Building Piece* – then put the body back in the self-portraits with blood and hair and feathers and water, then in the later work took it out again. In the siluetas, we catch her in between: the work is still about body. About its removal, and about tracing it, the hard work of carving those shapes in the ground, in the heat (or was it the cold). Later on when she was in Italy on the Prix de Rome fellowship, she started making earthworks that weren't site specific, and carving and burning into the trunks of trees taken from the forest. These re-placings of earth and arbour seem significant, as images of unnatural exile.

And yet – even in the images where the body is not visible, it is still there; bodiliness is still felt. Schneemann comments on this in her talk: 'the incredible presence, how *inhabited* it is.'[13] In Santería there is a belief that the gods and spirits can inhabit a plethora of natural

forms. 'I'm not interested in the formal qualities of my materials, but their emotional and sensational ones,' Mendieta said.[14] Her work was about exploring what we can know about the earth from working with it. About the materiality of the elements, and being guided to work through them; harnessing them, like the first human who figured out how to put fire to work for herself. And the role of the body, in this ritual of serving and being served by the elements.

When Schneemann said *We have forgotten the dangers of depicting the explicit female body, how much anger and resistance that inspired*, she was saying that by depicting the emotional, the sensual quality of material, Mendieta risked the kinds of misreading she was given, for instance, by Donald Kuspit in 1996: 'Mendieta clearly had a troubled sense of self, as her very self-centred art – in which there are not only no men, but no other women – suggests [. . .] Mendieta preferred to have narcissistic intercourse with Mother Earth than sexual intercourse with a man.'[15] Or by Calvin Tomkins, who described Mendieta as having 'an original and somewhat morbid style of art-making which combined elements of performance art and earth art; she used her tiny but voluptuous body (she was four feet ten inches tall) in direct and visceral encounters with raw nature'.[16] Morbid? Voluptuous? Are we even looking at the same body, the same body of work?

Her husband Carl Andre, on the other hand, was the master of matter, the 'materialist' as a 2011 *New Yorker* headline calls him. His 2013 show at the Turner Contemporary, Margate, was called *Mass & Matter*. In 1988 he was put on trial for her death, and acquitted.

/

The physicists called in by the prosecutor calculated that Mendieta fell 269 feet in 4.21 seconds at 120 miles per hour. There is a lesson in mass and matter.

/

At the trial Andre's lawyers tried to use her work to argue that she was morbid, suicidal, disturbed.[17]

/

The curator at Dia Beacon, Philippe Vergne, gave his take on the story to Tomkins:

> Carl broke something, and he was ostracized, and it's part of the story. But the work is there. We are a museum, not a court of law, and he is one of the most important artists of our time.

Maya Gurantz comments in the *Los Angeles Review of Books*:[18]

> *Carl broke something.* Something. Not someone, not a woman, or an artist on the verge of a major career who hasn't been able to make work for 32 years because she's dead. He broke something. Not just a thing, but *some* thing. Some thing over there. He broke it.

Carl broke something, but his life has gone on, has accommodated that disruption. Mendieta's couldn't, because she was too dead.

I feel myself – slipping – into the self-righteous – outrage – the anger – the kind you always – find in – essays about Mendieta. [*gasps*] I feel we have every right to it. He still gets massive shows, his work sells for millions of dollars. He still lives in the same apartment. [*hisses*] They say his new wife does window paintings.

'To myself, I am invisible,' Andre tells Tomkins. To the rest of the world he's pretty damn visible, Abe Lincoln beard, overalls and all. But where is Ana Mendieta?

/

She died on the 8th of September, 1985. Carl Andre called 911. This is what he said:

> My wife is an artist and I am an artist and we had a quarrel about the fact that I was more, eh, exposed to the public than she was and she went to the bedroom and I went after her and she went out of the window.[19]

I can imagine the frustration that built up over the summer. Sensing, in Rome, that she was breaking through. The feeling of a new

year beginning that September, projects taking shape, commissions to fulfil. The ambition, wanting to do more, create a space in the world for herself.

I can't imagine his sang-froid in these moments after his wife disappeared through the window, the professional explanation; that is a detachment I can't imagine.

In his true crime account of Ana's death and the ensuing investigation, Robert Katz describes the state of the body the police discovered.[20] I regret reading it: the female body reduced to abjection, again.

She is buried, with her parents, in Cedar Rapids, Iowa. In the siluetas, she photographed herself with flowers growing out of her body.

Kathy Acker is my abject

When I talk about this book, people want examples. *Who are your monsters* they ask, and Kathy Acker is usually the first one I say. *Ah*, they nod. *Yes. Art monster.* But she's a tricky one. Drawing closer to her I feel susceptible to the very trap I was hoping to avoid: the art monster as heroine, or anti-heroine; as rhetorical flourish, or figurehead, instead of a (once) living, breathing person.

Kathy Acker is, in a sense, my abject, a writer who brings me up against the limits of myself. There are biographical echoes: we're both from Jewish families in New York; we both left the US for Europe; her second husband, like mine, was (is) a composer, and they both trained at UCSD with the same advisor. We have similar interests in the erotic and occult corners of French literature as well as in high French theory. She was intensely networked into the world of female artists and critics that so inspire me – she knew Eleanor Antin, Carolee Schneemann, Martha Rosler; she even slept with some of their husbands.[1]

And yet her voice had never particularly spoken to me, not until I started researching this book. Flip through the early pages of *Blood and Guts in High School* and you'll be greeted by doodles of penises and labia ('My cunt red ugh' she writes), scenes of graphic sex, violence, incest, rape.[2] It wasn't so much the violence or the filth that turned me off. My issues with Kathy Acker have had far more to do with our differing attitudes towards literary history: who we write from, and towards.

/

Woolf said that as women writers we 'think back through our mothers', to a heritage of work made by women writers like Jane Austen, and the Brontës, and George Eliot, but the lineage Acker laid claim to is a male one.[3] 'Melville & Burroughs & Hawthorne & Berrigan &

Kerouac,' she scrawled in a diary entry on the title page of her copy of Herman Melville's *White Jacket*, not to mention Georges Bataille and Jean Genet.[4] Outlaws, yes, queer, of course, but always male. It's true she used a Burroughs- and David Antin-inspired method of cutting up and plagiarising to – as an 80s feminist critic would have put it – subvert the tradition through appropriation, feminising Don Quixote and Charles Dickens's Pip. But I also get the sense that Acker wanted to be *part* of it, to transcend her gender and rank up there with the big swinging dicks. Look at her light up when Angela McRobbie compares her to William Faulkner, in a conversation they filmed at the ICA in 1987, visible on YouTube. The incorporation of other texts into her work, which some people call appropriation and still others plagiarism, she called *piracy*. Kathy Acker was a legendary self-mythologiser, and it was among the pirates she cast herself. I'm sure some of this was deliberate and born of necessity; to be an experimental writer in the 1980s was to be a male writer, and women writers had to negotiate that bias however they could, including building up a monstrous self-regard. Her private writings show her questioning the way she positions herself, and reaffirming her place in the American literary tradition. On the title page of *White Jacket* she wrote:

> Kerouac Burroughs what the hell am I doing? Drunk now. Am I living out their myths? I am the main writer in the US. So why this necessity to throw myself outside the world?
>
> [. . .] A woman following Burroughs & Kerouac. American writing. American writing is very important, I mean the tradition of Burroughs & Kerouac that is the tradition the tradition of the human who makes his own way. [. . .] No other writers have done this. [Approaching the bottom of the page] Blood on the line carve out your blood. This is the tradition, Adventurers. Pirates, Con men.[5]

Why this necessity to throw myself outside the world? Acker self-abjected right out of social convention and nicety. Her girl heroes – the queen-regents of misrule, the bear-ladies, the roaring girls, the benevolent tyrants of city thieves and city murderers – draw their sharp swords and restore to the honest citizens of the city their lost jewels. In *Portrait*

HERMAN MELVILLE

was born in New York City in
1819. At the age of 18 he shipped
as cabin-boy on a voyage to
Liverpool. He abandoned the
sea for literature in 1844, and
literature for a minor post in the
New York Custom House in 1866
—a post he held for 19 years.
He died in New York in 1891.

Melville & Burroughs & Hawthorne
& Berrigan & Kerobac.

those in exile who chose exile. those unlike Sylvère who don't look to the world's opinions. No, I'm not concerned w/ fashion.

Herman Melville

Melville sd. I'm going to do any-thing I can to see the world I mean the whale & he did & it wasn't any fun. Whether you die or not isn't crucial. Lowell Melville's one hero. there are those who don't understand. Most don't understand. the tradition is very strong & it isn't compromisable & it's the only thing we call art. ®

WHITE JACKET

OR

The World in a Man-of-War

With an Introduction by

WILLIAM PLOMER

So when the teachers come & they tell you how to write a poem & they blab about technique or the art entrepeneurs put the make on you you have to be in a certain fashion you have to hang out at these clubs you have to explain why you do what you do w/ these explanations you don't even need to shit on their faces cause all that crap like the univer-sities doesn't exist. ®

GROVE PRESS, INC. / NEW YORK

Call me Ishmael. You want to teach writing? You want to make a soul node. Flesh against my flesh.

Kathy Acker, annotations on the title page of Herman Melville's
White Jacket: or, The World in a Man-of-War, 1856.

of an Eye – another wink at Bataille – the girl pirate Moll Cutpurse declares, 'If a member of my gang misbehaves, I send him to the gallows. I'm king.'[6] And in *Empire of the Senseless* she writes: 'As long as I can remember, I have wanted to be a pirate.'[7]

In a 1996 interview with Acker, the literary critic Larry McCaffery supplied a list of 'outlaw' artists who comprised the tradition he believed Acker is writing into: 'Sade, Baudelaire, Rimbaud, Lautréamont, Jarry, the surrealists and dadaists, Bataille, Artaud, Genet, Burroughs, Johnny Rotten, Patti Smith, Charles Bukowski.' Acker agrees, says she thinks of these people as following the ' "black path" of the poète maudit', and that it was her reading of Kristeva's *Powers of Horror* that helped her realise she was on it.[8] 'The path of abjection', she calls it, which 'present[s] the human heart naked so that our world for a moment explodes into flames'.[9]

What's interesting about this list – and it's a group of names you always, *always* see associated with Acker – is the way it functions to legitimise her work within a certain masculinist or at best androgynous avant-garde tradition. Those we cite, with whom we choose to affiliate – it's a strategic choice, a way of controlling how we're read. I don't blame Acker or her defenders for doing it. Her work is *so* transgressive that it's unsurprising she would try to find a male pack in which to run, ride bikes, get tattoos, bodybuild, get that gold tooth: anything to protect herself, and to distance herself from femininity, because everyone knows femme-y girls can't be outlaws, only princesses and mommys.

Acker, unloved and deserted by her mother, who likened having a baby to having cancer, who could not abide the idea of motherhood.

So I am her abject as well.

But the result of placing Acker on the path of abjection is that it imprisons her there; it generates the same readings of her, over and over. The path of abjection, for Acker as for the others, is a feint. It's part of a genuine social and aesthetic programme, an ethos, sure, that part's real. But the game of referencing is also a bit of PR, and I think there's more to say about Acker, the body, and the outlaw text than reading her through these bad boy forebears would allow. Despite the claims she makes about the abject in her McCaffery interview and

elsewhere, we need to take a larger view of the role of embodiment in Acker's work.

It was in her work that Acker took the most chances, violated the most mores. She took the (more or less) well-behaved texts of others and spliced them with her own imaginings, riffing on them, blending and recombining. She borrowed from art high and low, from works of great literature to romance novels, encompassing everything in between. 'To mix them up in terms of content and formally. / Offended everyone', she recalls in her essay 'Dead Doll Humility', breaking the sentence *and* the sequence.[10]

Acker practised literature as collage, as bricolage, as slash: separating but also conjuncting, bringing things together. Other people called this plagiarism, if they were doing her down, or appropriation, if demonstrating their knowledge of such practices.[11] Slash: a genre of fan fiction that queers the original. How else are we going to consider the work of a writer that sneaks up on Cervantes and twists his characters back and forth across gender lines and centuries and cities and continents wringing meaning he never dreamed his novels contained? Sometimes she used parentheses to offset her own writing – often cribbed from her diaries – from the language she'd taken from other sources. (Parentheses as a pair of gentle slashes in the text.)

She's sceptical of a singular unified 'authentic' voice. Instead of 'authentic' she bills herself as 'schizophrenic'.[12] That she probably got from Deleuze and Guattari. Schizzy, she says in her 1983 *Bomb* interview, which could read as schizzy rhymes with *fizzy* or with an Italianate *zz* like *piazza* or *pizza*. There is a sweetness in her work, a neediness, a desire to communicate something, to connect. She found those connections in other people's writing, responded to them, wove them together with her own, so the collage of it is sometimes hard to discern. Sometimes I know for sure when it's her, but other times I think I get a glimpse of something else. As if Acker's writing, her tone, her touch, has overgrown what she's borrowed, like moss on a grave. Or sometimes the two have blended into an astringent cocktail I'm not sure I like. I don't even really want to know what's what.

And yet there is a Kathy Acker voice: it is unmistakable. There is simply no way of reading it and thinking you're reading anyone else.

It's filthy and conversational, engaging and off-putting, earnest and mocking. Above all, it's hilarious.

Here is a paragraph from her novel *Empire of the Senseless* (1988) which I think goes to the heart of the problem of Kathy Acker, the voice, and the abject:

> 'Don't touch me but whip my cunt' the young whore said to me. [. . .]
>
> I laughed at myself and gave her what she wanted. I pierced myself through her belly-button. I thrust and pushed her own blood up her womb. As her red head rose out of the white fur, her mouth opened: monstrous scarlet. Tiny white shells appeared in that monster sea. 'My little dead shark. Better than dead fish.' I whispered to her while I fucked her in her asshole.
>
> Stray sprays of my sperm streamed down the stuffed animal's left leg.[13]

This is why I avoided Kathy Acker for so long. The first time I read this, back in grad school, I put it right back down. I had come across Acker's name in academic studies of twentieth-century experimental feminist literature, and I sought her out within that context, but found nothing like the lyricism of Jeanette Winterson or high-Shakespearean eloquence of Djuna Barnes. I couldn't understand Acker's work as feminist or even as literature. The mix of high and low, the refusal to pin down the narrative into some recognisable reality, the insane goings-on with the stuffed animal (try to imagine the Angel in the house contending with that last line!), it was so – *bizarre*. It was like sexy Mad Libs, completely random words thrown together around other words like *cunt* and *fuck*. I could make no sense of Kathy Acker. There was no reading this book.

I find this ironic now in a way I couldn't appreciate then, eager, as I was, to crack the code of any text I encountered, no matter how impenetrable. Ironic because the book is highly penetrable – and it wants to penetrate us. Ironic because the book is about senselessness and illegibility, the ways in which patriarchy and late capitalism degrade language. It is an asemic novel about asemia: writing without language, which really is a dressed-up form of *noise* (something she would have

learned from her time around the avant-garde composers). The novel's called senseless but it's actually sense-full, sensuous. It's just that it's up to you to receive the sensations, to intuit what to do with them. It can't tell you what it's about; no one can. Acker's prose is a kind of slash-trash poetry, the kind that upends everything you thought art was supposed to do; we're fed all kinds of claptrap about art and empathy and actually, *actually*, Acker shows us that art slashes at our received nonsense about it, and that 'poetry is what fucks up this world'.[14]

I had thought that Acker was teaching women to hate their bodies, and to revere cock. I had it wrong. Like Louise Bourgeois holding *Fillette* or Lynda Benglis holding the dildo, she'd grabbed that dick like a toy and was using it as a lightning rod to channel her own power. She sang in the first person of the cunt seizing the phallus between its delicate little teeth, but mainly she sang of the body that *felt*.

What does the body mean when it has sex all the time? When it's sick all the time? What does the body mean when it is female, when it has been hurt, when it has been pleasured? What does the body mean in the age of AIDS, when almost everyone in your community has been felled by the disease and your government doesn't care, and all the people walking down the street with you every day don't seem to either? What does the body mean when it is pierced and tattooed and trained to precision and your sister is the president of her tennis club? What does it mean when the body is oppositional? Grotesque? Beautiful? Hard? Soft? Slick? Smooth?

In an essay on Goya, Acker takes particular interest in the 'Black Paintings', which he did on the walls of his farmhouse outside Madrid between 1820 and 1824.

> Goya, who had before always been interested in making money out of his work and was successful at it, didn't want to show these paintings to anyone. He refused to have language. Why?
>
> [. . .]
>
> The only reaction against an unbearable society is equally unbearable nonsense.[15]

For Acker, who for good reason mistrusts conventional narrative, the body offers its own language that is at least a place to start.

/

From early on, she was interested in the problem of the mind, the desiring body, and the language with which to speak it. I am thinking, for instance, of a film called *Blue Tape* that she made in 1972 with the artist Alan Sondheim, when she was twenty-six, in which they talk about philosophy, perception, power, the structure of desire, and perform sex acts on screen.[16] It is emotionally cramped and questionable on the level of consent for both of them; it is in all senses the inverse of *Fuses*, and both parties considered it an embarrassing, failed experiment. Here is Chris Kraus on the film (I quote at length because this is useful):

> Acker, unknown, could not have picked a better ally or adversary than Sondheim, who, at thirty-one, had just written a three-hundred-page tract called *A General Theory of Reality*, purporting to investigate states of emotion through consciousness-hierarchies. In the mid-seventies, high minimalism ruled in the art world. The uncompromising deadpan purity of artists such as Robert Smithson and Agnes Martin dominated the landscape and it seemed the only way a newcomer like Sondheim could break through was by making work that was denser and more difficult, to the point of being absolutely incomprehensible. It was a mannerist phase, in which a puritan work ethic was highly rewarded. Sondheim's most impenetrable musings were praised by Robert Horvitz in *Artforum* as proof of 'the seriousness of his commitment'. Like the metaphysical poets three centuries before them, the minimalists saw the mind as high, the body low. Acker's guttural insertions of herself into found histories and biographies ('No one touches me; I'm constantly horny; I think only about sex. I don't like sexual explosions getting mixed up with hampering my work. I'll do anything to fuck' – *Lives of Murderesses*) were like an atom bomb exploding on the minimalist horizon. When Sondheim faces Acker, *Blue Tape* becomes a shoot-out between high minimalism and what would become punk's new narrative.[17]

Young Acker, blinking through spectacles at the camera, looking like a young Emma Goldman (says Chris Kraus) while Sondheim reads out a letter she sent him and they argue, politely but urgently, about power and who said what and what they meant. She looks impossibly young and vulnerable, her face smooth, almost unrecognisable except for her voice, the same voice as when she's older, that New York twang. Sondheim is a hoot, young and nervous and pretentious, scared of his body and scared of hers, subject to her charms but already wary of them. 'You're a very powerful person,' he tells her. 'And God knows if you're powerful now what you're gonna be like in a couple of years. [. . .] You're gonna burn people. You're gonna kill people, you really are.'

Cut to an image of her fondling her breasts. Black and white breasts and hands are all we see, like a Man Ray photograph brought to life. He desperately tries to talk about *externals* and *history* instead of 'what's going on inside of me'; as she touches herself she maintains her position of power and he tries to focus on reason and she goes on fondling her nipples. In voiceover he races onward, talking about hierarchies and structures of thought, defending himself from the physical onslaught: *I would rather talk about sexuality than do it.* He is striving for self/knowledge, his disembodied voice all mind against body, while there on the screen she is body only, disenvoiced body, she speaks with her fingers, she nuances her nipples.

In the next scene the screen fills with a shot of her vulva and clit and his fingers stroking them. It is hard to say why, but compared with the blurry jouissance of *Fuses* this feels invasive, too literal. I do not want to see Kathy Acker's muff. But then the mirroring power of the filmed sex act sets in, bringing with it arousal, an arousal I don't want, not here, not in this context, but it's science and it's the body, and here I am getting turned on by Kathy Acker getting fingered, and then – *ow! your fingers are too dry,* she reproaches him, or *that's too high,* or *oooh, what the hell are you* doing – she interrupts this visual pleasure with her fishwife protestations. It's Brecht, pure alienation technique, in an echo of the ways in which experimental film itself uses disruptions like static or jump cuts to keep us from getting too comfortable as viewers; it interrupts and short-circuits

our (narcissistic) visual pleasure. This is not pornography, Acker reminds us, but sex acts on film; there is a difference and she's well aware of it, having done her time as a stripper and performer in the 42nd Street sex clubs. The goal isn't to get us off but to make us think about how and why we get off. This isn't going to be a heteronormative teleological sexual interlude, not if Acker can help it: *I'm never gonna come*, she tells him.

There's an imbalance in power because she is able to pleasure him more than he can pleasure her, as we find in the next scene, in which she performs various sex acts on his lower torso; he desperately clings to his train of thought as she tries to throw him off off off. She is tonguing his asshole and he is saying *I am wondering if I am going to come as I am desperately trying to hold on to my language [. . .] it puts a certain force into my words that I'm not quite sure I can get out.* He forces himself to talk about abstractions and political structures but it's very difficult when she is forcing him into his concrete body. It goes on for long enough that it, too, slips the conventions of pornography to become an act of sexual terrorism exacted on the hegemony of reason. Sondheim, who demonstrates admirable self-awareness even in these torturously pleasurable situations, says he's afraid he will fall into a place where he doesn't understand any more; he wants to hold on to speech, to understanding, *I want to hold on to myself.* He recommits to his role in the project. *Ok what I'm doing is phenomenology it's very abstract there's a certain pulling in my penis and a certain heat and she has her finger in my anus and that feels real good and I keep tightening my muscles and wondering how much of me is in her and as long as I can think this everything is ok I'm afraid of losing having to yell having to give in in a certain way*; then he wonders if his holding back is actually a way of *winning. the battle.* When he comes he screams like a little girl and begs the camera operator to cut.

Then we see Kathy without her glasses and she is startlingly pretty. She runs her hands all over her face like Hannah Wilke in *Gestures*, which she would only make two years later (did she see *Blue Tape* when it was screened at the St Mark's Poetry Project?). Acker runs her fingers all over her lips and teeth, this powerful mouth that just made a man lose himself, over her fingers and arms, the source of her

womanly charms according to all the painters, she takes possession of her body, of its strength its beauty its power, every inch of it, its fur, its curves, its knees (Kathy Acker's knees!), its toes.

It ends with her writing – first read in his voice, then in her own. *I am tired of the words I my I my I my*, as if with regret for the harm she has caused, in her monstrous her-ness, her skilful corporeality. For using her great gift to vanquish a mind.

/

While some of Acker's writing on sex does seem calculated to shock or amuse, it also seems to be trying to reclaim that life of the body – to bring it into bounds not as 'pornography' but as realism. Acker's language is visceral, which, classically trained as she was, she would have known derives from the Latin *viscera*, the plural of viscus, internal organs. Emotion in antiquity was thought to dwell in the spleen, the kidneys, the stomach, the intestines, the bowels. All feelings were gut feelings. The word *repel* is a physical one as well, comes from the Latin *repellō*, to drive back, but in *pellō* there is contact, there is touch – and not only because we also hear in it *pellis*, or skin.

The things that repel us touch us, even as they push us away; there is skin contact. I dive into Acker not the way I would read another author, start to finish, but dipping in and out, on the lookout not exactly for beauty but not *not* for beauty, either. No beauty that would make sense in any particular context but something that would leap off the page at me. *There's a kind of beauty, you know*, she says is what she was going for. *But I didn't want to have to mean by it.*[18] She didn't write for people to read her cover to cover anyway, she said somewhere. The books of hers I've read (by no means all) are piled up with post-its sticking out of the tops of them, like frilly mohawks. My scribbled reactions, too many to bring together, resist cohering into a reading, a viewpoint on Acker.

She'd hate that anyway.

Or no: if I were lucky and she were feeling indulgent she'd read what I'd written, maybe her brows would twitch together, she'd repeat

one of the words I'd said, like *grotesque*, like *abject*, like *bowels*, and go *yeah*, and then say something different, something unrelated, and end by pointing out that what I'd cooked up as my Acker reading was only part of the story; that Ackerness escaped.

/

Ackerness, I want to say, is a language of the body, not of the rebellious superego. Ackerness is using the body to access the unconscious, to find a language that situates the mind firmly in the body – what she called a *body language*.

To access the unconscious, the surrealists wrote while sleeping. Acker famously wrote while masturbating:

> One thing I do is stick a vibrator up my cunt and start writing – writing from the point of orgasm and losing control of the language and seeing what that's like.[19]

It was her worries about 'self-censorship' that prompted her desire to find a language to let the body speak, she went on; one that could resist 'expectation' – that is, the fisherwoman pulling the line of the imagination taut, bringing it back in. Fifty years after 'Professions for Women', Acker is finally able to let her imagination go where Woolf's couldn't. 'I wanted to see what language passes through my mind – I don't know how to say this precisely – as I'm going through sex,' she said. 'What does that language look like?' In her 1996 novel *Pussy, King of the Pirates*, Acker shares some of that language:

> While I masturbate, my body says: Here's a rise. The whole surface, ocean is rippling, a sheet that's metal, wave after wave. As *it* (what's this *it?*) moves toward the top, as if towards the neck of a vase, *it* crushes against *itself* moving inwards and it increases in sensitivity. The top of the vase, circular, is so sensitive that all feelings, now circling around and around, all that's moving is now music.[20]

Both Woolf and Acker, at their radically different historical moments, describe the practice of writing as inevitably being faced with some kind of self-censorship, sustaining internalised feelings that they're

doing something wrong, that they need to police their thoughts, language, imagery. That writing itself is a process of grasping after the fish that you know you should leave alone; and that writing is also a project of finding a way to relinquish your conscious, censoring mind. Acker touches herself and the body speaks; out comes the writing, language born of touch, coruscating language, like her gold tooth, winking. To open ourselves to the vicissitudes of the unconscious, let the images float up as they will – Woolf and Acker have been attending to Freud and the surrealists, but they have appropriated their automatic techniques in the service of the feminist revolution. The fisherwoman and the masturbating girl are engaged in the same activity.

Hélène Cixous, too, likens writing done in secret, because done in fear, to masturbating. With this simile she redeems both women's writing and self-pleasure, recuperating them from the realm of shame. In Cixous's essay, the body of writing and the body of the writer are finally, explicitly, shown to be one and the same. *Jouissance* made literal, masturbation as literary process.

Acker:

> Dreaming and masturbation are different techniques of writing. The writings I get from masturbation aren't fantasy narratives but are descriptions of architectures, of space shifts, shifting architectures, opening spaces, closing spaces.[21]

Hélène Cixous:

> Censor the body and you censor breath and speech at the same time.[22]

/

Acker uses an essay about her other love, besides sex and literature – bodybuilding – to write about the fraught relationship between language and the body, how the one can't express the other, but is called upon to try. The essay is perceptive and spare; she quotes Canetti, Wittgenstein, Heidegger, any of whom might be surprised to find themselves called on to elucidate this particular activity. Bodybuilding

is revealed to be not some lowly activity for meatheads but a rich site for understanding what it means to live in the body. She calls the actions of her workout – counting, focusing, imagining, repeating – '*the language of the body*'.[23] Through these repetitions, she writes, 'I am able to meet that which cannot be finally controlled and known: the body. In this meeting lies the fascination, if not the purpose, of bodybuilding. To come face to face with chaos, with my own failure or a form of death.'[24] Though it may lack the cultural capital of ballet or the social cachet of, say, tennis, bodybuilding is actually a nexus of some of the most basic epistemological, philosophical and political quandaries.

Above all, in this essay Acker reckons with the abject, recuperating the body from its grip. 'In our culture, we simultaneously fetishize and disdain the athlete, a worker in the body. For we still live under the sign of Descartes. This sign is also the sign of patriarchy. As long as we continue to regard the body, that which is subject to change, chance, and death, as disgusting and inimical, so long shall we continue to regard our own selves as dangerous others.'[25]

/

The body, the body, lust and the body. She set them in words when she could, or she called on other people to help. She read some bits of Rimbaud aloud for the BBC in 1997:

> I have the pale blue eyes of my Gallic ancestors, the narrow skull, and their clumsiness in fighting. I think that my clothes are as barbaric as theirs. From them I inherit idol worship and love of sacrilege. Oh. And all the vices. Anger, lust. Lust magnificent above all.

With this they have spliced in images of New York City. The Chrysler Building. Super subtle. The camera pans down to ground level, to plants, to cyclists, to cars, as Acker continues reading in voiceover.

> Wasn't there once a time when I felt my youth was a fabulous thing, to be written on sheets of gold? Good luck and despair? I was the great creator of festivals of triumphs of dramas.

The camera comes to rest on a lily, bursting open, its stamen waving a little in the wind.

> I tried to invent new flowers, new planets, new kinds of flesh, new languages. I thought I had acquired supernatural powers. I, I who thought I was a magician, an angel, outside morality.

Whoever's edited this segment is forcing a phallic reading of the work, the kind that made me resist it all those years. But working from within these texts, and working *on* these texts, which are bodies, which are new kinds of flesh, Acker's after new languages that will explode our ideas about the body, at precisely the 'sublime point' (as Kristeva writes) 'at which the abject collapses in a burst of beauty that overwhelms us – and that' (quoting Céline, another poète maudit) ' "cancels our existence".'[26]

Because it is, in the end, Acker's own body she is capturing in words; the body that has read and metabolised Rimbaud and Burroughs and all the others, the body that has trod the path of abjection and disease, the able body which, powerful, can build itself up through repetition, the queer body that takes its pleasure where it pleases without regard for category or label. The body that is, for Acker, a philosophy in the first person.

meat

How are the monsters? asked A, as we sat, bemasked, beside the Canal St Martin.

Coming along, I said. I'm working like crazy. *De manière acharnée.*

I said it in French for emphasis. *Acharnée* felt like the right word for the kind of feral desperate writing I have done for this book, in all the interstices between responsibilities: when my son is at nursery, or with his father; early in the morning before anyone is awake; late at night when I can hardly keep my eyes open. Online at the supermarket. Waiting for the metro. While pushing a stroller. When I got home I looked up the etymology, to see what deeper urge to speak had broken through my English. *Acharné. À + carne.* Literally, *to the flesh.* It was as if I needed to talk about this book, and the process of writing it, in the language of meat.

In my research I kept coming across meat-related monstrosities: Schneemann's *Meat Joy*, Hannah Wilke's wall sculptures like slices of prosciutto, Eva Hesse's bits of dried thinned jerky. The absent correlative steak for Sutapa Biswas's housewife's knives. Kathy Acker commenting that if she allowed her breast cancer to be treated by conventional medicine she 'would soon be dead, rather than diseased, meat'.[1] The meat dress worn by Lady Gaga, whose designer said, 'It won't last, that's the beauty of it.'* The dress itself was a reference to Jana Sterbak's *Flesh Dress: Vanitas for an Albino Anorectic* (1987), fifty pounds of flank steak sliced and sewn into dress form which prompted the art historian Sarah Milroy to read it as an icon of 'female disobedience'.[2] These works are implicitly about decay, and transformation. About the way women and their bodies are treated, and the far ranges of perversity where we sometimes don't mind, as in Tori

* Lady Gaga, of course, calls her fans 'little monsters'.

Amos's 'Blood Roses', from her savage album *Boys for Pele* : that some-
times we're *nothing but meat*.

And then there was the work of the British artist Helen Chadwick
(1953–96), whose use of meat was part of a career-long attempt to bring
the body into art. A 1991 self-portrait depicts not the artist herself but
her hands holding a brain. 'Selfhood as conscious meat,' she wrote.[3]
Two years earlier she photographed, in marbled, unexpectedly shiny
close-up, some raw meat from the butcher's shop. Chadwick layered
these images, printed in Cibachrome transparencies, between panes of
glass, and then mounted them on the wall, backlighting them with
fluorescent strip lights. They were part of a series of 'meat lamps' she
called *Enfleshings*.

In another piece, *Anatoli* (1989), she placed a filament of electrical
light at the heart of a slab of raw beef. Chadwick indicated that she
saw the light as a reference to enlightenment rationality; enfleshing
the light eradicates the body-mind split. 'In a way,' she said, it is 'the
most – I can't say extreme, that's the wrong connotation but direct
and fundamental of the meat lamps, because it is what it is, energy
and flesh.'[4]

She wrote that she wanted 'to catch [. . .] the body at the moment
when it's about to turn. Before it starts to decay, to empty . . . '[5] In
the *Enfleshings*, we see light/life captured in an instant – even though
the animal we're looking at, as well as, I am sorry to say, the person
who made the piece, is long dead.

/

Chadwick's work is an example of how powerfully the eye can intuit
information about texture, and touch, and perhaps even smell and
taste. But according to Marina Warner, Chadwick 'chafe[d] at the
Western emphasis on sight as the prime instrument of perception',
and sought out 'the limits of the visible'.[6] Warner, who knew her
well, recalls that Chadwick spoke frequently of wanting to invest her
images with 'the discharge of energy that occurs in touch'.[7] Through
a career that explored the materiality and force not only of meat and
light but of chocolate, worms, tongues, oysters, flowers, embryos,

urine and landscape, she found herself often in the role of the pro-
vocateur, and even, according to some who knew her, relished it.[8]
She wanted to test the boundaries of disgust, to find out where they
bordered on or overlapped with pleasure, to make an art that would
be *sensational*.

She was interested, above all, in using art not to stabilise the body, but
to capture its fugitive quality. A project she made in art school involved
making clothing by painting latex on to women's bodies. 'It looked like
bits of old skin,' she said.[9] She turned her cervical smear test into a work
of art in a chapel in Clerkenwell run by a small sect of doctor-priests
(*Blood Hyphen*, 1988). In *Viral Landscape* (1989) she scraped parts of her
body and collected the cells, put them under a microscope and enlarged
the images, then layered them over photographs she took of the Pem-
brokeshire coast, adding a colour wash using water from the Mediterranean
in a reference to her mother's Greek heritage. The photographs – made
on a rotating camera for a panoramic effect – are huge, four feet high and
fifty feet long, in a continuous frieze of images, and very beautiful, a bit
like if you took what you see when you close your eyes and tinted it in
pinks and blues. To make a 'virus' visible in the air takes on particular
meaning now, as I write in the midst of the Covid pandemic, but they
had their own resonance in her own time, during the AIDS epidemic,
and as the world began to confront the pressing problem of environmen-
tal pollution. Chadwick has conveyed her physicality uncontained by her
skin, and as a question of immediate concern to us all.

'The virus attacks the replication material of the cell to effect its
continued proliferation,' Chadwick wrote. 'Essentially it is no more
than chemical information, lifeless outside a biological system; a "dis-
sident" cultivating the possibility of change, if prejudiciously for its
own ends.'[10]

A mysterious virus would kill her at the age of forty-two.

/

Chadwick was, for her time, unusual in her use of multiple media.
But her practice centred on photography, and her deviations from it
were explorations of its limits. Although we have a tendency to think

of the photograph as having an indexical relationship to reality – that is, of being a trace of something that once happened in the real world, a person who once lived, captured by the lens – Chadwick sought to complicate the relationship between image and world.[11] She was after something more mysterious and bodily. 'Photography is my skin,' she once wrote.[12] In *Ego Geometria Sum* (1983) she took photographs of herself and layered them on to objects that corresponded to various moments in her life – an incubator like the one in which she was held as a premature infant, a pram, a bed, a vaulting horse, a piano.

This work expands and explodes our sense of what photography can be: not flat, presented on a wall, but a three-dimensional engagement with memory and space; she used a particular process to make it look as if the image had been conjured forth from the wood of the objects, like the spirits animating them. The works of art are themselves like little bodies, wearing her skin – 'flesh into form,' she wrote.[13]

'I want to catch the physical sensations passing across the bodies— sensations of gasping, yearning, breathing, fullness . . .'[14]

/

In her 1986 installation *Of Mutability* Chadwick pushed these questions further.* First shown at the ICA in London, *Of Mutability* comprises two parts, in adjoining rooms: *The Oval Court* and *Carcass*. Without either, the piece would be incomplete. It is one enormous vanitas: in one room, the placid blue *Oval Court*, in the centre of which is a Rococo reflecting pool. On the walls are columns modelled on the Bernini canopy at St Peter's in Rome, festooned with foliage and crowned with images of Chadwick's crying face. In the other, a two-metre-tall glass tower stands full of vegetal and other unidentifiable peachy brown matter, striated like a geographic cross-section. It is actually nine months' worth of domestic compost, collected from her own and a few other houses on her street, Beck Road in Hackney, a

* The V & A curator Mark Haworth-Booth reportedly spent every penny he had in his acquisitions budget to buy *The Oval Court* for their photography collection (according to Frances Morris in 'The Legacy of Helen Chadwick').

development of artists' studios to which Chadwick moved in the late 1970s. A 'tower of corruption and decay', she called it.[15]

Archival footage from the BBC shows her climbing up a ladder with a pail, not a hair out of place on her shiny Louise Brooks bob ('so precise it looks as if it has been worked out mathematically').[16] We see Chadwick pushing it around with a little shovel: carrots, baked beans, bit of grass. No meat, she requested, wary of making something too smelly. 'I think it's quite exquisite, visually. I've seen paintings that haven't got the same tactile quality as this.' *Carcass* is a gratuitous gesture, garbage for garbage's sake, Hackney's refuse – literally, artists' filth – on show on the Mall. 'I have to top it up every day,' she says in her South London accent. 'I hadn't actually bargained for that. All the layers seem to keep sinking – better to keep it nice and topped up.' The weight of it started a process of fermentation; the piece was constantly bubbling. 'Percolating', as she puts it.[17] The column invites questions around domesticity, change, foment beneath the surface. Life, creation, fertility. Another statement, like the virus images, of her awareness of environmental issues, an apprehension of the pressing need not to sacrifice the natural for the sake of the man-made. There is more to say than one might at first think about a pile of garbage in a glass column.

The experiment, however, would prove impermanent. As the artist Gavin Turk recalls, who visited the ICA that day to find the exhibit closed: 'there was a tiny little crack and a bit of it was oozing out and it made a stink as well but then they tried to move it and it all fell over and the whole thing kind of exploded, and gallons of this stuff, this gunge, went all over the floor [. . .] and [took] out the top floor of the ICA, it was brilliant.'[18] According to some who visited at the time, the odours threatened to waft up towards Buckingham Palace.[19] The ICA removed the column, apparently without consulting Chadwick, who was furious. Later installations of the work merely projected an image of *Carcass*, which goes against the whole idea of the piece.★

★ Chadwick taught at Goldsmiths' art programme in the 1980s, at a time when the YBAs were studying there. It is no stretch to imagine that they all saw *Of Mutability*, and specifically *Carcass*, and that this is an often unacknowledged reference point informing the work of Damien Hirst, Sarah Lucas, etc.

Helen Chadwick, detail from *The Garden of Delights*
at the centre of *The Oval Court*, 1986, from the
installation *Of Mutability*, Barbican Centre, London, 2004.

/

At first it was *Carcass* that captured my imagination. But the more I
looked at *The Oval Court*, the more it revealed its charms. Perhaps, like
Eva Hesse, I was wary, too, of conventional aesthetic beauty; I uncon-
sciously rejected it as decorative; not 'challenging', contemporary and
abject like the column of refuse. In contrast, *The Oval Court* looks deeply
traditional, like the background of a Renaissance tapestry, white forms
on a serene blue background. As you get closer, you realise they are
actually photocopied images of Chadwick's own body collaged with a
range of props and dead animals.★ The contrast between the art histor-
ical tradition and what we're actually seeing is acute.

There are twelve collages in all. The governing ambiance is of sky, or
water; the images swim, or float, together, in this Mediterranean, Yves

★ The lamb was brought to her by her brother, a shepherd; it died of natural causes.
See Warner, *Helen Chadwick, The Oval Court*.

Klein, dental articulating paper blue. In one area a nude self-portrait shows Chadwick bending over backwards – or swinging like an acrobat on a trapeze – to share a kiss with a lamb. In another – still nude, a robe around her neck, she appears to vomit out, instead of being fed, grapes and oranges and a cornucopia of fruit-like forms. Here her legs, looking like eels in a pair of patterned tights, are caught up in a fishing net with dozens of whitebait spilling from it, as if swimming towards her. There her face is twinned, each turning away from the other, in a Janus pose; some kind of rope is being twined up her abdomen, and pulled by her own hand. As if to underline the degree of craft involved in creating these images, there are strings everywhere – rolled up in a ball; around a bunch of asparagus; or with a pair of scissors poised around it, which stand ready to cut, like Atropos, the thread of life.

Images of love and fertility, death and life, human and animal abound, amid references to the deep range of arcane and mythological research she amassed over the course of her life, but these are always made with a little wink – as in the section showing not Leda and the swan, but Chadwick and the goose. She called it 'a stitching together of so many different references, ultimately postmodern, a bowerbird theft [. . .] There were ironies twisting their way in so the conventional reading didn't account for their appearances.'[20]

The final touch to the reflecting pool is the five gold balls that are distributed on top of the reflecting pool in a gentle semi-circle. She was trying to find a form to serve as a 'counterpoint' to the photocopies, 'which are physicality as image and very frail – to create the tactile simultaneously as an absolute. The sphere is an idealised form. Here they represent fingertips exploded as spheres.'[21] The smoothness and complete impermeable beauty of the balls – though they have a slight rib to them – make them seem permanent, 'beyond change', she said, 'whereas the images they are – they have no absolute entity or meaning'.[22] The documentary shows her dusting off the balls with a feather, like a Roman courtesan indulging her client. But in the next scene we see her handling the gold leaf she used to create the 'skin' of the spheres; it is so light and delicate it folds and crumples and disappears as she

rubs her hands together, leaving only a fine sparkle on her palms: 'It's just dirt like any other now.'[23]

/

The images were made on a photocopy machine that Canon rented to her for a special price, which she then painstakingly assembled from hundreds of test copies. The BBC footage shows her with an enormous animal tongue on the machine. It's so surreal, she's twisting it this way and that, she says, to get the 'nicest bits' (she sounds like a butcher), the best textures. She presses a dead bunny to the glass. 'Once you've done what you need to do it is somewhat revolting.'

She wasn't the first to make Xerox art – Esta Nesbitt did it in the 60s, and Penny Slinger in the 70s – but photocopy machines were not in wide use until the late twentieth century; the art produced with them will therefore have different resonance in a time of scarcity versus a time when any sixteen-year-old boy can sneak into the secretary's office at school and photocopy his butt crack.

The photocopy, even more than the photograph, ought to be the direct, literal, light-copy of the thing itself. The literal trace of the object on the glass. Yet – as the sixteen-year-old scrutinising the image of his crack will know – the photocopy machine does not present a one-to-one image of the object copied. There will always be some distortion, beginning with the reduction of the object to shades of grey – or, in the case of *The Oval Court*, blue. And – as Michael Keaton indelibly reminds us in the 1996 science fiction comedy *Multiplicity* (1996), a copy of a copy will never be as sharp as the original. In *Of Mutability*, the edges of the figures blur – as if they were disappearing into the water. The photocopy may be more indexical, but not more true to life.

Chadwick was excited about working with photocopy machines; for her it was like 'sabotaging the conventions of business machinery [and] computer technology'. She used the photocopy machine as a camera, and then she took the copies and delicately sutured them together. 'Each image is a composite, a mosaic of hundreds of pieces of

photo copy. In that way I was able to construct images which couldn't exist photographically in any other way.'[24]

Of Mutability inhabits the realm of the decorative in order to corrupt it. Marina Warner writes at length on the role of the Rococo in the work, tracing it back to *rocaille*, a term originally used to refer to irregular pearls, but adopted by artists and designers to refer to 'eccentric forms [. . .] rare materials and bizarre, even grotesque excrescences, as in grottoes'.[25] Rococo art teaches us to see the beauty in monstrosity as consisting of unpredictability, an excess of texture. Chadwick was drawn to Rococo specifically because of its relationship to sensory pleasure:

> it's very decorative, it isn't static, everything is moving, pulsing. There isn't a single focus, there's a myriad of points expressed elliptically in a sinuous line, and the drama of that, the idea of the eye being intoxicated, never able to stop, was something I wanted to establish in my installation. There isn't a hierarchy [. . .] Everything takes you and leads you on to the next.[26]

This description – the pulse, the lack of official perspective – is right out of Bataille's *informe*, or formless. In contrast to the Kantian notion of beauty as formed and therefore bounded, formlessness is an attribute of the sublime, and of limitlessness.[27] The *informe* belongs to the regime of the 'unverifiable, on the non-hierarchized'; it consists of material that 'makes no sense [. . .] Bataille's "matter" is shit or laughter or an obscene word or madness: whatever cuts all discussion short'.[28] This description applies handily to much of Chadwick's work – particularly to the memorable *Piss Flowers* of 1991–2, a casting of the shapes created by Chadwick's and her partner's streaks of warm urine in the snow, a piece which Marina Warner characterises as an important part of how we approach the body in Chadwick's work. *Piss Flowers* 'indicated another track on the map of desire [and gender], neither parody nor worship. Neither the battle of the sexes nor the Eternal Feminine but something combinatory, mutual, humorous, acknowledging human baseness without wallowing in abjection.'[29] Without *wallowing* in abjection – that's the distinction. Evoking it, maybe. Or operating in another zone altogether.

/

So finally it is *Carcass* that is the living sculpture, a study in containment and leakage, never the same from one day to the next, and *The Oval Court* which, in Chadwick's words, 'stretched out like a blue corpse in the next room'.[30] This was precisely Chadwick's approach to the nude, according to Warner; 'For her, it was intimately intwined with the tradition of the nature morte, the still life.'[31] In Chadwick's day feminism still hadn't got over its iconoclastic anti-nude tirades of the 1980s, and she apparently got into quite a lot of trouble with the feminists for showing her body the way she did. But though she said she respected their 'theoretical position', it directly contradicted what she was after as an artist. She was trying to depict the sensation of pleasure and desire, 'and the way to do that is through the body – so the body was central to the project':

> The idea of a denial of one's body as a no-go area to explore themes of sexuality and desire seemed so tortuous that although I could sympathise with the theoretical position it just again didn't square with my own needs and choices that I wanted to make. And I felt it might just be possible – admittedly a tightrope act – to make images of the body but the self that would somehow circumnavigate that so called male gaze. I wanted to open up a space for the woman as the subject of feeling. For them to not read the work as a series of objects or symbols that they could interpret but a much more direct response of *I love this, I know what this feels like*.[32]

For Chadwick the body is a site (sight) of 'pleasure, not power'. In *The Oval Court* she wanted to create figures 'drifting freed from tyranny of reality', the tyranny of shame.[33] In her research she looked at the *Song of Songs*, its sensual weirdness (*Thy two breasts are like two young roes that are twins, which feed among the lilies*) informing her exploration of the body and its pleasures. As she wrote in her notebook:

> Self with self – not shared, contested, display enigma of own state
> mystery of sensation
> Beloved = animal = self
> [. . .]
> Self as naked – immune to shame. Not licentious conceit, nor concession to Antique or Mythology but declare power of

love – redemptive & liberating – freed from Adamic contagion. Shame
& make voyeurism and sexual possession
[. . .]
Triumph of pleasure – sublime desire[34]

On one of the walls, between the columns, is a small hand-mirror
(*Mirror*, 1984), made of Venetian glass. Layered on to the mirror are
a pair of ornate silver eyes, dripping silver teardrops, surrounded by
daisies (Chadwick's signature flower). The viewer is invited to con-
template her own mutability, as she walks through the gallery. I can't
see the actual mirror itself, in the pictures I see online; I just see a
black half and a blue half. Instead of seeing myself reflected there, I
see opacity.

Chadwick extended the mirror motif in a 1986 work called *Vanitas
II*, a self-portrait in which she poses nude from the waist up against
a curtained background, holding in one hand a round mirror, into
which she gazes, studiously, and in the other hand a feather, much like
the one we saw her using to stroke the golden balls of *The Oval Court*.
Her face is heavily, garishly made up, her hair in its precision-cut bob.
Her right nipple kisses its reflection in the glass. A peach curtain the
colour of her nipples drapes softly above and behind her. She's pulled
a bit of the lace curtain forward, to lie on her chest, softening the
image, prettifying it.

The reaction from the 'Stalinist' – her word (remember Wilke's 'fas-
cist feminism') – feminist brigade was not good. 'It's been generating
extreme hostility. The reactions are getting more extreme. I've been
accused of driving men out to rape young girls [. . .] The image of
vanity I despise and it's about the despicable hold that a kind of vanity
in what one does has over you.'[35]

'Feminism was arguing that you shouldn't see the naked female
body,' she said in another interview. 'I disagreed [. . .] I was looking
for a way of creating a vocabulary for desire where I was the subject,
the object, and the author . . . rather than trying to see the female as a
desired object, you had to see yourself as a desiring subject.'[36] A decade
after Hannah Wilke was misread by Lucy Lippard and Lynda Beng-
lis was misread by Rosalind Krauss, the hardline feminists were still

unable to accept when a feminist artist was portraying her own nude body in order to spark a conversation about its discursive meanings, and how it came to accrue them. She was trying to be the subject, and not merely the object, of the gaze. To be subject and object in one.[37]

'It isn't purloined,' Sutapa Biswas said to me over coffee one morning, referring to Chadwick's use of her body, as we discussed Biswas's own experiences in the feminist representation wars. It isn't gratuitous, she says. 'We are in her subjectivity. Beauty must be allowed. She found a way to admire the beauty of the female body outside the sexist male gaze. It's never uncomplicated or pure, but it can be admired.'

Chadwick stopped depicting her body in her work after this controversy, and perhaps this is why, in her 1991 self-portrait, she presented only a brain, cupped by her hands. A wink at her feminist critics, a making literal of the complaint that women are valued for their bodies and never for their brains. The artist's hands, here, are like the surgeon's, or the butcher's, or that of some ancient Egyptian priest, preparing a body for mummification. But whether the camera depicts a beautiful naked woman or the animal brain that is meant to refer to her own, it's a pointed reminder that whether we're loved for our bodies or our brains, we are nothing but meat.

/

A few years later, Chadwick said that in *Of Mutability*, 'I have exchanged the moralities of the vanitas, homo bulla – man, a bubble, for a world blown from the impassive bubble chamber of a photocopier [. . .] Physicality is reduced to surface, a mere echo of itself, the corporeal imploded into grains of dust. Dismembered into manifold fragments, the subject shatters.'

'Out of the copier, no longer separate from other things, I am now limitless.'

'At the speed of light, I no longer exist.'[38]

decreate to create

I heard the writer Kate Zambreno talking about childbirth as an act of decreation on a podcast the other day. The day of labour is a major 'mortality event', she said, speaking of giving birth to her first child, and the impending arrival of her second. While the chances of dying in labour are much higher for women of colour and working-class women than for middle-class white women like herself (and like myself), nevertheless it's a moment that's fraught with danger, 'an extreme act of decreation', she said, during which we risk losing ourselves, our individuality, our *I*, an act of self-effacement that prefigures those constantly required by motherhood itself.[1]

The term *decreation* comes from theology but I admire Zambreno's appropriating it for the domain of extreme bodily experience. 'Decreation,' writes Chris Kraus in *Aliens and Anorexia*, her book about Simone Weil: 'a plateau at which a person might with all their will and consciousness, become a thing'.* You could see the act of medicalised childbirth in this way: though we weren't in a hospital per se, but in a Parisian clinic, I still had an epidural, a heart monitor, and a tube in my arm; the nurse who tried to insert it messed up so many times that she left me covered in bruises. (In the video of our son's bloodless bris, eight days after his birth, my arms as they hold him are painted in angry purples and yellows. When I went to the pharmacy to get some arnica, the pharmacist asked *who did that to you*.) But I wasn't a thing; I was alive, and my being alive was *engagé*, as they say, on the line, at stake. The epidural did not work the first time it

* Simone Weil uses the term in her notebooks: 'The self,' she writes, 'is only a shadow projected by sin and error which blocks God's light'; decreation is an escape from this shadow. 'We participate in the creation of the world by decreating ourselves.' Quoted in Leland de la Durantaye, *Giorgio Agamben: A Critical Introduction*, Stanford, CA: Stanford University Press, 2009, p. 23.

was given and I laboured without medication to ten centimetres, at which point they re-administered it which made my heart rate plunge, and the baby's as well. Suddenly the room was the site of a code blue; doctors rushed in; Ben was ushered to the side; there was talk of an emergency C-section; whatever they gave us worked but they immediately made me start pushing. A thing cannot push. A thing does not have pain that must be anaesthetised. Out of my living body came the person I created.

/

In the realm of art, might we think of decreation as an act of undoing – or 'undoing to do better', as the scholar Mary Ann Caws, one of my mentors, writes in ~~Undoing Art~~, her book with Michel Delville.[2] Their poetics of erasure 'pursues a logic which considers the artwork as an unfinished object that awaits future readings and negotiations to be provisionally refashioned, recycled, and reconsumed'.[3] It initiates, in the reader, 'something of an excitation, a stimulation to further thought: what is this ACTION about?'[4] Decreation is in this sense co-creative – inviting a collaboration, pressing the viewer or reader onward. The finished work is the death mask of its conception, but the unfinished, or *de*-finished, work is forever open. Work that has been created and then somehow obscured. 'What cannot be – and so is – said.'[5] I think here of Eva Hesse accepting the unknown future for her materials, Sutapa Biswas actively seeking out the textures a future life would confer on the material of *Housewives*, Julia Margaret Cameron refusing to edit out the fingerprints and stray hairs and bits of the world to purify her photographs, Kara Walker's sugar statue, entirely destroyed except for the paw, Helen Chadwick's rotting column, Ana Mendieta's earth-scorchings, which leave the soil forever altered, and foretell our own climate emergency.

The feminist act of decreation is making something that one acknowledges will fail, will decay. The work will not endure. The performance is documentable on video but not reproducible. Different from the decisions of artists like Agnes Martin or Georgia O'Keeffe to destroy their work, because the work *itself* enacts its subjection to decay. What

a political statement to make: I do not care if this work endures, if the buyer gets his money's worth, if it can continue to circulate within a capitalist economy where art becomes a place to park your millions.

Instead of striving, competing – to fail. To accept your name (like your body) will not survive. To welcome it, rather.

And the decreation of motherhood: the acceptance of the self as finite, the act of procreation as prolongation of the material of the self, and the unbearable knowledge and impossible acceptance of our children's eventual finitude. 'Mothers are makers of death,' wrote Claudia Dey in the *Paris Review*.[6] When I read that sentence, I had such an uncanny moment of recognition that I was irrationally convinced I had already written those words. I looked through my journals, my published writing, searched my hard drive: I hadn't. Dey had spoken the collective unconsciousness of motherhood.

'Use the I to break down I,' Kraus glosses Weil, and neither of them was talking about mothering.[7] The act of making is the act of unmaking the self, with its imperatives and fears, full of contingency, full of potential. Motherhood, like art-making, is an act of accepting that ultimate control to prevent catastrophe or failure does not lie in our hands. It is a staggering act not only of self-effacement but of self-relinquishing, creating something that is subject to the failures of the body. Humans can make nothing impervious to time.

/

It is in the context of these ideas around decreation that I want to conclude with Vanessa Bell's 1912 portrait of her sister Virginia Woolf sitting in a striped deckchair. She wears a navy dress with a white collar, and a little red tie. Red stockings. A wide-brimmed straw hat with flowers on it. And where her face should be, a patch of paint. This portrait, for me, addresses all the problems I have been exploring throughout this book. The problem of how to overthrow story as the pre-eminent way of speaking a woman's experiences as a body. How to address the materiality of body through art. How to depict the female body without either catering to or rejecting the male gaze. How to deal with the instability of identity, which rushes to any

attempt to depict the self, or the sister whose face one knows as well, or better, than one's own. How to be an artist, or a writer, how to live up to the challenge, to embody it. How to live our lives in all their fullness and ambiguity, admitting nothing, relinquishing nothing.

/

Bell's art was an entire way of life. Even the furniture at Charleston, her home in Sussex, was covered with it, pinks and blues and mauves and greens, an entire kingdom of paint, gambolling across every available surface; to stand in a room in that house is to feel one has been dipped in a post-impressionist painting. Yet the soap opera of her life has muted Bell's own artistic achievement. One of the quieter, more self-effacing members of the Bloomsbury group, Bell was nicknamed 'the Saint'. Most of the writings about, and dramatisations of, Bloomsbury give a sense of Bell as earth mother, withdrawing from London to her Sussex farmhouse to grow children and vegetables, painting the chairs and her lovers.

Married to the critic Clive Bell, she carried on affairs with painter and critic Roger Fry and the artist Duncan Grant. Her daughter Angelica believed her father was Clive, learning only when she was seventeen that actually it was Duncan. Angelica went on to marry David 'Bunny' Garnett, the writer and publisher who had been her biological father's lover, and, at one point, her mother's romantic rival. Together, Bell and Grant led a companionable life that can't be mapped on to any conventional idea of sexuality or partnership; their queer experiments in art and life help us find new shapes for our own emotional and artistic lives.

/

When the Dulwich Picture Gallery put on an exhibition devoted to Bell's work, in 2017, it was a long overdue chance for Bell to shine in her own right. The show celebrated the period when Bell was first married and having children, as well as discovering the liberating effects of post-impressionism – the period when she made this portrait

of her sister. The show's co-curator, Sarah Milroy, told me that for Bell, those years were full of the 'imagined freedoms of modernity'. Her 1910–13 paintings epitomise this sense of 'energy and explosive curiosity and wonder about this new world that they were emerging into, from out of the dark shadows' of the Victorian age.[8]

The house in Hyde Park Gate where Bell, Woolf and their siblings grew up was dark and narrow, hung with heavy velvet curtains. As the 'Angel of the House', following the deaths of her mother and older stepsister, Bell was asked to uphold a thousand rules and regulations. She would escape that world to her art classes at the Royal Academy, where she was taught by John Singer Sargent. He critiqued her work for being too grey; looking at the work that followed, it seems she heeded his advice.

But what really set Bell on her path was Roger Fry's *Manet and the Post-Impressionists* show at the Grafton Gallery in 1910, which granted her permission to pursue line and colour almost to the point of abstraction. In Paris she had seen the work of Cézanne, Seurat and Degas, but the way they were now bursting on the scene in London had an electrifying effect on Bell's world. 'All was a sizzle of excitement, new relationships, new ideas, different and intense emotions seemed crowding into one's life,' she wrote.[9]

Although Bell's work generally adheres more to the figurative than to the abstract, it is nevertheless dedicated to creating rhythm and life through colour and line. Her subject, she said later in a talk, was 'this painter's world of form and colour'.[10] Her designs for the Omega Workshops suggest that she learned collage and movement from the cubists, too. She verged on abstraction through her use of colour-blocking, transforming a portrait into an expressionist exercise. A 1915 portrait of twenty-three-year-old Garnett – face flushed, his two pink nipples babyishly small – sets him against a fauve mauve background which is fragmented, yet ordered, by a dark blue abstraction. The fields of colour vibrate with movement, the brushstrokes not only visible but jagged, darting.

In her aim to capture raw sensuality and the beauty of form on the canvas, she felt herself to be utterly unfashionable. When Grant sent her oranges and lemons from Tunisia, she wrote to tell him: 'They are

so lovely that against all modern theories I stuck them into my yellow Italian pot and at once began to paint them. I mean one isn't supposed nowadays to paint what one thinks is beautiful.'[11] The wildness of the painting she started that day, *Oranges and Lemons* (1914), demonstrates that she was more radical than she gave herself credit for; with its curling foliage, the painting is full of life, and anything but still.

Her work is what finally convinces me that anyone can be an art monster: that monstrosity, understood in its broadest, most marvellous form, dwells more in the surprise of the work, than the personal life of the artist making it. Bell's art countered symbolism with intense sensuality and a celebration of the tactile. The beauty of the surface takes us back to the material of the work, to physical encounter. It roots us in the moment, and, as her sister would put it, in life itself.

/

We are here, in 1912, with the recently married Virginia Woolf posing in a deckchair for her sister the painter. Woolf is thirty years old and working on a novel, in between breakdowns. Four years earlier she told Clive Bell in a letter that she hoped to 're-form the novel and capture multitudes of things at present fugitive, enclose the whole, and shape infinite strange shapes'.[12] But at this early point it is Vanessa who has taken the lead in shaping infinite strange shapes, beginning with her sister's face.

The previous year, Bell herself had suffered a miscarriage and a breakdown while travelling in Turkey, at the time of her affair with Roger Fry. At Christmas in 1912 she collapsed from exhaustion. And, Woolf's biographer Hermione Lee writes, just as Virginia had difficulty accepting Vanessa's marriage to Clive Bell in 1906, Vanessa found it ' "bewildering and upsetting" to think of Virginia as one of a couple'.[13] Several times that year, Virginia suffered breakdowns and had to take to bed. As she wrote to Ethel Smyth in 1930, looking back on this period, 'I married Leonard Woolf in 1912, . . . & almost immediately was ill for 3 years.'[14] Lee speculates that the pressure Leonard Woolf inadvertently placed on Virginia, combined with the great need she felt to finish her first novel (*The Voyage Out*, 1915), was responsible

for this inability to go on. The difficulty she had writing this novel would be matched only by the challenge of *The Years*. Reading the proofs of that novel, in 1936, she wrote, 'I have never suffered, since *The Voyage Out*, such acute despair on re-reading, as this time' and '[n]ever been so near the precipice to my own feeling since 1913.'[15]

Bell painted her sister's portrait four times in 1912. The first is relatively straightforward, if heavily influenced by the paintings Bell had seen in Roger Fry's second post-impressionist exhibition at the Grafton Gallery that year; 'the tentative outlining of form with dark colour is a technique frequently found in early experiments in English Post-Impressionism,' writes Bell's biographer Frances Spalding.[16] Next are two in an armchair at Asheham, Sussex, where the Woolfs had a house at this time. In the first, Woolf, seen in profile, leans over in the chair, wearing a green cardigan and crocheting something pink. Her nose is clearly delineated through contouring, but her mouth – pink – is cross-hatched with peach, as if it's been sewn shut. Her right eye is invisible; the left one, on our side, is a beige-y splotch with a pink zig-zag beneath. Here, too, she is confidently outlined in dark grey or soft black paint. The next armchair portrait has those same outlines, but it looks as if a particularly careful child has coloured between them. The face is completely obscured. As is the final portrait, the one in the deckchair.

Spalding wrote about the four portraits in the exhibition catalogue for the Dulwich Picture Gallery's Vanessa Bell show in 2017, speculating that there is an 'indeterminacy' to them, as if Bell were unclear 'how much information she wishes to provide' in the second portrait; this question has been resolved in the third by the 'emphatic veil of descending brushmarks that obliterate the face':

> At first one might wonder if the painting is finished, but the sitter and
> the chair are satisfactorily arranged within the confines of the canvas;
> and the handling of paint, though swift and summary, has sufficient
> consistency to give the spectator the impression that the painting is a
> whole, finished and complete.[17]

This is certainly a form of undoing, of re-forming the portrait, of shaping strange shapes which are, after all, nothing more strange or

familiar than the faces of the ones we love. It prefigures Hélène Del-
maire's painting over her subject's faces, the erasure of the original
painting in *Portrait of a Lady on Fire* (a part, therefore, an intertext,
of the final painting we see at the end), predates by two years Mary
Richardson's slashes to Velasquez's canvas (sewn up, covered-over,
but irrevocably there, now part of the surface of the work). They
encourage, writes Spalding, the viewer to take 'a more active role' in
reading the canvas, and ask us to think about the limits of personal-
ity and selfhood; this is a 'radical solution to portraiture that suggests
new ways of thinking about identity', that anticipates (or helped fuel?)
Woolf's own agnosticism on the subject of intrinsic being, so delight-
fully mocked in her 1928 experimental/spoof biography *Orlando*.[18]

The art historian Lisa Tickner writes about another series of paint-
ings Bell made, revising her image until she had it right – those made
at, and of, Studland Beach in Dorset. Over the various iterations, cul-
minating in *Studland Beach* (held by the Tate), the forms get simpler and
somehow tighter; it seems as if details evaporate, but Tickner argues
that this 'rigorous simplification' can be seen as a 'distillation – rather
than the rejection or transcendence – of social experience'.[19] The move
towards abstraction is an intensification, not a vacating, of emotion
and meaning.

Like her sister, Bell was predominantly interested less in character
than in form, in the relationship of the outline of the body to the heft
of the flesh, the presence of human life reduced to its essential form. 'I
often look at a picture [. . .] without seeing in the least what the things
are,' she wrote to Leonard Woolf in January 1913. '[C]ertain qualities
in life, what I call movement, mass, weight, have aesthetic value.'[20]
The faces are opaque, in the dual senses of being both non-translucent
(like plaster) and obscure; they are resistant; they raise the problem
of the visible. What is it we see when we look? Even at something we
know as well as the face of someone we love – or at our own? In Bell's
paintings Woolf's is a face that doesn't resolve, an oblique self-portrait.
A self-portrait in another key, perhaps.

Bell is in effect trying out an experiment like that which her sister
would attempt twenty years later – how to have things both ways,
representative and abstract, essay and fiction, granite and rainbow.

Looking at these paintings I think back to something Kathy Acker said in passing, once – poetry is what fucks up this world. Poetry is disturbing because it uses the language of everyday life and transforms it into something we can't understand with our conscious minds. As we'll recall Mary Ruefle said of Shelley's line, *Pinnacled dim in the intense inane:* 'One of my favorite lines in all of poetry, but what does it *mean*?' In Bell's painting we look and look for Virginia Woolf wondering where her face is and at the same time knowing absolutely that we are looking at it.

It has always struck me as significant that Woolf would have chosen the name *Pargiter* for her autofictional family. It is a very concrete name, quite literally associated with construction and façade-finishing. Mitchell Leaska, who edited the unpublished manuscripts of the novel for a 1978 edition, ventures a theory that Woolf came across the verb *to parget* in Joseph Wright's dictionary (Wright appears in a digression in the text), where it is defined as meaning 'to plaster with cement or mortar, esp. to plaster the inside of a chimney with cement made of cowdung and lime'. Leaska checks the OED and finds a pargeter listed as 'a plasterer; a whitewasher'; and 'by figurative extension [. . .] one who glosses and smoothes things over'.[21]

Pargeting, according to Tim Buxbaum of the Society for the Protection of Ancient Buildings (SPAB), is 'the ornamentation of plastered and rendered building facades that would otherwise be smooth, lined-out or roughcast'.[22] There is most certainly the suggestion of outward smoothness and decoration to conceal what is otherwise rough and unfinished. But to come back to Wright's reference to chimney pargeting – working within that conduit up and out of the family home into the open air outside – all is cowdung and lime, that which is excreted from the animal body and quarried from the earth. Lime is porous; as such whatever it coats is allowed to breathe; moisture can evaporate through it, instead of being trapped within. To parget with cowdung and lime is not only to apply a coating of white plaster to cover over any imperfections, but to use organic material to sustain life. In Woolf's attempting novel, she wanted to read the pargeting both ways – as whitewashing, but also as giving form to life itself. Likewise – and two decades earlier – Bell has pargeted over her sister's

literal resemblance, not because she has something to hide, or is being withholding, but because there are some things which may be said more effectively by not saying them at all.

We are between figuration and abstraction, slashing and uniting, obscuring and revealing.

/

Woolf envied Bell for having paint and brush as her tools, with all their expressive capacities. 'Words are an impure medium,' she wrote in a 1934 essay on the painter Walter Sickert. 'Better far to have been born into the silent kingdom of paint.'[23] And yet Bell's paintings and home decorations are anything but silent; they shout and scream in a cacophony of colour and shape, rude lines and sudden gentle shading. We need synaesthetic metaphors to accommodate Bell's vision: a whole symphony of impure sounds hurtles off her canvases. Though their meaning is conveyed on another, less intellectual plane, they are far from inarticulate. As Bell wrote in a 1936 letter to her son Julian, 'it seems to me always the *visual* relationship that is important in painting. There is a language simply of form and colour that can be as moving as any other and that seems to affect one quite as much as the greatest poetry of words.'[24] Her husband Clive Bell devised a theory of significant form, which he defined as 'lines and colours combined in a particular way, certain forms and relations of forms, stir our aesthetic emotions'.[25] And her lover Roger Fry advanced his own aesthetic theory, namely that artists 'do not seek to imitate form, but to create form; not to imitate life, but to find an equivalent for life', as he wrote in his preface to the catalogue for the second post-impressionist exhibition in 1912.[26]

Rereading these statements, articulated at the very beginning of the twentieth century, which are so often cited in essays and included in anthologies of modernist documents, I am surprised to find their authors articulating ideas which I thought so feminist, so rooted in the feminist uprisings of the later twentieth century. 'Form is emotion,' Schneemann wrote in her diary in the early 60s.[27] It's

possible to see, of all places, the root of this feminist uprising in Bell's feminist appropriations of post-impressionism. This is art for art's sake and art in the service of the revolution, all at once, and more powerful as an aesthetics because it refuses to choose between self and others, between the individual and the collective, the private and the public.

Bell's own aesthetic writings have been overlooked because they have not taken place in the expected places of the essay and the monograph, but in her letters and in her work. Her reputation has also suffered because she is so often affiliated with a particularly domestic form of Bloomsbury. These portraits show that she was nevertheless just as radical, just as much of an art monster, as any of the others. Bell articulates her own theory of significant form in her refusal to participate in a discourse of being and representation that made no place for discomfort or profound association. In *Bodies That Matter*, Judith Butler clears space for 'the site where discourse meets its limits, where the opacity of what is not included in a given regime of truth acts as a disruptive site of linguistic impropriety and unrepresentability'.[28] That mulchy patch where the face should be is one such disruptive site: disarticulation is as important as articulation. Silence speaks. In Vanessa Bell's faceless portraits of her sister, feeling is thick as paint.

/

Radical feminist expression is a making visible of what we have been told to cover up, to correct, to make smaller, mainstream. We do not all come to language or image in the same way along the same path; we can revel in the many ways we have turned language and image into sites of resistance, places of reinvention and generation, and we can loudly, excessively call for others to speak their bodies with the same commitment to destabilise, in whatever terms they find to do it. As Edouard Glissant urges in his *Poetics of Relation*, 'we clamour for the right of opacity for everyone'.[29] I appreciate the materiality of his argument, his reading of opacity as a key element in the way we relate to one another, as a safeguard of our individual

personhood which 'is not enclosure within an impenetrable autarchy but subsistence within an irreducible singularity'. There is something physical which connects us: our experiences of embodiment, varied though they are.

Woolf would not write her book about the professional and sexual lives of women; instead she would write several, none of which fully succeeded in articulating the relationship she intuited between them, that night in her bath. The words she called on to articulate it for her wriggled out of her grip, like whatever was tugging on the fisherwoman's line. Her complaint, in 1937, in the midst of turning the factual portion of *The Pargiters* into *Three Guineas*, was that words 'never make anything useful', while at the same time acknowledging that 'it is their nature not to express one simple statement but a thousand possibilities'.[30] They shape and twist, unreliably, excessively, and lead us to places (and books) we didn't intend them to. But she makes peace with this unreliability and even strangeness in her work, devoting herself ultimately to reshaping the 'masculine sentence', breaking expected sequences. Their power allows them to break free of whatever we might wish or intend for them; we may send them out towards our point, a phonetic lasso, but they shatter into a million pieces the moment they land on their object. Nothing can be grasped with words, not even words. They make nothing 'useful', perhaps, but they can be used in 'new orders so that they survive, so that they create beauty, so that they tell the truth'.[31]

The artists I have been considering in this book found ways to work against language, work against image, against received ideas, to signify outside the usual paths. 'If I have an intent,' wrote Helen Chadwick, 'it is to open up a crease in language and look at what cannot be articulated – the phenomena of consciousness, the enigma and riddles of selfhood, the momenta of sexuality and emotionality.'[32] When she writes this, she is with Hélène Cixous, telling women they must speak up, that they can't afford not to, though their language may be strange and even illegible. She is with Audre Lorde, who after being diagnosed with breast cancer in 1977, realised that what she most 'regretted' in her life to that point was her 'silences'. 'Of what had I *ever* been afraid?

[. . .] I was going to die, if not sooner then later, whether or not I had ever spoken myself.'[33]

Like Cixous, Lorde's project is to make women's writing and speaking not only a vital means of self-expression, but an ethical obligation.

> What are the words you do not yet have? What do you need to say? What are the tyrannies you swallow day by day and attempt to make your own, until you will sicken and die of them, still in silence? Perhaps for some of you here today, I am the face of one of your fears. Because I am woman, because I am Black, because I am lesbian, because I am myself – a Black woman warrior poet doing my work – come to ask you, are you doing yours?[34]

Find the words to do the work. But they may not be the ones you'd think you'd need. The opposition between speaking up and being silenced is a false one; some of us, even when we think we're speaking up, are at the same time being silenced. When we tell our stories that they don't believe, or worse, don't listen to. When we tell our stories in a mode we think they'll approve of, and they do – to a point. When we let their way of looking at our bodies shape the art we make with them. What I have found, in piecing together this monstrous network, is the dare to articulate something beyond speaking or silence that is a paradoxical alchemy of both. Something like what Woolf conjures as an aesthetic, historical, feminist problem for Lily Briscoe at the end of *To the Lighthouse*, in which, trying to work her way through the insurmountable problem of bringing order to her painting, all she can think of is Mrs Ramsay, and the world in which she thrived. The Angel, in other words. As she mulled over the feeling of outright *opposition* between Mr Ramsay and her picture, 'Phrases came. Visions came. Beautiful pictures. Beautiful phrases. But what she wished to get hold of was that very jar on the nerves, the thing itself before it has been made anything.'[35] The painting she works on is all a blur, until the very last pages, as Lily becomes aware that Mr Ramsay and his two children will finally have reached the lighthouse. She draws a line down the centre of the canvas, and it organises it, and succeeds in bringing the various forms into the right relation with each other, and it is the right balance between blur and focus, and she has had her

vision. Woolf gave her clearest enunciation about the problems and ecstasies and solutions of creativity to the figure of a painter, a double for her sister, a portrait with no face, only a name.

The power of language, and image, is to convey something besides, in addition to, above, below, beyond what we mean. When we speak we will inevitably use the wrong words, which will be the right ones. The affect they produce will carry. 'Words are dangerous things let us remember,' Woolf also wrote. 'A republic might be brought into being by a poem.'[36]

right after

Soon after I finished the final draft of this book, I found myself by chance on a layover in Milwaukee, between stops in America to see family. I knew that Eva Hesse's fibreglass piece *Right After* (1969) was at the Milwaukee Art Museum, so I caught an expensive taxi downtown to be able to spend some time with it.

It was made for a show at the Jewish Museum called *A Plastic Presence*; Hesse had promised the curator, a friend, that she would contribute, and although she was ill and tired and overworked, she wanted to make something new – she was always and ever steaming at full speed towards the future.[1] Suspended from the ceiling by translucent fisherman's wire, and running up to eighteen feet long, depending on how it's displayed, *Right After* is a supple, lacy web of fibreglass, tangled like the old computer cables we have in a large Tupperware under the bed, thickly coated with resin: drippy, organic, alive. It looks like a problem – but it has its own knotty logic, weighted in space, lots of things connected to other things. Parts of it had frayed. I wanted to grip the stuff in my hand, feel it against my palm. It was so close to me I could have done it – but of course I didn't, not only out of the same kind of obedience to the social contract that keeps us from shouting at the theatre, but out of respect for the fragile material, the desire to help the piece survive by quashing my childish instinct to touch it.

I took notes while I stood with the work, and thought about the problem of beauty it posed for Hesse. When she first conceived the piece in late 1968, she had imagined something quite 'simple [. . .] absurd and totally strange', just 'irregular wires and very little material'. Coming back to it to prepare for the show at the Jewish Museum, she found that working it and reworking it was a mistake; that through this process the piece 'left the ugly zone and went to the beauty zone'.[2]

When I saw it, it wasn't lit particularly dramatically, but it still

seemed to glow from within, ucky and aflame. In some photographs it looks electrified; in one dramatic image it is shown entirely in the dark and it hangs, glinting, like stalactites glimpsed in a cave. This is a property inherent to the material, as Hesse told Cindy Nemser: 'If you use fibreglass clear and thin, light does beautiful things to it [. . .] it is there, part of its anatomy.'[3] Here and there the piece is gathered by black fishhooks (which according to some reports are bent fragments of clothing hangers), which make a strong visual counterpoint to the webbing, but they can't fully interrupt the flow of the current running through it.

/

Right After, she called it. After what? I wondered, contemplating this work that Hesse all but disavowed. Hesse made it in collaboration with Doug Johns, the day after she came home from her first surgery to treat the brain tumour she had developed that year. She must have been yearning for the illness to be behind her, to move on with her life, get back to work. That notion of *after*, the way it reaches forward to a not-guaranteed future, will have been potent and poignant and desperate. But maybe it captures a feeling we can all understand. 'The work is the death mask of its conception,' wrote Walter Benjamin.[4] What we manage to produce can never be as alive and dynamic as the idea we had for it.

/

After what she perceived to be the failure of this piece, Hesse decided to execute the same idea, but this time with a less beautiful, more honest material – rope. (If beauty is an art sin, rope is the art penance, reminiscent of flagellation and punishment.) Maybe the first work's title reaches forward to the next one – what she did after. 'I want to extend my art perhaps into something that doesn't exist yet,' she told Cindy Nemser.[5]

/

Until that day in Milwaukee I had never seen any of Hesse's work in person; I made the time to seek it out, to make it more than theoretical, to encounter its texxture, its plastic presence, for myself. As I contemplated the weave of it, it occurred to me that randomness was one of its principles. Hesse didn't know how it was going to turn out, and what she learned from the experience of making it, of over-making it, was that she had to trust the material, and to know when to stop.

In an artist statement for her first independent sculpture show at the Fischbach Gallery in November 1968, Hesse wrote: 'I would like the work to [. . .] find its way beyond my preconceptions.' It was her 'main concern', she said, 'to go beyond what I know and what I can know'.[6] Following the thread from Woolf in her bath to this moment in the Milwaukee Art Museum, I have sometimes felt that I, too, was writing beyond my preconceptions, beyond what I knew or could know, writing not according to outline but on intuition. Looking back over it now, to me this book resembles one of Hesse's tangled hanging sculptures. I've traced something like a narrative through kinks and contortions, possibly losing track of it altogether, suspending it from a few rough-hewn hooks, and coming out through what is only one of many possible exits. If the line frays a bit here and there, like my laptop cable, so much the better. There are, too, many other strands I yearned to weave in. Right after this, I will write another book, one which emerged, joyfully, from those unfollowed threads. Thanks to Eva, I have had my vision.

<div style="text-align: right">– Paris, Liverpool, London
2017–23</div>

list of illustrations

(3.66 × 12.19 × 3.66 m). Installation view at Twenty Six by Twenty Six, Vassar College Art Gallery, Poughkeepsie, New York, May 1– June 6, 1971. Photo: Lynda Benglis. © 2023 Lynda Benglis/VAGA at ARS, New York/DACS, London.

68 Eva Hesse, *No title*, 1970. Latex, rope, string and wire. Dimensions variable. Purchase, with funds from Eli and Edythe L. Broad, the Mrs. Percy Uris Purchase Fund, and the Painting and Sculpture Committee. Inv. N.: 88.17a-b. Whitney Museum of American Art, New York. © The Estate of Eva Hesse. Courtesy Hauser & Wirth. Photo: Digital image Whitney Museum of American Art / Licensed by Scala.

69 Eva Hesse with rope sculpture, photographed by Hermann Landshoff, c. 1968. Münchner Stadtmuseum, Sammlung Fotografie, Munich / Archiv Landshoff. Photo Scala, Florence/bpk, Bildagentur für Kunst, Kultur und Geschichte, Berlin.

71 Eva Hesse, *Vinculum I*, 1969. Fibreglass, polyester resin, rubber tubing, staples and metal screen. 261.6 × 58.5 × 78.6 cm (103 × 23 × 31 in). Private collection. © The Estate of Eva Hesse. Courtesy Hauser & Wirth. Photo: Christie's Images / Bridgeman Images.

77 John Everett Millais, *Emily Patmore*, 1851. Fitzwilliam Museum, University of Cambridge. Photo: Bridgeman Images.

80 Julia Margaret Cameron*, The Angel in the House*, 1873. Courtesy Liverpool Libraries and Information Services Special Collections.

82 Julia Margaret Cameron, *Woman Making Lace*, 1872. Courtesy Liverpool Libraries and Information Services Special Collections.

93 Diego Velázquez's *Rokeby Venus*, slashed by a suffragette in March 1914. Photo: Illustrated London News Ltd/Mary Evans.

95 Elisabeth Vigée-Lebrun, *Self-Portrait with her daughter, Julie*, 1786. Musée du Louvre, Paris. Photo: agefotostock/Alamy.

111 Kara Walker, *Burn*, 1998. Cut paper and adhesive. Installation dimensions: 92 × 48 in (233.7 × 121.9 cm). © Kara Walker, courtesy of Sikkema Jenkins & Co. and Sprüth Magers.

120 Kara Walker, *Figa*, 2014. Sugar on polystyrene. 55 × 136 × 88 in (139.7 × 345.4 × 223.5 cm). Installation view at DESTE Foundation Project Space, Slaughterhouse, Hydra, Greece, 2017. © Kara Walker, courtesy of Sikkema Jenkins & Co. and Sprüth Magers. Photo: Fanis Vlastaras & Rebecca Constantopoulou.

257 Helen Chadwick, detail from *The Garden of Delights* at the centre of *The Oval Court*, 1986. Collage of blue-toned photocopies. Installation view, *Of Mutability*, Barbican Centre, London, 2004. © Estate of the artist, courtesy Richard Saltoun Gallery. Photo: Victoria and Albert Museum, London.

plates

1t Rebecca Horn, *Touching the walls with both hands simultaneously (Mit beiden Händen gleichzeitig die Wände berühren)*, from *Berlin – Übungen in neun Stücken (Berlin – Exercises in Nine Parts)*, 1974–5. © 2023 Rebecca Horn / DACS, London / VG Bild-Kunst, Germany. Photo: Helmut Wietz.

1b Cindy Sherman, *Untitled #175*, 1987. Chromogenic colour print. 120.7 × 181.6 cm (47 ½ × 71 ½ in). © Cindy Sherman. Courtesy the artist and Hauser & Wirth.

2 Jenny Saville, *Propped*, 1992. Oil on canvas. 84 × 72 in (213.4 × 182.9 cm). © Jenny Saville. All rights reserved. DACS, London, 2023. Courtesy Gagosian.

3 Laura Knight, *Self-Portrait with Model*, 1913. National Portrait Gallery, London. Photo © Stefano Baldini / © Estate of Dame Laura Knight. All rights reserved 2023 / Bridgeman Images.

4 Lorna Simpson, *Without really trying*, 2019. Collage on paper, 2 framed collages. Overall installation dimensions variable. Left, framed: 20 × 12 × 1 ½ in (30.5 × 50.8 × 3.8 cm). Right, framed: 19 × 14 ³⁄₁₆ × 1 ½ in (48.3 × 36 × 3.8 cm). © Lorna Simpson. Courtesy the artist and Hauser & Wirth. Photo: James Wang.

5 Kara Walker, *A Subtlety, or the Marvelous Sugar Baby, an Homage to the unpaid and overworked Artisans who have refined our Sweet tastes from the cane fields to the Kitchens of the New World on the Occasion of the demolition of the Domino Sugar Refining Plant*, 2014. Polystyrene foam, sugar. Approx. 35.5 × 26 × 75.5 feet (10.8 × 7.9 × 23 m). Installation view at Domino Sugar Refinery, a project of Creative Time, Brooklyn, NY, 2014. © Kara Walker, courtesy of Sikkema Jenkins & Co. and Sprüth Magers. Photo: Jason Wyche.

6 Sutapa Biswas, *Housewives with Steak-knives*, 1985. Oil, acrylic, pastel, pencil, white tape, collage on paper mounted onto canvas. 245 × 222 cm

14*t* Helen Chadwick, *Enfleshings I*, 1989. Transparency on lightbox. Tate
Gallery, London. © Estate of the artist, courtesy Richard Saltoun
Gallery. Photo: © Tate.

14*b* Helen Chadwick, *The Oval Court*. Installation photo from the ICA
exhibition, *Of Mutability*, 1986. © Estate of the artist, courtesy Rich-
ard Saltoun Gallery. Photo: courtesy Leeds Museums & Galleries
(Henry Moore Institute Archive).

15*t* Vanessa Bell, *Virginia Woolf in a Deckchair*, 1912. Collection of Mimi
and Peter Haas. © Estate of Vanessa Bell. All rights reserved, DACS
2023. Photo: Sotheby's/akg-images.

15*b* Virginia Woolf, annotated front cover of Volume I of the *Three
Guineas* notebook. Monks House Papers, The Keep at the Univer-
sity of Sussex. Reproduced by courtesy of The Society of Authors,
Literary Representative of the Estate of Virginia Woolf.

16 Eva Hesse, *Right After*, 1969. Fibreglass, polyester resin, wire.
Approximately $5 \times 18 \times 4$ ft ($1.52 \times 5.49 \times 1.22$ m). Milwaukee Art
Museum, Wisconsin. Gift of Friends of Art, M 1970.27. © The Estate
of Eva Hesse. Courtesy Hauser & Wirth.

notes

the slash

1 Virginia Woolf, 'Speech before the London/National Society for Women's Service, January 21 1931', *The Pargiters*, ed. Mitchell Leaska, New York: Harvest/HBJ, 1977, p. xxviii.

angels and monsters

1 Hermione Lee, *Virginia Woolf*, London: Chatto & Windus, 1996, p. 593.
2 Virginia Woolf, 'Speech before the London/National Society for Women's Service, January 21 1931', *The Pargiters*, p. xxix.
3 ibid., p. xxxi.
4 Woolf, *To the Lighthouse* (1927), New York: Harcourt Brace & Company, 1981, p. 148. Hereafter *TTL*.
5 ibid., p. 149.
6 ibid., p. 150.
7 Woolf, 'Professions for Women' [posthumous essay version], *The Essays of Virginia Woolf, Vol. 6 1933–1941* [hereafter *E6*], ed. Stuart N. Clarke, London: Hogarth Press, 2011, pp. 479–84, p. 481.
8 Jenny Offill, *Dept. of Speculation*, London: Granta, 2014, p. 8.
9 Chris Kraus, *I Love Dick* (1997), Los Angeles: Semiotext(e), 2006, p. 218; Angela Carter, *The Sadeian Woman and the Ideology of Pornography*, New York: Pantheon, 1979, p. 27; Carolyn Burke, *Lee Miller: A Life*, New York: A. A. Knopf, 2005, p. 296.
10 Offill, *Dept. of Speculation*, p. 8.
11 *E6*, p. 483.

12 Woolf, *A Room of One's Own*, New York: Harcourt, 1929, p. 81. Here-
 after *AROO*.

13 *TTL*, p. 193.

14 Leaska, *The Pargiters*, p. xxxviii.

15 ibid., p. xl.

16 ibid., p. xxxix.

17 Carolee Schneemann, *More Than Meat Joy: Performance Works
 and Selected Writings*, ed. Bruce McPherson, Kingston, NY:
 Documentext/McPherson & Company, 1979, 1997, p. 238. We
 don't know what was written on the scroll in this performance,
 but Schneemann read aloud from the script of a film called *Kitch's
 Last Tape*, which included the now-famous 'I met a man' speech.
 At a 1977 performance in Telluride, this speech was written on the
 scroll.

18 Schneemann clearly associated Michelson with gate-keeping for the
 patriarchy, but in her own interview with MacDonald Michelson
 expressed regret for not having taken Schneemann's work more ser-
 iously in the 60s. See Scott MacDonald, *Avant-Doc: Intersections of Docu-
 mentary and Avant-garde Cinema*, Oxford: Oxford University Press, 2015,
 p. 43.

19 Schneemann, 'The Obscene Body/Politic', *Art Journal*, 50:4 (Winter
 1991), pp. 28–35, p. 31.

20 Quoted in Quinn Moreland, 'Forty Years of Carolee Schneemann's
 "Interior Scroll" ', *Hyperallergic*, 29 August 2015.

21 Schneemann, 'The Obscene Body/Politic,' pp. 31–2.

22 Sabine Breitwieser, *Carolee Schneemann: Kinetic Painting*, Munich: Pres-
 tel, 2015, p. 14.

23 Schneemann, 'The Obscene Body/Politic', p. 29.

24 ibid., p. 28.

25 Schneemann, *More Than Meat Joy*, p. 52.

26 Jeffrey Jerome Cohen, 'Monster Culture (Seven Theses)', in *Monster
 Theory: Reading Culture*, ed. Jeffrey Jerome Cohen, Minnesota MN:
 University of Minnesota Press, 1996, p. 13.

27 cf. Pliny's accounting of the 'monstrous races', which includes people
 from India and Ethiopia (*Natural History*, vol. 7, 512–27), or Aristotle's
 Generation of Animals 1:1187–8.

28 In Sandra M. Gilbert and Susan Gubar, *The Madwoman in the Attic: The Woman Writer and the Nineteenth-Century Imagination*, New Haven: Yale University Press, 1979, 2nd ed. 2000, p. 240.

29 Hesiod, *Theogony*, in *The Homeric Hymns and Homerica*, trans. Hugh G. Evelyn-White, London: William Heinemann, 1914, line 585; Aristotle, *Generation of Animals*, trans. A. L. Peck, Cambridge, MA: Harvard University Press, 1942, 2:737a. Disability too Aristotle finds 'monstrous', and associates it with the female; Simone de Beauvoir quotes Menander in *The Second Sex* (1949), trans. Constance Borde and Sheila Malovany-Chevallier, New York: Knopf, 2010, p. 98. I am indebted to Annabelle Hirsch for pointing me to this quote.

30 Gilbert and Gubar, *Madwoman*, p. 240.

31 Anne Carson, 'Dirt and Desire', *Men in the Off Hours*, New York: Knopf, 2000, p. 133.

32 Beauvoir, *The Second Sex*, p. 163.

33 ibid., p. 167.

34 Susan Stryker, 'My Words to Victor Frankenstein above the Village of Chamonix', in *The Transgender Studies Reader*, ed. Susan Stryker and Stephen Whittle, New York: Routledge, 2006, pp. 244–56, p. 247.

35 St Augustine, *The City of God Against the Pagans*, ed. R. W. Dyson, Cambridge: Cambridge University Press, 1998/2010, p. 708.

36 Kraus, *I Love Dick*, p. 218.

37 Adrienne Rich, *Arts of the Possible: Essays and Conversations*, New York: W. W. Norton, 2001, p. 8.

38 Schneemann, *More Than Meat Joy*, p. 9.

39 Terry Eagleton, *The Ideology of the Aesthetic*, Oxford: Blackwell, 1990, p. 13.

40 Kathy Acker, *Don Quixote*, New York: Grove Atlantic, 1986, p. 39.

41 Lucy R. Lippard, interview with Judy Chicago, *Artforum*, vol. 13, 1974, p. 62.

42 Maggie Nelson, *The Art of Cruelty: A Reckoning*, New York: W. W. Norton, 2011, p. 67.

43 Kraus, *I Love Dick*, p. 211.

44 Rachel Cusk, 'Can a Woman Who Is an Artist Ever Just Be an Artist?', *New York Times*, 7 November 2019.

45 ibid.

46 ibid.

47 ibid., p. 35.

carry that weight

1 In Frances Spalding, *Vanessa Bell: Portrait of the Bloomsbury Artist* (1983), London: I. B. Tauris, 2016, p. 320.

2 Rebecca Solnit, 'If I Were a Man', *Guardian*, 26 August 2017.

3 In *Rebecca Horn: Musée de Grenoble*, Grenoble: Réunion des Musées Nationaux, 1995, p. 16.

4 In *Rebecca Horn: The Glance of Infinity*, ed. Carl Haenlein, Zurich: Kestner Gesellschaft, Scalo Verlag, 1997, p. 58.

5 Horn is one in a long line of twentieth-century female artists who reclaimed the use of non-traditional artistic materials, especially textiles. With its array of surrealist materials – ostrich eggs, feathers, hair (animal and human), sticks, gloves, musical instruments, beds, and shards of glass – Horn's work continues the explorations made by female surrealists in the 1930s like Meret Oppenheim (who was Horn's mentor) or the fashion designer responsible for the lobster dress, Elsa Schiaparelli, women who appropriated the animal to themselves as if to reclaim, voluntarily, an unconsciousness of which they had always, collectively, been accused. This strand of female surrealist work interrogates the primary themes of tactility, excess and femininity by thinking about hands and claws, and what it is they might be grasping for.

6 Paul B. Preciado in conversation with Lauren Bastide, *La Poudre* podcast, episode 79, 29 July 2020.

7 The 'first-person industrial complex', as Laura Bennett called it in an article for *Slate*, asks young women to comply with certain narratives – even fragmented, anti-narrative narratives (like, say, the one I'm writing now), and then cash their cheques for two hundred dollars, while whomever owns the website racks up ad revenue as the author is viewed, and viewed, and viewed. A one-time fee for the author; an endlessly renewable source of income for the owner. Laura Bennett, 'The First-Person Industrial Complex', Slate.com, 14 September 2015.

8 Nancy Princenthal, *Unspeakable Acts: Women, Art, and Sexual Violence in the 1970s*, New York: W. W. Norton, 2019, p. 9.

9 Toni Morrison, 'The Site of Memory', in *Inventing the Truth: The Art and Craft of Memoir*, ed. William Zinsser, Boston: Houghton, 1987, pp. 109–13, p. 110.

10 Carolee Schneemann, *Up to and Including Her Limits*, New York, NY: C. Schneemann, 1973–6, p. 5.

11 Lucy R. Lippard, 'The Pains and Pleasures of Rebirth: European and American Women's Body Art', in *From the Center: Feminist Essays on Women's Art*, New York: E. P. Dutton, 1976, pp. 123–4.

12 'Suzanne Lacy: Women Fight Back', SFMoMA, online.

13 Moira Roth, ed., *The Amazing Decade: Women and Performance Art in America, a source book*, Los Angeles: Astro Artz, 1983, p. 20.

14 Princenthal, *Unspeakable Acts*, p. 9.

15 https://www.suzannelacy.com/ablutions/

16 Princenthal, *Unspeakable Acts*, p. 80.

17 Virginia Woolf, *Three Guineas* (1938), ed. Jane Marcus, New York: Harcourt, 2006, p. 170. Hereafter *3G*.

the hand-touch sensibility

1 The interview happened too late for inclusion in Nemser's landmark book *Art Talk* (New York: Scribner, 1975), which came out that year, though when it was republished in 1995 she added three artists, none of whom was Wilke.

2 Cindy Nemser, 'Conversation With Hannah Wilke, 1975' in *Hannah Wilke: Art for Life's Sake*, ed. Tamara Schenkenberg and Donna Wingate. St. Louis, MO: Pulitzer Arts Foundation, 2021; parts omitted from the exhibition catalogue can be heard on the full audio conversation between Hannah Wilke and Cindy Nemser, 1975, Cindy Nemser papers. Interview, audiotape, transcript and edited transcript copyright Cindy Nemser and Marsie, Emanuelle, Damon, and Andrew Scharlatt, Hannah Wilke Collection & Archive, Los Angeles/VAGA at ARS, New York.

3 Nemser, 'A Conversation with Eva Hesse', in Mignon Nixon, *Eva Hesse*, Cambridge, MA: MIT Press, 2002, pp. 1–32, p. 11. This interview has been published in several different incarnations over the years; the two main versions I will cite are the original, first published in *Artforum* in the May 1970 issue (with Hesse's *Contingent* on the cover, published the month she died), and this slightly rearranged edition. A still different version is in Nemser's 1975 book *Art Talk: conversations with 12 women artists*.

4 Interview with Nemser, in Nixon, *Eva Hesse*, pp. 16–17.

5 The Vietnam War would end in April 1975; Nemser's interview with Wilke took place on 18 February of that year.

6 Interview with Linda Nochlin in *Reclaiming the Body: Feminist Art in America*, Michael Blackwood Productions, 1995.

7 Ebony G. Patterson to Lori DeGolyer, *Bomb Magazine*, 2 June 2020.

8 Nemser, 'Interview with Helen Frankenthaler', *Arts*, November 1971. My thanks to Karen Wilkin for tracking down this reference.

9 'The Legacy of Helen Chadwick', Institute of Contemporary Art, 9 March 2016, YouTube.

10 Virginie Despentes, 'Cette histoire de féminité, c'est de l'arnaque', *Le Monde*, 9 July 2017. All translations from French are mine unless otherwise noted.

11 Andrea Long Chu, *Females*, London: Verso, 2019, p. 11.

12 Julia Kristeva, *Powers of Horror: An Essay on Abjection*, trans. Leon S. Roudiez, New York: Columbia University Press, 1982, p. 3. Hereafter *POH*.

13 *POH*, p. 2.

14 Beauvoir, *The Second Sex*, p. 167.

15 ibid., p. 3.

16 Documentary, *The Art of Helen Chadwick*, Illuminations Media, 2004.

17 Riccardo Venturi, 'Genieve Figgis: Almine Rech Gallery, Paris', *Artforum*, April 2018.

18 Wilke made *Gestures* the day after the sudden death of her brother-in-law, Hal Scharlatt; this may contribute something of the video's memento mori feeling. My thanks to Marsie Scharlatt for bringing this connection to my attention.

objects of vulgarity

1 She would ultimately make five casts of this dildo – in bronze, in lead, in aluminium, in tin – for works called *Parenthesis* and *Smile*.

2 Quoted in Lucy Lippard, 'Transformation Art', *Ms.*, (Oct 1975), p. 34.

3 Mikhail Bakhtin, *Rabelais and His World* (1968), trans. Hélène Iswolsky, Bloomington, IN: Indiana University Press, 1984, pp. 25, 26.

4 Mary Russo, *The Female Grotesque: Risk, Excess, and Modernity*, New York: Routledge, 1995; Barbara Creed, *The Monstrous-Feminine: film, feminism, psychoanalysis* (1993), London: Routledge, 2015, p. 58.

5 Lynda Nead, *The Female Nude: Art, Obscenity and Sexuality*, London: Routledge, 1992, p. 7.

6 ibid., p. 2.

7 Russo, *The Female Grotesque*, p. 4.

8 Rosalind Krauss, *Bachelors*, Cambridge, MA: MIT Press, 1999, p. 235.

9 Christine Ross, 'Redefinitions of abjection in contemporary performances of the female body', in *Res 31* (Spring 1997), pp. 149–56, p. 149.

10 ibid., p. 150.

11 Elizabeth Grosz, 'The Body of Signification', in John Fletcher and Andrew Benjamin, eds., *Abjection, Melancholia, and Love: The Work of Julia Kristeva*, New York: Routledge, 1990, pp. 80–103, p. 81.

12 Carolee Schneemann (transcribed by Raegan Truax-O'Gorman), 'Regarding Ana Mendieta', *Women & Performance*, 21:2 (2011), pp. 183–90, p. 183.

13 ibid., pp. 185–6.

14 ibid.

15 Suzie Mackenzie, 'Under the Skin': interview with Jenny Saville, *Guardian*, 22 October 2005.

16 Luce Irigaray, 'When Our Lips Speak Together', trans. Carolyn Burke, *Signs*, 6:1 (Autumn 1980), pp. 69–79, p. 69.

slash/aesthetics

1 Luce Irigaray, *Speculum of the Other Woman* (1974), trans. Gillian C. Gill, Ithaca, NY: Cornell University Press, 1985, p. 142.

2 Catherine Clément and Hélène Cixous, *The Newly Born Woman* (1975), trans. Betsy Wing, Minneapolis, MN: University of Minnesota Press, 1986, p. 33.

3 Cixous, 'Laugh of the Medusa' (1975), trans. Keith Cohen and Paula Cohen, *Signs*, vol. 1, No. 4 (Summer, 1976), pp. 875–93, p. 887.

4 Irigaray, *Speculum of the Other Woman*, p. 142.

5 Kathy Acker, *Empire of the Senseless*, New York: Grove Press, 1988, p. 12.

6 Lucy R. Lippard, 'What is Female Imagery?', in *From the Center: Feminist Essays on Women's Art*, New York: E. P. Dutton, 1976, pp. 80–89, pp. 83, 84.

7 Lippard, 'Sweeping Exchanges: The Contribution of Feminism to the Art of the 1970s', in *Art Journal*, Fall/Winter 1980, pp. 362–5, p. 363.

8 Virginia Woolf, *E6*, p. 481.

9 Linda Nochlin, *Women Artists: The Linda Nochlin Reader*, ed. Maura Reilly, New York: Thames & Hudson, 2015, pp. 44–5.

10 Yishay Garbasz, with Vivian Sobchack, *Becoming*, New York: Mark Batty Publisher, 2010, p. 179.

11 Sobchack, in *Becoming*, pp. 185–6.

on sensation

1 Susan Sontag, 'Against Interpretation', in *Against Interpretation and Other Essays*, NY: Farrar, Straus & Giroux, 1966, p. 14.

2 ibid., p. 9.

3 ibid.

4 Virginia Woolf, 'Speech [Manuscript Notes]', *The Pargiters*, p. 164.

5 Mary Ruefle, *Madness, Rack, and Honey: Collected Lectures*, New York: Wave Books, 2012, p. 38.

6 ibid., p. 40.

7 ibid., pp. 40–41.

8 ibid.

9 ibid., p. 42.

10 Woolf, 'Letter to a Young Poet' (1932), *Collected Essays of Virginia Woolf, Vol. 5: 1929–1932*, ed. Stuart Clarke, Boston: Houghton Mifflin Harcourt, 2010, p. 315. Hereafter *E5*.

11 Maura Reilly, 'A Dialogue with Linda Nochlin, the Maverick She', in Linda Nochlin, *Women Artists: the Linda Nochlin Reader*, ed. Maura Reilly, London: Thames & Hudson, 2015, p. 21.

on articulation

1 Carolyn Heilbrun, *Writing a Woman's Life*, New York: Ballantine, 1989, p. 113.

2 Edouard Glissant, *Poetics of Relation* (1990), trans. Betsy Wing, Ann Arbor, MI: University of Michigan Press, 1997, p. 11.

3 Eve Kosofsky Sedgwick, *Tendencies*, Durham, NC: Duke University Press, 1993, p. 8, italics mine.

4 Clarice Lispector, *Água Viva* (1973), trans. Idra Novey, New York: New Directions, 2012.

5 Émilie Notéris, *Alma Matériau*, Paris: Paraguay Press, 2020, p. 35 (my translation); Quinn Latimer, *Like a Woman: Essays, Readings, Poems*, Berlin: Sternberg Press, 2017; Kraus, *I Love Dick*, p. 164.

6 This piece is also referred to as *Untitled (Rope Piece)* but the Whitney, who owns it, refers to it as *No Title*.

7 Donna Haraway, 'The Promises of Monsters: A Regenerative Politics for Inappropriate/d Others', in Lawrence Grossberg, Cary Nelson, Paula A. Treichler, eds., *Cultural Studies*, New York: Routledge, 1991, pp. 295–337, p. 325.

8 Quoted in Lawrence Grossberg, *We gotta get out of this place: conservatism and postmodern culture*, New York: Routledge, 1992, pp. 141–2.

9 ibid., p. 54.

10 Hesse to Nemser, in Nixon, *Eva Hesse*, p. 19.

11 Eileen Myles, 'Writing', in *I Must Be Living Twice: New and Selected Poems 1975–2014*, New York: Ecco, 2015, p. 234.

12 Nisha Ramayya, Sandeep Parmar and Bhanu Kapil, *Threads*, London: Clinic Publishing, 2018, p. 37.

13 Jane Marcus, *Art & Anger: Reading Like a Woman*, Columbus, OH: Ohio State University Press, 1988, p. 215.

14 ibid., p. 216.

15 ibid., p. 219.

16 ibid., p. 329.

the angel in the image

1 Coventry Patmore, *The Angel in the House: the Betrothal*, London: John W. Parker and Son, 1854, pp. 5, 29.

2 ibid., p. 58.

3 Mrs Motherly, *Nursery Poetry*, London: Bell and Daldy, 1859, p. 50.

4 Emily Tennyson, quoted by Phyllis Rose, 'Milkmaid Madonnas', in Sylvia Wolf, *Julia Margaret Cameron's Women*, New Haven, CT: Yale University Press, 1998, p. 13.

5 Colin Ford, *Julia Margaret Cameron: A Critical Biography*, Los Angeles: J. Paul Getty Museum, 2003, p. 69; Roger Fry, 'Mrs. Cameron's Photographs', in Virginia Woolf, Julia Margaret Cameron, Roger Fry, *Julia Margaret Cameron*, Los Angeles: J. Paul Getty Museum, 2018, p. 79.

6 Fry, 'Mrs. Cameron's Photographs', p. 76.

7 Woolf, *AROO*, p. 89.

8 Amanda Hopkinson, *Julia Margaret Cameron*, London: Virago, 1986, p. 20.

9 Julia Margaret Cameron, letter to John Herschel, 31 December 1864. The Herschel correspondence is in the Royal Society, at 6–9 Carlton House Terrace, London.

10 Julian Cox, '"To . . . startle the eye with wonder & delight": The Photographs of Julia Margaret Cameron', in Julian Cox and Colin Ford, *Julia Margaret Cameron: The Complete Photographs*, Los Angeles: Getty Publications, 2003, p. 57.

11 Cox and Ford, *Julia Margaret Cameron*, p. 373.

12 Griselda Pollock and Rozsika Parker, *Old Mistresses: Women, Art and Ideology* (1981), London: I. B. Tauris, 2013, pp. 9, 10.

13 See ibid., *Old Mistresses*, pp. 59–63.

14 ibid., p. 62; Mary Lamb, 'On Needlework' (1814), in Anne Gilchrist, *Mary Lamb*, Boston: Roberts Brothers, 1884, pp. 244–54.

15 In Pollock and Parker, *Old Mistresses*, p. 63.

16 See Frances Borzello, *Seeing Ourselves: Women's Self-Portraits* (1998), London: Thames & Hudson, 2018, p. 31.

17 Linda Nochlin, 'Why Have There Been No Great Women Artists?' *ARTNews*, January 1971, reprinted in *Women Artists: The Linda Nochlin Reader*, ed. Maura Reilly, London: Thames & Hudson, 2015, pp. 42–68, p. 52.

sibyls and slashers

1 Pollock and Parker, *Old Mistresses*, p. xix.

2 ibid., p. 90.

3 ibid., pp. 89–90.

4 ibid.

5 Frances Borzello, *Seeing Ourselves*, p. 33.

6 Described in Henry James, 'Notes on Novelists' (1914), *Selected Literary Criticism of Henry James*, ed. Morris Shapira, London: Heinemann, 1963, pp. 157–8.

7 In *A Room of One's Own*, Woolf imagines that Shakespeare had a sister, called Judith, who was as inspired and adventurous as he, as gifted a writer, who ran away from home and an arranged marriage and tried to get work in the theatre, but whereas her brother, by virtue of his sex, became a great playwright, she herself was knocked up by the actor-manager Nick Greene, and in her shame, 'killed herself one winter's night and lies buried at some cross-roads where the omnibuses now stop outside the Elephant and Castle'. *AROO*, p. 48.

8 See Lynda Nead, *The Female Nude*, and Catherine McCormack, *Women in the Picture: Women, Art and the Power of Looking*, London: Icon Books, 2021.

9 Borzello, *Seeing Ourselves*, pp. 35–6.

10 ibid.

11 ibid.

12 Claude Phillips, *Daily Telegraph*, 17 April 1914.

extreme times call for extreme heroines

1 Karen Finley, 'Karen Finley', in *Angry Women*, ed. Andrea Juno and V. Vale, New York: Re/Search Publications, 1991, p. 41.

2 See, for instance, Michelle Cliff's essay 'Object into Subject: Some Thoughts on the Work of Black Women's Artists', in *Making Face, Making Soul/Haciendo Caras: Creative and Critical Perspectives by Women of Color*, ed. Gloria Anzaldúa, San Francisco: Aunt Lute, 1990, pp. 271–90.

3 Cindy Nemser, *Art Talk*, p. 326.

4 Holland Cotter, ' "It's About Time!" Betye Saar's Long Climb to the Summit', *New York Times*, 4 September 2019. I have retained the lower-case 'b' for Black to reflect the original punctuation, here as elsewhere.

5 Aunt Jemima was a portrait of a real woman, a former slave called Nancy Green. She was employed as the cook for a judge in Chicago, and won a competition held by the makers of Aunt Jemima pancake flour to find a face for their brand, which they'd named for an old minstrel's song by the Black comedian Billy Kersands. Green made her debut at the 1893 World's Columbian Exposition, for which they built her the world's largest flour barrel, and she stood outside of it at a griddle telling stories and jokes and serving up thousands of pancakes. As her fame grew, she travelled to make demonstrations of the product around the country. Green signed a lifetime contract with the company, and her face would be used in its packaging and ads for the next 130 years. She did not share in the proceeds. Quaker Oats wouldn't retire Aunt Jemima until the summer of 2020, under pressure from the Black Lives Matter movement.

6 Betye Saar, 'Influences', *Frieze* 182 (September 2016).

7 Deborah Willis and Carla Williams, *The Black Female Body: a photographic history*, Philadelphia, PA: Temple University Press, 2002, p. ix.

8 Lubaina Himid, 'Fragments', *Feminist Arts News*, 2:8, Autumn 1988, p.8.

9 Sacha Bonét, 'Reimagining Black Futures', *Paris Review Daily*, 24 June 2020.

10 Lorna Simpson, *Give Me Some Moments*, Gallery exhibition, Hauser & Wirth, New York, 2019.

11 Nadja Sayej, 'Betye Saar: the artist who helped spark the black women's movement', *Guardian*, 30 October 2018.

12 Ellen Y. Tani, 'Keeping Time in the Hands of Betye Saar', *American Quarterly*, 68:4, December 2016, pp. 1081–1109, p. 1081, review of *Betye Saar: Still Tickin'*, Museum De Domijnen, Sittard, The Netherlands, 28 June–15 November 2015; Scottsdale Museum of Contemporary Art, Scottsdale, Arizona, 30 January–1 May 2016.

13 Wendy N. E. Ikemoto, quoted in Sayej, 'Betye Saar: the artist who helped spark the black women's movement'.

14 The full title of Walker's work was *At the behest of Creative Time Kara E. Walker has confected: A Subtlety, or the Marvelous Sugar Baby, an Homage to the unpaid and overworked Artisans who have refined our Sweet tastes from the cane fields to the Kitchens of the New World on the Occasion of the demolition of the Domino Sugar Refining Plant.*

15 Jessica Kramer, 'Kara Walker Addresses Art and Controversy at the Newark Public Library', *Huffington Post*, 13 March 2013.

16 Hilton Als, 'The Shadow Act', *New Yorker*, 8 October 2007.

17 See Georges Vigarello, *The Silhouette: From the 18th Century to the Present Day*, trans. Augusta Dörr, London: Bloomsbury, 2012.

18 Kramer, 'Kara Walker Addresses Art and Controversy at the Newark Public Library'.

19 Betye Saar interview, PBS series *I'll Make Me a World*, 1999, quoted in Thomas McEvilly, 'Primitivism in the Works of an Emancipated Negress', in *Kara Walker: My Complement, My Enemy, My Oppressor, My Love*, ed. Philippe Vergne (Minneapolis, MN: Walker Art Center, 2007). Quoted in Zadie Smith, 'What Do We Want History to Do to Us?', *New York Review of Books*, 27 February 2020.

20 Howardena Pindell, quoted in Michael Corris and Robert Hobbs, 'Reading Black Through White in the Work of Kara Walker', in *Art History*, 26:3 (June 2003), pp. 422–41, p. 430. See also Maria del Guadalupe Davidson's excellent chapter 'Black Silhouettes on White Walls: Kara Walker's Magic Lantern', in Sherri Irvin, ed., *Body Aesthetics*, Oxford: Oxford University Press, 2016, pp. 15–36.

21 Smith, 'What Do We Want History to Do to Us?'

22 Laura Mulvey and Peter Wollen, directors, *Riddles of the Sphinx*, BFI Films, 1977.

23 Louise Bourgeois, *Destruction of the Father Reconstruction of the Father: Writings and Interviews 1923–1997*, ed. Marie-Laure Bernadac and Hans-Ulrich Obrist, Cambridge, MA: MIT Editions/Violette Editions, 1998, p. 190.

24 'The Way I See It' with Kara Walker, BBC Radio 3, 2 December 2019.

25 Jerry Saltz, 'Making the Cut: Kara Walker, Wooster Gardens', *Village Voice*, 24 November 1998.

26 Hamza Walker, 'Cut It Out', essay accompanying a Kara Walker exhibition at the Renaissance Society, University of Chicago, January–February 1997, reprinted in *NKA: Journal of Contemporary African Art* (Fall/Winter 2000), pp. 108–13, p. 110.

27 Doreen St Félix, 'Kara Walker's Next Act', *New York Magazine*, 17 April 2017.

difficult conversations

1 Quoted in Aruna D'Souza, *Whitewalling: Art, Race & Protest in 3 Acts*, Brooklyn, NY: Badlands Unlimited, 2020, pp. 24–5.

2 Quoted in Calvin Tomkins, 'Why Dana Schutz Painted Emmett Till', *New Yorker*, 3 April 2017. Screenshots widely available on the internet.

3 Eva Respini in conversation with Christopher Ehlers, 'Banalities, Absurdities, and Anxieties', *Dig Boston*, 29 August 2017.

4 Coco Fusco, 'Censorship, Not the Painting, Must Go: On Dana Schutz's Image of Emmett Till', *Hyperallergic*, 27 March 2017.

5 Elizabeth Alexander, 'Can You Be BLACK and Look at This? Reading the Rodney King Videos', *Public Culture*, vol. 7, 1994, pp. 77–94, pp. 78, 79.

6 D'Souza, *Whitewalling*, p. 113.

7 Dana Schutz statement, quoted in Randy Kennedy, 'White Artist's Painting of Emmett Till at Whitney Biennial Draws Protests', *New York Times*, 21 March 2017.

8 Tomkins, 'Why Dana Schutz Painted Emmett Till'.

9 Audre Lorde, 'The Transformation of Silence into Language and Action' (1977), *Your Silence Will Not Protect You*, London: Silver Press, 2017, p. 1.

10 D'Souza, *Whitewalling*, pp. 56–7.

11 ibid., p. 32.

12 Quoted in ibid., pp. 33–4.

13 She has been compared to the painter Maria Lassnig for this reason, on whom more to come in part III.

14 Zadie Smith, 'Getting In and Out', *Harper's*, July 2017.

get out your steak knives, Kali

1 Gilane Tawadros, 'Beyond the Boundary: the Work of Three Black Women Artists in Britain', *Third Text*, 3:8–9 (1989), pp. 121–50, p. 145.

2 'Housewives with Steak Knives – Sutapa Biswas', British Museum, promotional material for Tantra Exhibition, 28 November 2020.

3 Sutapa Biswas, *Lumen*, London: Ridinghouse, 2021, p. 28.

4 Tawadros, 'Beyond the Boundary', p. 145.

5 ibid., p. 146.

6 Biswas, 'Artist's Statement 1987', in *Sutapa Biswas*, London: Institute of International Visual Arts, 2004, p. 20.

7 Biswas, *Lumen*, p. 23.

8 Ammar Kalia, 'The art of tantra: is there more to it than marathon sex and massages?' *Guardian*, 21 September 2020.

9 Biswas, Artist's statement, Camden VOX, Camden Commissions at Swiss Cottage Library, June 2018–January 2019.

10 'Airport virginity tests banned by Rees', *Guardian*, 3 February 1979.

11 Biswas, *Lumen*, p. 31.

12 'White Painting (1951)', Robert Rauschenberg Foundation website.

13 Biswas, *Lumen*, p. 31.

14 Nanette Salomon, 'Judging Artemisia: a Baroque Woman in Modern Art History', in *The Artemisia Files: Artemisia Gentileschi for Feminists and Other Thinking People*, ed. Mieke Bal, University of Chicago Press, 2005, pp. 57–8.

15 Biswas, *Lumen*, p. 30.

16 Personal correspondence between Greenhalgh and Biswas, reproduced with their consent.

17 Griselda Pollock, 'Tracing Figures of Presence, Naming Ciphers of Absence' (1998). Reprinted in Biswas, *Lumen*, pp. 49–73, p. 52.

18 Yasmin Yureshin, 'Reworking Myths: Sutapa Biswas', reprinted in *Visibly Female, Feminism and Art: an Anthology*, ed. Hilary Robinson, London: Camden Press, 1987, p. 37; originally in *Spare Rib*, December 1986.

19 'Housewives with Steak Knives – Sutapa Biswas'.

20 Ramayya, Parmar and Kapil, *Threads*, p. 37.

21 Lubaina Himid, *Thin Black Line(s)*, Newcastle-upon-Tyne: Making History Visible Project, Centre for Contemporary Art, UCLAN, 2001, pp. 10, 12.

22 Jeffrey Jerome Cohen, 'Monster Culture (Seven Theses)', p. 4.

23 Quoted in Rebecca Peabody, *Consuming Stories: Kara Walker and the Imagining of American Race*, Oakland, CA: University of California Press, 2016, p. 131.

24 Kabir Jhala, 'Sutapa Biswas: "Our reckoning with empire has certainly begun, but we've only scratched the surface"', *The Art Newspaper*, 24 June 2021.

25 Quoted in William Dalrymple, 'The Great Divide: The violent legacy of Indian Partition', *New Yorker*, 29 June 2015.

26 Stuart Hall, 'Cultural Identity and Diaspora', *Identity, Community, Culture, Difference*, ed. Jonathan Rutherford, London: Lawrence & Wishart, 1990, pp. 222–37.

27 Biswas, *Lumen*, p. 44.

let it blaze!

1 Monk's House Papers, B16.f, vol. 2, University of Sussex, accessed via *The Three Guineas Reading Notebooks*, ed. Vara Neverow and Merry M. Pawlowski, hosted by Southern Connecticut State University.

2 The comparison is Jane Marcus's, in *Art & Anger: Reading Like a Woman*, Columbus, OH: Ohio State University Press, 1988, p. 75.

3 *D4*, p. 77, 30 December 1935.

4 My thanks to the French journalist Lauren Bastide, whose feminist podcast La Poudre (powder) inspired this connection.

5 Clément and Cixous, *The Newly Born Woman*, p. 95.

6 *3G*, p. 5.

7 ibid., p. 121.

8 ibid., p. 135.

9 ibid., p. 131.

10 ibid., pp. 132–3.

11 ibid., p. 135.

12 ibid., p. 32.

13 And yet for all its anger, the quotation marks pile up, like a buffer, the command 'Let it blaze' contained within the note contained within my citation of the text itself. Triple quote quote quote. If you wrap up your thought bombs nice and tight do they explode more forcefully? *3G*, p. 34.

14 Monk's House Papers, B16.f, vol. 2, pp. 9–10.

15 *3G*, pp. 217–18fn39.

16 Rebecca Wisor, 'About Face: The *Three Guineas* Photographs in Cultural Context', *Woolf Studies Annual*, vol. 21 (2015), p. 3.

17 ibid., p. 4.

18 James E. MacColl and W. T. Wells, 'The Incitement to Disaffection Bill, 1934', *The Political Quarterly* 5.3 (July 1934), pp. 352–64, quoted in Wisor, p. 7.

19 Wisor, 'About Face', p. 7.

20 *D4*, p. 77.

21 *3G*, p. 165.

22 ibid., p. 14.

23 Roland Barthes, *Camera Lucida: Reflections on Photography* (1980), trans. Richard Howard, New York: Hill & Wang, 2010, p. 73.

24 Susan Sontag, *Regarding the Pain of Others*, New York: Farrar, Straus & Giroux, 2003, p. 6.

25 Virginia Woolf, *The Diary of Virginia Woolf, Vol. 5, 1936–41*, ed. Anne Olivier Bell and Andrew McNeillie, Harmondsworth: Penguin, 1984, pp. 155–6 and 188–9 (hereafter *D5*); letter to A. G. Sayers, 11 October 1939: 'But at least I haven't been sent to prison – rather, on the contrary, to Coventry' (*The Letters of Virginia Woolf, Vol. 6: 1936–41*, ed. Nigel Nicolson and Joanne Trautmann Banks, London: Hogarth Press, 1980, p. 363, hereafter *L6*).

26 Vita Sackville-West was among those who resented the book. Cf. her letter in Louise DeSalvo and Mitchell Leaska, eds., *The Letters of Vita Sackville-West to Virginia Woolf*, London: Hutchinson, 1984, p. 440/1985, pp. 412–13 – and Woolf's reply in *L6*, pp. 242–3 – and then another from Vita of 23 July 1938 (1984, p. 442/1985, pp. 414–15) and Woolf's reply in *L6*, p. 258.

27 'I didnt [sic] get so much praise from L. as I hoped' (*D5*, p. 133).

28 'The contemporary reviews on both sides of the Atlantic reveal a number of rhetorical strategies that deny the authority of the text by denying it the authority of [its] anger', Brenda Silver, 'The Authority of Anger: "Three Guineas" as Case Study', *Signs: Journal of Women in Culture and Society*, 16:2 (1991), pp. 340–70, p. 346.

29 Theodora Bosanquet, *Time and Tide*, 4 June 1938; Graham Greene, *Spectator*, 17 June 1938; Queenie Leavis, 'Caterpillars of the Commonwealth, Unite!', *Scrutiny*, September 1938; Keynes quoted in Quentin Bell, *Virginia Woolf: A Biography. Mrs Woolf, 1912–1941*, Vol. 2, London: Hogarth, 1972, p. 205; *L5*, 1979, p. xvii.

30 Quentin Bell, *Virginia Woolf*, p. 205.

31 E. M. Forster, *Virginia Woolf*, Cambridge: Cambridge University Press, 1942, p. 23.

32 *L6*, p. 218.

this monster the body

1 *D4*, p. 129 (2 November 1932); Kraus, *I Love Dick*, p. 218.

2 *E4*, p. 473.

3 *D4*, p. 142.

4 ibid., p. 133.

5 ibid., p. 146.

6 ibid., p. xviii.

7 Leaska, *The Pargiters*, p. xviii.

8 Sidonie Smith, 'The Autobiographical Eye/I in Virginia Woolf's "Sketch"', in *Subjectivity, Identity, and the Body: Women's Autobiographical Practices in the Twentieth Century*, Bloomington: Indiana University Press, 1993, p. 102, quoted in Christine Froula, *Virginia Woolf and the Bloomsbury Avant-Garde*. Smith is referring to the way Woolf writes about her sexual assault at the hands of her half-brother George Duckworth in 'A Sketch of the Past' (1939).

9 Smith, *Subjectivity, Identity, and the Body*, p. 102.

10 Virginia Woolf, 'A Sketch of the Past' (1939), in *Moments of Being* (1972), ed. Jeanne Schulkind, New York: Harcourt Brace Jovanovich, 1985, p. 72.

11 Woolf, 'On Being Ill' (1926), *E4*, pp. 317–29, p. 318.

12 ibid.

13 In the legendary 1981 anthology *This Bridge Called My Back*, and in 1984 in Lorde's collection *Sister Outsider*. Audre Lorde, 'The Master's Tools Will Never Dismantle the Master's House', *Your Silence*, pp. 89–93.

14 Lorde, *Your Silence*, p. 89.

15 Adrienne Rich, 'Towards a More Feminist Criticism' (1981), *Blood, Bread, and Poetry: Selected Prose 1979–1985*, New York: W. W. Norton, 1986, p. 88.

16 Rich, 'The Burning of Paper Instead of Children', *The Will to Change* (1971), in *Collected Poems, 1950–2012*, ed. Pablo Conrad, New York: W. W. Norton, 2016, p. 303.

17 bell hooks, *Teaching to Transgress: Education as the Practice of Freedom*, New York: Routledge, 1994, p. 170.

18 Hortense J. Spillers, 'Mama's Baby, Papa's Maybe: An American Grammar Book', *Diacritics*, 17:2 (Summer 1987), pp. 64–81, p. 67, 68.

19 ibid., p. 66.

20 ibid., p. 68.

21 Harryette Mullen, 'Blah-blah', *Sleeping with the Dictionary*, Berkeley and Los Angeles: University of California Press, 2002, pp. 12–13; 'licked all over' is from 'Present Tense', p. 57.

22 ibid., p. 67.

23 ibid., p. 56.

24 Cathy Park Hong, *Minor Feelings: An Asian-American Reckoning*, New York: One World, 2020, p. 97.

25 Woolf, *The Pargiters*, p. xxx.

26 Hong, *Minor Feelings*, p. 100.

27 Theresa Hak Kyung Cha, *DICTEE* (1982), Berkeley: University of California Press, 2001, p. 1.

28 ibid., p. 133.

29 ibid., p. 106.

30 ibid., p. 4.

31 ibid., p. 75.

32 ibid., p. 3.

33 ibid., p. 32.

34 ibid., p. 162.

35 Rich, *Arts of the Possible*, p. 49.

36 ibid., p. 37.

37 ibid., p. 100.

body awareness

1 Maria Lassnig, 'About Painting Body Feelings', trans. Catherine Schelbert and Howard Fine, in *Works, Diaries & Writings*, London: Koenig, 2015, p. 63.

2 Lassnig, '1000 Words', trans. Nick Somers and Alexander Scrimgeour, *Artforum*, Summer 2008.

3 Natalie Lettner, Lassnig's biographer, in conversation with Katy Hessel, *Great Women Artists* podcast, 28 July 2020.

4 Lassnig, *Works, Diaries & Writings*, p. 45.

5 ibid., p. 33.

6 'Inside Out: Maria Lassnig in conversation with Frieze co-editor Jörg Heiser', *Frieze*, 2 November 2006.

7 ibid.

8 Lassnig, *Film Works*, ed. Eszter Kondor, Michael Loebenstein, Peter Pakesch and Hans Werner Poschauko, Vienna: Austrian Film Museum with INDEX Edition, 2021, p. 137.

9 Kasia Redzisz and Lauren Barnes, 'Introduction: The Body Decides', *Maria Lassnig*, ed. Kasia Redzisz and Lauren Barnes, catalogue for Tate Retrospective, London: Tate Publishing, 2016, p. 14.

10 Carolee Schneemann, 'Maria Lassnig, 1919–2014', *Artforum*, 1 October 2014.

11 Lassnig, *Film Works*, p. 12.

12 ibid., p. 54.

13 'Inside Out: Maria Lassnig in conversation with Frieze co-editor Jörg Heiser'.

fuses

1 Carolee Schneemann in conversation with Stephanie LaCava, *Harper's*, 19 October 2017.

2 Schneemann, 'Eye Body', in *More Than Meat Joy*, ed. Bruce McPherson, New Paltz, NY: Documentext, 1979, p. 52.

3 André Breton, *Position politique du surréalisme*, Paris: Editions du Sagittaire, 1935.

4 Schneemann, *More Than Meat Joy*, p. 13.

5 Georges Bataille, *Histoire de l'œil* (1928), Paris: Gallimard, 1993.

6 Schneemann, *More Than Meat Joy*, p. 238.

7 Kate Haug, 'An Interview with Carolee Schneemann' (1998), in *Experimental Cinema: The Film Reader*, ed. Wheeler Winston Dixon and Gwendolyn Audrey Foster, London: Routledge, 2002, p. 174.

8 'Karen Finley', *Angry Women*, p. 71.

9 Haug, 'An Interview with Carolee Schneemann', p. 175.

10 Scott MacDonald, 'Carolee Schneemann's Autobiographical Trilogy', *Film Quarterly*, 34:1, Autumn, 1980, pp. 27–32, p. 27.

11 Schneemann, *Imagining Her Erotics: Essays, Interviews, Projects*, Cambridge, MA: MIT Press, 2002, p. 43.

12 MacDonald, 'Carolee Schneemann's Autobiographical Trilogy', p. 28.

13 Interview in Scott MacDonald, *A Critical Cinema 2*, Berkeley: University of California Press, 1988, pp. 135–51, p. 135. Interview held on 2 November 1979.

14 Interview in MacDonald, *A Critical Cinema 2*.

15 ibid.

16 Susan Sontag, 'Against Interpretation', p. 14.

17 Excerpts from complete text originally written for Guggenheim Foundation Grant, 1976; text used in *Intercourse with . . .* videotape performance and lecture, 1977. Published in *Hannah Wilke: A Retrospective*, University of Missouri Press, 1989.

18 Schneemann, *More Than Meat Joy*, p. 58.

19 Duncan White, *Expanded Cinema: Art, Performance, Film*, London: Tate Publishing, 2011, p. 87.

20 Erica Levin, 'Dissent and the Aesthetics of Control: On Carolee Schneemann's *Snows*', *World Picture Journal*, 26, Summer 2013, n.p.

21 Haug, 'A Conversation with Carolee Schneemann', p. 183.

22 Schneemann, *More Than Meat Joy*, p. 18.

23 Massimiliano Gioni, interview with Carolee Schneemann, *Mousse Magazine* 48, April–May 2015.

24 White, *Expanded Cinema*, p. 86.

25 Levin, 'Dissent and the Aesthetics of Control: On Carolee Schneemann's *Snows*', n.p.

her body is a problem

1 Alloway et al., 'Letters', p.9; Cindy Nemser, 'Lynda Benglis: A Case of Sexual Nostalgia', *Feminist Art Journal*, Winter 1974–5, p. 7.

2 Lucy R. Lippard, 'Make Up: Role-Playing and Transformation in Women's Art', *The Pink Glass Swan*, New York: The New Press, 1995, p. 92.

3 Lippard, 'The Pains and Pleasures of Rebirth: European and American Women's Body Art', pp. 123–4.

4 ibid.

5 Quoted in Nancy Princenthal, *Hannah Wilke*, Munich: Prestel Verlag, 2010, p. 67.

6 Judith Barry and Sandy Flitterman-Lewis, 'Textual Strategies: The Politics of Art-Making', *Screen* 21:2, Summer 1980, pp. 35–48, p. 37.

7 ibid., p. 39.

8 Johanna Fateman, 'Last Days at Hot Slit: The Radical Feminism of Andrea Dworkin', *Last Days at Hot Slit* (2019), ed. Johanna Fateman and Amy Scholder, Los Angeles: Semiotext(e), 2021.

9 Amelia Jones, ed., *Sexuality* (Whitechapel Documents in Contemporary Art), London: Whitechapel Gallery, 2014, p. 76.

10 ibid.

11 Sutapa Biswas, *Kali*, short film, 1984.

12 Willis and Williams, *The Black Female Body*, p. 3.

13 Quoted in Nead, *The Female Nude*, p. 75.

14 Interview with Claudette Johnson, 'Giving Space to the Presence of a Black Woman', Tate website, 25 May 2021.

15 Adrienne Rich, ' "It Is the Lesbian in Us . . ." ', in *On Lies, Secrets and Silence: Selected Prose 1966–1978*, London: 1980, pp. 199–202, p. 199. Rich's essay was first published in *Sinister Wisdom*, 1:3, Spring 1977, pp. 6–9.

16 Mira Schor, 'Backlash and Appropriation', p. 251.

17 Diana Crane, *The Transformation of the Avant-Garde: the New York Art World, 1940–85*, Chicago: University of Chicago Press, 1987, p. 3.

18 Laura Mulvey, 'Impending Time: Mary Kelly's Corpus', in *Visual and Other Pleasures*, Basingstoke: Palgrave Macmillan, 2009, p. 148.

19 Lynda Nead, 'Representation, Sexuality, and the Female Nude', *Art History*, 6:2, June 1983, p. 230.

20 Schneemann, 'The Obscene Body/Politic', p. 29.

21 Princenthal, *Hannah Wilke*, p. 68.

22 Hannah Wilke, *Intercourse With . . .* , originally written for Guggenheim Memorial Foundation Grant, in *Hannah Wilke: A Retrospective*, ed. Thomas Kochheiser, Columbia, University of Missouri Press, 1989, p. 139.

23 ibid.

24 Barbara Schwartz, 'Young New York Artists', *Crafts Horizon*, October 1973, p. 50. Wilke went on making vulvic images throughout her life even when she was ill, until she had her bone marrow transplant.

25 Kraus, *I Love Dick*, p. 212.

26 Cindy Nemser, 'Conversation with Hannah Wilke, 1975', edited audio-tape transcript in *Hannah Wilke: Art for Life's Sake*, p. 93.

27 ibid.

28 Hannah Wilke, in *Hannah Wilke 1940–1993*, Berlin: Neue Gesellschaft für Bildende Kunst, 2000, p. 141.

29 Hannah Wilke, *Intercourse With . . .* (1977), quoted in Amelia Jones, *Body Art/Performing the Subject*, Minneapolis, MN: University of Minnesota Press, 1998, p. 183.

30 Quoted in Blackwood, *Reclaiming the Body: Feminist Art in America* documentary.

vanitas

1 Princenthal, *Hannah Wilke*, p. 111.

2 John Berger, *Ways of Seeing*, London: Penguin, 1972, p. 51.

3 A transcript of the letter is available on the British Library's website. The original is held in the Berg Collection at the New York Public Library, and is printed in *The Journals and Letters of Fanny Burney (Madame D'Arblay)*, ed. Joyce Hemlow et al., 12 vols. (Oxford, 1972–84), vol. 6 (1975), pp. 596–616.

4 ibid.

5 Julia L. Epstein, 'Writing the Unspeakable: Fanny Burney's Mastectomy and the Fictive Body', *Representations*, 16, Autumn, 1986, pp. 131–66, pp. 131, 137.

6 ibid., p. 135.

7 Burney in Hemlow, ed., *The Journals and Letters of Fanny Burney*.

8 ibid., p. 148.

9 There remains the question of how the doctors were so sure it was breast cancer, and that amputation was the only option. When Burney's only child was born in 1794, the baby contracted thrush and transmitted

it to his mother while feeding, resulting in an abscess on her nipple. The doctors recommended she stop breastfeeding immediately. '[T]hey have made me wean my Child!' she wrote at the time. 'What that has cost me!' (p. 142). It was a medical commonplace at the time that there was a causal link between complications from breastfeeding and breast cancer, which would have reinforced belief all around that it was indeed a malignant tumour that afflicted her. Modern physicians have doubted whether that was the case, given that she lived for so many years after the operation.

10 Patricia Allmer, *Angels of Anarchy: Women Artists and Surrealism*, Munich: Prestel, 2009, p. 23.

11 See Antony Penrose, *The Lives of Lee Miller* (1985), London: Thames & Hudson, 2021, pp. 24–5.

12 Carolyn Burke, *Lee Miller*, p. 16.

13 Susan Sontag, *Illness as Metaphor*, New York: Farrar, Straus & Giroux, 1977, p. 87.

14 Kathy Acker, 'The Gift of Disease', *Guardian*, 18 January 1997. Oddly enough, I can't find this article online on the *Guardian*. Perhaps it was judged irresponsible, and taken down?

15 Matias Viegener, *The Assassination of Kathy Acker*, New York: Guillotine Press, 2018, p. 9.

16 ibid., pp. 8, 9.

17 Jo Spence, *Cultural Sniping: The Art of Transgression*, London: Routledge, 1995, p. 101, quoted in Anne Boyer, 'The Kinds of Pictures She Would Have Taken', in *A Handbook of Disappointed Fate*, Brooklyn: Ugly Duckling Presse, 2018, p. 184.

18 Stella Bolaki, 'Re-Covering the Scarred Body: Textual and Photographic Narratives of Breast Cancer', *Mosaic, a journal for the interdisciplinary study of literature*, 44:2, June 2011, pp. 1–17, p. 5.

19 'Jo Spence: Putting Ourselves in the Picture', BBC Arena, 1987.

20 Boyer, *A Handbook of Disappointed Fate*, p. 180.

21 ibid., p. 60.

22 Sara Ahmed, *Living a Feminist Life*, Durham, NC: Duke University Press, 2017, p. 184.

23 Lorde, *The Cancer Journals*, p. 61.

24 ibid., pp. 14–15.

25 *Kathy Acker: The Last Interview*, ed. Amy Schoelder and Douglas A. Martin, Brooklyn, NY: Melville House, 2018, p. 119.

26 Ahmed, *Living a Feminist Life*, p. 184.

ucky

1 This story is detailed in Joyce Wallace Scott's beautiful memoir *Entwined: Sisters and Secrets in the Silent World of Artist Judith Scott*, Beacon, MA: Beacon Press, 2016.

2 Eve Kosofsky Sedgwick, *Touching Feeling: Affect, Pedagogy, Performativity*, Durham, NC: Duke University Press, 2002, p. 14.

3 ibid.

4 ibid., p. 15.

5 Quoted in ibid., p. 15.

6 Rosalyn Driscoll, *The Sensing Body in the Visual Arts: Making and Experiencing Sculpture*, London: Bloomsbury, 2020, p. 107.

7 ibid.

8 ibid., p. 108.

9 ibid.

10 Sedgwick, *Touching Feeling*, p. 17.

11 ibid.

12 *Encountering Eva Hesse*, ed. Griselda Pollock and Vanessa Corby, Munich: Prestel, 2006, p. 32; Anne M. Wagner, 'Another Hesse', in Nixon, *Eva Hesse*, p. 93, 106.

13 Eva Hesse, *Diaries*, ed. Barry Rosen with Tamara Bloomberg, Zürich: Hauser & Wirth, 2020, p. 285 (28 October 1960).

14 ibid.

15 ibid., p. 412 (1964).

16 April 1965. Quoted by Marcie Begleiter, 'Finding Eva's Voice', Medium.com, 2 Nov 2015.

17 ibid.

18 Nemser, in Nixon, *Eva Hesse*, p. 6.

19 Lisa Robertson, *Nilling: Prose Essays on Noise, Pornography, the Codex, Melancholy, Lucretius, Folds, Cities and Related Aporias*, Toronto: Book*hug Press, 2012, p. 45.

20 Quoted in *Eva Hesse*, directed by Marcie Begleiter, 2016.

21 Judith Scott and Joyce Wallace Scott, 'Entwined', *Granta* 140: 13 October 2017.

22 Quoted in *Eva Hesse*, directed by Marcie Begleiter.

23 Anne Michaels, *Infinite Gradation*, London: House Sparrow Press, 2017, p. 31.

24 Quoted in Lucy R. Lippard, *Eva Hesse* (1976), New York: Da Capo Press, 1992, p. 131.

25 Nemser, in Nixon, *Eva Hesse*, p. 9.

26 John Perreault, 'The Materiality of Matter', *Village Voice*, 28 November 1968, p. 19.

27 Rosalind Krauss, 'Eva Hesse: Contingent', *Bachelors*, Cambridge, MA: MIT Press, 1999, pp. 91–100.

28 Quoted in *Eva Hesse Drawing*, ed. Catherine de Zegher, New Haven, CT: Yale University Press, 2006, p. 179.

29 'Fling, Dribble and Drip', *Life*, February 1970, p. 66. Quoted in Lippard, *Eva Hesse*, p. 172.

30 ibid.

31 *Eva Hesse*, directed by Marcie Begleiter.

the nature of fire

1 Ingeborg Bachmann, *Malina: a novel* (1971), trans. Philip Boehm, New York: Holmes & Meier, 1990, p. 58.

2 Susan Sontag, 'Against Interpretation', p. 3.

3 Ara Osterweil, 'Bodily Rites: the Films of Ana Mendieta', *Artforum*, November 2015.

4 Linda Montano, 'An Interview with Ana Mendieta', in ' "Earth from Cuba, Sand from Varadero": A Tribute to Ana Mendieta', ed. Clayton Eshleman and Caryl Eshleman, *Sulfur* 22 (1988), p. 66.

5 Ana Mendieta in Olga Viso, ed. *Unseen Mendieta: The Unpublished Works of Ana Mendieta*. Munich: Prestel, 2008, p. 297.

6 Sontag, *Illness as Metaphor*, p. 14.

7 Elizabeth Gumport, 'The Long Exposure of Francesca Woodman', *New York Review of Books*, 24 January 2011.

8 Harryette Mullen, *Sleeping with the Dictionary*, p. 30.

9 'Ana Mendieta: A Selection of Statements and Notes', p. 70. All follow-
 ing quotes in this section are from this text.

10 Mendieta, in Viso, ed. *Unseen Mendieta*, p. 297.

11 According to her cousin Raquel 'Kaki' Mendieta, in the film *Ana Mendi-
 eta: Fuego de Tierra*, directed by Kate Horsfield, Nereyda Garcia-Ferraz
 and Branda Miller, 1987.

12 Mendieta, quoted in Judith Wilson, 'Ana Mendieta Plants Her Garden',
 Village Voice, 13–19 August 1980, p. 71.

13 'Regarding Ana Mendieta', p. 186 (italics mine).

14 Mendieta, quoted in Channing Gray, 'Earth Art', *Providence Journal Bul-
 letin*, 21 April 1984.

15 Donald Kuspit, 'Ana Mendieta, Autonomous Body', in Gloria Moure,
 ed., *Ana Mendieta*, Barcelona: Fundacio Antoni Tàpies; Santiago de
 Compostela: Centro Galego de Arte Contemporanea, 1997.

16 Calvin Tomkins, 'The Materialist', *New Yorker*, 27 November 2011.

17 See Robert Katz, *Naked by the Window: The Fatal Marriage of Carl Andre
 and Ana Mendieta*, New York: Atlantic Monthly Press, 1990, throughout
 but specifically p. 350.

18 Maya Gurantz, ' "Carl Broke Something": On Carl Andre, Ana Mendi-
 eta, and the Cult of the Male Genius', *Los Angeles Review of Books*, 10
 July 2017.

19 Katz, *Naked by the Window*, p. 114.

20 ibid., p. 2.

Kathy Acker is my abject

1 To further knot the knots, her first book, *Childlike Life of the Black
 Tarantula*, was republished by a publisher founded by Lucy Lippard
 and Sol LeWitt called Printed Matter Press in 1978. In an interview
 with Sylvère Lotringer – her former lover and later Chris Kraus's
 husband – Acker called LeWitt her 'patron' (*Kathy Acker: The Last
 Interview*, p. 86).

2 In Germany in 1986, *Blood and Guts in High School* was added to a list of
 books considered harmful to juveniles.

3 *AROO*, p. 76.

4 Copied from image in 'Kathy Acker's Library', curated by Julian Brim-mers, *Paris Review* 225, Summer 2018, pp. 239–55, p. 243. Kathy Acker's library has been reconstituted at the University of Cologne.

5 ibid.

6 Kathy Acker, *Portrait of an Eye*, New York: Grove Press, 1992, pp. 23, 25.

7 Kathy Acker, *Empire of the Senseless*, New York: Grove Press, 1988, p. 20.

8 Larry McCaffery, 'The Path of Abjection: An Interview with Kathy Acker', in *Some Other Frequency: Interviews with Innovative American Authors*, Pennsylvania Studies in American Fiction, Philadelphia: University of Pennsylvania Press, 1996, pp. 19, 28.

9 Kathy Acker, *Bodies of Work: essays*, London: Serpent's Tail, 1997, p. 7.

10 Quoted in Carol Becker, *The Subversive Imagination: The Artist, Society, and Social Responsibility*, London: Routledge, 2014, p. 22.

11 A plagiarism controversy erupted in the UK in 1989, when an over-zealous journalist for Publishing News published an exposé claiming that entire portions of Harold Robbins's 1974 novel *The Pirate* were reprinted word for word in her novel *The Adult Life of Toulouse Lautrec*, which the feminist Pandora Press had recently published. Robbins's publisher asked Pandora's parent company to withdraw the book. They asked her to sign a public apology to Robbins. She claimed to have done so, but Chris Kraus's research assistant was unable to find it any-where. Acker herself would vent her frustration in her essay 'Dead Doll Humility' (1990): she '[u]nderstood that she had lost. Lost more than a struggle about the appropriation of four pages [. . .] Lost her belief that there can be art in this culture.' See Chris Kraus, *After Kathy Acker*, Los Angeles: Semiotext(e), 2018, p. 235.

12 See, for instance, Acker's 1995 interview with Rosie X for *Geekgirl*, in 'Deleted material from *Kathy Acker: The Last Interview*', Melville House website, 10 March 2019.

13 Acker, *Empire of the Senseless*, p. 95.

14 Footage of Acker reading, included in Barbara Caspar's documentary, *Who's Afraid of Kathy Acker?*, 2008.

15 Acker, *Bodies of Work*, p. 18.

16 I feel very sure she saw Schneemann's *Fuses*, or at least knew about it; she was friendly with Schneemann as well as Stan Brakhage, and her interest in sex would have led her to it.

17 Chris Kraus, 'Sex, Truths, and Videotape', *FEED Magazine*, 2000, reprinted in http://www.lightindustry.org/bluetape.

18 *Kathy Acker: The Last Interview*, p. 30.

19 'Kathy Acker: Where Does She Get Off?', interview with R. U. Sirius, io 2 (1994) http://www.altx.com/io/acker.html.

20 Kathy Acker, *Pussy, King of the Pirates*, New York: Grove Press, 1996, p. 32.

21 Laurence A. Rickels, 'Body Bildung', in *Kathy Acker: The Last Interview*, p. 169.

22 Cixous, 'Laugh of the Medusa', p. 880.

23 Acker, *Bodies of Work*, p. 147.

24 ibid., p. 150.

25 ibid.

26 *POH*, p. 210. BBC footage included in Barbara Caspar's documentary *Who's Afraid of Kathy Acker?*

meat

1 Acker, 'The Gift of Disease'.

2 Sarah Milroy, 'The Flesh Dress: A Defence', *Canadian Art* (1991), pp. 71–2.

3 Marina Warner, *Forms of Enchantment: Writing on Art & Artists*, London: Thames & Hudson, 2018, p. 112.

4 *The Art of Helen Chadwick* [video file], Illuminations Media, 2004.

5 Helen Chadwick, *Enfleshings, with an essay by Marina Warner*, London: Secker & Warburg, 1989, p. 39.

6 Warner, *Forms of Enchantment*, p. 116.

7 ibid.

8 Frances Morris, 'The Legacy of Helen Chadwick'.

9 Documentary, *The Art of Helen Chadwick*.

10 Warner, *Forms of Enchantment*, p. 116.

11 This has been, since Barthes, a major concern of photographic theory; see Geoffrey Batchens, ed., *Photography Degree Zero*, Cambridge, MA: MIT Press, 2009, and James Elkins, ed., *Photography Theory (The Art Seminar)*, London: Routledge, 2006.

12 Helen Chadwick, 'Soliloquy to Flesh', in *Enfleshings*, p. 109.

13 She thought of these as *composite images* in an early 1980s journal entry: 'Veiling of image over form as in EGS [*Ego Geometria Sum*] freed from 'terrestrial' prison – liberates as a series of composite images (not even a single instance as in a moment at which photograph is fixed . . .) → Newtonian/Platonic view of reality as matter/mechanical model opened into quantum mechanics – open dynamic, inter-related fixing of occurrences as an 'image' i.e. FICTIONS. Helen Chadwick, Notebook 2003.19/E/6:147, Helen Chadwick Collection, Henry Moore Institute, Leeds (hereafter HMI). See also Chadwick, *Enfleshings*, p. 11.

14 Chadwick, *Enfleshings*, p. 39.

15 In BBC footage included in documentary, *The Art of Helen Chadwick*, Illuminations Media, 2004.

16 Waldemar Januszczak, 'Invading Your Space', *Guardian*, 18 November 1987.

17 Documentary, *The Art of Helen Chadwick*.

18 Morris, 'The Legacy of Helen Chadwick'.

19 See Marina Warner, *Helen Chadwick, The Oval Court*, London: Afterall Books, 2022.

20 In Mark Sladden, ed., *Helen Chadwick*, London: Barbican Gallery, 2004, p. 17.

21 Nicholas James, *Helen Chadwick: Of Mutability*, London: CV/VAR, 2011, n.p.

22 Documentary, *The Art of Helen Chadwick*.

23 ibid.

24 Judith Collins, re-edited transcript of interview between Helen Chadwick and Judith Collins, at T ICA 955/7/7/59, and T 971.20. Quoted in Imogen Racz, 'Helen Chadwick's *Of Mutability*: process and postmodernism', *Journal of Visual Art Practice* 16:1 (2017), pp. 61–76.

25 See Warner, *Helen Chadwick, The Oval Court*.

26 James, *Helen Chadwick, Of Mutability*, n.p.

27 Immanuel Kant, *Critique of the Power of Judgment* (1790), trans. Paul Guyer and Eric Matthews, Cambridge: Cambridge University Press, 2000, p. 128.

28 See Yve-Alain Bois and Rosalind Krauss, *Formless: a user's guide* (Cambridge, MA: MIT Press, 1997), pp. 29–31. 'Unverifiable . . .

non-hierarchized' is a reference Bois and Krauss make to Michel Leiris, writing on spittle in Bataille's critical dictionary in *Documents*. See Georges Bataille et al., *Encyclopaedia Acephalica: comprising the Critical dictionary & related texts*, London: Atlas Press, 1995, pp. 79–80.

29 Warner, *Forms of Enchantment*, p. 119.

30 Documentary, *The Art of Helen Chadwick*.

31 Warner, *Forms of Enchantment*, p. 115.

32 Documentary, *The Art of Helen Chadwick*.

33 Chadwick, Notebook 2003.19/2/7, HMI.

34 ibid.

35 Interview with Waldemar Januszczak, *Guardian*, 18 November 1987.

36 Interview with Emma Cocker, 'Indifference in Difference', 2 December 1995 (draft). Box 135, HMI; published in *MAKE, Women's Art Magazine*, London, n.71, August 1996, p.22. Quoted in Warner, *Helen Chadwick, The Oval Court*.

37 She wrote in her journal:

> I as subject/object: artist/artwork/model
> Self: kind of autobiog.
> [. . .]
> Autobiog. & Self dramatization of libido: images of pure feeling & inner sensation, reveal intensity of feeling
> Perceive oneself to feel
> Felt from inside, not objective gaze but projection.

Chadwick, Notebook 2003.19/2/7, HMI.

38 Chadwick, *Enfleshings*, p. 29, 39; Chadwick, Notebooks 2003.19.7, HMI.

decreate to create

1 Jordan Kisner, 'Kate Zambreno on Giving Birth as an Act of Decreation', *Literary Hub*, Thresholds podcast, 19 August 2020.

2 Mary Ann Caws and Michel Delville, ~~Undoing Art,~~ Macerata: Quodlibet, 2017, p. 9.

3 ibid., p. 15.

4 ibid., p. 10.

5 ibid., p. 11.

6 Claudia Dey, 'Mothers as makers of death', *Paris Review Daily*, 14 August 2018.

7 Chris Kraus, 'Supplement B: Ecceity, Smash and Grab, the Expanded I and Moment', *French Theory in America*, ed. Sylvère Lotringer and Sande Cohen, London: Routledge, 2013, pp. 303–8.

8 Conversation with Sarah Milroy, 16 January 2017, in the context of a piece I wrote on the Dulwich show for the *Guardian*, where some of this writing originated.

9 In a 1934 memoir about Roger Fry, Memoir VI, quoted in Spalding, *Vanessa Bell*, pp. 92–3.

10 Talk given at Leighton Park School, Reading, in 1925; quoted in Spalding, *Vanessa Bell*, p. xviii.

11 25 March 1914; *Selected Letters of Vanessa Bell*, ed. Regina Marler, London: Bloomsbury, 1993, p. 160 (hereafter *SL*).

12 Virginia Woolf, *The Letters of Virginia Woolf, Vol. 1: 1888–1912*, ed. Nigel Nicholson and Joanne Trautmann, New York: Harcourt Brace Jovanovich, 1979 (hereafter *L1*), p. 356.

13 Hermione Lee, *Virginia Woolf*, p. 318.

14 VW to ES, 15 March 1930, Virginia Woolf, *The Letters of Virginia Woolf, Vol. 4: 1929–1931*, ed. Nigel Nicholson and Joanne Trautmann, New York: Harcourt Brace Jovanovich, 1979 (hereafter *L4*), p.151.

15 Lee, *Virginia Woolf*, p. 322.

16 Frances Spalding, 'Vanessa, Virginia, and the Modern Portrait', in *Vanessa Bell*, ed. Sarah Milroy and Ian A. C. Dejardin, exhibition catalogue, London: Dulwich Picture Gallery, 2017, pp. 64–71, p. 69.

17 ibid.

18 ibid.

19 Lisa Tickner, 'Vanessa Bell: Studland Beach, Domesticity, and "Significant Form" ', *Representations* 65, Winter, 1999, pp. 63–92, p. 66.

20 *SL*, pp. 133–4.

21 Leaska, *The Pargiters*, p. xiv.

22 Tim Buxbaum, 'Pargeting', The Building Conservation Directory, 2001. Repr. https://www.buildingconservation.com/articles/pargeting/pargeting.htm

23 Virginia Woolf, 'Walter Sickert: A Conversation' (1934), *E6*, p. 39.

24 *SL*, p. 406.

25 Clive Bell, *Art*, New York: Frederick A. Stokes, 1913, p. 8.

26 *Modernism: an anthology of sources and documents*, eds. Vassiliki Kolocotroni, Jane Goldman, Olga Taxidou, Edinburgh: Edinburgh University Press, 1998, p. 190.

27 Schneemann, *More Than Meat Joy*, p. 13.

28 Judith Butler, *Bodies That Matter: on the discursive limits of 'sex'*, London: Routledge, 1996, p. 53.

29 Glissant, *Poetics of Relation*, p. 194. 'Opacities,' he writes, 'can coexist and converge, weaving fabrics. To understand these truly one must focus on the texture of the weave and not on the nature of its components. For the time being, perhaps, give up this old obsession with discovering what lies at the bottom of natures.' In other words, we have to renounce the habit of reading for the usual meanings of words, and images.

30 Woolf, 'Craftsmanship', BBC broadcast 1937, later published, posthumously, in *The Death of the Moth* (1942). *E6*, p. 625.

31 ibid.

32 Helen Chadwick, 'Objects, Signs, Commodities', Camera Austria International, 37, Summer 1991, p. 9. Quoted in Mary Horlock, 'Between a Rock and a Soft Place', in *Helen Chadwick*, ed. Mark Sladen, London and Ostfildern-Ruit: Barbican Art Gallery and Hatje Cantz Verlag, 2004.

33 Audre Lorde, 'The Transformation of Silence into Language and Action' (1977), in *Your Silence Will Not Protect You*, London: Silver Press, 2017, p. 2.

34 ibid., p. 3.

35 *TTL*, p. 193.

36 Virginia Woolf, 'Royalty' (1939), *The Moment & Other Essays*, San Diego: Harcourt Brace Jovanovitch, 1974, p. 240.

right after

1 In his *Artforum* review, the art critic Robert Pincus-Witten said *Right After* 'carried the show'. Robert Pincus-Witten, 'Frank Lincoln Viner, Craig Kauffman, DeWain Valentine, Peter Alexander, Bruce Beasley, Robert Bassler, The Gianakos brothers and Eva Hesse', *Artforum*, 8:5, January 1970.

2 Interview with Cindy Nemser, in Nixon, *Eva Hesse*, pp. 16–17.

3 Transcript of Cindy Nemser's interview with Hesse; quoted in Helen Cooper, *Eva Hesse: a retrospective*, New Haven, CT: Yale University Press, 1992, p. 44.

4 Walter Benjamin, 'Post No Bills', *One-Way Street* (1928), trans. Edmund Jephcott, Cambridge, MA: Belknap Press, 2016.

5 Cindy Nemser, 'A Conversation with Eva Hesse', *Artforum*, 8:9 (May 1970), pp. 59–63, p. 63.

6 Quoted in Cooper, *Eva Hesse: a retrospective*, p. 45.

bibliography

Acker, Kathy, *Don Quixote*, New York: Grove Atlantic, 1986.

—*Empire of the Senseless*, New York: Grove Press, 1988.

—*Portrait of an Eye*, New York: Grove Press, 1992.

—*Pussy, King of the Pirates*, New York: Grove Press, 1996.

—'The Gift of Disease', *Guardian*, 18 January 1997.

—*Bodies of Work: Essays*, London: Serpent's Tail, 1997.

Ahmed, Sara, *Living a Feminist Life*, Durham, NC: Duke UP, 2017.

'Airport virginity tests banned by Rees', *Guardian*, 3 February 1979.

Alexander, Elizabeth, 'Can You Be BLACK and Look at This? Reading the Rodney King Videos', *Public Culture,* vol. 7, 1994, pp. 77–94.

Allmer, Patricia, *Angels of Anarchy: Women Artists and Surrealism*, Munich: Prestel, 2009.

Alloway, Lawrence, Max Kozloff, Rosalind Krauss, Joseph Masheck and Annette Michelson, 'Letters', *Artforum*, December 1974, p. 9.

Als, Hilton, 'The Shadow Act', *New Yorker*, 8 October 2007.

'Ana Mendieta: A Selection of Statements and Notes', *Sulfur* 22 (1988).

Ana Mendieta: Fuego de Tierra, directed by Kate Horsfield, Nereyda Garcia-Ferraz and Branda Miller, 1987.

Aristotle, *Generation of Animals*, trans. A. L. Peck, Cambridge, MA: Harvard University Press, 1942.

The Art of Helen Chadwick, Illuminations Media, 2004.

Bachmann, Ingeborg, *Malina: a novel* (1971), trans. Philip Boehm, New York: Holmes and Meier, 1990.

Bakhtin, Mikhail, *Rabelais and His World* (1968), trans. Hélène Iswolsky, Bloomington, IN: Indiana University Press, 1984.

Barry, Judith and Sandy Flitterman-Lewis, 'Textual Strategies: The Politics of Art-Making', *Screen* 21:2 (Summer 1980), pp. 35–48.

Barthes, Roland, *Camera Lucida: Reflections on Photography* (1980), trans. Richard Howard, New York: Hill and Wang, 2010.

Bastide, Lauren, 'Paul Preciado', *La Poudre* podcast, episode 79, 29 July 2020.

Bataille, Georges, *Histoire de l'œil* (1928), Paris: Gallimard, 1993.

—et al., *Encyclopaedia Acephalica: comprising the Critical dictionary & related texts*, London: Atlas Press, 1995.

Beauvoir, Simone de, *The Second Sex* (1949), trans. Constance Borde and Sheila Malovany-Chevallier, New York: Knopf, 2010.

Becker, Carol, *The Subversive Imagination: The Artist, Society, and Social Responsibility*, London: Routledge, 2014.

Begleiter, Marcie. 'Finding Eva's Voice', Medium.com, 2 Nov 2015.

Bell, Clive, *Art*, New York: Frederick A. Stokes, 1913.

Bell, Quentin, *Virginia Woolf: A Biography. Mrs Woolf, 1912–1941*, Vol. 2, London: Hogarth, 1972.

Berger, John, *Ways of Seeing*, London: Penguin, 1972.

Biswas, Sutapa, *Kali,* short film, 1984.

—'Artist's Statement 1987', in *Sutapa Biswas*, 20. London: Institute of International Visual Arts, 2004, p. 20.

—Artist's statement, Camden VOX, Camden Commissions at Swiss Cottage Library, June 2018–January 2019.

—*Lumen,* London: Ridinghouse, 2021.

Bois, Yve-Alain and Rosalind Krauss, *Formless: a user's guide*, Cambridge, MA: MIT Press, 1997.

Bolaki, Stella, 'Re-Covering the Scarred Body: Textual and Photographic Narratives of Breast Cancer', *Mosaic, a journal for the interdisciplinary study of literature*, 44:2 (June 2011), pp. 1–17.

Bonét, Sacha, 'Reimagining Black Futures', *Paris Review Daily*, 24 June 2020.

Bosanquet, Theodora, review of *Three Guineas*, *Time and Tide*, 4 June 1938.

Borzello, Frances, *Seeing Ourselves: Women's Self-Portraits* (1998), London: Thames & Hudson, 2018.

Bourgeois, Louise, *Destruction of the Father Reconstruction of the Father: Writings and Interviews 1923–1997*, ed. Marie-Laure Bernadac and Hans-Ulrich Obrist, Cambridge, MA: MIT Editions/Violette Editions, 1998.

Boyer, Anne, 'The Kinds of Pictures She Would Have Taken', in *A Handbook of Disappointed Fate*, Brooklyn: Ugly Duckling Presse, 2018.

Breitwieser, Sabine, *Carolee Schneemann: Kinetic Painting*, Munich: Prestel, 2015.

Breton, André, *Position politique du surréalisme*, Paris: Editions du Sagittaire, 1935.

Brimmers, Julian, 'Kathy Acker's Library', *Paris Review* 225 (Summer 2018), pp. 239–55.

Burke, Carolyn, *Lee Miller: A Life*, New York: A. A. Knopf, 2005.

Burney, Frances, *The Journals and Letters of Fanny Burney (Madame D'Arblay)*, ed. Joyce Hemlow, et al., 12 vols, Oxford: Oxford University Press, 1972–84.

Butler, Judith, *Bodies That Matter: on the discursive limits of 'sex'*, London: Routledge, 1996.

Cameron, Julia Margaret, Letter to John Herschel, 31 December 1864, Herschel correspondence, Royal Society, 6–9 Carlton House Terrace, London.

Carson, Anne, 'Dirt and Desire', *Men in the Off Hours*, New York: Knopf, 2000.

Carter, Angela, *The Sadeian Woman and the Ideology of Pornography*, New York: Pantheon, 1979.

Caughie, Pamela L., *Virginia Woolf and Postmodernism: Literature in Quest and Question of Itself*, Urbana and Chicago: University of Illinois Press, 1991.

Caws, Mary Ann, and Michel Delville, ~~Undoing Art~~, Macerata: Quodlibet, 2017.

Cha, Theresa Hak Kyung, *DICTEE* (1982), Berkeley: University of California Press, 2001.

Chadwick, Helen, *Enfleshings, with an essay by Marina Warner*, London: Secker and Warburg, 1989.

Chu, Andrea Long, *Females*, London: Verso, 2019.

Cixous, Hélène, 'Laugh of the Medusa' (1975), trans. Keith Cohen and Paula Cohen, *Signs*, vol. 1, No. 4 (Summer, 1976), pp. 875–93.

Clément, Catherine and Hélène Cixous, *The Newly Born Woman* (1975), trans. Betsy Wing, Minneapolis, MN: University of Minnesota Press, 1986.

Cohen, Jeffrey Jerome, 'Monster Culture (Seven Theses)', in *Monster Theory: Reading Culture*, ed. Jeffrey Jerome Cohen, Minn, MN: University of Minnesota Press, 1996.

Cooper, Helen, ed., *Eva Hesse: a retrospective*, New Haven, CT: Yale University Press, 1992.

Corris, Michael, and Robert Hobbs, 'Reading Black Through White in the Work of Kara Walker', in *Art History*, 26:3 (June 2003), pp. 422–41.

Cotter, Holland, ' "It's About Time!" Betye Saar's Long Climb to the Summit', *New York Times*, 4 September 2019.

Cox, Julian, ' "To . . . startle the eye with wonder & delight": The Photographs of Julia Margaret Cameron', in Julian Cox and Colin Ford, *Julia Margaret Cameron: The Complete Photographs*, Los Angeles: Getty Publications, 2003.

Crane, Diana, *The Transformation of the Avant-Garde: the New York Art World, 1940–85*, Chicago: University of Chicago Press, 1987.

Creed, Barbara, *The Monstrous-Feminine: film, feminism, psychoanalysis* (1993), ondon: Routledge, 2015.

Cusk, Rachel, 'Can a Woman Who Is an Artist Ever Just Be an Artist?', *New York Times*, 7 November 2019.

Dalrymple, William, 'The Great Divide: The violent legacy of Indian Partition', *New Yorker*, 29 June 2015.

Davidson, Maria del Guadalupe, 'Black Silhouettes on White Walls: Kara Walker's Magic Lantern', in Sherri Irvin, ed. *Body Aesthetics*, Oxford: Oxford University Press, 2016, pp. 15–36.

DeGolyer, Lori, 'Interview with Ebony G. Patterson', *Bomb Magazine*, 2 June 2020.

Despentes, Virginie, 'Cette histoire de féminité, c'est de l'arnaque', *Le Monde*, 9 July 2017.

DeSalvo, Louise, and Mitchell Leaska, eds., *The Letters of Vita Sackville-West to Virginia Woolf*, London: Hutchinson, 1984.

Driscoll, Rosalyn, *The Sensing Body in the Visual Arts: Making and Experiencing Sculpture*, London: Bloomsbury, 2020.

Dey, Claudia, 'Mothers as makers of death', *Paris Review Daily*, 14 August 2018.

D'Souza, Aruna, *Whitewalling: Art, Race & Protest in 3 Acts*, Brooklyn, NY: Badlands Unlimited, 2020.

Durantaye, Leland de la, *Giorgio Agamben: A Critical Introduction*, Stanford, CA: Stanford University Press, 2009.

Eagleton, Terry, *The Ideology of the Aesthetic*, Oxford: Blackwell, 1990.

Epstein, Julia L., 'Writing the Unspeakable: Fanny Burney's Mastectomy and the Fictive Body', *Representations*, 16 (Autumn, 1986), pp. 131–66.

Eva Hesse, directed by Marcie Begleiter, 2016.

Fateman, Johanna, 'Last Days at Hot Slit: The Radical Feminism of Andrea Dworkin', *Last Days at Hot Slit* (2019), ed. Johanna Fateman and Amy Scholder, Los Angeles: Semiotext(e), 2021.

Finley, Karen, 'Karen Finley', *in Angry Women*, ed. Andrea Juno and V. Vale, New York: Re/Search Publications, 1991.

Ford, Colin, *Julia Margaret Cameron: A Critical Biography*, Los Angeles: J. Paul Getty Museum, 2003.

Forster, E. M., *Virginia Woolf*, Cambridge: Cambridge University Press, 1942.

4 Artists: Robert Ryman, Eva Hesse, Bruce Nauman, Susan Rothenberg, Michael Blackwood Productions, 1987.

Froula, Christine, *Virginia Woolf and the Bloomsbury Avant-Garde: War, Civilization, Modernity*, New York: Columbia University Press, 2005.

Frueh, Joanna, 'The Body Through Women's Eyes', in *The Power of Feminist Art: The American Movement of the 1970s, History and Impact*, ed. Norma Broude and Mary D. Garrard, New York: Abrams, 1994.

Fry, Roger, 'Mrs. Cameron's Photographs', in Virginia Woolf, Julia Margaret Cameron, Roger Fry, *Julia Margaret Cameron*, Los Angeles: J. Paul Getty Museum, 2018.

Fusco, Coco, 'Censorship, Not the Painting, Must Go: On Dana Schutz's Image of Emmett Till', *Hyperallergic*, 27 March 2017.

Garbasz, Yishay, with Vivian Sobchack, *Becoming*, New York: Mark Batty Publisher, 2010.

Gilbert, Sandra M., and Susan Gubar, *The Madwoman in the Attic: The Woman Writer and the Nineteenth-Century Imagination*, New Haven: Yale University Press, 1979, 2nd ed. 2000.

Gioni, Massimiliano, 'Interview with Carolee Schneemann', *Mousse Magazine* 48 (April–May 2015).

Glissant, Edouard, *Poetics of Relation* (1990), trans. Betsy Wing, Ann Arbor, MI: University of Michigan Press, 1997.

Gray, Channing, 'Earth Art', *Providence Journal Bulletin*, 21 April 1984.

Greene, Graham, review of *Three Guineas*, *Spectator*, 17 June 1938.

Grossberg, Lawrence, *We gotta get out of this place: conservatism and postmodern culture*, New York: Routledge, 1992.

Grosz, Elizabeth, 'The Body of Signification', in John Fletcher and Andrew Benjamin, ed., *Abjection, Melancholia, and Love: The Work of Julia Kristeva*, New York: Routledge, 1990, pp. 80–103.

Gumport, Elizabeth, 'The Long Exposure of Francesca Woodman', *New York Review of Books*, 24 January 2011.

Gurantz, Maya, '"Carl Broke Something": On Carl Andre, Ana Mendieta, and the Cult of the Male Genius', *Los Angeles Review of Books*, 10 July 2017.

Haenlein, Carl, ed., *Rebecca Horn: The Glance of Infinity*, Zurich: Kestner Gesellschaft, Scalo Verlag, 1997.

Hall, Stuart, 'Cultural Identity and Diaspora', *Identity, Community, Culture, Difference*, ed. Jonathan Rutherford, London: Lawrence & Wishart, 1990, pp. 222–37.

Haraway, Donna, 'The Promises of Monsters: A Regenerative Politics for Inappropriate/d Others', in Lawrence Grossberg, Cary Nelson, Paula A. Treichler, ed., *Cultural Studies*, New York: Routledge, 1991, pp. 295–337.

Haug, Kate, 'An Interview with Carolee Schneemann' (1998), in *Experimental Cinema: The Film Reader*, ed. Wheeler Winston Dixon and Gwendolyn Audrey Foster, London: Routledge, 2002, p. 175.

Heilbrun, Carolyn, *Writing a Woman's Life*, New York: Ballantine, 1989.

Hesiod, *Theogony*, in *The Homeric Hymns and Homerica*, trans. Hugh G. Evelyn-White, London: William Heinemann, 1914.

Heiser, Jorg, 'Inside Out: Maria Lassnig in conversation with Frieze co-editor Jörg Heise', *Frieze*, 2 November 2006.

Hesse, Eva, *Diaries*, ed. Barry Rosen with Tamara Bloomberg, Zürich : Hauser & Wirth, 2020.

Hessel, Katy, 'Natalie Lettner', *Great Women Artists* podcast, 28 July 2020.

Himid, Lubaina, 'Fragments', *Feminist Arts News* (2:8, Autumn 1988), pp. 8–9.

—*Thin Black Line(s)*, Newcastle-upon-Tyne: Making History Visible Project, Centre for Contemporary Art, UCLAN, 2001.

Hong, Cathy Park, *Minor Feelings: An Asian-American Reckoning*, New York: One World, 2020.

hooks, bell, *Teaching to Transgress: Education as the Practice of Freedom*, New York: Routledge, 1994.

Hopkinson, Amanda, *Julia Margaret Cameron*, London: Virago, 1986.

Horlock, Mary, 'Between a Rock and a Soft Place', in *Helen Chadwick*, ed. Mark Sladen, London and Ostfildern-Ruit: Barbican Art Gallery and Hatje Cantz Verlag, 2004.

Horn, Rebecca, *Rebecca Horn: Musée de Grenoble*, Grenoble: Réunion des Musées Nationaux, 1995.

'Housewives with Steak Knives – Sutapa Biswas', British Museum, promotional material for Tantra Exhibition, 28 November 2020.

Irigaray, Luce, 'When Our Lips Speak Together', trans. Carolyn Burke, *Signs*, 6:1 (Autumn 1980), pp. 69–79.

—*Speculum of the Other Woman* (1974), trans. Gillian C. Gill, Ithaca, NY: Cornell University Press, 1985.

James, Henry, 'Notes on Novelists' (1914), *Selected Literary Criticism of Henry James*, ed. Morris Shapira, London: Heinemann, 1963.

James, Nicholas, *Helen Chadwick: Of Mutability*, London: CV/VAR, 2011.

Januszczak, Waldemar, 'Invading Your Space', *Guardian*, 18 November 1987.

Jhala, Kabir, 'Sutapa Biswas: Our reckoning with empire has certainly begun, but we've only scratched the surface', *The Art Newspaper*, 24 June 2021.

Johnson, Claudette, 'Giving Space to the Presence of a Black Woman', Tate website, 25 May 2021.

Jones, Amelia, *Body Art/Performing the Subject*, Minneapolis, MN: University of Minnesota Press, 1998.

Jones, Amelia, ed., *Sexuality* (Whitechapel Documents in Contemporary Art), London: Whitechapel Gallery, 2014.

Jo Spence: Putting Ourselves in the Picture, BBC Arena, 1987.

Kalia, Ammar, 'The art of tantra: is there more to it than marathon sex and massages?', *Guardian*, 21 September 2020.

Kant, Immanuel, *Critique of the Power of Judgment* (1790), trans. Paul Guyer and Eric Matthews, Cambridge: Cambridge University Press, 2000.

Katz, Robert, *Naked by the Window: the Fatal Marriage of Carl Andre and Ana Mendieta*, New York: Atlantic Monthly Press, 1990

Keats, Jonathon, 'The Afterlife of Eva Hesse', *Art and Antiques*, April 2011.

Kennedy, Randy, 'White Artist's Painting of Emmett Till at Whitney Biennial Draws Protests', *New York Times*, 21 March 2017.

Kisner, Jordan, 'Kate Zambreno on Giving Birth as an Act of Decreation', *Literary Hub*, Thresholds podcast, 19 August 2020.

Kolocotroni, Vassiliki, Jane Goldman, Olga Taxidou, eds., *Modernism: an anthology of sources and documents*, Edinburgh: Edinburgh University Press, 1998.

Kramer, Jessica, 'Kara Walker Addresses Art and Controversy at the Newark Public Library', *Huffington Post*, 13 March 2013.

Kraus, Chris, *I Love Dick* (1997), Los Angeles: Semiotext(e), 2006.

—'Sex, Truths, and Videotape', *FEED Magazine*, 2000, repr. http://www.lightindustry.org/bluetape.

—'Supplement B: Ecceity, Smash and Grab, the Expanded I and Moment', *French Theory in America*, ed. Sylvère Lotringer and Sande Cohen, London: Routledge, 2013, pp. 303–8.

—*After Kathy Acker*, Los Angeles: Semiotext(e), 2018.

Krauss, Rosalind, *Bachelors*, Cambridge, MA: MIT Press, 1999.

Kristeva, Julia, *Powers of Horror: An Essay on Abjection*, trans. Leon S. Roudiez, New York: Columbia University Press, 1982.

Kuspit, Donald, 'Ana Mendieta, Autonomous Body', in Gloria Moure, ed., *Ana Mendieta*, Barcelona: Fundacio Antoni Tàpies; Santiago de Compostela: Centro Galego de Arte Coontemporanea, 1997.

LaCava, Stephanie, 'Interview with Carolee Schneemann', *Harper's*, 19 October 2017.

'Suzanne Lacy: Women Fight Back', SFMoMA, online.

Lamb, Mary, 'On Needlework' (1814), in Anne Gilchrist, *Mary Lamb*, Boston: Roberts Brothers, 1884, pp. 244–54.

Lassnig, Maria, '1000 Words', trans. Nick Somers and Alexander Scrimgeour, *Artforum*, Summer 2008.

—*Works, Diaries & Writings*, London: Koenig, 2015.

—*Film Works*, ed. Eszter Kondor, Michael Loebenstein, Peter Pakesch and Hans Werner Poschauko, Vienna: Austrian Film Museum with INDEX Edition, 2021.

Latimer, Quinn, *Like a Woman: Essays, Readings, Poems*, Berlin: Sternberg Press, 2017.

Leavis, Queenie, 'Caterpillars of the Commonwealth, Unite!' *Scrutiny*, September 1938.

Lee, Hermione, *Virginia Woolf*, London: Chatto & Windus, 1996.

'The Legacy of Helen Chadwick', panel discussion, Institute of Contemporary Art, 9 March 2016, online.

Levin, Erica, 'Dissent and the Aesthetics of Control: On Carolee Schneemann's *Snows*', *World Picture Journal*, 26 (Summer 2013).

Lippard, Lucy R., 'Interview with Judy Chicago', *Artforum*, 13 (1974), p. 62.

—'Transformation Art', *Ms.*, (Oct 1975), p. 34.

—*Eva Hesse* (1976), New York: Da Capo Press, 1992.

—*From the Center: Feminist Essays on Women's Art*, New York: E.P. Dutton, 1976.

—'What is Female Imagery?', *From the Center: Feminist Essays on Women's Art*, New York: E. P. Dutton, 1976, pp. 80–89.

—'Sweeping Exchanges: The Contribution of Feminism to the Art of the 1970s', in *Art Journal*, Fall/Winter 1980, pp. 362–5.

—*The Pink Glass Swan*, New York: The New Press, 1995.

Lispector, Clarice, *Água Viva* (1973), trans. Idra Novey, New York: New Directions, 2012.

Lorde, Audre, *The Cancer Journals* (1980), San Francisco: Aunt Lute Books, 1997.

—*Your Silence Will Not Protect You*, London: Silver Press, 2017.

MacColl, James E. and W. T. Wells, 'The Incitement to Disaffection Bill, 1934', *Political Quarterly* 5.3 (July 1934), 352–64.

MacDonald, Scott, 'Carolee Schneemann's Autobiographical Trilogy', *Film Quarterly*, 34:1 (Autumn, 1980), pp. 27–32.

—*A Critical Cinema 2*, Berkeley: University of California Press, 1988, pp. 135–51.

—*Avant-Doc: Intersections of Documentary and Avant-garde Cinema*, Oxford: Oxford University Press, 2015.

Mackenzie, Suzie, 'Under the Skin': interview with Jenny Saville, *Guardian*, 22 October 2005.

Marcus, Jane, *Art & Anger: Reading Like a Woman*, Columbus, OH: Ohio State University Press, 1988.

Marler, Regina, ed., *Selected Letters of Vanessa Bell*, London: Bloomsbury, 1993.

McBride, Jason. *Eat Your Mind: The Radical Life and Work of Kathy Acker*, New York: Simon & Schuster, 2022.

McCaffery, Larry, 'The Path of Abjection: An Interview with Kathy Acker', in *Some Other Frequency: Interviews with Innovative American Authors*, Pennsylvania Studies in American Fiction, Philadelphia: University of Pennsylvania Press, 1996.

McCormack, Catherine, *Women in the Picture: Women, Art and the Power of Looking*, London: Icon Books, 2021.

McEvilly, Thomas, 'Primitivism in the Works of an Emancipated Negress', in *Kara Walker: My Complement, My Enemy, My Oppressor, My Love*, ed. Philippe Vergne, Minneapolis, MN: Walker Art Center, 2007.

Michaels, Anne, *Infinite Gradation*, London: House Sparrow Press, 2017.

Milroy, Sarah, 'The Flesh Dress: A Defence', *Canadian Art* (1991).

Montano, Linda, 'An Interview with Ana Mendieta', in ' "Earth from Cuba, Sand from Varadero": A Tribute to Ana Mendieta', ed. Clayton Eshleman and Caryl Eshleman, *Sulfur* 22 (1988).

Moreland, Quinn, 'Forty Years of Carolee Schneemann's "Interior Scroll"', *Hyperallergic*, 29 August 2015.

Morrison, Toni, 'The Sites of Memory', *Inventing the Truth: The Art and Craft of Memoir*, ed. William Zinsser, Boston: Houghton, 1987, pp. 109–13.

Mrs Motherly, *Nursery Poetry*, London: Bell and Daldy, 1859.

Mullen, Harryette, *Sleeping with the Dictionary*, Berkeley and Los Angeles: University of California Press, 2002.

Mulvey, Laura, *Visual and Other Pleasures*, Basingstoke: Palgrave Macmillan, 2009.

Mulvey, Laura, and Peter Wollen, directors, *Riddles of the Sphinx*, BFI Films, 1977.

Myles, Eileen, 'Writing', in *I Must Be Living Twice: New and Selected Poems, 1975–2014*, New York: Ecco, 2015, p. 234.

Nead, Lynda, 'Representation, Sexuality, and the Female Nude', *Art History*, 6:2 (June 1983).

—*The Female Nude: Art, Obscenity and Sexuality*, London: Routledge, 1992.

Nelson, Maggie, *The Art of Cruelty: A Reckoning*, New York: W. W. Norton, 2011.

Nemser, Cindy, 'Interview with Helen Frankenthaler', *Arts*, November 1971, p. 51.

—'Lynda Benglis: A Case of Sexual Nostalgia', *The Feminist Art Journal*, Winter 1974–5.

—*Art Talk: conversations with 12 women artists*, New York: Scribner, 1975.

—Unpublished audio conversation between Hannah Wilke and Cindy Nemser, 1975, Cindy Nemser papers, Getty Institute, 3024629/2013 .M.21.

—'Conversation with Hannah Wilke, 1975' in *Hannah Wilke: Art for Life's Sake*, ed. Tamara Schenkenberg and Donna Wingate, Princeton, NJ: Princeton University Press, 2022.

Nixon, Mignon, *Eva Hesse*, Cambridge, MA: MIT Press, 2002.

Nochlin, Linda, *Women Artists: The Linda Nochlin Reader*, ed. Maura Reilly, New York: Thames & Hudson, 2015.

Notéris, Émilie, *Alma Matériau*, Paris: Paraguay Press, 2020.

Offill, Jenny, *Dept. of Speculation*, London: Granta, 2014.

Oransky, Howard, ed., *Covered in Time and History: The Films of Ana Mendieta*, Berkeley: University of California Press, 2015.

Osterweil, Ara, 'Bodily Rites: the Films of Ana Mendieta', *Artforum*, November 2015.

Parker, Rozsika, and Griselda Pollock, *Old Mistresses: Women, Art and Ideology* (1981), London: I. B. Tauris, 2013.

Patmore, Coventry, *The Angel in the House: the Betrothal*, London: John W. Parker and Son, 1854.

Peabody, Rebecca, *Consuming Stories: Kara Walker and the Imagining of American Race*, Oakland, CA: University of California Press, 2016.

Penrose, Antony, *The Lives of Lee Miller* (1985), London: Thames & Hudson, 2021.

Perreault, John, 'The Materiality of Matter', *Village Voice*, 28 November 1968.

Philips, Claude, *Daily Telegraph*, 17 April 1914.

Pliny, *Natural History,* vol. 7, trans. W. H. S. Jones, Cambridge, MA: Harvard University Press, 1956.

Pollock, Griselda, 'Feminism and Modernism', in Rozsika Parker and Griselda Pollock, eds, *Framing Feminism: Art and the Women's Movement 1970–85*, London: Pandora, 1987.

—'Tracing Figures of Presence, Naming Ciphers of Absence' (1998), reprinted in *Lumen*, pp. 49–73, p. 52.

Pollock, Griselda, and Vanessa Corby, eds., *Encountering Eva Hesse*, Munich: Prestel, 2006.

Princenthal, Nancy, *Hannah Wilke*, Munich: Prestel, 2010.

—*Unspeakable Acts: Women, Art, and Sexual Violence in the 1970s*, New York: W. W. Norton, 2019.

Racz, Imogen, 'Helen Chadwick's *Of Mutability*: process and postmodernism', *Journal of Visual Art Practice* 16:1 (2017), pp. 61–76.

Ramayya, Nisha, Sandeep Parmar and Bhanu Kapil, *Threads*, London: Clinic Publishing, 2018.

Reclaiming the Body: Feminist Art in America, Michael Blackwood Productions, 1995.

Redzisz, Kasia, and Lauren Barnes, 'Introduction: The Body Decides', in *Maria Lassnig*, ed. Kasia Redzisz and Lauren Barnes, catalogue for Tate Retrospective, London: Tate Publishing, 2016.

Reilly, Maura, 'A Dialogue with Linda Nochlin, the Maverick She', in Linda Nochlin, *Women Artists: the Linda Nochlin Reader*, ed. Maura Reilly, London: Thames & Hudson, 2015.

Respini, Eva, in conversation with Christopher Ehlers, 'Banalities, Absurdities, and Anxieties', *Dig Boston*, 29 August 2017.

Rich, Adrienne, 'The Burning of Paper Instead of Children', *The Will to Change* (1971), in *Collected Poems, 1950–2012*, ed. Pablo Conrad, New York: W. W. Norton, 2016.

—*On Lies, Secrets, and Silence: Selected Prose 1966–1978*, New York: W. W. Norton, 1979.

—*Blood, Bread, and Poetry: Selected Prose 1979–1985*, New York: W. W. Norton, 1986.

—*Arts of the Possible: Essays and Conversations*, New York: W. W. Norton, 2001.

Robertson, Lisa, *Nilling: Prose Essays on Noise, Pornography, the Codex, Melancholy, Lucretius, Folds, Cities, and Related Aporias*, Toronto: Book*hug Press, 2012.

Rose, Phyllis, 'Milkmaid Madonnas', in Sylvia Wolf, *Julia Margaret Cameron's Women*, New Haven, CT: Yale University Press, 1998.

Ross, Christine, 'Redefinitions of abjection in contemporary performances of the female body', *Res 31* (Spring 1997), pp. 149–56.

Roth, Moira, ed., *The Amazing Decade: Women and Performance Art in America, a source book*, Los Angeles: Astro Artz, 1983, p. 20.

Ruefle, Mary, *Madness, Rack, and Honey: Collected Lectures*, New York: Wave Books, 2012.

Russo, Mary, *The Female Grotesque: Risk, Excess, and Modernity*, New York: Routledge, 1995.

Saltz, Jerry, 'Making the Cut: Kara Walker, Wooster Gardens', *Village Voice*, 24 November 1998.

Saar, Betye, 'Influences', *Frieze* 182 (September 2016).

Salomon, Nanette, 'Judging Artemisia: a Baroque Woman in Modern Art History', in *The Artemisia Files: Artemisia Gentileschi for Feminists and*

Other Thinking People, ed. Mieke Bal, University of Chicago Press, 2005, pp. 57–8.

Sayej, Nadja, 'Betye Saar: the artist who helped spark the black women's movement', *Guardian*, 30 October 2018.

Schneemann, Carolee, *Up to and Including Her Limits*, New York: C. Schneemann, 1973–6.

—'The Obscene Body/Politic', *Art Journal* 50:4 (Winter 1991), pp. 28–35.

—*More Than Meat Joy: Performance Works and Selected Writings*, ed. Bruce McPherson, Kingston, NY: Documentext/McPherson & Company, 1979, 1997.

—*Imagining Her Erotics: Essays, Interviews, Projects*, Cambridge, MA: MIT Press, 2002.

—(transcribed by Raegan Truax-O'Gorman) 'Regarding Ana Mendieta', *Women & Performance*, 21:2 (2011), pp. 183–90.

—'Maria Lassnig, 1919–2014', *Artforum*, 1 October 2014.

Schoelder, Amy and Douglas A. Martin, eds., *Kathy Acker: The Last Interview*, Brooklyn, NY: Melville House, 2018.

Schor, Mira, 'Backlash and Appropriation', *The Power of Feminist Art: The American Movement of the 1970s, History and Impact*, eds. Norma Broude and Mary D. Garrard, New York: Abrams, 1994.

Scott, Joyce Wallace, *Entwined: Sisters and Secrets in the Silent World of Artist Judith Scott*, Beacon, MA: Beacon Press, 2016.

Scott, Judith and Joyce Wallace Scott, 'Entwined', *Granta* 140: 13 October 2017.

Sedgwick, Eve Kosofsky, *Tendencies*, Durham, NC: Duke University Press, 1993.

—*Touching Feeling: Affect, Pedagogy, Performativity*, Durham, NC: Duke University Press, 2002.

Schwartz, Barbara, 'Young New York Artists', *Crafts Horizon* (October 1973), p. 50.

Silver, Brenda, 'The Authority of Anger: "Three Guineas" as Case Study', *Signs: Journal of Women in Culture and Society*, 16:2 (1991), pp. 340–70.

Simpson, Lorna, *Give Me Some Moments*, Gallery exhibition, Hauser & Wirth New York, 2019.

Sirius, R. U., 'Kathy Acker: Where Does She Get Off?' *io* 2 (1994) http://www.altx.com/io/acker.html.

Sladden, Mark, ed., *Helen Chadwick*, London: Barbican Gallery, 2004.

Smith, Sidonie, *Subjectivity, Identity, and the Body: Women's Autobiographical Practices in the Twentieth Century*, Bloomington: Indiana University Press, 1993.

Smith, Zadie, 'What Do We Want History to Do to Us?', *New York Review of Books*, 27 February 2020.

Solnit, Rebecca, 'If I Were a Man', *Guardian*, 26 August 2017.

Sontag, Susan, 'Against Interpretation', in *Against Interpretation and Other Essays*, NY: Farrar, Straus & Giroux, 1966.

—*Illness as Metaphor*, New York: Farrar, Straus & Giroux, 1977.

—*Regarding the Pain of Others*, New York: Farrar, Straus & Giroux, 2003.

Spalding, Frances, *Vanessa Bell: Portrait of the Bloomsbury Artist* (1983), London: I. B. Tauris, 2016.

—'Vanessa, Virginia, and the Modern Portrait', in *Vanessa Bell*, ed. Sarah Milroy and Ian A. C. Dejardin, London: Dulwich Picture Gallery, 2017, pp. 64–71.

Spence, Jo, *Cultural Sniping: the Art of Transgression*, London: Routledge, 1995.

Spillers, Hortense J. 'Mama's Baby, Papa's Maybe: An American Grammar Book', *Diacritics*, 17:2 (Summer 1987), pp. 64–81.

St Augustine, *The City of God Against the Pagans*, ed. R. W. Dyson, Cambridge: Cambridge University Press, 1998/2010.

St Félix, Doreen, 'Kara Walker's Next Act', *New York Magazine*, 17 April 2017.

Stryker, Susan, 'My Words to Victor Frankenstein above the Village of Chamonix', in *The Transgender Studies Reader*, ed. Susan Stryker and Stephen Whittle, New York: Routledge, 2006, pp. 244–56.

Tani, Ellen Y., 'Keeping Time in the Hands of Betye Saar', *American Quarterly*, 68:4 (Dec 2016), pp. 1081-1109.

Tawadros, Gilane, 'Beyond the Boundary: the Work of Three Black Women Artists in Britain', *Third Text*, 3:8-9 (1989), pp. 121–50.

Tickner, Lisa, 'Vanessa Bell: Studland Beach, Domesticity, and "Significant Form",' *Representations* 65 (Winter, 1999), pp. 63–92.

Tomkins, Calvin, 'The Materialist', *New Yorker*, 27 November 2011.

—'Why Dana Schutz Painted Emmett Till', *New Yorker*, 3 April 2017.

Urbina, Ian, 'The Challenge of Defining Rape', *New York Times*, 11 October 2014.

Venturi, Riccardo, 'Genieve Figgis: Almine Rech Gallery, Paris', *Artforum*, April 2018.

Viegener, Matias, *The Assassination of Kathy Acker*, New York: Guillotine Press, 2018.

Vigarello, Georges, *The Silhouette: From the 18th Century to the Present Day*, trans. Augusta Dörr, London: Bloomsbury, 2012.

Walker, Hamza. 'Cut It Out', essay accompanying a Kara Walker exhibition at the Renaissance Society, University of Chicago, January–February 1997, reprinted in *NKA: Journal of Contemporary African Art* (Fall/Winter 2000), pp. 108–13.

Walker, Kara, 'The Way I See It', BBC Radio 3, 2 December 2019.

Warner, Marina, *Forms of Enchantment: Writing on Art & Artists*, London: Thames & Hudson, 2018.

—*Helen Chadwick, The Oval Court*, London: Afterall Books, 2022.

White, Duncan, *Expanded Cinema: Art, Performance, Film*, London: Tate Publishing, 2011.

Who's Afraid of Kathy Acker?, directed by Barbara Caspar, 2008.

'White Painting (1951)', Robert Rauschenberg Foundation website.

Wilke, Hannah, *Hannah Wilke: A Retrospective*, ed. Elisabeth Delin Hansen, Kirsten Dybbøl, and Donald Goddard, Copenhagen: Nikolaj, Copenhagen Contemporary Art Center, 1988.

—*Hannah Wilke 1940–1993*, Berlin: Neue Gesellschaft für Bildende, 2000.

Willis, Deborah, and Carla Williams, *The Black Female Body: a photographic history*, Philadelphia, PA: Temple University Press, 2002.

Wisor, Rebecca, 'About Face: The *Three Guineas* Photographs in Cultural Context', *Woolf Studies Annual*, vol. 21 (2015).

Woolf, Virginia, *To the Lighthouse* (1927), New York: Harcourt Brace & Company, 1981.

—*A Room of One's Own*, New York: Harcourt, 1929.

—'Speech before the London/National Society for Women's Service, January 21 1931', *The Pargiters*, ed. Mitchell Leaska, New York: Harvest/HBJ, 1977.

—*Three Guineas* (1938), ed. Jane Marcus, New York: Harcourt, 2006.

—*The Diary of Virginia Woolf, Vol. 4: 1931–35*, ed. Anne Olivier Bell and Andrew McNeillie, New York: Harcourt Brace Jovanovich, 1983.

—*The Diary of Virginia Woolf, Vol. 5: 1936–41*, ed. Anne Olivier Bell and Andrew McNeillie, Harmondsworth: Penguin, 1985.

—*The Letters of Virginia Woolf, Vol. 1: 1888–1912*, ed. Nigel Nicholson and Joanne Trautmann, New York: Harcourt Brace Jovanovich, 1979.

—*The Letters of Virginia Woolf, Vol. 4: 1929–1931*, ed. Nigel Nicholson and Joanne Trautmann, New York: Harcourt Brace Jovanovich, 1979.

—*The Letters of Virginia Woolf, Vol. 6: 1936–41*, ed. Nigel Nicolson and Joanne Trautmann Banks, London: Hogarth Press, 1980.

—*The Essays of Virginia Woolf, Vol. 4: 1925–28*, ed. Andrew McNeillie, New York: Harcourt, 1994.

—*The Essays of Virginia Woolf, Vol. 5: 1929–1932*, ed. Stuart Clarke, Boston: Houghton Mifflin Harcourt, 2010.

—*The Essays of Virginia Woolf, Vol. 6: 1933–1941*, ed. Stuart N. Clarke, London: Hogarth Press, 2011, pp. 479–84, p. 481.

—*The Moment & Other Essays*, San Diego: Harcourt Brace Jovanovitch, 1974.

—*Moments of Being (1972)*, ed. Jeanne Schulkind, New York: Harcourt Brace Jovanovich, 1985.

—Monk's House Papers, B16.f, vol 2, University of Sussex, accessed via *The Three Guineas Reading Notebooks*, ed. Vara Neverow and Merry M. Pawlowski, hosted by Southern Connecticut State University.

Viso, Olga, ed. *Unseen Mendieta: The Unpublished Works of Ana Mendieta*, Munich: Prestel, 2008.

Wilson, Judith, 'Ana Mendieta Plants Her Garden', *Village Voice*, 13–19 August 1980.

X, Rosie, 'Interview with Kathy Acker', *Geekgirl*, in 'Deleted material from *Kathy Acker: The Last Interview*', Melville House website, 10 March 2019.

Yureshin, Yasmin, 'Reworking Myths: Sutapa Biswas', reprinted in *Visibly Female, Feminism and Art: an Anthology*, ed. Hilary Robinson, London: Camden Press, 1987, p. 37; originally in *Spare Rib*, December 1986.

Zegher, Catherine de, ed., *Eva Hesse Drawing*, New Haven, CT: Yale University Press, 2006.

acknowledgements

It is a primary concern of feminism to ensure parents have access to sufficient childcare, and that carers receive the recognition and compensation they deserve. This book would not exist without the people who looked after my son while I wrote: thank you, Helen Bretherton, Viktória Szeidl, and the staff at Blackburne House in Liverpool and at the *halte garderie* Club des Petits Gavroches in Paris.

Parts of the section about Rebecca Horn were published in an earlier incarnation in *Frieze Masters*. Thanks to Jennifer Higgie for commissioning me. Some of the writing on Woolf and *The Pargiters* originated as a paper given at the Woolf and Translation conference at the Sorbonne Nouvelle in 2015; my thanks to Claire Davison and Catherine Lanone for the invitation to speak. Part of the writing on Lynda Benglis, Carolee Schneemann, and Hannah Wilke appeared in an essay on *Aeon*; thank you to Marina Benjamin for asking me to do something, and for the impeccable and inspiring editing. Some of the writing on Vanessa Bell appeared in a *Guardian* piece on the exhibition at the Dulwich Picture Gallery in 2017; thank you, Charlotte Northedge, for the assignment.

The writing of this book during the pandemic was assisted by the Société des Gens de Lettres, whose support made a huge difference at a very difficult moment, as well as by the *fonds de solidarité* from the French government. *Merci infiniment*. This book was also supported by a grant from the Silvers Foundation.

Special thanks to the staff and guards at the INHA at the Bibliothèque nationale in Paris for their help, patience, and kindness during a very trying time, and to everyone at the Sydney Jones library at the University of Liverpool for fulfilling my many book orders, interlibrary loan requests, and later returns, and for tolerating my propensity to borrow books and then skip town. Thank you to whoever runs

aaaaarg, you have saved me so many times when I couldn't get to a library, whether because of lockdown or lack of childcare.

Warm gratitude as well to Tony Penrose, Matias Viegener, Robert Winter, Jason McBride, Barbara Caspar, Women Make Movies, Marsie Scharlatt of the Hannah Wilke Collection & Archive who went above and beyond to make this a better book, Nancy Princenthal, Karen Wilkin, the Getty Center Research Institute, Marcie Begleiter, Grace Hong at Galerie LeLong, the estate of Ana Mendieta, Rebecca Horn, Annika Karpowski at the Galerie Thomas Schulte, Jenny Saville, the Gagosian Gallery, Lorna Simpson, the estate of Laura Knight, the Maria Lassnig Foundation, Claudette Johnson, Hollybush Gardens, the Jo Spence Memorial Archive, Jessica Ledwich, the estate of Eva Hesse, Hauser & Wirth, Steven Dearden and the Liverpool Central Library, Kara Walker and Sikkema Jenkins & Co., the estate of Theresa Hak Kyung Cha, Laura Graziano at the UC Berkeley Art Museum and Pacific Film Archive, the Woodman Family Foundation, Leon Borensztein, the estate of Helen Chadwick and Richard Saltoun Gallery, Vara Neverow for generous assistance accessing the *Three Guineas* reading notebooks, everyone at DACS, Lynda Benglis, Nicole Root, and everyone at the Benglis studio, Rachel Churner at the Schneemann Foundation and Lotte Johnson at the Barbican for their expertise and generosity, and Karen Di Franco who kindly showed me Carolee Schneemann's *Cézanne, She Was a Great Painter* when I couldn't track down a copy that didn't cost $600, and borrowed books from the library for me, delivering them in Paris when we were both there for work. And deepest gratitude to Cecilia Mackay, the most astounding, magical, and devoted picture researcher, without whom this book would be a pale shadow of itself.

Thank you, Alba Ziegler-Bailey, who was there reading and telling me to keep writing even when I didn't know what this was, which was most of the time, and my deep gratitude to Sarah Chalfant, Emma Smith, Ekin Oklap, Alexandra Christie, Katie Cacouris, and Kristina Moore at the Wylie Agency.

To Clara Farmer, Charlotte Humphery, Kaiya Shang, Jessica Spivey, Graeme Hall, and Annie Lee at Chatto/Vintage, and to Ileene Smith, Ian Van Wye, and Na Kim at Farrar, Straus and Giroux, thank you. And a massive thank you to the brilliant Amanda Waters at Chatto,

who came on board at a crucial moment in the life of this project and saw just what it needed to take its final shape.

I owe thanks to so many thoughtful friends and colleagues, who talked with me, advised me, inspired me, read pages, gave me places to write, and were generous in innumerable ways: Patricia Allmer, Katherine Angel, Jo Applin, Jacquelyn Ardam, Jenn Ashworth, Susan Barbour, Sutapa Biswas, Adèle Cassigneul, Christen Clifford, Amanda Dennis, Stacey D'Erasmo, Allison Devers, Karen Di Franco, Seb Emina, Merve Emre, Philomena Epps, Elisabeth Fourmont, Deborah Friedell, Felicity Gee, Geoff Gilbert, Sinéad Gleeson, Imogen Greenhalgh, Anne Haeming, Alyssa Harad, David Hering, Lubaina Himid, Annabelle Hirsch, Vlatka Horvat, Mark Hussey, Julie Kleinman, Michael Kurcfeld, Emily LaBarge, Stephanie LaCava, Helen Legg, Natasha Lehrer, Deborah Levy, Anne Marsella, Courtney J. Martin, Douglas A. Martin, Catherine McCormack, Cécile Menon, Jean Mills, Sam Mirlesse, Ben Moser, Sandeep Parmar, Antony Penrose, Griselda Pollock, Róisín Quinn-Lautrefin, Lisa Robertson, Anna Backman Rogers, Derek Ryan, Shannon Smith, Sabrina Stent, Jayne Tuttle, Francesca Wade, Joanna Walsh, Marina Warner, Emily Wells, and the truly tremendous Tremendous Women of WhatsApp who sustained me throughout the pandemic.

Particular thanks to Anna Backman Rogers and Shannon Smith, who valiantly read the first draft in its entirety when it was far too long and digressive, and offered me invaluable advice about how to focus and move forward, and to Joanna Scutts and Alyssa Harad for rigorously and sensitively reading its next incarnation with such patience, generosity, and insight.

My family, as ever, give me an abundance of love and support and patience and I am so grateful to them – love and thanks to the Elkins, Eisners, and Hackbarths.

To Julien, who will one day read about all the things his mother was contemplating as he took shape in her body, and when she wasn't feeding and nurturing and cuddling him (and even, often, when she was). Merci chaton for keeping me company throughout all of this.

And finally to Ben, who writes the music while I write the words, you are my love and the safeguard of my sanity. I couldn't do this with anyone else.

index

Page numbers in *italics* refer to illustrations.

A Note About the Author

Lauren Elkin's essays have appeared in many publications, including *The New York Times*, *The Guardian*, *Frieze*, and *The Times Literary Supplement*. Her book *Flâneuse* was named a notable book of 2017 by *The New York Times Book Review* and was a finalist for the PEN/Diamonstein-Spielvogel Award for the Art of the Essay. A native New Yorker, she lived in Paris for twenty years and now resides in London.